Nostalgia and
Videogame Music

Studies in Game Sound and Music

Series editors: Melanie Fritsch, Michiel Kamp, Tim Summers, and Mark Sweeney

Intellect's Studies in Game Sound and Music publishes accessible, detailed books that provide in- depth academic explorations of topics and texts in video game audio. Titles in this series present detailed analysis, historical investigation, and treatment of conceptual and theoretical issues related to game audio.

The series does not seal game audio into a scholarly suburb but is instead outward-looking: it seeks to engage game audio practitioners and researchers from a range of disciplines, including anthropology, performance studies, computer science, media studies, psychology, sociology, and sound studies, as well as musicology.

Titles in the series:
The Legend of Zelda: Ocarina of Time by Tim Summers
Nostalgia and Videogame Music: A Primer of Case Studies, Theories, and Analyses for the Player-Academic edited by Can Aksoy, Sarah Pozderac-Chenevey, and Vincent E. Rone
The Music of Nobuo Uematsu in the Final Fantasy *Series* edited by Richard Anatone

Nostalgia and Videogame Music

A Primer of Case Studies, Theories, and Analyses for the Player-Academic

EDITED BY

Can Aksoy, Sarah Pozderac-Chenevey, and Vincent E. Rone

Bristol, UK / Chicago, USA

First published in the UK in 2022 by
Intellect, The Mill, Parnall Road, Fishponds, Bristol, BS16 3JG, UK

First published in the USA in 2022 by
Intellect, The University of Chicago Press, 1427 E. 60th Street,
Chicago, IL 60637, USA

A catalogue record for this book is available from
the British Library.

Copy editor: MPS Limited
Cover designer: Aleksandra Szumlas
Production manager: Laura Christopher
Typesetter: MPS Limited

Print ISBN (h/bk) 978-1-78938-551-9
Print ISBN (p/bk) 978-1-78938-585-4
ePDF ISBN 978-1-78938-552-6
ePUB ISBN 978-1-78938-553-3

Part of the Studies in Game Sound and Music series
ISSN: 2633-0652 / Online ISSN: 2633-0660

To find out about all our publications, please visit our website.
There you can subscribe to our e-newsletter, browse or download our current
catalogue and buy any titles that are in print.

www.intellectbooks.com

This is a peer-reviewed publication.

Contents

Dedication and Acknowledgments

To my sister, Stacey E. Perrone, the first person I played videogames with.

—Vin

To Aurélie, my Family, and everyone else who understands that gaming is high art.

—Can

To Amelia and Naomi.

—SPC

Vin: I have endless admiration and gratitude for Tim Summers, Will Gibbons, and Steven Reale for their advice, encouragement, and help getting this project rolling—we hope to do you and the field proud. Jelena Stanovnik, Laura Christopher, and the Intellect staff were exceptionally hospitable and courageous for investing in and supporting this project, especially through the throes of the COVID-19 pandemic. To all the authors involved in this project, thank you for your flexibility and trust. Thanks to my dear "frenemy" Michael Vitalino for collaborating with me on our chapter and for reading other drafts when you did not have to. I learned a lot from our writing together. To Andrew and my Godson AJ Bucci for lending me their encyclopedic knowledge of videogames—I knew those hours playing were not wasted! My beloved nieces Emma and Ava rekindled my love for videogames. Thank you for spending time with your crazy uncle playing *Zelda* until we could not see straight (we'll get Rocco started soon!). Our time together ultimately led to this book. To Vincent Sr., Margaret, Stacey, and Susan for their love and patience listening to me talk about this topic as if they were as interested in it as much as I. Finally, Can and Sarah believed in this project enough to join me on this adventure. You both kept me sane and never ceased to teach me things every time we spoke. We make a great team, and it would not have been possible without you two. Thank you so much.

Can: I want to first thank my wife Aurélie Chevant-Aksoy, who provided invaluable, patient support as an editor, muse for good ideas, and creator of concrete phrasing for abstract concepts. I also thank my parents, Asuman and Ercument Aksoy, who are delighted that buying me *Final Fantasy VII* as a child has resulted in academic research. Finally, I want to express gratitude to my co-editors Vincent

and Sarah. It was an absolute privilege to collaborate with both of you and I cannot wait for our next project together.

Sarah: Many thanks to Houghton Library at Harvard University and the New York Public Library for allowing me to use their images in my essay. To the staff at the Jim Crow Museum of Racist Memorabilia, thank you for your work identifying and dismantling racist stereotypes. To the attendees of the very first North American Conference on Video Game Music, thank you for the feedback on the presentation that would eventually result in my essay on *BioShock Infinite*, and to all the members of the ludo community, thank you for contributing to such an encouraging timbre within our field. I owe a deep debt of gratitude to Diane Dingler, who told me about the racist history of Dan Emmett and "Dixie" right alongside the theory and technique she taught me during voice and piano lessons in Mount Vernon, OH. To my brothers, Jon and Matt, thank you for being right beside me as I explored scary dungeons and old wells. To Benjamin, my husband, the best teammate I could imagine, thank you for your encouragement, thoughtful discussion, and willingness to aid in videogame footage capture, which have been essential to my research. And finally, to Vin, who suggested this project and brought the three of us editors together, and to Can, who gamely jumped into our field and contributed so much of his experience and insight, thank you—I have learned so much from both of you.

Introduction

Vincent E. Rone

> *My past is not a memory. It's a force at my back. It pushes and steers. I may not always like where it leads me, but like any story, the past needs resolution. What's past is prologue.*
>
> —Samus, *Metroid: The Other M*

A consequence of today's videogame industry is the design of its products pointing to the future and the past simultaneously. Regarding the former, the sophisticated visual graphics of the latest game suggest cutting-edge technology and the drive among companies to develop the next great thing for consumers. The increasing technological sophistication of games allows players to immerse themselves in complex worlds, which can indicate progress and the future. Regarding the latter, anyone familiar with the vast repertoire of videogames knows they provide opportunities to reflect on and even simulate the past. Videogames can recreate visual and aural markers of historical periods, for example. To that point, videogames provide something far deeper for players, sites of nostalgic memory. Players and academics increasingly have become aware of the role nostalgia plays in videogames since at least 2008, noting that our past experiences as players shape our analyses of games.[1] Academic literature thus began to articulate what so many players and fans already knew. That is why, in 2022, it sounds like a no-brainer that videogames can provoke nostalgia. Many games from the early 2000s onward contain allusions and references to their 1980s and 1990s ancestors, suggesting those who grew up playing those earlier videogames have grown into nostalgic adults, the so-called "Nintendo Generation" of players. More importantly, however, videogames put those who engage with them in a theoretically self-conscious position. Videogames invite fans to tread into academic realms to understand more deeply the relationship

[1] Taylor and Whalen make this claim in their pioneering work, "Playing the Past: An Introduction," in *Playing the Past*, 4, 6.

between their playing experiences and nostalgia, a crossover that potentially blurs the distinction between players and academics. Videogames thus have entered a postmodern moment in which they display their relationship to nostalgia.

Videogame music, or VGM, plays an essential role in this relationship, and the time is ripe to address it. This book consciously gives a platform for readers who see (or may wish to see) themselves as situated between the player/fan and academic separation I mentioned above. These player-academics "do" ludomusicology and have an advantageous position to consider the complex relationship between nostalgia and VGM. Such a conversation considers nostalgia as a methodological tool to understand VGM and how the former can result from the latter. Music itself already has a widely recognized ability to provoke a strong longing for the past. For instance, Svetlana Boym, perhaps *the* voice of nostalgia studies, refers to music as a memorative sign, "the permanent accompaniment of nostalgia—its ineffable charm that makes the nostalgic teary-eyed and tongue-tied and often clouds critical reflection on the subject."[2] Psychologist Clay Routledge asserts music increases autobiographical recall, as well as the social and emotional connectedness among those who share music-based nostalgia, and he explains how the emotions inspired by music also influence how people perceive nostalgia.[3] Moreover Sandra Garrido, Jane W. Davidson, and Lauren Istvandity all discuss the concept of "the lifetime soundtrack," whereupon people create and curate repertories of music integrated into their memories, interpersonal relationships, and the past. Such works indicate the close, mutually informing relationship nostalgia has with music.[4] Yet the player-academics writing for this anthology believe said relationship amplifies tenfold when examined through the lens of ludomusicology.

To initiate this conversation, this book makes two central claims. First, we believe VGM has a special relationship with nostalgia, where the former can provoke the latter more powerfully than other components of videogames. Second, we also believe nostalgia provides a necessary tool—both theoretical and practical—to understand how VGM affects those who engage with it. Anyone who has played a videogame knows the difficulty or at least the impracticality of avoiding music altogether without turning off the volume or music/sound. Players also repeatedly encounter music in a wide range of contexts. During gameplay, sometimes the music repeats on an endless loop in a wall-to-wall scenario; at other times, the music closely adapts to player interactivity. Such prevalence makes the

[2] Boym, *The Future of Nostalgia*, 4.

[3] Routledge, *Nostalgia: A Psychological Resource*, 40–41, 54–55.

[4] Garrido and Davidson, *Nostalgia, Music and Memory*, 1–3, 29–43; Istvandity, *The Lifetime Soundtrack*.

music hard to forget. Some tunes lodge themselves into our memories so firmly that they demand future action, like an itch that needs scratching.[5] Once those catchy melodies take up residence in our minds, we hum them, program them into our cell phones as ringtones, download soundtracks, search for remixes and covers on OCRemix or Spotify, attend concerts, and create or perform musical arrangements. Players and fans saturate their lives with VGM because of its high degree of emotional associativity. One or two notes can trigger deeply moving memories of the past almost immediately, and players also report having intensely personal and subjective connections to videogames and their music. But it is not just reflective. VGM also invites engagement and demands present action to scratch the itch.

In short, players, fans, and academics know quite well that VGM functions as a powerful carrier of nostalgia. For example, look up the soundtrack to an iconic game on YouTube and glance at the comment section—contributors just gush about how this or that music track cues some treasured memory of a videogame. To that end, we editors model the opening of this book with the approach many ludomusicologists take—as certainly many player-academics do throughout the following pages—the personal heuristic. Can Aksoy, Sarah Pozderac-Chenevey, and I provide brief personal histories to connect with readers who may have had analogous experiences with videogames and their music. More importantly, we do so to demonstrate that discourses about nostalgia cannot be wholly objective and necessitate subjectivity to a degree. These heuristics invite readers to use this book to help them make (better) sense of their experiences with videogames and their music, ones they may treasure or consider vital to their identities. Those experiences necessarily come to the fore when theorizing nostalgia and videogames themselves.

Can Aksoy writes how:

Videogame music was the first musical genre I felt I discovered on my own. Like many kids born in the '80s, my week orbited around Friday afternoon visits to a now extinct, yet then ubiquitous *Blockbuster* video rental store. Renting a game was my reward for finishing homework and surviving another grueling piano lesson that I never managed to practice enough for. Most games I rented featured a sound test function in the options menu where you could play all the game's music. Accordingly, every Sunday, I transformed my bedroom into a videogame recording studio. I first posted 8 × 10 flyers that said "QUIET—RECORDING IN PROCESS" with a picture of a red lightbulb, then set up set up my Casio boom box to tape game

[5] The itch-scratch metaphor borrowed with gratitude from Alexander Nunes, whose work appears later in this volume.

themes emerging from my crusty, two-knob TV. I would then cover each tape's jacket sleeve with drawings of the game's characters. I treasured this collection. When I was not rocking out to them on my Walkman, I stored these recordings in a padded sleeve that I still have today. As an adult, I am still subsumed by nostalgic memories whenever I hear these songs. Tracks like *Sonic the Hedgehog's* "Green Hill Zone" floor me with a bittersweet longing for a time when my days revolved around school being out and my only worry was accruing rental-store late fees.

Can's childhood description pictorializes 1990s American popular culture. Block-buster, Casio boom boxes, knobbed/tube televisions, cassette tapes, and Sega's *Sonic the Hedgehog*—all these things amount to what Netflix, LED TVs, MP4s, and the Playstation 5 might suggest to today's (and tomorrow's) fans. Can focalizes childhood, simpler times, and the process of collecting tunes for his everyday enjoyment, as opposed to centralizing his memories around a specific game.

As for me,

my friends Andrew, Chris, Dan, Juan, Larry, Leann, and I met at my house several times a week to play *The Legend of Zelda: Ocarina of Time* in 1999. The game's soundtrack quickly became crucial to my experience and memories because, as a musician, being able to "play" the Ocarina was a game changer. *Ocarina's* music had it all—ambience, atmosphere, catchy melodies, seductive soundscapes. I regularly improvised ocarina melodies like "Serenade of Water" and "Song of Time" on the piano and used to wander in the Forest Temple just to listen to the music. We still talk about those summer days with *Zelda*.

In 2010, I introduced my nieces Emma and Ava to *Twilight Princess*. Andrew and his son AJ brought it over one day, and the five of us played what felt like all night. I rediscovered how closely *Twilight Princess* resembled *Ocarina of Time*, especially in terms of music. The music of *Twilight Princess* vividly cued all the memories I had with my friends from 1999. Thereafter, Emma, Ava, and I made *Twilight Princess* our weekly bonding experience during my winter and summer breaks from UC Santa Barbara. Just like I did in *Ocarina of Time's* Forest Temple, Emma and Ava wandered in Ordon Village of *Twilight Princess* to listen to the music of Link's initial home. I also played that track for them on the piano. We still send each other YouTube links and text messages with *Zelda* themes and talk about how much fun we had playing *Twilight Princess* together.

At 19 years old, I encountered *Ocarina of Time* in 1999 with my best friends. At 30, I reignited my love of games with *Twilight Princess* in 2010 with my nieces. And now, at 41, part of my intellectual identity is bound to understanding how nostalgia and VGM work together, having already published a few articles about it. Even so, I never reflected on how much these experiences could help me strengthen important

relationships in my life, over that stretch of time, and at such different stages in my life. That is, until I began this book project.

I emphasize the continuity and maintenance of important relationships centered around a shared site of nostalgic and emotional significance, *Zelda* and its music. I connected the experiences of my early 20s to those in my 30s and again into my 40s. My story, I think, counters the prevailing narrative that suggests people start forming relationships with videogames much earlier in life.

Finally, Sarah Pozderac-Chenevey has

fond memories of several games, but *The Legend of Zelda: Ocarina of Time* was the defining game of my childhood. In a way, it set me on the path that led to this book! My brothers and I spent summers running around the woods, wielding sticks and practicing our jump attacks as we pretended to be Link. *Twilight Princess* was released while I was an undergrad, and I spent Saturdays sitting in a folding chair (the cord for my GameCube controller didn't reach the couch) enjoying the musical references to *Ocarina of Time*. I became curious about how these potent nostalgia triggers might change how the game was perceived, so I employed my now-husband as a case study, since he had never played any other *Zelda* games. I quizzed him about his experiences in *Twilight Princess* in the hopes of figuring out if the game was somehow different if it were experienced in musical isolation.

The single most important thing about *Ocarina of Time*, though, was that it made me believe that girls could play videogames. Even as a ten-year-old child, I had absorbed the stereotype that videogames were for boys. But when I found the Kokiri sword before my brothers and gained access to the Great Deku Tree, I knew that videogames were for me, too. Every musical allusion to *Ocarina of Time* in every *Zelda* game I have played since then carries with it nostalgia for my childhood and memories of that feeling of empowerment.

Now I am a mom, and as I introduce my oldest daughter to some of my favorite game franchises, I experience a mixture of nostalgia for my own childhood and curiosity about what her nostalgia for these games will be like. When she played *Pokémon: Let's Go Pikachu!*, the music and sound effects sent me back to sixth grade and catching all 151 on my Blue version. What will the music of *Animal Crossing: New Horizons* evoke in her twenty years from now?

Sarah initially struggled with what many female players have faced—typically male gatekeepers who try to restrict who qualifies as a "gamer," thus the bitter. But she won in the end; that's pretty sweet and the source of her nostalgia. VGM played a fundamental role in the content of our memories, and it likely allowed us to recall them in more detail than if it were absent. Our stories, we hope, invite readers to

contemplate the nostalgic potential of VGM and the relationships it allows them to form. We therefore have designed the following pages to help readers perceive this potential along the way, a map of sorts for those who wish to take this journey.

The subjectivity underpinning the engagement with memories, however, points to the complexities nested in any attempts at theorizing or defining nostalgia efficiently. Contributing to such difficulties lies the notion that nostalgia is so personal that those who experience it subconsciously can assume its universality. Yet that is also why people often fumble when called to define nostalgia. Consequently, studies of nostalgia often are plagued with decentralized, diffuse methodologies and equally fuzzy neologisms. The chameleon-like elusiveness of nostalgia led Boym to deem it as not belonging to any one discipline,[6] for it intersects with psychology, neuroscience, history, literature, economics, popular culture, art, and music to name a few. People furthermore treat nostalgia at any given time as symbol, process, act, emotion, object, state of mind, or any combination thereof (and even interchangeably). Jilly Boyce Kay, Cat Mahoney, and Caitlin Shaw put it best, suggesting nostalgia's definitions "are vast, contended, and often contradictory, and the pluralization of its potential meanings must be acknowledged when considering its relationship to mediation."[7] There is no one correct way to describe a phenomenon paradoxically so widely felt but deeply personal. Attempting to smooth out this apparent polarity into a methodological tool can become quite messy and poses some challenges:

1. Nostalgia's conflicted past.
2. Historical ambivalence toward nostalgia and videogames in academia.
3. How many nostalgias are there? A preponderance of taxonomies and types.

This introduction presents an overview of each challenge, which the following essays address more fully. Importantly, each player-academic writing for this volume notes how nostalgia has been manifesting itself in ludomusicology since there was a term for the academic field.

Challenge no. 1: Nostalgia's conflicted past

Who are you, that do not know your history?

—Ulysses, *Fallout New Vegas*

[6] Boym, *The Future of Nostalgia*, xvii.
[7] Kay, Mahoney, and Shaw, "Introduction," 5.

The use of nostalgia to investigate VGM requires much conceptualization and theorizing, a symptom of a larger issue in nostalgia studies. Those who write about nostalgia, especially in the humanities, feel compelled to relay its checkered past before theorizing into the future. The discussion of this first challenge therefore presents two broad narrative themes about the history of nostalgia, which inevitably will surface and intertwine throughout this book. First, return and turning back. Johannes Hofer invented the term "nostalgia" in 1688 to define a neurological disorder of homesickness among soldiers and their desire to return to their homes.[8] Some player-academics writing in this anthology theorize nostalgia with metaphors referring to these original contexts. Although this medical understanding lasted until the 1900s, nostalgia began a long transitional phase from pathology to cultural aesthetic in Europe and North America throughout the nineteenth century. In the early 1800s, Friedrich Schiller's medical treatments of nostalgia included the active and free associations of ideas, therapeutic exposure to the pastoral countryside, and the reliving of childhood memories.[9] The domains where nostalgia was understood to operate, mental turmoil and lost homeland, gradually shifted to exterior sensuous relief and memory. Videogames and their music align much more smoothly with the latter pair than they do with the former.

A similar change occurred in societal attitudes toward nostalgia. Nineteenth-century thinkers regarded nostalgia as having to do with the body and time,[10] a critical theme in facilitating present-day study of videogames as enactments of returning and turning back. The growing emphasis of nostalgia's associations with somatic triggers and memories of a past irretrievable may account for why the phenomenon became so closely associated with the work of Marcel Proust. In his 1913, "A la recherché du Temps Perdu," Proust theorizes nostalgia by reminiscing about how the taste of a madeleine cookie transported him to childhood experiences at his aunt's home. The conceptual pinballing of nostalgia led to its de-medicalization and consequently broadened the possibilities of understanding it as far more dynamic and widespread than previously considered: pain for some, pleasure for others—thus, the bittersweet. The historical understanding of nostalgia as rooted in bodily, sensory triggers enables readers to understand how VGM cues autobiographical memory through aural markers—somatic stimuli—amplified further by the physicality of gameplay. This narrative thread necessarily focuses on the terminological and associative conditions of nostalgia through which readers can delve more deeply into their relationships with VGM.

[8] Anspach, "Medical Dissertation on Nostalgia by Johannes Hofer, 1688," 376–91.

[9] Austin, *Nostalgia in Transition*, 1–14.

[10] Lowenthal, *The Past Is a Foreign Country*, 48.

The second thread, crystallizing nostalgia through objects, deals more closely with how fans and players often regard videogames and their music as consumable materials, which emerges from nostalgia's origins. The diffuse past of nostalgia has influenced the widespread production of nostalgic objects. For example, by the 1920s and 1930s, Western society generally settled on nostalgia as something of a wistful looking back to a bygone era against the backdrop of World War I and the Great Depression. This general characteristic facilitated the application of nostalgia to almost all parameters of life, thus allowing it to function as a sort of coping mechanism against historical traumas. Connotations of nostalgia therefore became more uniform while its signifiers expanded rapidly.[11] This propensity has only intensified due to the American predilection to commodify and consume the past in the form of objects.[12] A contemporary example of such past attitudes occurs in the AMC series *Mad Men* (2007–15), specifically the first season finale. The titular character Don Draper begins a sales presentation by talking about the delicate potency of nostalgia and the bond it allows buyers to form with a product. He then unveils a Kodak wheel-shaped slide projector, affectionately titled "The Carousel," and begins a slide show highlighting key moments of his life moving backward in time. Amid these images, Don calls the Carousel a time machine, something that allows us to travel like a child would and visit places "we ache to go again ... where we know we're loved." Sure enough, his colleagues, some misty-eyed, feel the nostalgic tug at their heart strings by the conclusion of the presentation.[13] Although set within a fictional story, the *Med Men* example illustrates some important characteristics of nostalgia. First, it connotes a longing for the past. Second, Don's words point to the interrelatedness of nostalgia, treasured memories, and positive emotions. Finally, "The Carousel" projector symbolized people's ability to localize their nostalgia into tangible objects. Almost anything could induce nostalgia—foods, trinkets, art, architecture, film, music, and recently videogames.

By the 1970s, the crystallization of nostalgia through objects had become a highly lucrative industry,[14] right around the time videogames entered the popular-culture scene. Artists and capitalists positioned nostalgia as a driving force behind manufacturing and marketing products, which exploited people's obsession with previous eras. Apropos of readers here, the recent historic crises of 9/11, the War

[11] Sprengler, *Screening Nostalgia*, 19–23.

[12] Sprengler, *Screening Nostalgia*, 28; Lowenthal, *The Past Is a Foreign Country*, 32–33.

[13] Weiner and Weith, *Mad Men*, "The Wheel."

[14] Sprengler, *Screening Nostalgia*, 28–29. See also Fenty's regard for videogames as "objects of nostalgia," in "Why Old School Is Cool," 24–28.

in Iraq, the 2008 Great Recession, and COVID-19 have reified predilections for nostalgia. How many of us throughout 2020 and 2021, for example, yearned for pre-coronavirus days or projected nostalgically into the future as to what life might be like if COVID-19 no longer posed a threat? We poignantly reflected on things we took for granted: Gathering in large groups, going to performances, singing in choirs, and entering public spaces without a second thought ... or face mask. Nostalgia allows us to mitigate the anxieties of the present with the old, the authentic, the past, and even a simulated future. For these reasons, nostalgia is very "in" and has manifested itself visibly in the hot market of retro-themed merchandise.[15] Developers of Nintendo since at least the 2006 debut of the Wii, for example, repackaged classic game characters and their music from the 1980s and 1990s. Although nostalgia offers a good investment, the caveat of milking of old tropes and the recycling of beloved themes can risk annoyed groans from a once rapt fan base. This frequently occurs with the excessive number of reboots, remakes, prequels, and sequels that inundate film and videogame industries. Despite such potential drawbacks, videogames and their music serve as objects by which new players can instantiate nostalgic relationships, while veteran players can look back longingly to their gaming pasts.

Challenge no. 2: Historical ambivalence toward nostalgia and videogames in academia

Stay a while, and listen!

—Deckard Cain, *Diablo II*

In addition to a conflicted past marked by shifting definitions, nostalgia garnered negative connotations among the intelligentsia between the 1970s and early 2000s, which presented some comparisons and implications for videogames and their music. The intellectual consensus about nostalgia amounted to suspicion and subjected it to sharp postmodern deconstruction, owing to the apparent connection nostalgia has with reactionary politics and capitalist material production. On the one hand, academia categorized nostalgia with mechanisms to perpetuate—even glorify—racism, sexism, and other forms of historical discrimination. The rose-colored glasses of nostalgia easily could lead people to prioritize "the good old days," which likely were neither as good as they remember nor universally good for everyone. People could manipulate nostalgia to falsify the

[15] Lowenthal, *The Past Is a Foreign Country*, 52–54.

past, exploit emotions for profit, and prevent historical continuity.[16] Brent Ferguson, T. J. Laws-Nicola, Jessica Kizzire, and Sarah Pozderac-Chenevey all tackle these issues throughout their chapters. Moreover, the postmodern deconstruction of nostalgia beginning in the 1970s parallels almost all too well the shaky grounds on which games and videogames shortly thereafter entered academic discourse. The most typical studies of videogames had to do with the correlation between play and aggressive, violent behavior.[17] On the other hand, nostalgia seemed to exemplify some cynical postmodern theories. For instance, nostalgia fit Jean Baudrillard's notions of simulation and the hyper-real, where everything is artificial.[18] Fredric Jameson also wrote most scathingly about nostalgia as a hopeless looking backward, an unfortunate consequence of the search for meaning through pastiche and artificial euphoria. In practice, Jameson's diagnosis led to skeptical regard for nostalgia's presence in cultural and artistic media. He provides an example, the nostalgia film, which he dismisses as a "hack" genre.[19] It is not difficult to see how the terms *simulation*, *hyper-real*, *pastiche*, and *artificial euphoria* can apply to videogames and their music perhaps even more apparently than they can to nostalgia, as evidenced by Justin Sextro's chapter. Perhaps the relationship these postmodern terms have to nostalgia and VGM may explain in part why the latter two seem to occupy so much social but not much academic discourse. Because of such postmodern critiques, however, academics sat ill at ease with analyzing nostalgia, as well as with its overall utility.

Case in point, the postmodern ambivalence toward nostalgia appears in music scholarship, as well, which may explain why the field has treated the topic quite thinly. Ironically, the elements for researching nostalgia's connection to music exist within the fields of musicology and music theory.[20] The study of affect deals with music's relationship with emotion, and research into semiotics investigates the different ways music can refer to something outside itself, which almost always requires a sense of musical memory. Even outside postmodern scholarship, fans frequently search for musical clues in their favorite media. These usually take

[16] Lowenthal, *The Past Is a Foreign Country*, 31.

[17] Feshbach and Singer, *Television and Aggression*; Friedrich-Cofer and Huston, "Television and Violence," 364–71; Anderson and Bushman, "Effects of Violent Video Games," 353–59.

[18] Baudrillard, *Simulacra and Simulation*, 75–78, 121–28.

[19] Jameson, *Postmodernism*, 19, 279–98.

[20] Theodor Zwinger remarked on Swiss soldiers' susceptibility to (pathologized) nostalgia at the sound of a "certain rustic cantilena" in 1710, and Jean-Jacques Rousseau expanded on this idea in his *Complete Dictionary of Music*. Both quoted in Kangas, "Classical Style, Childhood, and Nostalgia," 222.

the form of leitmotifs—musical phrases that refer to a specific person, object, or idea—a subject Can Aksoy's chapter treats in greater depth. The presence of leitmotifs in a new trailer for a film or game, for example, provokes almost immediate speculation about who or what might appear. Even so, postmodern scholarship of musical nostalgia has been limited, tending to focus on a specific composer or even single work, such as Ryan R. Kangas's work on Gustav Mahler's Fourth Symphony. Nostalgia's characteristic slipperiness and the prestige of "absolute music," that which (supposedly) deals with nothing outside itself, both likely have contributed to this lacuna.[21] Music scholarship still waits for an explicitly theorized application of nostalgia, and we editors believe the subfield of ludomusicology has the strongest shot at doing so.

In fact, we believe videogames and their music have contributed to and can help explain the explosion of nostalgia studies within the last twenty years. Moreover, videogames exemplify popular culture's unslakable appetite for nostalgia. Players co-script their virtual experiences, which chart the unfolding of a journey that encodes itself into autobiographical memories, constituting a type of lived experience. Players recollecting their experiences then can shape part of their identities. VGM in turn accompanies this process and makes those memories even more indelible and retrievable. For these reasons, videogames constitute formidable postmodern carriers for nostalgia, complex primary texts in which parts of the past are built into their design and music. This proposition has become so widespread that the academy has begun to make room for significant discourse, which likely would not have been possible without two groundbreaking works. First, Espen Aarseth recasts videogames not as entertainment programs but as texts requiring significant effort to interpret in his 1997 book *Cybertext: Perspectives on Ergodic Literature*.[22] Next comes a book any aspiring ludomusicologist should know: *Game Sound: An Introduction to the History, Theory, and Practice of Video Game Music and Sound Design* (2008) by Karen Collins, a pivotal work that theorizes game sound and music with immersion, as well as somatic and affective triggers.[23] These two works arguably provide the foundational texts for ludology and ludomusicology, respectively. They also enable videogames to share the same conceptual space as affective states, relationship-building, and emotional investment, which paved the way for studies like this one.

Academic texts since the 2010s, however, lay further groundwork for analyzing nostalgia with videogames and their music, located in the burgeoning "retro"

[21] See Botstein, "Memory and Nostalgia."

[22] Aarseth, *Cybertext*, 13–17.

[23] Collins, *Game Sound*.

studies subfield. Works like *Retromania: Pop Culture's Addiction to Its Own Past* by Simon Reynolds (2010), Mark Fisher's *Ghosts of My Life: Writings on Depression, Hauntology and Lost Futures* (2014), and Jean Hogarty's *Popular Music and Retro Culture in the Digital Age* (2019) observe nostalgia as a cultural motivator of aesthetic and consumable art.[24] And the profitability of "retro" has led scholars to adopt consumer theories in their discussions—a central theme in Sebastian Diaz-Gasca's chapter—which can explain the perception that the lucrative commercialization of nostalgia in VGM concerts may save the symphony orchestra.[25] Retro studies help clarify the tension between players' love of the past reflected in lasting objects amid rapid, inexorable technological advancement and the nigh-immediate obsolescence of previous technologies left in its wake. Understanding videogames and their music in this capacity might not have been possible without academia's positive recasting of nostalgia, one that attracted player-academics with a wide toolbox of methodological skills. Both nostalgia studies and ludomusicology have emerged within the past twenty-ish years; yet, at the time of this writing, they have barely crossed paths.

Challenge no. 3: How many nostalgias are there? A preponderance of taxonomies and types.

You are in a maze of twisty passages, all alike.

—*Zork I: The Great Underground Empire*

Nostalgia and VGM both presuppose intensely subjective experiences that facilitate overlap and mutual informing. Although subjectivity once presented a liability in academic circles, postmodernism has made room for the study of these two topics by categorizing the subjective experience as an epistemology. On the surface, the relationship between nostalgia and VGM relies heavily on subjective discourse, as the opening heuristics of this introduction suggest. This book readily acknowledges and accepts subjective positioning but also recognizes it requires the counterbalance of traditional, empirical methods of inquiry. An honest discussion about the fraught and delicate topic of nostalgia needs a careful balance between the subjective and objective. This is all to say that any epistemology examining nostalgia or its application to other disciplines present neither a fully accurate nor a

24 Reynolds, *Retromania*; Fisher, *Ghosts of My Life*; Hogarty, *Popular Music and Retro Culture*.

25 Needleman, "How Videogames Are Saving the Symphony Orchestra."

completely flawed account, and no one discipline can tell the whole story. Ludomu-sicologist Tim Summers provides an apt parallel to the plurality of methodologies required to analyze VGM.[26] In short, nostalgic readings of texts demand nuanced theorizations. Many theorists accordingly chip away at this challenge through one of two general approaches, which will become apparent in the pages ahead.

Player-academics working on nostalgia and VGM often emulate the approaches other scholars have used to discuss and categorize the former. First, some strive to make the slippery concept of nostalgia graspable through strict definitions, param-eters, and features. Psychologists generally regard nostalgia as an emotion that includes bitter and sweet affective states and measure it through psychometrics and personality study.[27] Similarly, neuroscientists like Frederick Barrett and Petr Janata refer to nostalgia as an affective state and use such measurement techniques to record the effects of music-based nostalgia.[28] Other social scientists theorize nostalgia by examining its role in patterns of consumption, behaviors, or present subcultures. For example, Morris Holbrook and Robert Schindler define nostal-gia as a preference toward objects common to someone's past within business and marketing purviews. Such a broad application, they write, "covers any and all liking for past objects that, for whatever reason, are no longer commonly experi-enced."[29] Notably, this framework of preference expands connotations of nostalgia beyond affect to include behavior. Regarding videogames, Laurie M. Taylor and Zach Whalen define nostalgia similarly as active processes of looking back to the past, trying to bring that past into the present, and bringing knowledge of the past to bear on the present and the future.[30] Strict definitions of nostalgia offer some foundational understanding of the phenomenon and facilitate discourse about how people perceive, experience, and talk about it. Indeed, some authors in this book adopt one, empirically derived definition of nostalgia as a methodological frame to discuss VGM, an example being the following chapter by Michael Vital-ino and me. Such an exacting approach relieves player-academics of the burden of theorizing nostalgia every time they write about it because they must get to the content of videogames and music—and all the other necessary subcategories of each requiring their attention.

[26] Summers, "Analysing Video Game Music: Sources, Methods and a Case Study."

[27] Castelnuovo-Tedesco, "Reminiscence and Nostalgia"; Kaplan, "The Psychopathology of Nostalgia"; Routledge, *Nostalgia*; Werman, "Normal and Pathological Nostalgia."

[28] Barrett and Janata, "Neural Responses to Nostalgia-Evoking"; Frederick S. Barrett et al., "Music-Evoked Nostalgia."

[29] Holbrook and Schindler, "Echoes of the Dear Departed Past."

[30] Taylor and Whalen, "Playing the Past: An Introduction," 3.

Second, the more frequently used approach entails creating taxonomies reflected in the several nostalgia types within the literature, many of which appear in essays of this book. Multidisciplinary voices hybridize scientific, social, and personal narratives, and they often present encyclopedic lists of possible nostalgic types. Examples of some taxonomies include Fred Davis's triple-ordered nostalgia in his landmark 1979 sociological study: *simple nostalgia* considers the past as better, simpler, and more desirable than the present; *reflexive nostalgia* demands people to question the truthfulness, authenticity, and accuracy of nostalgic claims via self-examination; and *interpreted nostalgia* allows people to objectify the nostalgia they feel by "raising analytically oriented questions concerning its sources, typical character, significance, and psychological purpose."[31] Another popular taxonomy focuses on the nostalgia people feel for their own past versus a past they never experienced, generally *personal* and *historical* nostalgias.[32] Finally, Boym offers the most famous taxonomy: *restorative* and *reflective* nostalgias, respectively, the active desire to recreate the past versus the passive longing for the past.[33] This brief sampling points to but a fraction of nostalgia types scholars have advanced and the disciplines required to construct its taxonomies. That's A LOT to keep track of!

The current state of the literature appears well primed for a ludomusicological perspective. The methods player-academics bring with them can help clarify and even richly texture how nostalgia operates within videogames and their music. In fact, this volume argues that ludomusicology itself, a multidisciplinary subfield of musicology and media studies, arose partly because of nostalgia. Nostalgia tied to VGM runs rampant within online periodical literature, blogs, comment threads, and fan reception, but its structural presence in ludomusicology proper has been comparatively thin. Among the outliers, William Gibbons recognizes nostalgia as contributing to his larger arguments. His recollection of playing *Zelda II* in *Unlimited Replays: Video Games and Classical Music* relies on nostalgic memory, as does his account with Stephen Reale in the introduction to *Music in the Role-Playing Game: Heroes and Harmonies*.[34] Other authors have written article-length studies about nostalgia and VGM, three of whom contribute to this

[31] Davis, *Yearning for Yesterday*, 18–24.

[32] Davis, *Yearning for Yesterday*, 8, 222; Lowenthal, *The Past Is a Foreign Country*, 4–6; Garrido and Davidson, *Nostalgia, Music and Memory*, 32–37; Tom Vanderbilt, "The Nostalgia Gap," *The Baffler*.

[33] Boym, *The Future of Nostalgia*, 41–56.

[34] Gibbons, *Unlimited Replays*, 1–3; Gibbons and Reale, "Prologue," 4–5.

volume: Jessica Kizzire, Sarah Pozderac-Chenevey, and myself.[35] Finally, Andra Ivănescu's *Popular Music in the Nostalgia Videogame: The Way It Never Sounded* has provided the first book-length study examining nostalgia and VGM. She theorizes player nostalgia for gaming's classic era through analysis of *nostalgia games*, contemporary games intentionally styled to look like those of the past,[36] not unlike what Jonathan Waxman and Reba Wissner discuss in their chapters. Aside from these examples, nostalgia has increasingly become an "elephant in the room" in ludomusicological circles. It stands on the precipice of becoming a term as widely adopted and theorized as, say, immersion or interactivity. But it just needs a little nudge out the door.

To that point, ludomusicologists have offered a sort of meta-cognitive reflection on the field, one that sees nostalgia as gradually moving away from the periphery and closer to central discussions. The premier issue of the *Journal of Sound and Music in Games* (Winter 2020) features a colloquy of four prominent scholars who investigate the benefits and dangers of VGM canons. That a discipline so young can address the topic of canon(s) attests to its rapid ascendancy in the academy and the high degree of self-awareness among its scholars. More importantly for this book, however, two of the four contributors suggest nostalgia informs the creation and curation of canons within ludomusicology. William Gibbons opens the colloquy by examining canon formation through live orchestral concerts of VGM. He mentions nostalgia playing an important role in which historical narratives about videogames and their music emerge as dominant.[37] Julianne Grasso follows by discussing how "musical practices around video games shore up the lived experiences of play," which unsurprisingly includes memory.[38] She examines fan-based musical arrangements of *The Legend of Zelda* themes as both processes and statements about the emotional affect of remembering play, a stone's throw away from nostalgia proper. The latter two essays by Hyeonjin Park and Karen Cook focus less on nostalgic motivations and more on the challenges posed by canon formation on inclusivity.[39] Moreover, the topics raised by Gibbons, Grasso, Park, and Cook also appear throughout the chapters of this book, respectively, by Elizabeth Hunt, Alexander Nunes, Brent Ferguson and T. J. Laws-Nicola, and

[35] Kizzire, "The Place I'll Return to Someday"; Pozderac-Cheveney, "A Direct Link to the Past"; and Rone, "Twilight and Faërie."

[36] Ivănescu, *Popular Music in the Nostalgia Videogame.*

[37] Gibbons, "Rewritable Memory," 75–77.

[38] Grasso, "On Canons as Music and Muse," 83.

[39] Park, "The Difficult, Uncomfortable, and Imperative Conversations," 87–94; Cook, "Canon Anxiety?" 95–99.

Sarah Pozderac-Chenevey. Given the overlap of ideas from differing perspectives, it becomes clear that nostalgia informs fundamental ideas within ludomusicology. We in this book wish to take this notion even further, to explode this moment by positing nostalgia itself as a fundamental idea within the discipline, not an auxiliary one. We attempt to give it that nudge.

Facing the challenges—The map and compass

It's dangerous to go alone, take this!

—Old Man, *The Legend of Zelda*

Accordingly, then, this volume acts as a primer of case studies, theories, and analyses in response to the preceding challenges. We player-academics position nostalgia centrally by attaching it to a variety of other concepts and disciplines and forging hybridized frameworks. This strategy, nonetheless, proved difficult in the making because we use frameworks from other fields not tailored to games or their music. The frameworks thus fit roughly and needed more leg work to show how one concept connects to nostalgia, which connects to videogames and their music, which connects back to the initial concept, and so on. Throughout the gestation of this book, Can, Sarah, and I quickly realized the essays demanded player-academics who can connect *several* dots. We authors did not have the luxury of drawing from tidy, definitive theoretical concepts and had to dirty our hands, stretch our minds, and play with ideas—pun intended, of course.

The plural disciplinary approaches we adopted have permitted us to synthesize voices and created unified narratives. On a global level, we have gained experiential knowledge and have formed emotional connections with games and their music, a crucial contribution of the media itself. Videogames and their music offer sites of identity and relationship forming, bonding, escapism, and confidence-building. We also have reached ages where the rigor of our intellectual training allows us to see perspective and critical distance from those necessary emotional moments. On a local level, however, we were obliged to provide more background information than might strike as standard for chapter- (and introduction-) length pieces. We typically had to describe the game, its music, components of its gameplay, and other details insofar as such information facilitates theoretical frameworks or the instantiation of nostalgia. We also had to decide from which perspectives, scholars, and definitions of nostalgia to draw. Consequently, all authors theorized nostalgia to a substantial degree before applying it to the VGM context(s) they wished to emphasize.

More importantly, the chapters throughout this anthology raise, (re)frame, and respond to epistemological questions about nostalgia and VGM. How the authors do so dictate their placement within the volume. The first part, Articulating Nostalgia and Videogame Music, offers foundational, overarching concepts that can apply to the rest of the anthology, as well as further study in the broader intellectual and fan communities. The first two chapters pick up where this introduction leaves off by laying the conceptual groundwork for nostalgia and VGM in greater detail. Michael Vitalino and I provide a psychological and neuroscientific reading of nostalgia. We then present examples as to how musical cues during videogame play can induce nostalgia and how it interacts with larger concepts within game studies. In other words, we attempt to track how nostalgia comes about in the brain through exposure to VGM during play. Sebastian Diaz-Gasca's chapter accounts for the other side of the coin. He theorizes nostalgia and VGM beyond gameplay, which he examines primarily through the lenses of consumption and commodification. Thus, he coins the term *paraludical consumption*, engaging with VGM "outside the game." While several authors throughout this book coin terms designed to give future scholars the tools to advance the body of knowledge within this field, these two essays offer some tools to do so.

The authors of the second part, Objectifying Nostalgia and Videogame Music, explain the origin of musical artifacts and entire events related to videogames and their music through nostalgia. Elizabeth Hunt takes on the commercialization of nostalgia as it relates to the wildly popular symphonic performances of VGM, namely *Video Games Live*, *The Legend of Zelda: Symphony of the Goddess*, and *Pokémon: Symphonic Evolutions*. She discusses how symphony orchestras use nostalgia to curate VGM repertoires from a body of games that have become Proustian symbols of childhood. Next, Can Aksoy examines videogame leitmotifs that provoke nostalgia. When videogames commodify nostalgic references into a form of gameplay entertainment, he argues, they expel players from fully immersing in virtual experiences. Aksoy then explains how leitmotifs reverse this antipathy between a videogame's intentional nostalgic references and immersion. By studying leitmotifs in *Final Fantasy* games, his work theorizes how a nostalgic leitmotif can act as a mnemonic device that increases gameplay immersion. This conclusion has the potential to speak to broader musicological circles. Jonathan Waxman tracks the rise of a new type of game through nostalgic artifacts in which fans remember bad cult movies fondly for their badness. In this production, fans celebrate badness in games or movies coalesced through nostalgic engagement. These essays comment most closely on the notion of crystallizing nostalgia through objects and the artistic, capitalistic implications discussed above.

In the third part, Subjectifying Nostalgia and Videogame Music, authors focus less on the material manifestations of nostalgia and more on its relationship to the

subjective and the abstract. This focus manifests in authors foregrounding different frameworks of nostalgia—the preponderance of taxonomies and types—and hybridize terms to arrive at new definitions of or perspectives about nostalgia. Alexander Nunes theorizes *liminal nostalgia* as emerging from moments where players gain musical literacy within *The Legend of Zelda* series. The "playing" of melodies via the controller in *Ocarina of Time* constitutes liminality, the threshold between the real and the virtual, which triggers nostalgia. He argues that covers of VGM provide the metaphorical scratch to the itch instantiated by liminal nostalgia in gameplay. Reba Wissner discusses music's functions within point-and-click games and proffers an *inter-media nostalgia*. She argues that *The Twilight Zone: The Game* maintains the aural aesthetic of the original television show of the 1950s and 1960s. Rather than immersing players into fully constructed virtual worlds, point-and-click games facilitate immersion through repeated playthroughs and allow players to absorb musical markers of the show through osmosis. Justin Sextro's essay investigates how *EarthBound* uses quotes, references, and samples of popular music, themselves nostalgic markers, while simultaneously parodying JRPG conventions. The soundtrack, he maintains, creates an imaginary American suburban soundscape where nostalgia shapes the game narrative and engages with the lived experiences of players. These chapters test the boundaries of existing definitions of nostalgia and focus overall on the subjectivity necessary for the nostalgia to occur.

Finally, authors in Confronting Nostalgia and Videogame Music theorize ways to evaluate real history and examine historically pernicious applications of nostalgia, a correlation to the historical ambivalence with which academia has regarded the topic. Brent Ferguson and T. J. Laws-Nicola focus on three types of nostalgia present in music videos within the JRPGs: *retro nostalgia* in *Rhythm Heaven Fever*, *episodic (Proustian) nostalgia* in *Yakuza 0*, and *future nostalgia* in *Omega Quintet*. Each music video promotes the commercial success of the game but also allows a look into oppressive social and gender structures within the current hyper-capitalistic Japanese society. Jessica Kizzire argues for nostalgia as a form of historical consciousness in her chapter about *Fallout 3*. Her reading of aural markers in carefully curated popular and patriotic songs within the game's alternative timeline reveals two applications of nostalgia. On the one hand, the popular music situates players within mid-century American aesthetics. On the other hand, the patriotic songs ironically demonstrate the politicization of nostalgia to mobilize restoration, to get back to "the way things were." Finally, Sarah Pozderac-Chenevey reveals how *BioShock Infinite* repeatedly challenges players to confront historical racism of early twentieth-century America and the nostalgia it produced. She argues that musical depictions of racism surface in the form of minstrelsy and related imagery. Such markers call to mind the historical racism of the US and the dangers inherent

to the nostalgia that often fuels dangerous ideologies. Although this book accepts nostalgia as beneficial, authors of this section warn against the very real effects of its abuse from ethical and historical standpoints.

Postscript

The ending isn't any more important than any of the moments leading to it.
—Dr. Rosalene, *To The Moon*

Throughout our compiling this book, Can, Sarah, and I have learned that most authors discuss nostalgia in relation to equally fuzzy terms within game scholarship including immersion, liminality, transmediation, interactivity, and so on. These relatively new terms possess neither the universality nor the longevity in the collective mind as nostalgia. Discerning readers of this volume will see how we authors adopt such concepts as fundamental to understanding nostalgia's relationship to VGM. Moreover, the following chapters demonstrate how those concepts, with the addition of the widely theorized leitmotif, overlap with the mechanisms by which players and fans of VGM experience music-based nostalgia. We also hope this volume balances the representation between standard, canonic titles versus cult classics, niche, and lesser-known gems. Recalling the previous section, we editors believe the qualities of this book poise it to comment meaningfully on the state of research within ludomusicology and how its scholars have moved beyond attempts to legitimize the field within academia.[40]

This project also has reinforced anew what we player-academics—and most likely all manner of players—have experienced from the get-go: videogames demand commitments of time, energy, and emotion. They draw us into their worlds, which range from basic point-and-click scenes to sophisticated Tolkienesque virtual worlds. In that regard, VGM functions much like film music but with the added complexities of dynamism and responsiveness to player input. No other medium can possess or claim such a capability. For these reasons, we hope readers will regard the affective potential of VGM as perhaps the most powerful way to experience music-based nostalgia other than learning and playing an instrument. The elusive phenomenon of nostalgia can provide a fruitful, extremely rewarding (and fun!) way to understand videogames and their music more deeply. With map and compass in hand, the journey begins.

[40] Thanks to both peer-review readers who flagged this point independently of each other.

BIBLIOGRAPHY

Aarseth, Espen J. *Cybertext: Perspectives on Ergodic Literature*. Baltimore: The Johns Hopkins University Press, 1997.

Anderson, Craig A., and Brad J. Bushman. "Effects of Violent Video Games on Aggressive Behavior, Aggressive Cognition, Aggressive Affect, Physiological Arousal, and Prosocial Behavior: A Meta-Analytic Review of the Scientific Literature." *Psychological Science* 12, no. 5 (October 2001): 353–59.

Anspach, Carolyn Kiser. "Medical Dissertation on Nostalgia by Johannes Hofer, 1688." *Bulletin of the Institute of the History of Medicine* 2, no. 6 (August 1934): 376–91.

Austin, Linda M. *Nostalgia in Transition: 1780–1917*. Charlottesville: University of Virginia Press, 2007.

Barrett, Frederick S., and Petr Janata. "Neural Responses to Nostalgia-Evoking Music Modeled by Elements of Dynamic Musical Structure and Individual Differences in Affective Traits." *Neuropsychologia* 91 (2016): 234–46.

Barrett, Frederick S., Kevin J. Grimm, Richard W. Robins, Tim Wildschut, Constantine Sedikides, and Petr Janata. "Music-Evoked Nostalgia: Affect, Memory, and Personality." *Emotion* 10, no. 3 (2010): 390–403.

Baudrillard, Jean. *Simulacra and Simulation*. Translated by Sheila Faria Glaser. Ann Arbor: University of Michigan Press, 1994.

Botstein, Leon. "Memory and Nostalgia as Music-Historical Categories." *The Musical Quarterly* 84, no. 4 (Winter 2000): 531–36.

Boym, Svetlana. *The Future of Nostalgia*. New York: Basic Books, 2001.

Castelnuovo-Tedesco, Pietro. "Reminiscence and Nostalgia: The Pleasure and Pain of Remembering." In *The Course of Life: Psychoanalytic Contributions Toward Understanding Personality Development: Vol. III: Adulthood and the Aging Process*, edited by S. I. Greenspan and G. H. Pollack, 115–28. Washington, DC: US Government Printing Office, 1980.

Collins, Karen. *Game Sound: An Introduction to the History, Theory, and Practice of Video Game Music and Sound Design*. Cambridge: MIT Press, 2008.

Cook, Karen M. "Canon Anxiety?" *Journal of Sound and Music in Games* 1, no. 1 (Winter, 2020): 95–99.

Davis, Fred. *Yearning for Yesterday: A Sociology of Nostalgia*. New York: The Free Press, 1979.

Fenty, Sean. "Why Old School Is 'Cool': A Brief Analysis of Classic Video Game Nostalgia." In *Playing the Past: History and Nostalgia in Video Games*, edited by Laurie N. Taylor and Zach Whalen, 19–31. Nashville: Vanderbilt Press, 2008.

Feshbach, Seymour, and Robert D. Singer. *Television and Aggression: An Experimental Field Study*. San Francisco: Jossey-Bass, 1971.

Fisher, Mark. *Ghosts of My Life: Writings on Depression, Hauntology and Lost Futures*. Hampshire: Zero Books, 2014.

Friedrich-Cofer, Lynette, and Aletha C Huston, "Television and Violence: The Debate Continues." *Psychological Bulletin* 100, no. 3 (1986): 364–71.

Garrido, Sandra, and Jane W. Davidson. *Nostalgia, Music and Memory: Historical and Psychological Perspectives*. Cham: Palgrave Macmillan, 2019.

Gibbons, William. "Rewritable Memory: Concerts, Canons, and Game Music History." *Journal of Sound and Music in Games* 1, no. 1 (Winter 2020): 75–81.

Gibbons, William. *Unlimited Replays*. New York: Oxford University Press, 2018.

Gibbons, William, and Steven Reale. "Prologue: The Journey Begins." In *Music in the Role-Playing Game: Heroes & Harmonies*, edited by William Gibbons and Steven Reale, 1–6. New York: Routledge, 2020.

Grasso, Julianne. "On Canons as Music and Muse." *Journal of Sound and Music in Games* 1, no. 1 (Winter 2020): 82–86.

Hogarty, Jean. *Popular Music and Retro Culture in the Digital Age*. New York: Routledge, 2017.

Holbrook, Morris B., and Robert M. Schindler. "Echoes of the Dear Departed Past: Some Work in Progress on Nostalgia." In *NA – Advances in Consumer Research Volume 18*, edited by Rebecca H. Holman and Michael R. Solomon, 330–33. Provo: Association for Consumer Research, 1991.

Istvandity, Lauren. *The Lifetime Soundtrack: Music and Autobiographical Memory*. Sheffield: Equinox Publishing, 2019.

Ivănescu, Andra. *Popular Music in the Nostalgia Videogame: The Way It Never Sounded*. Cham: Springer International Publishing, 2019.

Jameson, Fredric. *Postmodernism: Or, the Cultural Logic of Late Capitalism*. Durham: Duke University Press, 1991.

Kangas, Ryan R. "Classical Style, Childhood, and Nostalgia in Mahler's Fourth Symphony." *Nineteenth-Century Music Review* 8, no. 2 (December 2011): 219–36.

Kay, Jilly Boyce, Cat Mahoney, and Caitlin Shaw. "Introduction." In *The Past in Visual Culture: Essays on Memory, Nostalgia and the Media*, edited by Jilly Boyce Kay, Cat Mahoney, and Caitlin Shaw, 1–10. Jefferson: McFarland, 2016.

Kaplan, Harvey A. "The Psychopathology of Nostalgia." *Psychoanalytic Review* 74 (1987): 465–86.

Kizzire, Jessica. "'The Place I'll Return to Someday': Musical Nostalgia in Final Fantasy IX." In *Music in Video Games: Studying Play*, edited by K. J. Donnelly, William Gibbons, and Neil Lerner, 183–98. New York: Routledge, 2014.

Lowenthall, David. *The Past Is a Foreign Country: Revisited*. New York: Cambridge University Press, 2015.

Needleman, Sarah E. "How Videogames Are Saving the Symphony Orchestra." *The Wall Street Journal*, October 12, 2015. https://www.wsj.com/articles/how-videogames-are-saving-the-symphony-orchestra-1444696737.

Park, Hyeonjin. "The Difficult, Uncomfortable, and Imperative Conversations Needed in Game Music and Sound Studies." *Journal of Sound and Music in Games* 1, no. 1 (Winter 2020): 82–94.

Pozderac-Chenevey, Sarah. "A Direct Link to the Past: Nostalgia and Semiotics in Video Game Music." *Divergence Press* 2 (June 2014). http://divergencepress. net/2014/06/02/2016-11-3-a-direct-link-to-the-past-nostalgia-and-semiotics-in-video-game-music/.

Reynolds, Simon. *Retromania: Pop Culture's Addiction to Its Own Past*. New York: Farrar, Straus and Giroux, 2011.

Rone, Vincent E. "Twilight and Faërie: The Music of Twilight Princess as Tolkienesque Nostalgia." In *Mythopoeic Narrative in The Legend of Zelda*, edited by Anthony G. Cirilla and Vincent E. Rone, 81–100. New York: Routledge, 2020.

Routledge, Clay. *Nostalgia: A Psychological Resource*. New York: Routledge, 2016.

Sprengler, Christine. *Screening Nostalgia: Populuxe Props and Technicolor Aesthetics in Contemporary American Film*. New York: Breghan Books, 2011.

Summers, Timothy. "Analysing Video Game Music: Sources, Methods and a Case Study." In *Ludomusicology: Approaches to Video Game Music*, edited by Michiel Kamp, Tim Summers, and Mark Sweeney, 8–31. Sheffield: Equinox Publishing, 2016.

Taylor, Laurie N., and Zach Whalen, "Playing the Past: An Introduction." In *Playing the Past: History and in Video Games*, edited by Laurie N. Taylor and Zach Whalen, 1–15. Nashville: Vanderbilt Press, 2008.

Vanderbilt, Tom. "The Nostalgia Gap." *The Baffler* 5 (December, 1993). https://thebaffler.com/salvos/the-nostalgia-gap.

Weiner, Matthew and Robin Weith, writers. *Mad Men*. Season 1, episode 13, "The Wheel." Directed by Matthew Weiner. Aired October 18, 2007, in broadcast syndication. Artisan/Lionsgate, 2015, Blu-Ray.

Werman, David S. "Normal and Pathological Nostalgia." *Journal of the American Psychoanalytic Association* 25 (1977): 387–98.

PART 1

ARTICULATING NOSTALGIA
AND VIDEOGAME MUSIC

1

A Player's Guide to the Psychology of Nostalgia and Videogame Music

Michael Vitalino and Vincent E. Rone

Introduction

At the time of this chapter's writing, *Music in the Role-Playing Game: Heroes & Harmonies* stands as the latest in a bevy of collected scholarly essays dedicated to videogame music (VGM). Its editors, William Gibbons and Steven Reale, include a telling passage: a "vein of nostalgia" runs through the choices of the contributing authors regarding the games they discuss in their chapters. "Nostalgia," the editors continue, "further suggests that each writer's experience with their chosen game is deeply personal—as does the fact that several authors' contributions feature significant autobiographical accounts of their experiences as players."[1] Gibbons and Reale also touch on some intimately related topics: VGM, autobiography, and nostalgia. In general, people acknowledge that music can trigger the emotion of nostalgia, which can be heightened when associated with other activities, in our case playing videogames (VGs). People also accept music as integral to VG experiences, as VGM shapes vivid memories by increasing players' immersive experiences. The features between VGM and nostalgia spur deeper analysis into the relationship between the two through their commonalities, interactions, and complementarity.

This chapter analyzes how VGM can give rise to nostalgic experiences and, conversely, how nostalgia can surface in VGM experiences through a two-fold approach. First, we supply readers with a compendium of scholarship among the fields of neuroscience, psychology, and ludomusicology within the purview of nostalgia and VGM. Second, we initiate significant discourse among these

[1] Gibbons and Reale, *Music in the Role-Playing Game*, 4–5.

three fields and generate a plural-disciplinary guide to how VGM during play can induce the emotion of nostalgia. A word on specific terminology: "we" refers to the authors, "people" means the general population, and "players" applies specifically to those who play VGs as a subset of the general populace. For purposes of breadth and scope, we confine the term VGM to music heard during play without sound effects to align with the premises of the scientific scholarship cited in this chapter.[2] Because the psychological and neuroscientific studies we cite do not consider VGM, we intervene by supplying practical VGM examples to foster dialogue across several disciplines.

Our first section, "Nostalgia and Cognition," examines psychological aspects of nostalgia and music to show their intimate relationship, made manifest in later sections. The highly subjective nature of feeling nostalgia requires a specialized framework for understanding; we therefore adopt Frederick Barrett et al.'s heuristic model of *person-* and *context-level* constructs to discuss nostalgia objectively.[3] We further this point by discussing Petr Janata's work on the medial prefrontal cortex (MPFC) of the brain, which governs aspects of music cognition and emotion. Because this area of the brain functions like a processing hub, it can augment feelings of VGM nostalgia.[4] This section acquaints readers with methods of empirical study relating to cognition and allows us to talk about nostalgia throughout this chapter with a degree of universality. In other words, we need a scientific framework to have meaningful discussions about emotions.

The second section, "VGM Inducing Emotion," follows the framework of the previous section by outlining principles for emotional induction, the process of bringing about or giving rise to emotion(s) through music. People often describe the emotional character of music, but that does not equate to how music makes them feel. They can perceive music as happy without it actually inducing happiness, and music's ability to arouse emotions depends on various aspects. We examine

[2] The distinction between sound and music in this context does not account sufficiently for examples that blur the two. Examples as early as the "Duck Shot" from *Duck Hunt* (1985) to *Ape Out*'s (2019) sophisticated integration of sound and music indicate the close relationship between both. While that discussion lies beyond our study, the scientific studies we rely on throughout the chapter confine our analyses and make the distinction clearer. Regarding our purview for music within gameplay alone, the following chapter of this anthology by Sebastian Diaz-Gasca picks up where we leave off by addressing nostalgia and VGM outside playing contexts.

[3] Barrett et al., "Music-Evoked Nostalgia," 390–403.

[4] In particular, see Janata, "Music and the Self," 131–42.

emotional induction through eight categories proffered by Patrick Juslin—brain stem reflex, rhythmic entrainment, evaluative conditioning, contagion, visual imagery, episodic memory, musical expectancy, and aesthetic judgment—and provide corresponding examples of VGM.[5] This section helps players examine musical components that influence their emotional states during gameplay, ones that can heighten or even instantiate their nostalgic experiences later in life.

Our final section, "Nostalgia through VGM," addresses why VGM provides people rich opportunities to experience music-based nostalgia, arguably more so than other audio–visual media. Game and ludomusicological scholarship about immersion reveals the deep emotional experiences, relationships, and memories players often forge while playing, which parallels many of the psychological and neuroscientific factors described in prior sections. Several scholars explain immersion as a tiered or process-driven experience, and we argue that heightened immersive states, depending on the nature and music of a particular game, lead to more powerful nostalgic memories. In turn, such memories replete with emotional associations and autobiographical significance can become indelible and all the more easily retrievable because of VGM. By guiding readers through our plural-disciplinary work, we hope to inspire future scholarship that investigates the possible intersections nostalgia and VGM invite.

Nostalgia and cognition: Where it all begins

People often have a hard time articulating their nostalgic experiences, likely because of the complexity of nostalgia itself. Psychologist Clay Routledge offers an insightful definition, which may account for such difficulty. Nostalgia, he argues, is an emotional state with some key characteristics: bittersweetness, a longing for personal and historical past, treasured memories typically social in nature, interpersonal relationships, positive emotional states, and autobiographical recall from childhood and adolescence.[6] Strong nostalgic experiences connected to music generally trace to the "reminiscence bump" of adolescence, broadly defined as between ages of 10 and 30 years—the typical age range when people are first

[5] These eight categories are adopted from Juslin, "From Everyday Emotions to Aesthetic Emotions," 235–66.

[6] Routledge, *Nostalgia*, 6–24. See Brent Ferguson and T. J. Laws-Nicola, "Playing Music Videos: Three Case Studies of Interaction between Performing Video Games and Remembering Music Videos" later in this volume. They discuss similar attributes of nostalgia against a literary backdrop, namely that of Marcel Proust.

exposed to VGs. Scholars describing the "reminiscence bump" often highlight the life-shaping events that occur during these years and the gradual emergence of adult identity.[7] Perhaps not coincidentally, this period also includes the emergence of musical taste.[8] Sandra Garrido and Jane W. Davidson, for instance, emphasize music's abilities to trigger nostalgia more powerfully than other stimuli and to facilitate the retrieval of deeply emotional memories; both depend largely on how prone listeners are to nostalgia and the autobiographical salience they invest in music.[9] A lot of overlap exists among the emotional state of nostalgia, the potential of music to stir emotions, and cues for autobiographical memory, a theme that will emerge often throughout this chapter.[10] Music, therefore, enjoys pride of place with nostalgia because it is a major trigger of the emotion and tends to accompany, even amplify, its defining characteristics. Readers of this chapter likely have no shortage of personal examples and associations to support these observations.

Nostalgic experiences by definition have a high degree of subjectivity. Within VGs, for example, players may become nostalgic for two extremely different games, *Mortal Kombat* (1992) and *Super Mario Bros. 3* (1990). The former may appeal to players because of particular characters (Scorpion, Sub-Zero, Raiden, and so on), their move and fatality set, narrative development, or design. Similarly, some love *Mario 3* for similar reasons, preferring Mario's Tanooki or Hammer Suit. Players moreover may become nostalgic for *Mario 3* over *Mortal Kombat* (or vice versa) because of the soundtrack. They also may prefer the battle-prone "Pit" track of *Mortal Kombat*. Other players, however, feel right at home with *Mario 3's* soporific "Music Box" track, a nostalgic throwback to the original *Super Mario Bros.* (1985) main theme. In sum, a plethora of features contributes to nostalgic inscription in our memories: character designs, graphics, genre, narrative, gameplay, music, and so forth. Yet this minute sample considers only the features of games, to say nothing about the individual players who interact with them! Accounting for individual preferences can become quite complicated because personal feelings do not translate well into axioms about nostalgia. Nevertheless, it is possible to contextualize non-empirical aspects of personal preference within

[7] Rathbone, Moulin, and Conway, "Self-Centered Memories," 1403–14; Janssen and Murre, "Reminiscence Bump in Autobiographical Memory," 1847–60; Holbrook, "Nostalgia and Consumption Preferences," 245–56.

[8] Holbrook and Schindler, "Some Exploratory Findings on the Development of Musical Tastes," 119–24.

[9] Garrido and Davidson, *Nostalgia, Music and Memory*, 32.

[10] Istvandity, *The Lifetime Soundtrack*, 53–76.

heuristic frameworks to understand better the many commonalities that emerge among nostalgic experiences.

Empirical study provides some stability in examining such subjective experiences. Barrett et al.'s heuristic model of *person-level* and *context-level* constructs, for example, applies specifically to music-based nostalgia to facilitate objective discussion.[11] *Person-level* constructs refer to differences among individuals such as their degree of nostalgia proneness and differences in personality traits. Neural activity of individuals, for instance, can predict nostalgia proneness, especially in those who have a propensity toward withdrawal motivation, the urge to move away from a situation.[12] Moreover, certain personality traits positively correlate with the likelihood of experiencing nostalgia.[13] One such trait is neuroticism: the tendency toward negative affect (sadness, loneliness, fear, anxiety, depression), which also encompasses the need to belong. Neuroticism often leads individuals to use nostalgia for relief from negative affective states.[14] Children and adolescents scoring high in neuroticism may feel isolated within social networks but yearn for acceptance from their peers. They can turn to VGs to satisfy their need to belong and form part of their identities. If such children become lead guitarists of *Rock Band* (2007), then they may feel a sense of accomplishment or the fulfillment of having members of a band count on them for their musical abilities. Children and adolescents can create treasured memories unadulterated by the pressures of daily life, experience a sense of freedom, and feel connected to others by playing VGs. Such tendencies and neural activities color the ability to experience nostalgia, and they operate independently from exposure to potentially nostalgic experiences.

The prior factors we discuss regarding person-level constructs typically do not resonate immediately with people's notions of nostalgia. Rather, *context-level constructs* entail the direct relationship between people and stimuli, the familiarity and association(s) people have with a piece of music. As we mentioned earlier, the confluence of developmentally significant life events and their accompanying emotions help people form strong autobiographical memories. As psychologist

[11] Barrett et al., "Music-Evoked Nostalgia," 390–403.

[12] Tullett, Wildschut, Sedikides, and Inzlicht, "Right-Frontal Cortical Asymmetry Predicts Increased Proneness to Nostalgia," 990–96.

[13] Barrett et al., "Music-Evoked Nostalgia," 392. The Big Five Inventory (BFI) traits and the "Affective Neuroscience Personality Scale" (ANPS) are often used in nostalgia-based psychological discourse.

[14] Seehusenet et al., "Individual Differences in Nostalgia Proneness," 904–08; Routledge, 25, 52–53, 90, 104, 109–14; a detailed study of personality-related differences appears in Vuoskoski and Eerola, "Measuring Music-Induced Emotion," 159–73.

Martin Conway writes, "emotional intensity and personal significance of an event give rise to autobiographical memories which are detailed, highly available for recall and comparatively resistant to forgetting."[15] Moreover, Routledge states individuals play the role of protagonist within their nostalgic memories.[16] People often describe their experiences of nostalgia differently based on their unique experiences. These context-level constructs acknowledge a degree of commonality among players and the genesis of their nostalgia.

Some vivid, retrievable memories occur in social settings, such as when people act as spectators or as active participants during VG play. People in either player or spectator capacity can share the palpable thrill of witnessing climactic moments, which often are punctuated by music. For example, fans may resonate deeply with Faye Wong's "Eyes on Me" from *Final Fantasy VIII* (1999). The song appears throughout the game and punctuates moments of characters falling in love, lost love, and the promise of reunification. Players and spectators alike who have followed the game from the start likely will feel a palpable, universal sense of relief when the two characters Squall Leonhart and Rinoa Heartilly finally reunite. Another example includes Red, the protagonist celebrity singer, in *Transistor* (2014). The story begins with an attempt on Red's life, which claims her voice. Mysteriously, her voice is sealed away in her weapon, the titular "Transistor" sword. A significant event of embodiment for players occurs upon Red's suicide at the end of the game. Her consciousness transfers into the Transistor, whereupon she reunites with her voice, and players hear her singing for the first time. Such instances exemplify context-level constructs that, when paired with person-level traits, enable people to recognize the universality of nostalgia despite their deeply subjective and personal experiences.

Neural activity, common to all living human beings, offers perhaps the most powerful empirical evidence for discussing nostalgia with objectivity. It also can broaden perspectives on the relationship between nostalgia and music considering both are processed in the same area of the brain. One domain of cognitive psychology, as described by neuroscientist Petr Janata, examines affective responses toward and cognition of music, as well as autobiographical recall.[17] Studies within the discipline often rely on the premise that specialized brain regions manage specific cognitive processes, called functional modularity.[18] This approach,

[15] Conway, *Autobiographical Memory*, 104.

[16] Routledge, *Nostalgia*, 8–24.

[17] For an introduction to this topic, see Janata, "Cognitive Neuroscience of Music," 1:111–34.

[18] A functional modular approach can measure brain activity through changes in blood flow via functional magnetic resonance imaging (fMRI).

however, does not mean that one area of the brain is solely responsible for a cognitive process; it is more accurate to conceptualize brain areas working to varying degrees within a large network. Even so, the medial prefrontal cortex (MPFC) stands out as particularly special. Located behind the center of the forehead, the MPFC governs memories and their associations as well as decision-making processes.[19] The MPFC also supports the integration of sensory information with self-knowledge, autobiographical memory, and emotion. Most importantly for this chapter, the MPFC directs autobiographical memory, decisions about the self, regulation of emotions, and affective responses to music.[20] Regarding music, Janata argues the MPFC "exhibits the properties of a mechanism that associates structural aspects [chords, melody, timbre, etc.] of a retrieval cue [the musical excerpt] with episodic memories [autobiography]."[21] For example, if players hear the famous "Item Catch" melody from the *Legend of Zelda* series, it cues an emotion and/or a vivid memory in them by virtue of repeated exposure to the gaming context. The MPFC's coordination of emotion, autobiography, and music distinguishes it as a key component in understanding the relationship between nostalgia and VGM, and it further enhances the degree of universality advanced by context-level constructs.

Studies examining the MPFC's relationship with music-based nostalgia predominantly use tonal music. The selection of tonal repertoire in these studies helps mitigate inaccessibility by allowing subjects to draw from background experience.[22] For purposes of this chapter, the term *tonality* broadly refers to a hierarchical structure in music, a sensation of pitch centricity, and a distinction between harmonic stability versus instability. Take, for example, the theme for *Tetris* (1984, adapted from the "Korobeiniki" Russian folk song) and the title theme of *Super Mario World* (1991). The pieces fit into the minor and major modes of Western music tonality, respectively, allowing listeners to identify one pitch as a stable point of reference. In addition, the melodic and harmonic content of both tunes make them easy to remember and sing. Conversely, examples like the track "I'll Kill You" from *Silent Hill* (1999) or the "Endless Staircase" from *Super Mario 64* (1996) avoid musical features that convey tonal hierarchy. The unstable *Silent*

[19] Euston, Gruber, and McNaughton, "The Role of Medial Prefrontal Cortex in Memory and Decision Making," 1057–70; and Ford, Addis, and Giovanello, "Differential Neural Activity During Search of Specific and General Autobiographical Memories Elicited by Musical Cues," 2515.

[20] Janata, "Brain Networks That Track Musical Structure," 111.

[21] Janata, "The Neural Architecture of Music-Evoked Autobiographical Memories," 2591.

[22] Tillmann, Bharucha, and Bigand, "Implicit Learning of Tonality," 885–913.

Hill example uses murky timbres, low registers, blunt punctuations of noise, and a crescendoing percussion pattern to unsettle players, while the "Endless Staircase" features a rising chromatic sequence on loop to deny players a sense of repose or tonal orientation. In these examples, the ear cannot gravitate towards any pitch center and remains adrift amid a sea of cacophonous clusters and spiraling sounds.

The brain continuously attends musical events, which allows quantitative observations of cognition. As people listen to music, observable activity in the MPFC further illuminates the relationship between music and emotion. The process of tonality tracking identifies brain areas that monitor melody and harmony, which accounts for listener responses in real time.[23] For example, electroencephalography (EEG) shows increased brain activity when music subverts listeners' expectations.[24] Tonality tracking has also been observed in networking areas of the brain that code representations of subjective feelings and reward processing.[25] The MPFC's sensitivity to consonance and dissonance informs tonal tracking, which reinforces Janata's view that tonality shapes personal affective experiences of music.[26] For example, the (tonal) *Tetris* theme has certain elements the brain responds to. The register, timbre, shape, and cadences of the melody largely align with listening expectations, making the theme predictable and comfortable.

In sum, the brain tracks elements of tonal music even without people having formal training in music. Importantly, the MPFC acts as a sort of hub where music, emotion, and autobiography converge.[27] And, like the person- and context-level constructs proffered by Barrett et al., the MPFC facilitates the understanding of nostalgia as an emotional state with specific characteristics by adding a measurable component to nostalgic experiences, particularly by way of music.

VGM *inducing emotion: How it happens*

We so far have offered a stabilizing definition of nostalgia and observed its close relationship to music. We then accounted for the subjective and objective parameters of nostalgia and music by adopting person- and context-level constructs,

[23] Janata et al., "The Cortical Topography of Tonal Structures Underlying Western Music," 2167–70.

[24] Janata, "Brain Networks," 114–15; and Bidelman and Krishnan, "Brainstem Correlates of Behavioral and Compositional Preferences of Musical Harmony," 212–16.

[25] Barrett and Janata, "Neural Responses to Nostalgia-Evoking Music," 244.

[26] Janata, "Brain Networks," 121.

[27] Janata, "Music and the Self," 131–38.

further concretized by the governing role of the MPFC regarding music, emotion, and memory. To account for how nostalgia arises in response to music, we now must examine how music causes emotional reactions. People often describe music with basic emotions: happy, sad, thrilling, scary. Such descriptors help listeners perceive musical content but, interestingly enough, do not necessarily account for how music makes them feel. In other words, listeners can perceive music as happy without it actually inducing happiness, and music's ability to arouse emotions depends on various aspects.[28] Patrick Juslin identifies eight categories that establish the mechanisms of music-based emotional induction: brain stem reflex, rhythmic entrainment, evaluative conditioning, contagion, visual imagery, episodic memory, musical expectancy, and aesthetic judgment: BRECVEMA.[29]

Brain stem reflexes respond to loud, surprising, and/or dissonant sounds signifying a possible threat. For example, the first six *Final Fantasy* (*FF*) games use sudden upward arpeggiations of a dissonant, fully diminished chord to signal the beginning of a battle. *Pokémon* (1996) similarly deploys a distinctive chromatic scale figure to open battles. Moreover, at a battle's conclusion in the *Mortal Kombat* games, the screen immediately turns dark while an ominous musical cue suddenly interrupts the stage music—all to portend the long-awaited spectacle of a gory fatality. VGM relies on this reactive impulse to induce heightened emotional states, much like the film-music technique of the "zinger."

Rhythmic entrainment accounts for the ways rhythmic material influences bodily processes. *FFVII*'s (1997) "Cosmo Canyon" conveys a calming, almost trance-like atmosphere through a recurring rhythmic motive. *Crypt of the Necrodancer* (2015) and *Cadence of Hyrule* (2019) require players to coordinate their movements with the music's beat to attack enemies. Players likely relate to music heightening their physical states in battles, races, or timed tasks with increased tempo or more complex rhythmic patterns. In the *Sonic the Hedgehog* series, obtaining "power sneakers" allows an avatar to move faster. The corresponding fast musical cue signals this enhanced state and can influence bodily interaction with the game. Rhythmic entrainment in VGM also relates to Karen Collins's identification of kinetic gestural interaction in which players participate

[28] Although semiotics aligns closely with this section, the topic lies beyond the scope of this chapter. For those interested in reading about musical semiotics (syntax, structure, and phenomena), especially within popular and film music, see Chapter 5 of Tagg, *Music's Meanings*, 155–94.

[29] Juslin, "From Everyday Emotions to Aesthetic Emotions," 235–66. See also Juslin and Västfjäll, "Emotional Responses to Music," 559–75.

bodily with the sound on screen.[30] Entrainment can produce feelings of connection and emotional bonding and closely aligns with the physical interaction of VG play.

Evaluative conditioning describes emotional induction resulting from repeated pairings of music with positive or negative stimuli. This process often occurs in VGM by associating melodic themes with characters or events, much like the leitmotif in cinematic and operatic practice.[31] The *Super Mario Bros.* "Starman" theme can elicit confidence and excitement because of its association with Mario's invincibility. The "Imperial March" in any *Star Wars* game may invoke fear or anxiety among players because of its association with Darth Vader, while the rustic sounds of "The Shire" theme in a *Lord of the Rings* game can provide a sense of comfort. Finally, "win" or "lose" cues, like *Zelda*'s "opening a chest" or "Link died" music, also qualify.

Contagion occurs when music possesses vocal traits but is performed on an instrument. Passages particularly "vocal" in character tend to feature step-wise motion, limited note range, and relaxed, often confined rhythmic patterns, all characteristics that would make them easy to sing. Importantly, hearing "vocal" material activates pre-motor brain regions typically used for singing.[32] Conversely, "instrumental" passages may exceed the range of singers, have awkward melodic leaps, or feature rapid note successions that would make singing them impossible. Although the distinction between vocal and instrumental idioms is not always clear cut, musicians generally examine notated features or hear how a passage "flows" to make such judgments. For non-musicians, this process is less straightforward. It can mean the difference between listening to a slow, lyric melody versus scales being played as rapidly as possible and in registers no human voice can reach. "Kraid's Lair" from *Metroid* (1986), for instance, begins with a vocal idiom, which then shifts to an instrumental one once the note values become shorter and therefore quicker. The repeated opening phrase suits the voice until the musical figure becomes too rapid to sing comfortably. In addition, the *Halo: Combat Evolved* (2001) theme and *Zelda*'s "Song of Time" use synthesized sounds to suggest vocal timbre fit to tropes of old and ancient through its verisimilitude of Western plainchant.[33] Several melodies from *The*

[30] Collins, *Game Sound*, 127.

[31] Can Aksoy discusses the leitmotif at length in his chapter, "Remembering The Rules: Immersive Nostalgia & *Final Fantasy* Leitmotifs" later in this volume. He demonstrates how the leitmotif is particularly suited as a carrier of nostalgic significance in VGM.

[32] Brown and Martinez, "Activation of Premotor Vocal Areas During Musical Discrimination," 59–69.

[33] Summers, "Analysing Video Game Music," 15–19. See also Cook, "Beyond the Halo," 183–200.

Legend of Zelda series connote vocality due to limited range and melodic shape, for example, "Zelda's Lullaby." Because these examples feature vocal qualities without being actually sung, they invite players to connect subconsciously without direct linguistic prompting.

Visual imagery accounts for the association between emotional reactions to music and the subjective mental images music conjures. Certain musical tropes have become standardized to suggest common environmental settings, such as electronic/metallic, percussive sounds for industrial settings; buoyant sounds for skies or water; and minor tonality in a low register for underground or suspenseful/horror settings. *Donkey Kong Country's* (1994) "Aquatic Ambience" deploys high-pitched drones within the strings, a descending melody, and registral contrast among instruments. These elements can suggest water, descent, and submersion. The "Monolith" and "Heliosphere" tracks from *No Man's Sky* (2016) feature heavy use of synthesized sounds and drawn-out bass tones to suggest the expansiveness of space. Tracks such as "The Island of Naxos" and "The Shores of Megaris" from *Assassin's Creed: Odyssey* (2018) feature a panoply of percussion instruments, lyre, bouzouki, and dulcimer cast within modal scales (chief among them Dorian and Phrygian), all of which suggest the game's setting of 431–422 BCE Greece. Musical tropes, patterns, instrumentation, and pitch language all can suggest particular cultures, places, as well as historical and futuristic settings.

Episodic memory facilitates our association between music and personal memories. People hear music within a game and encounter it again at a later point—within or across games. "Saria's Song"/"Lost Woods" from *The Legend of Zelda* franchise provides a good example. The theme appears in three titles: *Ocarina of Time* (1998), *Majora's Mask* (2000), and *Twilight Princess* (2006).[34] The "Velvet Room" theme of the *Persona* series reappears across multiple games in the series and remains recognizable despite no other shared musical elements across the games. Music evokes memories and emotions by virtue of the personal significance it brings for us—a "Darling, they're playing our tune" scenario. Incidentally, this component of BRECVEMA parallels the context-level constructs of Barrett because both focus on the direct relationship among subject, stimuli, and the associations that typically follow.

Musical expectancy arises from experience with a musical style and informs people's listening expectations as to music's trajectory and resolution.[35] Imagine pausing a VG and predicting how the music will follow. You might infer the music's

[34] Rone, "The Music of *Twilight Princess* as Tolkienesque Nostalgia," 85–96.

[35] Huron, *Sweet Anticipation*, 41–57, 144–57.

trajectory based on prior knowledge of its style. If a different outcome occurs, it may provoke a strong emotional reaction, such as thrill, surprise, disappointment, or rage. The "Barrier Trio" theme from *Mother 3* (2006) uses an asymmetrical and complex time signature to prevent the player from easily establishing a sense of periodicity or regularity.[36] The opening track of *BioShock* (2007), "Main Title— Going up, going down/Beyond the Sea," plays with the musical expectations of players by juxtaposing musical styles. The track opens with the swinging, tonal "Beyond the Sea," performed by Bobby Darin, but before long, the song fades mid-way into static, ambient sound, which then is interrupted by dissonant clusters from brass and strings.[37] Listeners must adjust their listening expectations quickly to three contrasting musical styles. Music expectancy therefore can violate, delay, or confirm expectations, which influences emotional states.

Aesthetic judgment denotes the multifaceted process of discerning how listeners receive and regard music. Aesthetic criteria are highly subjective but can include features like emotion, beauty, expressivity, craft, novelty, capacity to commu-nicate, and style.[38] In addition, aesthetic judgments often work in contexts that typically signal players to think, "this is important." For example, the acclaim of *FFVII*'s "One-Winged Angel" stems from both narrative placement (the final boss fight's soundtrack) and its distinction as the game's only track that includes a human, not synthesized, choir. Players recognizing the sound of choral music and its significance as a climactic timbral choice will likely regard this track highly for its aesthetic value. In contrast, the use of a soft instrumental arrangement of "Mad World" provides an example of musical irony when it occurs during Dominic "Dom" Santiago's sacrificial death scene in *Gears of War 3* (2011). The framing of music at key moments can stratify emotional reactions to different cues and prime players to make discerning aesthetic judgments.

To summarize, the components of BRECVEMA work to establish strong emotional responses that can invite nostalgic recollection later in life, which can work individually or in any combination to induce responses in the player. As players reflect on gaming experiences, the concomitant musical material strength-ens the capacity to remember initial playing contexts and their accompanying emotions. The significance of these eight components and their corresponding VGM examples offers players, game scholars, and ludomusicologists alike a

[36] 8-bit Music Theory, "Odd Time Signatures in Video Game Music," 7:43.

[37] Jessica Kizzire unpacks such musical moments and the nostalgic potential they engender in this volume's chapter, "Remembering Tomorrow: Music and Nostalgia in *Fallout*'s Retro-Future."

[38] Rentfrow, Goldberg, and Levitin, "The Structure of Musical Preferences," 1139–57.

veritable toolbox. It equips them with analytical tools to account for music-specific factors influencing their impressions and emotions.

Nostalgia through VGM: Why it happens

In the previous section, we demonstrated how emotional induction occurs through BRECVEMA and supplied several VGM examples. Such interactions between music and emotion have the potential to generate powerful memories, especially against the backdrop of all three generally being governed by the same area of the brain, the MPFC. All these things provide the groundwork to understand how music can trigger nostalgia and facilitate a framework to discuss these emotions objectively and with a degree of universality. Yet it seems any type of music can bring about nostalgia, so what makes VGM in particular stand out? As we intimate earlier, VGM immerses players by responding to their participation, and this section now surveys some theories on immersion as they can apply to VGs and VGM. We discuss how immersion bears an analogous relationship with nostalgia and how the former's interaction with music can induce the latter in ways other forms of music cannot.

Within the context of music's ability to induce emotion, immersion works similarly, as it facilitates affective experiences while playing VGs. Immersion, much like nostalgia, therefore avoids an unequivocal definition, especially regarding how people experience it and to which forms of media the definition applies. Oliver Grau, for example, offers a broad definition of immersion within the purview of art writ large that describes it as emotional involvement with what is happening, decreasing any critical distance between the self and the artistic object.[39] Nevertheless, many scholars agree on several defining characteristics such as feeling transported or engrossed, losing awareness of the real world, and lacking an awareness of time. VGs lend themselves easily to such characteristics, especially because of their ability to induce emotion. Aubrey Anable describes VGs as affective systems that open a form of a relation between their aesthetic, narrative and mechanical properties and players.[40] She maintains that VGs possess an almost unique ability to affect our emotions as compared to other media, a claim similar to that of this chapter and central to this anthology: that VGM has greater potential to produce nostalgia than other media.

[39] Grau, *Visual Art*, 13.
[40] Anable, *Playing with Feelings*, xii.

Jennett et al.
- **Engagement** invites people's investment of time and effort to learn how to play the game.
- **Engrossment** occurs when the emotional investment of players grows strong enough such that their awareness of gameplay mechanics disappears, which diminishes awareness of their surroundings.
- **Total Immersion** signals the feeling among players as if they constitute a presence in the game itself, whereupon only the virtual world matters.

Laura Ermi and Frans Mäyrä
- **Sensory Immersion** denotes the game's audio-visual information overpowering other sensory information from the real world.
- **Imaginative Immersion** allows players to imagine a wide range of activities within the virtual world, usually fostering empathy towards game characters.
- **Challenge-Based Interaction** invites players to participate within the virtual world through the game's tasks and rewards.

Andrew Glassner
- **Curiosity** refers to a desire to learn about the videogame.
- **Sympathy/Empathy** suggest players' sharing the avatar's perspective of the game world and forming an emotional bond with it.
- **Transportation** suggests the act of crossing between real and virtual worlds.

FIGURE 1.1: Multi-tiered frameworks of immersion.

Multi-tiered conceptualizations of VG immersion can bridge initial emotional experiences with VGs to subsequent feelings of nostalgia. Immersion happens in degrees of intensity, and many authors delineate these degrees into successive tiers or levels. For instance, Jennett et al., Laura Ermi and Frans Mäyrä, and Andrew Glassner all theorize three-tiered systems of immersion specifically within the purview of VGs.[41] These three systems of immersion share many commonalities and allow us to perceive games characteristic of each tier, as shown in Figure 1.1. Generally speaking, the first tiers of each system require players to learn how to play the game; this technical investment begins to decrease players' awareness of the real world and their sense of time. For example, puzzle and strategy games that rely almost exclusively on technique like *Pong* (1972), *Dr. Mario* (1990), *Candy Crush Saga* (2012) ostensibly satisfy the first tier, as the immersive component encompasses the perfecting of skill. Because such games do not facilitate relationships with avatars or participation in alternative realities, they do not fit easily into the second and third tiers. Thus, the first tier can comprise a wide range of games without needing an emotional component. The second tier of immersion, as defined in all three conceptualizations in Figure 1.1, elevates immersion by way

[41] Jennett et al., "Measuring and Defining the Experience of Immersion in Games," 641–61; Ermi and Mäyrä, "Fundamental Components of the Gameplay Experience," 1064–66; Glassner, *Interactive Storytelling*, 81–82.

of narrative unfolding or by encouraging players to form relationships with their avatars, which are characterized often by sympathy and empathy. The third tier entails activities within (and the crossing into) virtual worlds, which also presuppose the emotional investment. The second and third tiers then seem to apply most effectively to games with large, virtual worlds, such as any Middle-earth, *Star Wars*, *Grand Theft Auto*, or *Fallout* game. Each three-tiered approach to VG immersion culminates with activities and levels of engagement within the game worlds once the emotional component occurs. In other words, emotion acts as the currency, the price of admission for immersion to reach its full potential in games, especially those with avatars and alternative worlds. The emotional investment VGs invite by way of immersion becomes even more important against the backdrop of the MPFC's role in governing emotion and music cognition.

In a similar manner, the role of VGM contributes to immersive experiences and shapes the emotional experiences of players.[42] Isabella van Elferen outlines a multi-tiered analytical model to address this phenomenon.[43] The ALI model (*affect*, *literacy*, and *interaction*) incorporates ideas necessary to perceive the relationship between nostalgia and VGM, which parallel many elements as shown in Figure 1.1. Van Elferen describes affect as a personal investment in the forms of memory, emotion, and identification. Next, literacy denotes the kind of musical vocabulary players develop through habitual practices. Players condition themselves to expect certain genres, sounds, rhythms, and musical elements within certain VG contexts. Finally, interaction establishes a connection between the player's actions and the game soundtrack. Much of what van Elferen describes in the ALI model mirrors BRECVEMA, which supports the correlation between the psychological components of music-based nostalgia and VGM. The connections forged by interaction also include VGM's dynamism and changeability, recalling Elizabeth Medina-Gray's work on modularity, which enables soundtrack variations between playthroughs of a game and can have powerful effects on gaming experiences.[44] Playing VGs themselves amounts to interacting with music; each ALI component presumes an emotional, participatory connection between players and VGM, strengthening the conditions for nostalgia.

Interactivity, an independent but enabling component of immersion, figures crucially in discussing the ability to experience emotion and nostalgia while playing

[42] Collins, *Game Sound*, 133–35; Summers, *Understanding Video Game Music*, 57–84.

[43] van Elferen, "Analyzing Game Musical Immersion," 32–39.

[44] Medina-Gray, "Modularity in Video Game Music," 53–54; and Medina-Gray, "Meaningful Modular Combinations," 104–05.

VGs. We recognize interactivity as a relational component between players and games, which overlaps with the emotional significance of nostalgia and VGM. Interactivity depends on the dynamism of a game, its responses to player input, which can catalyze the speed and degree to which players are immersed. Katie Salen and Eric Zimmerman bolster our framework of interactivity by describing it as an "active relationship between two things" and trace its characteristics to VG contexts.[45] Games, for example, require direct player intervention, explicit actions that can change the outcome of the activity and advance the plot. Interactivity also qualifies VGs as a context-level construct by extending the participatory component into social dimensions, which can forge connections among individuals and groups.[46] Even while playing alone, we can form relationships with avatars in RPGs and action/adventure games. Salen and Zimmerman also proffer multi-tiered levels of interactive engagement: cognitive, functional, explicit, and beyond-the-object interactivity. Notably, the first and potentially fourth levels can predispose players to nostalgia.[47] Interactivity therefore requires an element of representation to allow interpretive contexts to emerge as they would in any social relationship. The social and interpersonal relationships implicit to VGs can enable us to remember experiences of play more vividly within the context of a shared experience. According to Zachary Whalen and Laurie Taylor, iconic characters like Samus Aran, Sonic the Hedgehog, Laura Croft, Cloud Strife, Master Chief, and Geralt of Rivia have become quotations of a shared past and activate nostalgia.[48] VGs thus have the ability to summon intensely autobiographical and social memories of youth, which mirrors the emotional induction of nostalgia itself.

The physical dimension of game input further contributes to the immersive potential in VGs and includes VGM. For example, interactivity requires a quality of repetition between two agents, as players and games themselves share repeated tasks including listening, speaking, and responding.[49] As Nicola Dibben argues, increased physiological arousal intensifies valence (i.e. perception of positive emotion) of music perception, transcending passive listening and intensifies emotional experiences with music.[50] The physicality of, say, the rapid and

[45] Salen and Zimmerman, *Rules of Play*, 58.

[46] Rachel Kowert dedicates her book to investigating social relationships as they arise in online gaming in *Video Games and Social Competence*.

[47] Salen and Zimmerman, *Rules of Play*, 58–60.

[48] Taylor and Whalen, "Playing the Past," 6. Sean Fenty expresses similar thoughts by describing VGs "objects of nostalgia," in "Why Old School Is 'Cool,'" 24–28.

[49] Salen and Zimmerman, *Rules of Play*, 59–60.

[50] Dibben, "The Role of Peripheral Feedback in Emotional Experience with Music," 79–115.

precise movements of fingers on the controller in tandem with the diegetic and non-diegetic sounds of a game will increase emotional responses to the music.[51] The act of "playing" instruments within a game, a ludic tool for such franchises as *Guitar Hero* and *The Legend of Zelda*, allows players a deeper understanding of games because of the physical engagement they require.[52] Music's responsiveness to player interactivity, the physical component of gameplay, and the intensified emotional responses that follow result in a performance of emotion, the physical manifestation of an emotional experience. Such emotional performativity allows us to identify VGM as part of ourselves, according to Karen Collins. She argues music and sounds of VGs respond to our actions in the form of immediate feedback, which makes VGM part of the self.[53] Increased physical engagement with music games and music within VGs constitutes a performance, which therefore can increase immersive experiences, emotional and autobiographical investment, and the potential for nostalgia.

Conclusion

We have provided a first step for readers to understand nostalgia and VGM in the form of a compendium that fosters plural-disciplinary dialogue among psychology, neuroscience, and ludomusicology. Our adoption of person-level and context-level constructs facilitates discussion of subjective emotions with a degree of universality, further supported by the governing role the MPFC plays in directing music, emotion, and autobiographical memory. We then demonstrated how music can induce emotions by way of BRECVEMA. Finally, such processes complement the emotion players invest in VGM through immersion. VGM therefore allows players to forge deep emotional connections with games, opening a web of associations for nostalgia to occur.

The allure of playing VGs stems from various motivations: the thrill of accomplishing a task, learning a skill set, unwinding from a stressful day, and so forth. Ludomusicology has emerged as a discipline partly as a result of the nostalgic relationships its scholars have with VGM in relation to their childhood and adolescent

[51] Collins, *Game Sound*, 125–27.

[52] Austin, "Introduction," 5; Lind, "Active Interfaces and Thematic Events," 92. See Alexander Nunes, "A Link between Worlds: Nostalgia and Liminality in Musical Covers of *The Legend of Zelda*" in this volume, as he discusses the liminal space between players and musical demands of the game as the locus for nostalgia.

[53] Collins, *Playing with Sound*, 44.

experiences, recalling the Gibbons and Reale excerpt quoted at the beginning of this essay.[54] Although players may not approach games intending to trigger emotions or form relationships, they arise as a natural consequence of play, which provides fertile ground for the seed of nostalgia. This chapter has described how that process occurs from the initial engagement between players and VGM to their nostalgic recollections about such experiences later in life. We offer readers a nexus of scholarship as a starting point to examine their own gaming experiences critically, especially regarding how nostalgia fits into them, a sort of how-to primer. In addition, we hope fellow scholars similarly adopt plural-disciplinary approaches to examine the crucial role nostalgia plays in VGs and VGM and further the breadth of ludomusicological discourse.

LUDOGRAPHY

Game series:

Fallout, 1997–2018.
Final Fantasy, 1987–2020.
Grand Theft Auto, 1997–2013.
Sonic the Hedgehog, 1991–2019.
Star Wars, 1982–2019.
The Legend of Zelda, 1986–2019.
The Lord of the Rings, 2002–20.

Individual games:

Ape Out. Gabe Cuzillo. Nintendo Switch. Devolver Digital, 2019.
Assassin's Creed: Odyssey. Unisoft Quebec. PlayStation 4. Ubisoft, 2018.
BioShock. 2K Boston. Xbox 360. 2K Games, 2007.
Cadence of Hyrule: Crypt of the NecroDancer Featuring The Legend of Zelda. Brace Yourself Games. Nintendo Switch. Nintendo, 2019.
Candy Crush Saga. King. iOS, Android. King, 2012.
Crypt of the NecroDancer. Brace Yourself Games. Microsoft Windows, OS X, Linux. Brace Yourself Games, 2015.

[54] Examples of such ludomusicologists include Melanie Fritsch, William Gibbons, Elizabeth Medina Gray, Steven Reale, Timothy Summers, Isabella van Elferen, and many contributors to this volume, ourselves included.

Donkey Kong Country. Rare. Super Nintendo Entertainment System. Nintendo, 1994.

Dr. Mario. Nintendo R&D1. Nintendo Entertainment System. Nintendo, 1990.

Duck Hunt. Nintendo R&D1, Intelligent Systems. Nintendo Entertainment System. Nintendo, 1984.

Final Fantasy VII. Square. PlayStation. PlayStation, 1997.

Final Fantasy VIII. Square. PlayStation. Square, 1999.

Gears of War 3. Epic Games. Xbox 360. Microsoft Studios, 2011.

Halo: Combat Evolved. Bungie. Xbox. Microsoft Game Studios, 2001.

The Legend of Zelda: Majora's Mask. Nintendo EAD. Nintendo 64. Nintendo, 1999.

The Legend of Zelda: The Ocarina of Time. Nintendo EAD. Nintendo 64. Nintendo, 1998.

The Legend of Zelda: Twilight Princess. Nintendo EAD. Nintendo Game Cube and Wii. Nintendo, 2006.

Metroid. Nintendo R&D1. Nintendo Entertainment System. Nintendo, 1986.

Mortal Kombat. Midway Games. Arcade. Midway Games, 1992 (series).

No Man's Sky. Hello Games. PlayStation 4. Hello Games, 2016.

Pokémon. Game Freak. Game Boy. Nintendo, 1996.

Mother 3. Brownie Brown. Game Boy Advance. Nintendo, 2006.

Pong. Atari. Arcade. Atari, 1972.

Rock Band. Harmonix. Xbox 360. MTV Games, 2007.

Silent Hill. Konami Computer. PlayStation. Konami, 1999.

Super Mario 64. Nintendo EAD. Nintendo 64. Nintendo, 1996.

Super Mario Bros. Nintendo EAD. Nintendo Entertainment System. Nintendo, 1985.

Super Mario Bros. 3. Nintendo EAD. Nintendo Entertainment System. Nintendo, 1990

Super Mario World. Nintendo EAD. Super Nintendo Entertainment System. Nintendo, 1991.

Tetris. Alexey Pajitnov and Vadim Gerasimov. Electronica 60. Infogrames, 1984.

Transistor. Supergiant Games. PlayStation 4. Supergiant Games, 2014.

BIBLIOGRAPHY

8-bit Music Theory. "Odd Time Signatures in Video Game Music." Uploaded January 14, 2019. https://youtu.be/5JRojRIA1ng?t=463.

Anable, Aubrey. *Playing with Feelings: Video Games and Affect*. Minneapolis: University of Minnesota Press, 2018.

Austin, Michael. "Introduction—Taking Note of Music Games." In *Music Video Games: Performance, Politics, and Play*, edited by Michael Austin, 1–22. New York: Bloomsbury Publishing, 2016.

Barrett, Frederick S., and Petr Janata. "Neural Responses to Nostalgia-Evoking Music Modeled by Elements of Dynamic Musical Structure and Individual Differences in Affective Traits." *Neuropsychologia* 91 (2016): 234–46.

Barrett, Frederick S., Kevin J. Grimm, Richard W. Robins, Tim Wildschut, Constantine Sedik-
ides, and Petr Janata. "Music-Evoked Nostalgia: Affect, Memory, and Personality." *Emotion*
10, no. 3 (2010): 390–403.

Bidelman, Gavin M., and Ananthanarayan Krishnan. "Brainstem Correlates of Behavio-
ral and Compositional Preferences of Musical Harmony." *Neuroreport* 22, no. 5 (2011):
212–16.

Brown, Steven, and Michael J. Martinez. "Activation of Premotor Vocal Areas During Musical
Discrimination." *Brain and Cognition* 63 (2007): 59–69.

Collins, Karen. *Game Sound: An Introduction to the History, Theory, and Practice of Video
Game Music and Sound Design.* Cambridge: MIT Press, 2008.

Collins, Karen. *Playing with Sound: A Theory of Interacting with Sound and Music in Video
Games.* Cambridge: MIT Press, 2013.

Conway, Martin A. *Autobiographical Memory—An Introduction.* Buckingham: Open Univer-
sity Press, 1990.

Cook, Karen. "Beyond the Halo: Plainchant in Video Games." *Studies in Medievalism* 27
(2018): 183–200.

Dibben, Nicola. "The Role of Peripheral Feedback in Emotional Experience With Music."
Music Perception 22, no. 1 (Fall 2004): 79–115.

Ermi, Laura, and Frans Mäyrä. "Fundamental Components of the Gameplay Experience:
Analyzing Immersion." *Neuron* 76, no. 6 (December 2012): 1057–70.

Euston, David R., Aaron J. Gruber, and Bruce L. McNaughton. "The Role of Medial Prefrontal
Cortex in Memory and Decision Making." *Neuron* 76, no. 6 (December 2012): 1057–70.

Fenty, Sean. "Why Old School Is 'Cool': A Brief Analysis of Classic Video Game Nostalgia."
In *Playing the Past: History and Nostalgia in Video Games*, edited by Laurie N. Taylor and
Zach Whalen, 19–31. Nashville: Vanderbilt Press, 2008.

Ford, Jaclyn Hennessey, Donna Rose Addis, and Kelly S. Giovanello. "Differential Neural Activ-
ity During Search of Specific and General Autobiographical Memories Elicited by Musical
Cues." *Neuropsychologia* 49 (2011): 2514–26.

Garrido, Sandra, and Jane W. Davidson. *Nostalgia, Music and Memory: Historical and Psycho-
logical Perspectives.* Cham: Palgrave Macmillan, 2019.

Glassner, Andrew. *Interactive Storytelling: Techniques for 21st Century Fiction.* Wellesley: AK
Peters, 2004.

Gibbons, William, and Steven Reale. "Prologue: The Journey Begins." In *Music in the Role-Play-
ing Game: Heroes & Harmonies*, edited by William Gibbons and Steven Reale, 1–6. New
York: Routledge, 2020.

Grau, Oliver. *Visual Art: From Illusion to Immersion.* Cambridge: MIT Press, 2003.

Holbrook, Morris B. "Nostalgia and Consumption Preferences: Some Emerging Patterns of
Consumer Tastes." *Journal of Consumer Research* 20, no. 2 (September 1993): 245–56.

Holbrook, Morris B., and Robert M. Schindler. "Some Exploratory Findings on the Develop-
ment of Musical Tastes." *Journal of Consumer Research* 16, no. 1 (1989): 119–24.

Huron, David. *Sweet Anticipation: Music and the Psychology of Expectation*. Cambridge: MIT Press, 2006.

Istvandity, Lauren. *The Lifetime Soundtrack: Music and Autobiographical Memory*. Sheffield: Equinox Publishing, 2019.

Janata, Petr. "Brain Networks That Track Musical Structure." *Annals of the New York Academy of Sciences* 1060 (2005): 111–24.

Janata, Petr. "Cognitive Neuroscience of Music." In *The Oxford Handbook of Cognitive Neuroscience*, edited by Kevin N. Ochsner and Stephen M. Kosslyn. 1: 111–34. Oxford: Oxford University Press, 2014.

Janata, Petr. "The Neural Architecture of Music-Evoked Autobiographical Memories." *Cerebral Cortex* 19, no. 11 (February 2009): 2579–94.

Janata, Petr. "Music and the Self." In *Music that Works: Contributions of Biology, Neurophysiology, Psychology, Sociology, Medicine and Musicology*, edited by Roland Haas and Vera Brandes, 131–42. Vienna: Springer, 2009.

Janata, Petr, Jeffrey L. Birk, John D. Van Horn, Marc Leman, Barbara Tillmann, and Jamshed J. Bharucha. "The Cortical Topography of Tonal Structures Underlying Western Music." *Science* 298 (2002): 2167–70.

Janssen, Steve M. J., and Jaap M. J. Murre. "Reminiscence Bump in Autobiographical Memory: Unexplained by Novelty, Emotionality, Valence, or Importance of Personal Events." *Quarterly Journal of Experimental Psychology* 61, no. 12 (December 2008): 1847–60.

Jennett, Charlene, Anna L. Cox, Paul Cairns, Samira Dhoparee, Andrew Epps, Tim Tijs, and Alison Walton. "Measuring and Defining the Experience of Immersion in Games." *International Journal of Human-Computer Studies* 66, no. 9 (September 2008): 641–61.

Juslin, Patrik N. "From Everyday Emotions to Aesthetic Emotions: Towards a Unified Theory of Musical Emotions." *Physics of Life Reviews* 10, no. 3 (2013): 235–66.

Juslin, Patrik N., and Daniel Västfjäll. "Emotional Responses to Music: The Need to Consider Underlying Mechanisms." *Behavioral and Brain Sciences* 31, no. 5 (2008): 559–75.

Kowert, Rachel. *Video Games and Social Competence*. New York: Routledge, 2014.

Lind, Stephanie. "Active Interfaces and Thematic Events in *The Legend of Zelda: Ocarina of Time*." In *Music Video Games: Performance, Politics, and Play*, edited by Michael Austin, 83–105. New York: Bloomsbury Publishing, 2016.

Medina-Gray, Elizabeth. "Modularity in Video Game Music." In *Ludomusicology: Approaches to Video Game Music*, edited by Michiel Kamp, Tim Summers, and Mark Sweeney, 53–72. Sheffield: Equinox Publishing, 2016.

Medina-Gray, Elizabeth. "Meaningful Modular Combinations: Simultaneous Harp Environmental Music in Two *Legend of Zelda* Games." In *Music in Video Games: Studying Play*, edited by K. J. Donnelly, William Gibbons, and Neil Lerner, 104–21. New York: Routledge, 2014.

Murray, Janet H. *Hamlet on the Holodeck: The Future of Narrative in Cyberspace*. New York: The Free Press, 1997.

Rathbone, Clare, Chris J. A. Moulin, and Martin A. Conway. "Self-Centered Memories: The Reminiscence Bump and the Self." *Memory & Cognition* 36, no. 8 (2008): 1403–14.

Rentfrow, Peter J., Lewis R. Goldberg, and Daniel J. Levitin. "The Structure of Musical Preferences: A Five-Factor Model." *Journal of Personality and Social Psychology* 100, no. 6 (June 2011): 1139–57.

Rone, Vincent E. "Twilight and Faërie: The Music of Twilight Princess as Tolkienesque Nostalgia." In *Mythopoeic Narrative in The Legend of Zelda*, edited by Anthony G. Cirilla and Vincent E. Rone, 81–100. New York: Routledge, 2020.

Routledge, Clay. *Nostalgia: A Psychological Resource*. New York: Routledge, 2016.

Salen, Katie, and Eric Zimmerman. *Rules of Play: Game Design Fundamentals*. Cambridge: MIT Press, 2004.

Seehusenet, Johannes, Filippo Cordaro, Tim Wildschut, Constantine Sedikides, Clay Routledge, Ginette C Blackhart, Kai Epstude, and Ad J.J.M. Vingerhoets. "Individual Differences in Nostalgia Proneness: The Integrating Role of the Need to Belong." *Personality and Individual Differences* 55 (2013): 904–8.

Summers, Timothy. "Analysing Video Game Music: Sources, Methods and a Case Study." In *Ludomusicology: Approaches to Video Game Music*, edited by Michiel Kamp, Tim Summers, and Mark Sweeney, 8–31. Sheffield: Equinox Publishing, 2016.

Summers, Timothy. *Understanding Video Game Music*. Cambridge: Cambridge University Press, 2016.

Tagg, Philip. *Music's Meanings: A Modern Musicology for the Non-Musos*. New York: Mass Media Music Scholars' Press, 2013.

Taylor, Laurie N., and Zach Whalen. "Playing the Past: An Introduction." In *Playing the Past: History and in Video Games*, edited by Laurie N. Taylor and Zach Whalen, 1–15. Nashville: Vanderbilt Press, 2008.

Tillmann, Barbara, Jamshed Bharucha, and Emmanuel Bigand. "Implicit Learning of Tonality: A Self-Organizing Approach." *Psychological Review* 107, no. 4 (2000): 885–913.

Tullett, Alexa M., Tim Wildschut, Constantine Sedikides, and Michael Inzlicht. "Right-Frontal Cortical Asymmetry Predicts Increased Proneness to Nostalgia." *Psychophysiology* 52, no. 8 (August 2015): 990–96.

van Elferen, Isabella. "Analysing Game Musical Immersion." In *Ludomusicology: Approaches to Video Game Music*, edited by Michiel Kamp, Tim Summers, and Mark Sweeney, 32–52. Sheffield: Equinox Publishing, 2016.

Vuoskoski, Jonna K., and Tuomas Eerola. "Measuring Music-Induced Emotion: A Comparison of Emotion Models, Personality Biases, and Intensity of Experiences." *Musicae Scientiae* 15, no. 2 (2011): 159–73.

2

And the Music Keeps on Playing: Nostalgia in Paraludical Videogame Music Consumption

Sebastian Diaz-Gasca

In my second year of university, I was chatting with some friends outside the faculty's tech office waiting for some loan gear for a film shoot when I heard a phone playing "To Zanarkand" as a ringtone. I turned around, and the owner of the phone noticed that I recognized the song. No words were exchanged, just a look, and a nod of affirmation. "Damn, that's a good game. And you're so cool for playing it." This interaction was not the start of a romantic comedy. Instead, it highlights how listening to videogame music outside of play creates nostalgic communities. For many years now, both players and fans of videogames have enjoyed videogame music (VGM) outside gameplay. These audiences can readily find soundtracks, samples, and references in songs, fan remixes, and orchestral arrangements online and in physical formats. People relive the game when they use its music as their ringtone, as part of a social media post, or play their own cover version of a song. I will always remember the encounter with that phone's owner. We shared something in common, simply because we had experienced the same game when we were younger. This interaction, one many gamers share, inspires important questions about nostalgia. Why do people engage with VGM beyond the gameplay experience? What is it about VGM that links us to our past? Why does VGM nostalgia have this power to create communities?

This chapter theorizes the nostalgia present in the personal and collective associations with VGM. Furthermore, it asserts that the marketing practices that form the basis of paraludical consumption drive this consumption further. I use the term *paraludical* (*para-* = outside, *ludos* = games) *consumption* to denote listening to game music outside the gameplay

environment.[1] Since VGM itself often intersects with and appears in non-gaming spaces, audiences, and popular music, paraludical consumption itself begins when listeners recognize the music as belonging to videogames. In other words, if you do not know that a song belongs to a game, you cannot conduct paraludical consumption. Paraludical consumption involves three distinct, interconnected factors: individual, social, and commercial interests.[2] I observe these factors individually and as part of a network that illustrates audience consumption habits and the role nostalgia plays therein, as well as the economic interests of the industries who profit from them. Overall, this paper codifies and maps the relationships of these three motivators. In doing so, it builds a model for paraludical consumption that uniquely highlights nostalgia as a central driver that shapes audiences' listening experiences of VGM. This model empowers scholars to explore videogame music-driven consumer research and theorize player experiences within and beyond gameplay.

This chapter first establishes that different modes of nostalgia exist and influence the types of VGM that will be consumed paraludically. After it demonstrates how nostalgia is a motivator of paraludical consumption. I focus on nostalgia as an experiential association by the individual and its influence on social consumption. Finally, the chapter concludes by highlighting how game designers and composers use nostalgia as a marketing tool to entice audiences to revisit a game (or its soundtrack) and to promote a specific intellectual property (IP). This financial incentive to use nostalgia in marketing is interlinked with in individual and social nostalgic associations. The three combined drive paraludical consumption.

Listening and remembrance: Modes of nostalgia in VGM

The nostalgia provoked by VGM determines how audiences appreciate, remember, and listen to soundtracks outside of gameplay. Yet theorizing this is difficult, as nostalgia is not the same for everyone. There are differences in the ways longing for past musical experiences is triggered and perceived in the present. VGM and nostalgia are general terms that require specification within the purview of

[1] In "Sutures and Peritexts," Michiel Kamp uses Gérard Genette's term *paratext* to describe elements outside the game that contribute to the understanding of the original text, 73. However, I favour *paraludical* over *paratextual* as I focus not on understanding the text but on gameplay (ludical) experience. The construction of the game as a text versus the construction of an interactive text is a discussion for another time.

[2] Diaz-Gasca, "Music Beyond Gameplay," 9; Diaz-Gasca, "Super Smash Covers!," 59.

paraludical consumption. Regarding the former, Claudia Gorbman's definition of film music provides a good starting point. Her work is arguably the broadest application to facilitate understanding of VGM: film music is any music used in a film.[3] Thus, any music used in a videogame is VGM. This theoretical approach clarifies multiple relationships between VGM and the various industries, as well as the complex motivators that determine music consumption that follow. To consider all music in a game as VGM isolates the musical element of game audio while including music from external sources and how these play out in paraludical consumption.

Licensed music in videogames qualify as examples of paraludical consumption when they become associated with the game and elicit memories of play. This is especially true when the song in question is featured various times in the game's narrative. For example, in his analysis of *Max Payne 2* (2003), Antti-Wille Kärjä discusses the use of "Late Goodbye" by Poets of the Fall. [4] The song is used at several points in the game, such as being played on a piano or sung by an NPC while listening to it through his headphones. "Late Goodbye" is also featured in the end credits of the game. In this case, the connection and the intention of the song to the game are quite overt. The song becomes an example of paraludical consumption if audiences listen to "Late Goodbye," and it summons associations with *Max Payne 2* and their memories of play.[5] Thus, a broad application of the term VGM therefore suits the wide range of possibilities with which people engage in paraludical consumption.

Nostalgia spurs paraludical consumption even further. As an emotional response, nostalgia is commonly understood to be a feeling of familiarity or longing for a past real or imagined. In videogames, nostalgia surfaces in the remembering of interactive experiences and in memories of events associated with the game. It motivates the (re-)consumption of cultural products depending on the extent of the emotional effect it has. Nostalgia in videogames, as Laurie Taylor and Zach Whalen suggest, constitutes a process of remembrance, an imperfect recollection of memories creating an imagined past.[6] If the past hinges on the reconstruction of memory, then nostalgia catalyzes this elicitation. Accordingly, game developers employ nostalgic design and composition choices to engage game audiences with

[3] Gorbman, "Narrative Film Music," 189.

[4] Kärjä, "Marketing Music through Computer Games," 30–31.

[5] Conversely, chiptunes lie outside this discussion unless they figured into a game's original soundtrack; however, they draw from retro audio textures and techniques not from the soundtrack. See Márquez, "Nostalgia Videolúdica," 7–8.

[6] Taylor and Whalen, "Playing the Past," 9.

the production of new games, merchandise, and, perhaps, old-school esthetics. All these markers contribute to audience's remembering interactive experiences of the game and the associations they forged with it.

Nostalgia also exists in paraludical consumption in design and marketing choices that aim to make nostalgia the centerpiece of consumerist consumption, most evident in the use of *retro* esthetics. The twentieth and twenty-first-century cultural economies are caught in a tension between extremely fast production rates and the desire to engage in nostalgia for the sake of accessing a specific time. Material products designed toward a retro esthetic attempt to address that tension. For example, music critic Simon Reynolds highlights the attraction of nostalgia in pop-culture consumption, as well as the rework and reinvention of previous IP and trademarks since audiences emotionally drawn to remembrance.[7] Moreover, there is an emotional connection between audiences and popular music; the latter draws the former to nostalgic consumption through the playback of memorable tracks or by familiar aural esthetics.[8] The use of retro esthetics in VGM highlights a very postmodern approach to design, one that knits together previous material in pastiche. The familiarity with the previous IP forms the basis of nostalgic associations that influence paraludical consumption.

An example of the use of musical remembrance and nostalgic design is *Super Smash Brothers Ultimate* (*SSBU*, 2018) for the Nintendo Switch. The game rewards players with songs and character themes from other game franchises, as well as versions/remixes from previous *SSB* games. All these tracks are stored in an achievement repository, "The Vault," and are available for casual listening when players are not battling. The soundtracks in "The Vault" are akin to Ryynänen and Heinonen's description of nostalgic consumption as a "practice for the future," a temporal frame where consumers maintain consumption practices with an IP throughout their lives and share experiences in an effort to include others in this nostalgic relationship.[9] This example demonstrates how nostalgia engages audiences by encouraging consumption and play through the elicitation of memories with soundtracks and how nostalgia is a reward in itself.

Retro esthetics are also an example of game consumption that is driven by nostalgia for obsolete technology. In *SSBU*, the game features 8- and 16-bit tracks that play during a battle. Reynolds describes retro as a fetishization of the style of previous periods that stands as the commodification of nostalgia, the result

[7] Reynolds, *Retromania*, 27.

[8] Cartwright, Besson, and Maubisson, "Nostalgia and Technology Innovation," 463.

[9] Ryynänen and Heinonen, "From Nostalgia for the Recent Past and Beyond," 190.

of "popular creativity [...] enmeshed in the market."[10] He suggests the time for a given style to become retro has shortened. Retro promises profit for cultural industries aided by the widespread ease of reproduction of and access to media. As the timeframe of retro shortens, so does the timeframe of what is current—a phenomenon exacerbated in videogames due to the rapid pace of their technological and esthetic advancements.[11] Similarly, Elizabeth Guffey observes differences between retro and nostalgia, such as the *timeless* retro esthetic encapsulating and condensing the look and feel of an era, and the focus on the obsolescence of a technology to present its appeal or charm.[12] Since new technology accelerates esthetic advancement, the speed of these changes makes certain design elements look dated fairly quickly. Sound design, visual graphics, and battle mechanics that seemed revolutionary immediately show their age.

The commodification of nostalgia and memory manifests itself in the esthetics and production processes of videogames. This commodification comes in the form of an emulation of past play or a style that esthetically resembles the past. Anna Reading and Colin Harvey proffer their notion of *nostalgic-play* as the use of nostalgia within gameplay, a conscious effort to trigger a longing for the past, identifiable in the production processes, design, and purchase of old games.[13] Nostalgic-play requires revisiting a past experience: getting a SNES Mini to play *EarthBound* (1994), dusting off the old Virtual Boy to replay *Wario Land* (1995). Conversely, Andra Ivănescu calls contemporary games that purposefully adopt (often to express appreciation for) antiquated game design *nostalgia games*.[14] Her work suggests that nostalgia for the past can be provoked by something only a few years old. A good example of a *nostalgia game* is *Super Meat Boy* (2010). This game includes a soundtrack with chiptune textures (sawtooth and square wave sounds) that hint at old-school game sounds, and the game capitalizes on 2D platform mechanics to reinforce that retro feel. Similarly, *Scott Pilgrim vs The World: The Game* (2010) also imitates arcade beat-'em-ups of the past with retro graphics and a soundtrack by chiptune band Anamanaguchi. In short, nostalgic consumption is experienced in gameplay as well as in game design.

[10] Reynolds, *Retromania*, 119.

[11] Can Aksoy describes this process, and the nostalgic games produced in response in "Remembering the Rules: Immersive Nostalgia in *Final Fantasy* Leitmotifs," located elsewhere in this volume.

[12] Diaz-Gasca, "Music Beyond Gameplay," 97; Guffey, *Retro*, 9.

[13] Reading and Harvey, "Remembrance of Things Fast," 168.

[14] Ivănescu, *Popular Music in the Nostalgia Videogame*, 15.

Videogames elicit various types of nostalgia depending on the individual's past experiences. This occurs by design, retro esthetics, or by specific artifacts, songs, or performances.[15] For example, Natasha Whiteman identifies *synchronic* and *diachronic* nostalgia.[16] The former denotes the futile effort to return to the past with source material as close as possible to the original form; one cannot turn back time.[17] Yet, VGM accommodates synchronic nostalgia, as listeners can replay audio files. Lauren Istvandity argues that recorded music has the ability to play back *perfectly*, as recordings mechanically replicate past sounds.[18] However, although one may have the ability to playback an audio file, replicating the original *musical experience* means something different, without which nostalgia might not occur. For example, "Gym Leader Battle" in *Pokémon Red/Blue* (1996) would not sound the same on today's HiFi systems as it did on old GameBoy speakers. Synchronic nostalgia considers one's first experience with the IP more authentic: *Pokémon Red/Blue* is the "one, true *Pokémon.*" The attempt to recapture first experiences has ramifications depending on the longevity of a franchise. In the case of *Pokémon*, younger audiences are more likely to have a broader *acceptable* canon (and Pokédex) than older audiences.

Conversely, diachronic nostalgia broadens the scope and is applicable to a greater repertoire of VGM. It accepts new versions of the source material, as audiences value references to previous experiences, characters, and scenarios.[19] The reinvention of an IP and its economic benefits inform videogame production and paraludical works of game music. Game developers release sequels or create series of games, which harken to previous games and maintain an esthetic consistency. Or the games have familiar narrative and thematic elements. On the other hand, game developers and fans produce new content based on the original material, which can encompass VGM covers (Maluka's "The Dragonborn Comes"), remixes (*Killer Cuts* for *Killer Instinct*), orchestral arrangements (*Symphony of the Goddesses*), and so on.[20] Through diachronic nostalgia, audiences relish in growing up and changing along with the game content. Spotting familiar elements in new games gives a certain *caché* (cultural capital) in recognizing something

[15] For additional information on this topic in this volume, refer to Alec Nunes's article, titled "A Link between Worlds: Nostalgia and Liminality in Musical Covers of *The Legend of Zelda.*"

[16] Whiteman, "Modalities of Nostalgia," 44.

[17] Alec Nunes also explores this notion in his chapter in this book.

[18] Istvandity, *The Lifetime Soundtrack*, 138.

[19] Whiteman, "Modalities of Nostalgia," 45.

[20] D'Alessandro, "A Remix Artist and Advocate," 461; Diaz-Gasca, "Music Beyond Gameplay," 119; Newman, *Playing with Videogames*, 82.

from the games past. Two forces operate here: building of social capital through spotting and recognizing game music and canonizing certain game elements by designers through incorporation. The synchronic/diachronic binary approach highlights two ways audiences perceive nostalgia and, moreover, value certain types of nostalgic engagements.

Nostalgia also influences an individual's mental image of the past. Svetlana Boym's work describes these temporal images in her bifurcation between restorative and reflective nostalgia.[21] She argues the former creates a romantic version of a past that fails to critique the context of memory. Restorative nostalgia is similar to Whiteman's synchronic nostalgia, as both favor a return to the original experience. Ivănescu's discussion of *nostalgia games* also adopts Boym's concept by highlighting how these contemporary, retro-styled games revel in their "signs of old age," critique the decay of cultural artifacts, and ultimately view the past in idealized terms.[22] Ivănescu further explains that popular music is prominently featured in this process because of its semiotic and paramusical meanings.[23]

For example, the music in the rebooted *Wolfenstein* games features music from a fictional, alternative timeline by performing hit songs that resulted from the victory of Nazi Germany. The music from the alternative timeline label "Neumond Records" demonstrates musical pastiche using Phillip Tagg's concept of style indicators.[24] The recordings replicate the stylistic and production characteristics of recordings from different eras and adapt them to the games' plot. The resulting semiotic incongruence between meaning already associated with period music (mostly nostalgia, happier times, post-war optimism) is juxtaposed in the games with Nazi versions of beloved bands. *Fallout* and *Bioshock* also use popular music to critique and contextualize a particular zeitgeist in similar ways.[25] VGM can aid in the creation of mental images that critique or romanticize the past, and this relationship with nostalgia crucially informs the ways audiences seek paraludical consumption.

Nostalgia also manifests itself in several layers of game design, ranging from esthetics, narratives, game mechanics, user interface, character design, world building, and, of course, music and sound. Vincent Rone discusses the use of musical and esthetic simile in *The Legend of Zelda: Twilight Princess* (2006), where Nintendo

[21] Boym, *The Future of Nostalgia*, 41.

[22] Ivănescu, *Popular Music in the Nostalgia Videogame*, 22.

[23] Ivănescu, *Popular Music in the Nostalgia Videogame*, 9–10; Tagg, *Music's Meanings*, 229–30.

[24] Tagg, *Music's Meanings*, 229–30.

[25] For more on this, refer to Sarah Pozderac-Chenevey's chapter, as well as Jessica Kizzire's, further in this volume.

replicated familiar sound effects and leitmotifs from *Ocarina of Time* following the initial controversy over *The Wind Waker's* (2002) departure from established *Zelda* norms.[26] Nostalgia ostensibly informed the Nintendo developers to consider what made fans fall in love with *Ocarina of Time* and thus produced and marketed *Twilight Princess* as a sort of homecoming. Rone argues that the use of familiar leitmotifs in the latter aurally places the player within the broader *Zelda* universe, but their strategic placement within the game's narrative serves a leitmotivic function by calling players back to similar contexts of previous titles—all of which contribute to a carnival ride of nostalgia. Against this backdrop, remember that videogames function as commercial products and artforms, financially driven artistic media packaged together. This incentivizes game developers to maintain aural consistency and thematic recognition. Nostalgia is deliberately used in VGM to establish a brand that will be more emotionally engaging with audiences due to its ease in recognition.

As a commercial cultural product, producers have strong reasons to build relationships with audiences and design games that effectively create associations to motivate future consumption. Nostalgia highlights the remembrance of experiences and associations with VGM bids audiences return to the soundtrack, the game, or people associated with it. It can result from a longing to recreate specific experiences (synchronic), to revisit familiar past experiences (diachronic), to color a moment in time (restorative), or even to critique it (reflective). These types of nostalgia work are present in the three main drivers of paraludical consumption: individual recall of experiences, the social, collective recollection and bonds created by VGM, and the marketing and financial interests of developers in creating a product that is familiar—all of which happen outside gameplay.

Nostalgia as a motivator for paraludical consumption

Nostalgia operates within the contexts of VGM with emphasis on its role in consumerism and audience engagement. This framework includes three general factors including experiential associations among individuals, sociocultural factors, and marketing imperatives. Regarding the first, fans of VGM are likely to have personal experiences with game music, which can come into sharp focus upon investigating musical representations of the self, the leitmotif, and semiotics. Second, the sociocultural factors stem from examining what happens when fans bring with them their personal associations and histories of the game into a

[26] Rone, "Twilight and Faërie," 84.

collective experience—a live concert, performing together, and so forth. Finally, an economic element traces itself to the financial components typical to a large-scale music performance (ticketing, licensing, venue hire, promotion, etc.), as well as the licensing agreements required to perform these original soundtracks. The importance of these three factors lies in the nature of videogames. Interactivity allows for players to become *prosumers*, having an active say in a game's design and in the type of experience it delivers because of the circular interaction among consumption, production, and commodity.[27] Music thus brings together these experiences and triggers nostalgia in various levels for audiences.

Factor one: Nostalgia as an experiential association

Individual experiences of game music often create experiential associations. Experiential associations, in turn, constitute the most important motivator for para-ludical consumption as they begin with the individual's relationship with VGM. Nostalgia anchors audiences to the place where the music was listened to, or the people who were present at that time, or the feelings felt because of/during play-through, and the events inside and outside the diegesis. The role of nostalgia in the experiential associations of individuals and VGM is tied to the functions of music in games as well as the environment in which this experience took place. The game, the act of playing, where we play, with whom, and other contextual information can connect individuals to their experiences.

Musical signposting is a good place to start. Audiences create associations with music through the recognition of leitmotifs, the surrounding context of which can create strong connections and memories. In videogames, music is used to create a diegesis as well as aurally cue plot points, characters, and settings. According to Thomas Baumgartner, Kai Lutz, Conny F. Schmidt, and Lutz Jäncke, music enhances audience emotional response to visual media.[28] Istvandity asserts that these responses are linked to music's ability to transport people to their past.[29] Matthew Bribitzer-Stull postulates that associations with music are linked to "emotion, memory, and meaning" and that this relationship forms through recognizable leitmotifs that aurally comment or signpost characters and events on screen.[30]

[27] Kline et al., *Digital Play*, 14.

[28] Baumgartner et al., "The Emotional Power of Music," 152.

[29] Istvandity, "The Lifetime Soundtrack," 150.

[30] Bribitzer-Stull, *Understanding the Leitmotif*, 95.

For example, "Zelda's Lullaby" first appeared in *The Legend of Zelda: A Link to the Past* (1991) to represent the namesake character and more broadly to the Royal Family of Hyrule. In a later series title, *Ocarina of Time* (1998), the motif is introduced when Link meets Princess Zelda, where she teaches the song to Link so others can identify him as an envoy of the Royal Family. Players memorize the song and create emotional associations to it through repetition of performance. The song advances key points in the plot—Link must play the lullaby to receive a reward, to solve a riddle, to complete a task, or to reveal a hidden path. Players of previous games would easily recognize the motif, but in this instance, the player has the added ability to perform the song in game. In this case, the act of performance now has diegetic consequences that align with the song's meaning, accrued throughout the series. This connection between individual players and music ultimately traces back to the association created when and how music was first presented.

The association created with VGM, when translated to a paraludical setting, starts with the representation of the self and remembrance of one's experiences surrounding the music. Istvandity describes this relationship with music as a part of the *lifetime soundtrack*, "the metaphorical canon of music that accompanies personal life experiences."[31] In the construction of narratives and memories, she writes, music aids in the creation of an archive that links various personal and social experiences surrounding a song. Istvandity also highlights how physical motion can occur as a response to music, thereby adding a layer of kinetic memory to musical memory.[32] The physical motion of manipulating the controller or keyboard while gaming contributes to the physical association forged with music. The link among players and diegetic events, motions and activities emphasizes another level of complexity similar to audiences experiencing music in and outside the game. The musical representation of self in the diegesis occurs through various playthroughs, control, and customization of an avatar like in *Skyrim* (2011), or it occurs through the performance of a character, such as those with a backstory and personality as in Kiri Miller's example of *Grand Theft Auto*.[33] The game soundtrack becomes a soundtrack of the self (the player), similar to how one might say "I died" when the avatar meets an untimely, diegetic demise during gameplay. VGM represents one's journey, a bond created through prolonged exposure

[31] Istvandity, "The Lifetime Soundtrack," 136.

[32] Istvandity, "The Lifetime Soundtrack," 150.

[33] Collins, *Playing with Sound*, 42; Miller, "Jacking the Dial," 425.

to the game environment and music and traceable to the interactive nature of the medium.[34]

Music also influences the performance of play while constructing the diegesis, the game world itself, which occurs often through semiotics. In *Grand Theft Auto*, Kiri Miller uses as an example of the way musical choice represents the player's *performance* of the character: how the actions of players and their choices of musical soundtrack while driving symbolize, either by confirming or contradicting, the expected behavior and physical appearance of the chosen (gangster) character.[35] Furthermore, music can connote or remind players of their virtual exploits, a personal, semiotic relationship between players and the game that often manifest outside the game world. For instance, people use the "Hey, listen!" sample from *Ocarina of Time* as a cell-phone notification, implying they will stop any activity to heed Navi's call. Such situations can gain meaning through the game's narrative contexts, which comprise, Robert Buerkle writes, "the whole of the diegesis." [36] This means that characters, plot, setting, and the aural landscape of a game altogether comprise a game's narrative. Music's part in the creation of space occurs through and contributes to semiotic representation.[37] Paraludical musical playback celebrates or commemorates this past setting through the meaning or the symbolism of the diegesis. To listen to VGM is to recreate a past setting. Recurring game series use this mnemonic effect to prepare players' expectations for recurring experiences within the series whilst simultaneously setting the narrative through music. The semiotic meaning allows audiences to revisit these emotions through nostalgia because of the context provided by narrative and the performance that happens within the diegesis.

Finally, semiotics plays a role in the faithful reproductions of digital music and facilitate much paraludical consumption. Repeated playback of music gives a soundtrack semiotic meaning within the contexts of the plot and character representation.[38] In turn, digital and analogue reproduction allows audiences to listen easily to the same audio file as the one in the game, which suggests synchronic nostalgia. Replaying or revisiting music works on two levels: the added layer of familiarity with associated musical meaning and the unmistakable, original sonic experience digital files can recall. This musical meaning directly relates to the

[34] Lind, "Active Interfaces and Thematic Events," 93.

[35] Miller, "Jacking the Dial," 425.

[36] Buerkle, "Of Worlds and Avatars," 176.

[37] Kamp, "Musical Ecologies in Videogames," 240; Summers, "Music and Transmediality," 254.

[38] van Elferen, "Fantasy Music," 5–6.

audience's willingness and ability to recall past experiences outside the original context of its origin. Nostalgia, an important factor in the paraludical consumption of VGM, occurs because of an individual's association of music with a past experience.

Factor two: Nostalgic associations in paraludical social consumption

Sociocultural factors influence how music binds people through experiencing, sharing, and celebrating events. Such experiences include *unisonance* between groups (i.e. the collective knowledge of a musical piece and its meaning) and *cultural capital*.[39] According to David Throsby, cultural capital is the collection of tangible objects or intangible ideas and/or practices to which groups attribute cultural significance.[40] To observe how groups attribute cultural capital, we can look at online communities, such as OverClocked Remix (OCR) and *Mario Paint* Hangout. These groups allow members to rework and remix VGM and, in the case of the latter, use a game to cover music. These sites also operate as forums with peer reviews and feedback from members and guests. For these groups, there is merit and value in the creation of new works. They are not just songs, they are evidence of engagement with a wider community. On the other hand, Benedict Anderson's notion of unisonance appears in performances of *Video Games Live* when the crowd reacts to well-known themes. The recognition goes beyond people knowing the song, it denotes a shared experience with and appreciation of a theme.[41] People engaging in paraludical consumption mimic the participatory nature of videogames by incorporating the social dimensions of play, spectatorship of play, and association(s) with other players based on cultural capital and unisonance.

VGM carries cultural capital within gaming circles. These social units use canonized VGM to authenticate group membership. Soundtracks also become cultural currency. Members share experiences about/with them and use music to teach newcomers the group's objectives. Consider the OverClocked Remix (OCR) community. On the webpage, people access tutorials on community practices and the creation of remixes, upload original remixes of game music, and participate in feedback and reception forums. This circulation of social capital demonstrates

[39] Anderson, *Imagined Communities*, 145; Makai, "Videogames as Objects and Vehicles of Nostalgia," 4.

[40] Throsby, "Sustainability and Culture Some Theoretical Issues," 14.

[41] Anderson, *Imagined Communities*, 145.

the group's collective commitment to media beyond that of an average consumer.[42] According to Whiteman, music thus becomes an important metric in determining authenticity, a negotiation that privileges nostalgia.[43] Popular content often highlights the demographics within a community, as members of certain age groups are drawn to remixes of soundtracks of their formative years.[44] For example, my first time in OCR was spent listening to every remix of the *Chrono Trigger* (1995) soundtrack, a game that hallmarks my nostalgia for childhood. Although important texts and songs abound in online forums, the song(s) privileged for remixing likely depends on its nostalgic value within the community.

While cultural capital connotes determining a hierarchy of value or canonization of VGM, unisonance deals with how groups of people collectively identify with VGM. Anderson expounds on unisonance as the feeling strangers share of belonging expressed within a common musical symbol, such as a national anthem.[45] Istvandity argues that groups collectively compile individual recollections of music into music groups and archive their memories.[46] In addition, Péter Makai suggests music facilitates stronger communal bonds among those who share nostalgic memories.[47] Thus, gameplay constitutes a shared communal experience, and VGM represents individual experiences with the diegesis, similar to how children share experiences while growing up and recollect them later in life. Audiences experience unisonance in live VGM performances, especially when reacting to songs and music from their preferred game(s).[48] Live cover bands exemplify this. They show importance to VGM beyond gameplay by re-enacting past playing contexts and summoning the associations of those contexts, often through images, sounds, or re-enactments of in-game movements.[49] Unisonance in paraludical consumption also connotes the exercising of social inclusion. As game demographics grow and become mainstream, VGM enters spaces not traditionally designed for them, thus allowing audiences to identify with other players, forge

[42] Jenkins, *Textual Poachers*, 46; Plank, "Musical (Re)Play on YouTube," 55; Whiteman, "Modalities of Nostalgia," 33.

[43] Whiteman, "Modalities of Nostalgia," 53.

[44] Krumhansl and Zupnick, "Cascading Reminiscence Bumps in Popular Music," 2057–59; Schubert, "Does Recall of a Past Music Event Invoke a Reminiscence Bump in Young Adults?" 1007–9.

[45] Anderson, *Imagined Communities*, 145.

[46] Istvandity, "The Lifetime Soundtrack," 141.

[47] Makai, "Videogames as Objects and Vehicles of Nostalgia," 4.

[48] Diaz-Gasca, "Super Smash Covers!" 56.

[49] Diaz-Gasca, "Super Smash Covers!" 57.

connections, and resonate through shared memories. Nostalgia drives paraludical consumption in social contexts through the curation and selection of songs that resonate with audiences and flag their personal memories. Audiences then can share those memories and discover commonalities with each other enabled by communal spaces.

Factor three: Nostalgia as a marketing tool in paraludical consumption

The third driver of paraludical consumption is the use of VGM nostalgia as a marketing tool. Videogame developers use nostalgia in their approaches to design. The economic motivations behind this strategy often result in the commodification of nostalgia to foster broader consumption of branding.[50] Although this practice is not relegated to music alone, VGM exemplifies the way in which merchandise, events, and products are extracted directly from a game and used to encourage the revisiting of game IP, resulting in the elongation of the shelf life of those products. I adopt Richard Rogers' approach, which suggests commodification denotes the removal of the use-value (tangible, useful features) of an object and introduces it to an exchange system. I also follow the notion of Kline et al.'s *digital design practices*, strategic decisions made by producers to target audiences while differentiating products.[51]

This commodification of VGM results from the economic process of game consumption, and the use of nostalgia in commodification aims to maximize returns. Alison Gazzard describes the use of nostalgia in the commodification of game elements in the shape of memorabilia.[52] Live performances, like *Symphony of the Goddesses* from *the Legend of Zelda* series, remove VGM from its original use-value and transform it into a diachronic festival of a consumable past. Live and online performance and reproduction of music form an important part of the game industry's business model as it creates a monetary exchange for accessing nostalgia.[53] Social media also highlights the commodification of the game experience at the hands of the consumers, and how the industry endorses these practices. Platforms such as Twitch have channels dedicated to game-music performers and also appeal to sponsorships for influencers. Developers also put content on social

[50] I recommend visiting Elizabeth Hunt's chapter and Reba Wissner's in this book for more on commodification.

[51] Kline et al., *Digital Play*, 21; Rogers, "From Cultural Exchange to Transculturation," 488.

[52] Gazzard, "Between Pixels and Play," 152.

[53] Gazzard, "Between Pixels And Play," 152; Kline, Dyer-Witheford, and de Peuter, *Digital Play*, 193.

media including game trailers and musical performances, as in the case of the official Nintendo YouTube channel's nostalgic celebrations of game anniversaries. Influencers and fan-generated content exemplify what Kline et al. call the *prosumer* model.[54] Videogame conventions like PAX (formerly the *Penny Arcade Expo*), for example, involve players by promoting live performances and include game soundtracks in panels and announcements. The videogame industry commodifies VGM and facilitates paraludical consumption through official channels. Inviting fans to participate in the generation and creation of this content simultaneously promotes a game for sustained consumption.

On the other hand, branding considers the production processes by which games can be uniquely recognized, in this case through music. The videogame industry uses music to trigger nostalgia as a cornerstone of "pulling the heartstrings" marketing.[55] Game developers long have capitalized on good aural branding, be it by composition or by the star power of VGM composers (notable examples include Koji Kondo's work in *Super Mario Bros.* and Nobuo Uematsu's compositions for *Final Fantasy*). Paraludical consumption thus can take place in peritexts—ads, teasers, and trailers—or in merchandise—CDs and musical downloads.[56] Nostalgic branding facilitates the paraludical consumption of VGM in two ways. First, familiar themes and sound effects from the game universe contribute to a brand. Examples of this include the *Star Wars* theme and its signature lightsaber sound effect. Second, original music composed for a videogame can be modified into a new style, like a *Star Wars* videogame with a soundtrack in the style of John Williams. This move allows direct musical associations with the diegesis of the game, as well as with film franchise itself.

Live concerts focused on the music of a game franchise present one of the strongest, large-scale cases of nostalgic musical branding. The production of *Zelda*'s *Symphony of the Goddesses* required a license from Nintendo to use the game content of the game series with clear branding relating to the game. As a result, imagery of iconic characters, game footage, typeface, screenings of interviews with the composers, and recognizable themes and leitmotifs all inundate the senses of the attendees.[57] The concert features live performances of tracks from the original soundtrack of title installments arranged for orchestra such that they

[54] Kline et al., *Digital Play*, 14.

[55] Reynolds, *Retromania*, iii.

[56] Kamp, "Suture and Peritexts," 73.

[57] For more information about this topic, visit Elizabeth Hunt's chapter elsewhere in this volume.

sound like they belong within the *Zelda* universe itself. The opening fanfares of the concerts begin this process, as string glissandos and ornamented arpeggios recall the familiar "Hyrule Field" theme. Branding in VGM consists of a mix of unisonance, style, and leitmotifs, which connect audiences to previous paraludical encounters with music and opens the path toward nostalgia. The economic motivations behind paraludic consumption use nostalgia to commodify and sustain audiences' continued consumption of VGM. Simultaneously, the game industry incorporates familiar musical themes in new games or licensed events in order to repackage familiar, nostalgic products to audiences.

Conclusion

Various manifestations of nostalgia influence the paraludical consumption of VGM, which allow for a range of experiences outside gameplay. Such manifestations include a longing for the original experience, critiquing, or romanticizing the past, and so on. The nostalgia both individuals and audiences feel can help determine the relationships and associations built around a musical piece. Nostalgia interacts with the various motivators of paraludical consumption of VGM, leading to an aggregated value that represents a game and also a timestamp in the player's life. Nostalgia then triggers the longing of players to revisit a particular space by way of music, specifically through the range of semiotic meaning(s) of the videogame's format.

Interaction, personal experience, social settings, and the push of industries to commercialize products also drive paraludical consumption. Due to the interactive nature of videogames, VGM enhances the experiences of players, even if the music belongs to the original soundtrack or is a licensed song in the game. VGM cues our nostalgia and amplifies our ability to recall associations with actions, places, people, and past experiences. VGM itself becomes virtually leitmotivic to our lives. Nostalgic reward in paraludical consumption lies in the aggregated level of meaning audiences invest within the music. Videogames, in turn, allow us to identify an experience as a personal endeavor, which can turn into a collective memory. As a sociocultural motivator, nostalgia helps us identify common experiences within larger groups. It becomes shared within groups and prompts the reworking and appropriation of game music evident in fan-generated content. In the same vein, public performances become places where audiences collectively feel nostalgia in a public setting through a sense of unisonance. Finally, game developers demonstrate the economic benefits of nostalgia in VGM by their using it to market and prolong the life of games and accompanying merchandise. Music thus becomes a mnemonic shorthand for the game, its licenses, and merchandise. All these discussions

61

show VGM continuing beyond gameplay, which constitutes an important element in the personal experiences of players, the social interactions they have, and the way the videogame industries engage their audiences.

LUDOGRAPHY

Chrono Trigger. SquareSoft. Super Nintendo Entertainment System. Nintendo, 1995.

EarthBound. Ape Inc., HAL Laboratory. Super Nintendo Entertainment System. Nintendo, 1994.

Killer Instinct. Rareware. Super Nintendo Entertainment System. Nintendo, 1995.

Mario Paint. Nintendo. Super Nintendo Entertainment System. Nintendo, 1992.

Max Payne 2: The Fall of Max Payne. Remedy Entertainment. Playstation 2. Rockstar Games, 2003.

Pokémon Red/Blue. Game Freak. Game Boy. Nintendo, 1996.

Scott Pilgrim vs. the World: The Game. Ubisoft. Playstation 3. Ubisoft, 2010.

Super Meat Boy. Team Meat. XBOX 360. Team Meat, 2010.

Super Smash Bros. Ultimate. Bandai Namco Studios. Nintendo Switch. Nintendo, 2018.

The Elder Scrolls V: Skyrim. Bethesda Game Studios. Playstation 3. Bethesda Softworks, 2011.

The Legend of Zelda: A Link to the Past. Nintendo. Super Nintendo Entertainment System. Nintendo, 1991.

The Legend of Zelda: Ocarina of Time. Nintendo. Nintendo 64. Nintendo, 1998.

The Legend of Zelda: The Wind Waker. Nintendo. Nintendo Game Cube. Nintendo, 2002.

The Legend of Zelda: Twilight Princess. Nintendo. Nintendo 64. Nintendo, 2006.

Virtual Boy Wario Land. Nintendo. Virtual Boy. Nintendo, 1995.

BIBLIOGRAPHY

Anderson, Benedict. *Imagined Communities: Reflections on the Origin and Spread of Nationalism*. London: Verso, 1991.

Baumgartner, Thomas, Kai Lutz, Conny F. Schmidt, and Lutz Jäncke. "The Emotional Power of Music: How Music Enhances the Feeling of Affective Pictures." *Brain Research* 1075, no. 1 (2006): 151–64.

Bribitzer-Stull, Matthew. *Understanding the Leitmotif: From Wagner to Film Music*. Cambridge: Cambridge University Press, 2015.

Buerkle, Robert. "Of Worlds and Avatars: A Playercentric Approach to Videogame Discourse." PhD diss., University of Southern California, 2008.

Cady, Elizabeth T., Richard Jackson Harris, and J. Bret Knappenberger. "Using Music to Cue Autobiographical Memories of Different Lifetime Periods." *Psychology of Music* 36, no. 2 (2008): 157–77.

Cartwright, Phillip, Ekaterina Besson, and Laurent Maubisson. "Nostalgia and Technology Innovation Driving Retro Music Consumption." *European Journal of Innovation Management* 16, no. 4 (2013): 459–94.

Collins, Karen. *Game Sound: An Introduction to the History, Theory, and Practice of VGM and Sound Design*. Cambridge: MIT Press, 2008.

D'Alessandro, Desiree. "A Remix Artist and Advocate." In *The Routledge Companion to Remix Studies*, edited by Eduardo Navas, Owen Gallagher, and Xtine Burrough, 461–70. London: Routledge, 2014.

Diaz-Gasca, Juan Sebastian. "Music Beyond Gameplay: Motivators in the Consumption of Videogame Soundtracks." PhD diss., Griffith University, 2015.

Diaz-Gasca, Sebastian. "Super Smash Covers! Performance and Audience Engagement in Australian VGM Cover Bands." *Perfect Beat* 19, no. 1 (2018): 51–67.

Duncan, Sean C. "Gamers as Designers: A Framework for Investigating Design in Gaming Affinity Spaces." *E-Learning and Digital Media* 7, no. 1 (2010): 21–34.

Gazzard, Alison. "Between Pixels And Play: The Role of the Photograph in Videogame Nostalgias." *Photography and Culture* 9, no. 2 (2016): 151–62.

Gorbman, Claudia. "Narrative Film Music." *Yale French Studies* no. 60 (1980): 183–203.

Guffey, Elizabeth E. *Retro: The Culture of Revival. Focus on Contemporary Issues*. London: Reaktion, 2006.

Istvandity, Lauren. "The Lifetime Soundtrack: Music as an Archive for Autobiographical Memory." *Popular Music History* 9, no. 2 (2015): 136–54.

Ivănescu, Andra. *Popular Music in the Nostalgia Videogame: The Way It Never Sounded*. Cham: Springer International Publishing, 2019.

Janata, Petr, Stefan T. Tomic, and Sonja K. Rakowski. "Characterisation of Music-Evoked Autobiographical Memories." *Memory* 15, no. 8 (2007): 845–60.

Jenkins, Henry. *Textual Poachers: Television Fans and Participatory Culture*. London: Routledge, 1992.

Jenkins, Henry. *Fans, Bloggers, and Gamers: Exploring Participatory Culture*. New York: New York University Press, 2006.

Juul, Jesper. *Half-Real: Video Games Between Real Rules and Fictional Worlds*. Cambridge: MIT Press, 2005.

Kamp, Michiel. "Musical Ecologies in Videogames." *Philosophy & Technology* 27, no. 2 (2014): 235–49.

Kamp, Michiel. "Suture and Peritexts: Music Beyond Gameplay and Diegesis." In *Ludomusicology: Approaches to Video Game Music*, edited by Tim Summers, Mark Sweeney, and Michiel Kamp, 73–91. Sheffield: Equinox Publishing, 2016.

Kärjä, Antti-Ville. "Marketing Music through Computer Games: The Case of Poets of the Fall and *Max Payne 2*." In *From Pac-Man to Pop Music: Interactive Audio in Games and New Media*, edited by Karen Collins, 27–44. Aldershot: Ashgate Publishing, 2008.

Kline, Stephen, Nick Dyer-Witheford, and Greig de Peuter. *Digital Play: The Interaction of Technology, Culture, and Marketing*. Montreal: MQUP, 2003.

Krumhansl, Carol Lynne, and Justin Adam Zupnick. "Cascading Reminiscence Bumps in Popular Music." *Psychological Science* 24, no. 10 (2013): 2057–68.

Lind, Stephanie. "Active Interfaces and Thematic Events in *The Legend of Zelda: Ocarina of Time*." In *Music Videogames: Performance, Politics, and Play*, edited by Michael Austin, 83–105. New York: Bloomsbury Academic & Professional, 2016.

Makai, Péter. "Videogames as Objects and Vehicles of Nostalgia." *Humanities* 7, no. 4 (2018): 123.

Márquez, Israel V. "Nostalgia Videolúdica: Un Acercamiento al Movimiento Chiptune." *Trans* 16 (2012): 2–21.

Medina-Gray, Elizabeth. "Analyzing Modular Smoothness in Video Game Music." *Music Theory Online* 25, no. 3 (2019). https://doi.org/DOI:10.30535/mto.25.3.2.

Miller, Kiri. "Jacking the Dial: Radio, Race, and Place in *Grand Theft Auto*." *Ethnomusicology* 51, no. 3 (2007): 402–38.

Miller, Kiri. "Grove Street Grimm: *Grand Theft Auto* and Digital Folklore." *Journal of American Folklore* 121, no. 481 (2008): 255–85.

Neil, John. "The Music Goes On and On and On…and On—Popular Music's Affective Franchise." In *Access All Eras: Tribute Bands and Global Pop Culture*, edited by Shane Homan, 83–102. Maidenhead: Open University Press.

Neumeyer, David. "Diegetic/Nondiegetic: A Theoretical Model." *Music and the Moving Image* 2, no. 1 (2009): 26–39.

Newman, James. *Playing with Videogames*. London: Routledge, 2008.

Plank, Dana M. "*Mario Paint Composer* and Musical (Re)Play on YouTube." In *Music Videogames: Performance, Politics, and Play*, edited by Michael Austin, 43–82. New York: Bloomsbury Academic & Professional, 2016.

Reading, Anna, and Colin Harvey. "Remembrance of Things Fast: Conceptualizing Nostalgic-Play in the *Battlestar Galactica* Videogame." In *Playing the Past: History and Nostalgia in Videogames*, edited by Laurie N. Taylor and Zach Whalen, 164–80. Nashville: Vanderbilt University Press, 2008.

Reynolds, Simon. *Retromania: Pop Culture's Addiction to Its Own Past*. New York: Faber & Faber, 2011.

Rogers, Richard A. "From Cultural Exchange to Transculturation: A Review and Reconceptualization of Cultural Appropriation." *Communication Theory* 16, no. 4 (2006): 474–503.

Rone, Vincent E. "Twilight and Faërie: The Music of *Twilight Princess* as Tolkienesque Nostalgia." In *Mythopoeic Narrative in the Legend of Zelda*, edited by Anthony G. Cirilla and Vincent E. Rone, 81–100. New York: Routledge, 2020.

Routledge, Clay. *Nostalgia: A Psychological Resource*. London: Taylor & Francis, 2015

Ryynänen, Toni, and Visa Heinonen. "From Nostalgia for the Recent Past and Beyond: The Temporal Frames of Recalled Consumption Experiences." *International Journal of Consumer Studies* 42, no. 1 (2018): 186–94.

Schubert, Emery. "Does Recall of a Past Music Event Invoke a Reminiscence Bump in Young Adults?" *Memory* 24, no. 7 (2016): 1007–14.

Steinkuehler, Constance A. "Why Game (Culture) Studies Now?" *Games and Culture* 1, no. 1 (2006): 97–102.

Summers, Tim. "Analysing Video Game Music: Sources, Methods and a Case Study." In *Ludomusicology: Approaches to Video Game Music*, edited by Michiel Kamp, Tim Summers, and Mark Sweeney, 8–31. Sheffield: Equinox Publishing, 2016.

Summers, Tim. *Understanding Video Game Music*. Cambridge University Press, 2016.

Summers, Tim. "Music and Transmediality: The Multi-Media Invasion of Jeff Wayne's Musical Version of *The War of the Worlds*." *Twentieth-Century Music* 15, no. 2 (2018): 231–58.

Tagg, Philip. *Music's Meanings: A Modern Musicology for Non-Musos*. New York: Mass Media's Scholar's Press, 2012.

Taylor, Laurie N., and Zach Whalen. "Playing the Past: An Introduction." In *Playing the Past: History and Nostalgia in Videogames*, edited by Laurie N. Taylor and Zach Whalen, 1–15. Nashville: Vanderbilt University Press, 2008.

van Elferen, Isabella. "Fantasy Music: Epic Soundtracks, Magical Instruments, Musical Metaphysics." *Journal of the Fantastic in the Arts* 24, no. 1 (2013): 4–24.

Whiteman, Natasha. "Modalities of Nostalgia in Fan Responses to *Silent Hill 4: The Room*." In *Playing the Past: History and Nostalgia in Videogames*, edited by Laurie N. Taylor and Zach Whalen, 32–50. Nashville: Vanderbilt University Press, 2008.

PART 2

OBJECTIFYING NOSTALGIA AND VIDEOGAME MUSIC

3

My Childhood Is in Your Hands: Videogame Concerts as Commodified and Tangible Nostalgic Experiences

Elizabeth Hunt

Picture yourself in a busy concert auditorium. The bustling excitement of the crowd becomes hushed as lights dim and the conductor enters the stage. In this moment of quiet anticipation, you hear a whisper from the individual seated to your left. "This guy has my whole childhood in his hands, no pressure!" How is this conductor so powerful? What could possibly be so important to the identity and life of this attendee that their "whole childhood" is in this conductor's hands? *Pokémon,* of course. At least, this was what happened in my attendance of the orchestral concert *Pokémon: Symphonic Evolutions.* A growing number of videogame fans are attending orchestral concerts featuring the music from their favorite videogames. Concerts of videogame music have become an increasingly widespread phenomenon within the seasons of classical music venues and the fan communities attending these concerts find the experience compelling. These concerts feature a sense of spectacle, with full-size orchestras playing videogame music spanning decades and franchises, and large video screens are often found hanging above the orchestra showing gameplay and cutscenes. Commercial success in videogame concerts can appear exceptional in comparison to traditional orchestral concerts. For example, 2012's *Distant Worlds* in London "took around two hours" to sell out.[1] This large fan community provides a reliable source of ticketing sales and has supported the widespread success of these concerts to the point of global success and frequent world tours.

With the success of videogame concerts, concert halls are increasing revenue by targeting audiences nostalgic for videogames and are, thus, taking part in a

[1] Ross, *Video Game Music,* 40.

videogame industry trend of commodifying nostalgia. This chapter examines the importance of nostalgia in videogame concerts by considering its role in informing repertoire curation and examining how certain videogames and videogame music have become artifacts symbolic of childhood. This will first involve a demonstration of the prosperous nature of nostalgic marketing in the videogame industry. Following Heineman's statement that "invoking the past [...] often drives consumer habits, marketing choices, and certain industry trends," we will see that videogame concerts invoke the past by presenting themselves as a celebration of their chosen franchise (or gaming in general).[2] Two concepts of concert success will be discussed in this chapter as case studies will analyze (1) commercial success via the commodification of nostalgia and (2) the triggering of nostalgic feelings to invoke positive emotions and enhance audience enjoyment. These successes will be drawn upon to show that traditional concert venues are increasingly turning to videogame concerts to increase their profits and subsequently suggest that they will continue to do so.

The history of videogame concerts

The success of videogame concerts around the globe demonstrates the extent of the audience reach and marketability of live orchestral game music productions. The first performance of videogame music in an orchestral concert was in 1987.[3] The show, *Family Classic Concert*, took place in Tokyo and was performed by the Tokyo String Music Combination Playing Group. *Family Classic Concert* met with such success that it has continued to be held annually, celebrating its 30th concert in 2017. From 1991 to 1996, a series called *Orchestral Game Music Concert* regularly sold out concerts and continued the development of videogame concerts in Japan.[4] However, Western audiences had to wait until 2003 for a live, orchestral videogame concert. Played by the Czech National Symphony Orchestra, *Symphonic Game Music Concert* debuted in Leipzig, Germany.[5] Additionally, the inception of the Eminence Symphony Orchestra in Australia in 2003 increased global interest in videogame concerts. Following positive receptions to the concerts in Europe and Australia, co-creators Jack Wall and Tommy Tallarico began working on their own creation. Their production *Video Games Live*

[2] Heineman, *Thinking About Video Games*, 19.

[3] Leicester, "From Bleeps of 'Pong' and 'Mario.'"

[4] Belinkie, "Video Game Music."

[5] Game Concerts, "Thomas Böcker."

(hereafter *VGL*) debuted with the LA Philharmonic at the Hollywood Bowl in 2005 and would go on to become the first global videogame concert. *VGL* has sold out arenas in South America, Asia, Europe, and Australia and is the most successful videogame concert series to date. One marker of this success is the Guinness World Record Tallarico that was awarded in 2016 at *VGL*'s 357th performance for "Most Video Game Concerts Performed."[6] After the success of the aforementioned concerts, several videogame concert series have continued to be developed across the globe. Of note for this study are *The Legend of Zelda: Symphony of the Goddesses* (2012–18, hereafter *SotG*) and *Pokémon: Symphonic Evolutions* (2014–16, hereafter *SE*). These are similar concert series as they toured the globe successfully for a number of years and are both based on Nintendo RPG franchises that have spanned a number of decades and consoles—*The Legend of Zelda* and *Pokémon*. Both offer typical videogame concert experiences of an orchestra playing music from across the franchise arranged specifically for concert performance while large screens above display video accompaniment to tell the videogame's narrative through gameplay footage and cutscenes. In looking over the brief history given here, we can see that videogame concerts have a global appeal that has been developing since the 1980s. Close discussion of *SotG* and *SE* will demonstrate that this demand lies in the tangible nostalgic experience created by videogame concerts.

The commodification of nostalgia

In videogame concerts, the intangible feeling of nostalgia is transformed into a tangible experience that can be consumed to satiate nostalgic desire. The concept discussed here of a tangible nostalgic experience requires an understanding of how nostalgia is used in modern discourse. This goes beyond looking at nostalgia as a feeling but as something that industries, in this case, the games industry, actively encourage in consumers. Once this has been established, this theory will be applied to videogame concerts to demonstrate how nostalgia can be consumed by audiences to generate positive reception.[7]

A feeling of nostalgia is an intangible feeling of desire for the past. Moreover, it is a desire for something immaterial—a return to our lived experiences of the past.

[6] Swatman, "Video Games Live Creator."

[7] For discussion of the psychology of nostalgia, music, and videogames, see Michael Vitalino and Vincent Rone's work in this volume, "A Player's Guide to the Psychology of Nostalgia and Videogame Music."

Kant's definition of nostalgia supports this as he states it is "less the desire to go home, and more the desire to be young again."[8] Furthermore, Sean Fenty describes nostalgia as "the yearning to return to some past period" and identifies that the "irrecoverable" nature of the past is key to nostalgia.[9] While the past is "irrecoverable," this yearning can temporarily be satiated by nostalgic experiences. These experiences have a positive effect as they emotionally return us to past moments of joy. In Proust's *A la Recherche du Temps Perdu*, when eating his madeleine "the narrator describes himself as being struck in a way that captures his attention," he eventually attributes this to "a long-buried memory that is gradually brought to the surface of consciousness."[10] This experience, the Proust Phenomenon, is a strike of nostalgia that brings with it a positive feeling of being returned to one's past. We often attempt to satiate our nostalgia and achieve this positive feeling as consumers by purchasing objects that sell us the idea of return and, in doing so, give the intangible feeling of nostalgia some sense of tangibility.

For videogame consumers, nostalgia is a response to rapid technological advancement. As technology develops, newer videogames and consoles with better sound quality and visuals are quickly released.[11] This means that gamers are constantly moving onto the next product, and, following Fenty, the past can never be repeated because too much change occurs in both the technology and the players. In an industry of such advancement, nostalgic feelings become a constant. This has spawned a significant nostalgia market for videogames and gaming memorabilia with gamers feeling the nostalgic impulse to recreate their past. The intangible feeling of nostalgia is made physical and interactable by videogames. Thus, like a childhood teddy bear becomes a nostalgic artifact, so do videogames. In holding the old bear, our nostalgia becomes tangible as it is attached to the object. While we can never truly return to our youth, we can hold it, touch it, and, in the case of videogames, play with it. The tangibility of videogames presents a "possibility of return, if we can only gain access to them."[12] Hence, new and nostalgically oriented products add promise to this nostalgia while also commodifying consumer nostalgia in a way that "make[s] game history easy to package and even easier to consume."[13] Now, nostalgic artifacts are being released as new products to appeal to nostalgic consumers.

[8] Quoted in Niemeyer, "Introduction: Media and Nostalgia," 8.

[9] Fenty, "Why Old School Is 'Cool'," 21.

[10] Smith, "Proust, the Madeleine and Memory," 38.

[11] Sloan, "Videogames as Remediated Memories."

[12] Fenty, "Why Old School Is 'Cool'," 22.

[13] Payne, "Playing the Déjà-New," 64.

Videogame products targeting nostalgic consumers include re-releases, remasters, and Plug In and Play consoles, such as 2016's Nintendo Classic Mini: Nintendo Entertainment System (hereafter Mini NES). Baade and Aitken refer to those targeted by such nostalgic artifacts as a "nostalgia demographic" and posit that popular culture's "aestheticization of nostalgia" has incited a re-release culture in the music industry.[14] This aestheticization of nostalgia is also present in the videogame industry where long-term gamers are targeted in particular. To demonstrate, the Mini NES's advertising includes phrases aimed at customers who played the original NES, showing an awareness of consumers' nostalgic tendencies. The webpage for the product urges reminiscence through the lines "remember your first Goomba stomp?" and "rediscover the joy of NES games."[15] Such advertising promises to transport consumers to their childhoods spent playing the original NES as Proust was transported to his childhood by eating the madeleines. Therefore, this marketing campaign focuses on nostalgia to incentivize older gamers to purchase the Mini NES. The commercial success of Nintendo's Plug In and Play consoles can be seen in the Mini NES's sales statistics, as sales of 2.3 million consoles on the first release demonstrate a thriving market for nostalgia-oriented products.[16] Thus, Nintendo clearly achieves high sales by targeting older gamers' sentimentality for systems of their youth.[17]

The success of the Mini NES is an example of the lucrative nostalgia market for videogames. For some gamers, videogames have achieved the nostalgic artifact status of the old teddy bear or Proust's madeleines. Moreover, the interactive nature of games allows them to take precedence in our memory as they hold "a perfect past that can be replayed, a past within which players can participate."[18] This is capitalized on by videogame concerts and exploited further through musical links. Music's presence strengthens the nostalgic experience as music is identified by Svetlana Boym as a "permanent accompaniment of nostalgia," and, according to Rousseau, can "act [...] as a memorative sign."[19] Videogames are rife with repeating, catchy melodies that accompany hours of play. As videogames have

14 McKittrick, "Scott Pilgrim Vs. The Veteran Gamer."

15 Nintendo, "Nintendo Classic Mini."

16 Peckham, "Nintendo Says It Sold over 2 Million Nes Classics."

17 For another discussion on the commodification of videogames, see Sebastian Diaz-Gasca's "And The Music Keeps Playing: Nostalgia in Paraludical Videogame Music Consumption" elsewhere in this volume.

18 Fenty, "Why the Old School Is 'Cool'," 22.

19 Kizzire, "'The Place I'll Return to Someday'"; Pozderac-Chenevey, "A Direct Link to the Past."

become nostalgic artifacts, so too has videogame music. The wish to hear these soundtracks in the grand manner of an orchestral concert follows Simon Reynolds's theory that "every generation as it ages will want to see its musical youth mythologised and memorialised."[20] Concerts of videogame music advance the current market of nostalgic consumables as merchandise is substituted with a live event. Therefore, videogame concerts offer consumers an opportunity to experience a return to their childhood in some tangible form. The success of the Mini NES demonstrates how profitable this promise of return can be.

Regarding this nostalgia demographic, an examination of Figure 3.1 will demonstrate how heavily videogame concerts rely on nostalgia for older game series in the curation of their repertoires. Figure 3.1 shows set list data taken from 38 *VGL* performances from 2005 to 2017 to indicate the videogames and franchises with music most frequently featured in *VGL* concerts.[21] William Gibbons has discussed *VGL* and why it is useful for repertoire analysis in his essay "Rewriteable Memory: Concerts, Canons, and Game Music History."[22] Furthermore, *VGL* is interesting to the canonization of videogame music due to its constantly changing set list. *VGL*'s website states:

> Whenever we go into an area we collect all the data from that region to see what the audience is most interested in hearing. We also take all the data and find out what the most wanted segments are that we currently do NOT have in our show and start creating new segments based on those figures.[23]

This was true in my own attendance as music from *Ōkami* was included due to a request made by an audience member through social media. This suggests that *VGL* focuses on playing what audiences want to hear, making popular taste and nostalgia a factor in the music included.

The age of a videogame or franchise is clearly relevant to its inclusion in a *VGL* show. In Figure 3.1, 57 per cent of the franchises or videogames featured are from before 2000, including four of the top five most frequently featured, and few titles present in the data were released within the last decade. By demonstrating a preference for pre-2000 videogames, *VGL* targets demographics for whom these videogames have fallen into 20- and 30-year nostalgia cycles. This exploits the nostalgia of a "market of people with disposable income who are nostalgic for

[20] Reynolds, *Retromania*, 31.

[21] Setlist.fm, "Video Games Live Concert Setlists and Tour Dates."

[22] Gibbons, "Rewritable Memory."

[23] "Video Games Live."

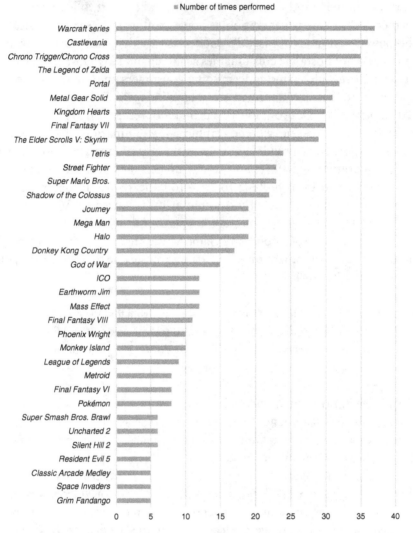

Analysis of set list data - *Video Games Live*

FIGURE 3.1: Data of videogames/franchises featured in *VGL* compiled from setlist.fm. Those appearing in less than 10 per cent of the collected data have not been included.

their childhoods."[24] Thus, *VGL* (and other concerts) are targeting gamers who can afford the expense of seeing a live orchestral concert and have the higher agency

[24] Metzger, "The Nostalgia Pendulum."

to choose to attend one. As seen in Figure 3.1, concerts rely on repertoires consisting of music from videogames from the 1980s and 1990s to target this nostalgia demographic. Videogames from these years have become strong nostalgic artifacts, and, in holding concerts featuring this music, classical venues can exploit this market and attract an audience.

Overall, Figure 3.1 is indicative of *VGL*'s nostalgically curated repertoire. The data demonstrate a preference for titles predating the millennium as these are games likely to have taken on a nostalgic status. However, the repeat performance of these nostalgic pieces potentially distorts the formation of a videogame music canon. This follows Carys Wyn Jones's statement that "a canon is the collection of works and artists that are widely accepted as the greatest in their field," and these are "works and artists that are studied in schools and universities, performed in concert halls and displayed in galleries."[25] The repeated performance of pieces to capitalize on audience nostalgia problematizes the formation of this canon as the "collection of works" presented is a nostalgic repertoire. This is one potential issue with including videogame music in classical music spaces. While videogame concerts attract a new demographic of nostalgic gamers to concert halls, nostalgia and sales have become a key factor in the performed videogame music canon. Nevertheless, discussion of Figure 3.1 restricts considerations to only a videogame/franchise's age. While this is relevant, videogame music is nostalgic because of more than simply a videogame's age as the function and use of music in videogames help to create nostalgic bonds.

Following nostalgic sounds

Through the above analysis, we can see that the potential to attract a nostalgia demographic impacts the repertoire selection of videogame concerts. Yet, videogame concerts do not only trigger nostalgic experiences by featuring music from older titles. Some musical selections are nostalgic because of the way they are experienced in-game. Examples of this are common in *SotG*. As *The Legend of Zelda* is a notable videogame franchise that spans decades, it is a prominent pre-2000 franchise like many of those in Figure 3.1. Demonstrating the omnipresence of the series, Pozderac-Chenevey confesses, "I was primed for nostalgia, as even the act of playing a Zelda game brought with it childhood memories," in reference to playing 2006's *The Legend of Zelda: Twilight Princess*.[26] Due to this, *SotG* is able to draw

25 Jones, *The Rock Canon*, 5.

26 Pozderac-Chenevey, "A Direct Link to the Past: Nostalgia and Semiotics in Video Game Music."

on music from an expansive franchise that has become ubiquitous in the life of Nintendo console owners. However, *SotG* enhances the nostalgia inherent in this history with its references to musical passages that stand out particularly within the gameplay, making them memorable and entwined with gamers' childhoods.

SotG adapts the style of a classical symphony consisting of four movements with each presenting the music of an installment in the franchise. Motifs and melodies included in the arrangements are often those that will have particularly stuck in players' memories. When hearing these themes in the concert, audience members immediately recognize themes prominent in their gameplay and so can draw upon memories of play and the youth related to this. One such example is the appearance of "Lost Woods" (or "Saria's Song") in the *Ocarina of Time* movement, named for the Nintendo 64 videogame the music is taken from. "Lost Woods" appears as environmental music in the Lost Woods area, a maze where the player must be attentive to the score and follow where it sounds loudest to find the correct path. Collins states that in gaming players "must rely on the audiovisual to navigate a game successfully."[27] This is literally so in the navigation of the Lost Woods, and so "the stakes for players' involvement, interpretation, and therefore attention are much higher."[28] Players are likely to remember "Lost Woods" due to this heightened attention. While this places the music prominently in player perception, the piece also has a narrative function as a fragment of the "Lost Woods" melody is used in-game as an ocarina melody called "Saria's Song." Players must remember and play "Saria's Song" on Link's (the player–character's) ocarina several times to progress gameplay.[29] As interacting with sound causes players "to retain the information more," the status of "Lost Woods" as an environmental, narrative, and play-input motif makes it extremely memorable.[30] Thus, "Lost Woods" is tied to player memory due to its continuous reiteration throughout *Ocarina of Time*. The prominence and nostalgic potential of "Lost Woods" are found in several motifs across *The Legend of Zelda* series.[31] Players must so frequently become familiar

[27] Collins, *Playing with Sound*, 22.

[28] Collins, *Playing with Sound*, 22.

[29] For further discussion of the use of the ocarina in Ocarina of Time, refer to Alec Nunes's "A Link Between Worlds: Nostalgia and Liminality in Musical Covers of *The Legend of Zelda*" elsewhere in this volume.

[30] Alec Nunes's "A Link Between Worlds: Nostalgia and Liminality in Musical Covers of *The Legend of Zelda*", 30.

[31] Refer to Sebastian Diaz-Gasca's "And The Music Keeps Playing: Nostalgia in Paraludical Videogame Music Consumption" in this volume for an examination of another theme, "Zelda's Lullaby."

with motifs to be successful in their gameplay that Pozderac-Chenevey argues that music is "tightly woven into the fabric" of the franchise.[32] With numerous melodies etched into players' memories, *SotG* can draw upon a breadth of thematic material to create a symphony based on a familiar repertoire. Several motifs offer the opportunity for a burst of nostalgia-triggered joy, an audible and visual Proust phenomenon, and so these moments of enhanced nostalgic pleasure occur many times throughout a single performance of *SotG*. These repeated moments of pleasure, thus, contribute toward audience enjoyment and the success of the show.

By featuring motifs that stand out in memories of gameplay, *SotG* triggers multiple nostalgic reminiscences and ensures its success through the positive response this incites in the audience. The intangible feeling of nostalgia becomes a tangible and consumable object in the event experience of *SotG* and other videogame concerts. Creating a symphony using music from *The Legend of Zelda* is possible due to the abundance of thematic material found throughout the franchise that can trigger feelings of nostalgia, however repertoire choice is important to guarantee that these nostalgic selections are curated carefully to provide a high emotional pay off and appease fans. If this is done successfully, audience nostalgia is maximized by creating small and frequent nostalgically generated moments of joy.

"I Choose You": Pokémon as a nostalgic artifact

Following that nostalgic ties are intertwined with repertoire choice and standout musical gestures, some musical selections are directed at reaching into audience members' childhoods and exploiting the effect of the positive nostalgic. The subsequent case study will bring together the ideas discussed regarding *SotG* and *VGL* to illustrate motif significance and repertoire curation within one concert series. This will allow further examination of how videogame franchises become intertwined with childhood memories and, as a result, become nostalgic artifacts. Moreover, analysis of musically expressed nostalgia outside of the concert hall will establish the bonds among nostalgia, music, and gamers, in this case *Pokémon* fans. These bonds are emphasized in attendance at *SE*, where nostalgia allows for an enhanced audience experience.

To become a nostalgic artifact, something must have been prominent in one's childhood and linked to positive memories. *Pokémon* was prominent in the culture of the late 1990s and early 2000s. Due to this, it has become a nostalgic artifact to

[32] Pozderac-Chenevey, "A Direct Link to the Past."

the children of this time. Between 1996 and 2001, *Pokémon* was omnipresent for many children. According to Joseph Tobin, "*Pokémon* at its peak was so successful that it could drop two-thirds and still be one of the world's most profitable children's products."[33] The first *Pokémon* videogames were released in 1996 and were swiftly followed by further games, a cartoon series and trading cards, serving to establish it as a dominant force in children's entertainment and videogames. This culminated in *Pokémon* becoming a "cultural practice" and "lifestyle" for children.[34] As a brand so prevalent, it could be considered part of children's lifestyles, *Pokémon* was (and still is) extremely lucrative. Consequently, Tobin claims that Pikachu, the most famous *Pokémon*, will "live on for many years to come, if nothing else than as an item of nostalgia."[35] *Pokémon*'s dominance in children's culture in the 1990s and early 2000s was extensive, and the generation who grew up with this ubiquity will likely look back on *Pokémon* and its characters as symbolic of their childhood due to this prevalence. Many adults who grew up at this time will see Pikachu and his fellow *Pokémon* cast as nostalgic artifacts because they will consider *Pokémon* to be inseparable from their youth.

To demonstrate how *Pokémon* fans have used music as a means of nostalgic expression, we can examine data from the music streaming service Spotify in the wake of *Pokémon Go*'s release. The mobile phone game *Pokémon Go* released in 2016 to immense success. Within its first week of release, the app achieved "7.5 million downloads," made "$14.04 million in revenue" and was "the most downloaded app in both the Android and Apple Stores."[36] However, particularly interesting for this study is the significant rise in streaming numbers for *Pokémon*-related music in this week. Articles state that Spotify streams of the song "Pokémon Theme," the theme song for the *Pokémon* cartoon series from 1998 to 1999, leapt by 362 per cent within the week.[37] Also, articles mention a rise in the streaming of other *Pokémon*-related songs and a large amount of user-created playlists titled "Pokémon" within the week following *Pokémon Go*'s release. Therefore, this demonstrates that individuals were inspired by the app to create playlists and stream music that reminded them of their *Pokémon*-filled childhoods. To support this, statistics dating from 2017 place the majority of *Pokémon Go* players between

[33] Tobin, "Conclusion," 290.

[34] Buckingham and Sefton-Green, "Structure, Agency, and Pedagogy," 12; Allison, "Cuteness as Japan's Millenial Product," 37.

[35] Tobin, "Conclusion," 290.

[36] Carpenter, "Pokémon-Related Songs Triple in Popularity."

[37] Jason Paige, vocalist, "Pokémon Theme," by John Siegler and John Loeffler, Spotify, track 1 on Pokémon, *Pokémon—2.B.A. Master*, Pokémon, 1999; Rys, "Can't Regret Them All."

the ages of 18 and 34 years, so these players will have likely encountered *Pokémon* during their youth when it was at peak popularity.[38] As *Pokémon Go* players are "old enough to have fallen in love with *Pokémon* the first time around," they are enjoying the game for its nostalgic symbolism.[39] This shows that many *Pokémon Go* players are seeking to recapture their childhood through play. This is further supported by a study into the motivations of using the app that found nostalgia to be "an important motive."[40] Furthermore, players' choice to listen to *Pokémon*-related music to complement their play supports Boym's statement that music is a "permanent accompaniment of nostalgia."[41] This demonstrates that players link music and play in their nostalgic expression. In addition, it demonstrates that players seek to consume music linked to their gaming childhoods to express and satiate nostalgia. *SE* provides an opportunity for this.

As nostalgic musical links are perpetuated by adult *Pokémon* fans, *SE* can rely on these same bonds to draw audiences. The streaming of *Pokémon*-related music in the wake of *Pokémon Go*'s release is evidence that music is important to the nostalgic recreation or reliving of the *Pokémon* player's youth. Therefore, ticket sales and audience satisfaction at *SE* are aided by the status of *Pokémon* as a nostalgic artifact. This was demonstrated in my own attendance of the concert when an individual seated next to me turned to his friends excitedly and uttered "This guy has my whole childhood in his hands, no pressure!" as the conductor took to the stage. That this individual has identified the series as representative of their childhood not only supports the above argument but also gives insight into the ways in which videogame concerts are viewed by their audiences. By choosing to attend the concert, the attendee clearly sees that the music of the game is as representative of their childhood nostalgia as the videogame itself. Their attendance at the concert allows them to revel in their nostalgic feelings associated with the videogame. Meanwhile, the importance placed upon the attendee's enjoyment of the concert shows that audience members attending *SE* hope for and anticipate this enjoyment. This individual placed such importance on *Pokémon* as a representation of their childhood that poor performance of the music, in their opinion, would sully or ruin these treasured memories. Due to this, the audience wants to enjoy the concert and so is already won over. As soon as the first chords strike a memory and the audience hears the title track for a videogame they have spent hours playing, they are swayed further by a burst of positive nostalgia. *SE*'s

[38] Business of Apps, "Pokémon Go Revenue and Usage Statistics (2019)."

[39] Villeneuve, "How Millenial Nostalgia."

[40] Zsila et al., "Motivations Underlying Augmented Reality Games."

[41] Kizzire, "'The Place I'll Return to Someday'."

audience is a nostalgia demographic, and the concert's success is aided by the audience's nostalgic feelings. As a result, the producers of *SE* and the classical venues it tours can feel assured, by virtue of the nostalgic symbolization that *Pokémon* has undergone, that there will be a pleased and paying audience.

SE becomes a nostalgic experience for its audience members through two pieces in particular—the opening piece, "Overture," and the final piece, "KISEKI." "Overture" combines both music and visuals to provide a nostalgic experience for the audience. As the concert's opening, the piece introduces the world of the *Pokémon* game series. On the screen above the orchestra, the menus of each main series installment (starting with *Pokémon: Red* and ending with *Pokémon: Y*) scroll across from right to left. This provides both an introduction to the pieces the audience can expect to hear, as each installment has its own piece in the concert, and a chronology of the series. As accompaniment to these visuals, "Overture" is a fully orchestrated rendition of peritextual music from *Pokémon: Red, Blue* and *Green*. This music features two distinctive themes, a frenetic, staccato motif, and a heroic, rising "call to adventure" melody. Acting as leitmotifs, variations on these themes have been implemented in the peritexts of every subsequent entry to the main *Pokémon* videogame series. Thus, these themes have become symbolic of the series.

By presenting these two themes synched to scrolling images relating to each installment, *SE* takes its audience on a sonic and visual "trip down memory lane" displaying the first thing players saw when playing these games. The recurring menu screens bombard the audience with memories of excitedly putting a new game cartridge in, booting it, and seeing that inviting "PRESS START" message accompanied by the image of a new Pokémon they will have the opportunity to catch in this installment. The visuals also emphasize the passage of time as the graphics improve and develop with each subsequent menu screen. As they are watching video screens showing how the series has developed, audience members who have played every installment (which, one would assume, would be most) are reminded of the aging of something they have aged with. Furthermore, presenting this visual timeline with music symbolic of youth, "Overture," as accompaniment accentuates this nostalgia. "Overture" calls forth memories of a play experience that is, following Fenty, "irrecoverable." Here, visuals forcefully induce nostalgic feelings in the audience which are heightened by the choice of music. Opening the concert with this gives a Proust Phenomenon burst of nostalgic joy from the start while also setting a precedent for the forthcoming nostalgic experiences audience members will have throughout an *SE* performance.

On the other hand, "KISEKI" creates a sense of nostalgia by inciting the sense of community encouraged by the *Pokémon* franchise. The ending theme from 2013s *Pokémon: X* and *Y* (the newest games presented in the show), "KISEKI"

accompanies the closing cutscenes to *X* and *Y*'s main storyline and as such is presented alongside these visuals in *SE*. A more obscure piece, "KISEKI" does not incite any of the franchise's history in the way that "Overture" and "Pokémon Theme" do with their links to the audience's youth. Instead, "KISEKI" triggers nostalgia for the actions involved in playing a *Pokémon* game (battling or trading with friends, collaborating, and working together to help collect all the Pokémon) and the storylines of these games, which often revolve around themes of team work and friendship with other players, Pokémon trainers, and one's Pokémon. To incite these feelings of community, the audience is encouraged to sing along to "KISEKI" as lyrics appear on the screens above the orchestra. Since cooperation and community are central to the *Pokémon* games, acting out these traits by singing with fellow audience members in "KISEKI" may trigger nostalgic feelings for said acts because they are part of a shared experience for the audience. Feelings of nostalgia are further supported by the lyrics of "KISEKI" which include references to time, e.g. "Treasure this gift, this precious time that we have." The lyrics take on a nostalgic meaning within the context of *SE* as the audience members singing along are reminiscing about their childhoods spent playing *Pokémon*. Unlike "Overture' or *SotG*'s "Lost Woods," "KISEKI" is a musical selection that triggers positive feelings through nostalgia by inciting feelings and themes of the *Pokémon* franchise.

In creating these nostalgic feelings during the show, *SE* is drawing on the established nostalgia of *Pokémon* fans to enhance their enjoyment of the concert. Fans attend *SE*, and other videogame concerts, with a pre-existing fondness for the music presented. As the videogames have become artifacts of their childhood memories, concerts provide audiences the opportunity to interact with their nostalgia in a tangible, consumable form. Moreover, the importance of these memories and strength of these emotions are so powerful that a conductor can indeed hold an entire childhood in their hands. This commodification of nostalgia makes the event a success as audiences tangibly experience something of the past they long to relive. Such success encourages positive reviews, both official and word of mouth, and ticket sales. Consequently, this prolongs tour potential and increases profit for tour producers and concert venues.

Conclusion: Videogame music and the classical venue

This rise in profits and audience numbers stimulated by videogame concerts is something that classical venues need. By bringing gamers to the classical venue, concerts like *SE* and *SotG* usher in an audience of individuals who have often not attended an orchestral concert before. Through this, the classical music venue is turning to

videogames as a draw for new audience members. The future of classical music venues is uncertain, with dwindling interest and audience numbers dramatized by headlines claiming classical music is either "dead" or "dying."[42] Classical music venues are continually struggling to turn a profit. In addition to this, Dobson states that "audiences for live classical concerts have been documented as an ageing population with younger audiences in decline."[43] This renders the concert hall's future uncertain "when factors such as declining health, mobility and social networks in older age are taken into consideration" in regard to its existing audience.[44] To ensure its survival, the classical music venue has sought ways to attract new audiences, particularly "those of parenting age and their offspring."[45] To attract this missing audience, venues are trying to find music that appeals to young/middle-aged adults and their children. Videogames' nostalgia demographic falls directly into this desired audience. By performing videogame music, classical music venues can attract this nostalgia demographic while also negating any lack of familiarity with the repertoire, which Dearn and Pitts identify as off putting to concert newcomers.[46] As this chapter demonstrates, videogames offer a familiar repertoire with nostalgic ties going back to gamers' childhoods. Concerts drawing on a repertoire of videogame music are a lucrative investment for the struggling classical venues of today due to this. Thus, ticket sales are increased by focusing on videogames' nostalgia demographic. Videogame concerts, with their repertoires drawing on nostalgic artifacts and triggers, attract individuals at an age with fond memories of gaming and a disposable income. Exploiting these consumers is a means for classical music venues to continue their business and attract new customers.

Videogame concerts present an opportunity for classical venues, not only to increase ticket sales but also to bring new audiences to orchestral and classical music. However, there is no assurance that videogame concert audiences will broaden their interests to attend other orchestral concerts. Furthermore, some may view the inclusion of this "non-traditional" art form in a "traditional" space negatively. Others might argue such concerts expand, modernize, and diversify the orchestral repertoire. Regardless, these ideas are not without their own issues which demand further academic discussion. As far as videogame concerts and nostalgia are concerned, clearly nostalgic feelings in audience members are considered in their curation and presentation. Due to the nostalgia that videogame players have for their favourite franchises and music, concert producers and venues

[42] Albright, "'Classical' Music Is Dying"; Vanhoenacker, "Requiem."

[43] Dobson, "New Audiences for Classical Music," 111.

[44] Dearn and Pitts, "(Un)Popular Music and Young Audiences," 44.

[45] Dearn and Pitts, "(Un)Popular Music and Young Audiences," 44.

[46] Dearn and Pitts, "(Un)Popular Music and Young Audiences," 44.

can rely on ticket sales when targeting nostalgic consumers. As a nostalgia demographic, concert audiences are aware of their nostalgic urges and seek out nostalgic experiences. Consumers consider the memories that these experiences trigger so important that their childhood can, indeed, be in a composer's hands. However, their childhood is safe as this nostalgia primes them for a positive experience. Attendance at videogame concerts is an act of nostalgic expression where gamers seek to have their nostalgia made tangible and consumable. Due to this, videogame music as a nostalgic artifact is a powerful consumerist tool.

LUDOGRAPHY

Ōkami. Clover Studio. PlayStation 2 and Wii. Capcom, 2006.

Pokémon. GameFreak. GameBoy et al. Nintendo, 1996–present.

Pokémon Go. Niantic. Android 5.0 or later and iPhone 5S or later. Niantic, 2016.

The Legend of Zelda. Nintendo. Nintendo Entertainment System et al. Nintendo, 1986–present.

BIBLIOGRAPHY

Allison, Anne. "Cuteness as Japan's Millennial Product." In *Pikachu's Global Adventure: The Rise and Fall of Pokémon*, edited by Joseph Tobin, 34–49. Durham: Duke University Press, 2004.

Buckingham, David, and Julian Sefton-Green. "Structure, Agency, and Pedagogy in Children's Media Culture." In *Pikachu's Global Adventure: The Rise and Fall of Pokémon*, edited by Joseph Tobin, 12–33. Durham: Duke University Press, 2004.

Collins, Karen. *Playing with Sound: A Theory of Interacting with Sound and Music in Video Games*. Cambridge: MIT Press, 2013.

Dearn, Lucy K., and Stephanie E. Pitts. "(Un)Popular Music and Young Audiences: Exploring the Classical Chamber Music Concert from the Perspective of Young Adult Listeners." *Journal of Popular Music Education* 1, no. 1 (2017): 43–62.

Dobson, Melissa C. "New Audiences for Classical Music: The Experiences of Non-Attenders at Live Orchestral Concerts." *Journal of New Music Research* 39, no. 2 (2010): 111–24.

Fenty, Sean. "Why Old School Is 'Cool': A Brief Analysis of Video Game Nostalgia." In *Playing the Past: History and Nostalgia in Video Games*, edited by Zach Whalen and Laurie N. Taylor, 19–31. Nashville: Vanderbilt University Press, 2008.

Gibbons, William. "Rewritable Memory: Concerts, Canons, and Game Music History." *Journal of Sound and Music in Games* 1, no. 1 (2020): 75–81.

Heineman, David S. *Thinking About Video Games: Interviews with the Experts*. Bloomington: Indiana University Press, 2015.

Jones, Carys Wyn. *The Rock Canon: Canonical Values in the Reception of Rock Albums*. Aldershot: Ashgate, 2008.

Kizzire, Jessica. "'The Place I'll Return to Someday': Musical Nostalgia in *Final Fantasy IX*." In *Music in Video Games: Studying Play*, edited by K. J. Donnelly, William Gibbons, and Neil Lerner, 183–98. London: Routledge, 2014.

McKittrick, Megan. "Scott Pilgrim vs. The Veteran Gamer: The Canonization and Commodification of Nostalgia in Anamanaguchi's 8-Bit Video Game Soundtrack." *Reconstruction: Studies in Contemporary Culture* 14, no. 1 (2014). http://reconstruction.digitalodu.com/Issues/141/McKittrick.shtml.

Niemeyer, Katharina. "Introduction: Media and Nostalgia." In *Media and Nostalgia: Yearning for the Past, Present and Future*, edited by Katharina Niemeyer, 1–23. Basingstoke: Palgrave Macmillan, 2014.

Payne, Matthew Thomas. "Playing the Déjà-New: 'Plug It in and Play TV Games' and the Cultural Politics of Classic Gaming." In *Playing the Past: History and Nostalgia in Video Games*, edited by Zach Whalen and Laurie N. Taylor, 51–68. Nashville: Vanderbilt University Press, 2008.

Pozderac-Chenevey, Sarah. "A Direct Link to the Past: Nostalgia and Semiotics in Video Game Music." *Divergence Press*, 2 (June 2014). http://divergencepress.net/2014/06/02/2016-11-3-a-direct-link-to-the-past-nostalgia-and-semiotics-in-video-game-music/.

Reynolds, Simon. *Retromania: Pop Culture's Addiction to Its Own Past*. London: Faber and Faber, 2011.

Ross, Daniel. *Video Game Music: Classic FM Handy Guides*. London: Elliott and Thompson, 2015.

Siegler, John, and John Loeffler. "Pokémon Theme." *Pokémon—2.B.A. Master*. Jason Paige, vocalist. Pokémon, compact disc. Originally released in 1999.

Sloan, Robin J. S. "Videogames as Remediated Memories: Commodified Nostalgia and Hyperreality in *Far Cry 3: Blood Dragon* and *Gone Home*." *Games and Culture* 10, no. 6 (2015): 525–50.

Smith, Barry, C. "Proust, the Madeleine and Memory." In *Memory in the Twenty-First Century: New Critical Perspectives for the Arts, Humanities, and Sciences*, edited by Sebastian Groes, 38–41. Basingstoke: Palgrave Macmillan, 2016.

Tobin, Joseph. "Conclusion: The Rise and Fall of the *Pokémon* Empire." In *Pikachu's Global Adventure: The Rise and Fall of Pokémon*, edited by Joseph Tobin, 257–92. Durham: Durham University Press, 2004.

Villeneuve, Marina. "How millennial nostalgia fueled the success of 'Pokemon Go'." *Detroit Free Press*, July 23, 2016. https://eu.freep.com/story/life/2016/07/23/pokemon-go-millennial/87452742/.

Zsila, Ágnes, Gábor Orosz, Beáta Bőthe, István Tóth-Király, Orsolya Király, Mark Griffiths, and Zsolt Demetrovics. "An Empirical Study on the Motivations Underlying Augmented Reality Games: The Case of *Pokémon Go* During and After *Pokémon* Fever." *Personality and Individual Differences* no. 133 (2018): 56–66.

4

Remembering the Rules:
Immersive Nostalgia in
Final Fantasy Leitmotifs

Can Aksoy

Introduction

This paper's goal is to explain how videogame leitmotifs can employ nostalgia to increase player immersion in virtual worlds. To highlight why this is an important discovery, it first theorizes how nostalgic references (unrelated to leitmotifs) in videogames normally hinder the player's immersion in virtual experiences. As adults with disposable incomes, many players desire to invest in reminders of the good ol' days. Developers profit from this impulse by selling re-released titles, remastered videogames, and nostalgia games (modern games that imitate older formats). At first glance, these new games look and sound like the old ones did. However, this nostalgic impression of gaming's yesteryear is highly curated and intentional. These genres bluntly reference what developers assume are a gamer's nostalgic memories—a monolithic interpretation of gaming's "classic" era. They also use cutting-edge technology to erase "classic" features that modern gamers would now find annoying. This editing affords the player the opportunity to circumvent an uncomfortable realization that may not now enjoy how their object of their nostalgia currently feels or sounds. This effort to preserve the entertainment value of nostalgic references in a videogame limits the player's ability to immerse. A player's awareness of modern editing in a retro-styled game generates a distracting, meta-textual awareness that one is participating in a simulation of the past. The abruptness of this realization interrupts synchronous immersion into a game as the reality of the present.

Nostalgic references in videogames *invert* into an immersive force when leitmotifs are their vehicle. A leitmotif is a short melody that has been symbolically associated with a person, thing, or concept in a multi-media work. These symbolic associations

can unobtrusively explain the functionality of game systems from the background of play. This makes them a powerful tool for increasing player immersion. Nostalgic memory associated with a leitmotif bolsters this process. When a videogame series consistently deploys the same leitmotifs over several titles, they become nostalgic references for the ardent fan. This process does not nullify the leitmotif's ability to explain gameplay mechanics in present games. Instead, these musical references also become mnemonic devices that prompt fans to recall gameplay rules from nostalgic memory. Leitmotifs can muster nostalgia to raise player immersion in their present virtual world. *Final Fantasy* (*FF*) games illustrate this phenomenon. Every entry in this long series (1987–present) draws on the same canon of leitmotifs. Contemporary *FF* games that have revised the traditional gameplay mechanics of the series (particularly 2016's *FFXV* and 2020's *FFVII Remake*) often play familiar leitmotifs to entertain longtime fans with their nostalgic memories of past titles. Yet this nostalgia does not distract players from immersion in present experiences. Instead, it reminds players that despite modern changes in contemporary titles, players still inhabit a familiar *FF* world governed by familiar rules. In sum, heavy-handed nostalgic references in videogames distract from game immersion. Leitmotifs create an exception to this rule by transforming a player's indulgence in nostalgic pasts into a force that bolsters immersion in present virtual experiences.

Nostalgic references vs. immersion in re-releases and nostalgia games

Immersion is a sensation widely attributed to videogames. Scholars who theorize it often catalogue several different phenomena that sum into a collective impression of immersion. This subjectivity makes defining immersion difficult. Gordon Calleja's *In Game: From Immersion to Incorporation* (2011) broadly defines it as "the shortening of the subjective distance between player and game environment, often yielding a sensation of inhabiting the space represented on-screen."[1] He describes immersion as the blended experience of virtual movement, interactions with virtual agents, engaging narrative, affective response, decision making, and in-game goal completion. Alison McMahan's *Immersion, Engagement, and Presence: A Method for Analyzing 3-D Video Games* (2003) asserts that immersion is an "excessively vague, all-inclusive concept" and attributes it to sensory experiences, love of the game, virtual presence, realism, social interactions, and how intelligently virtual worlds react to player input.[2] Many other scholars create

[1] Calleja, *In Game: From Immersion to Incorporation*, 2.
[2] McMahan, "Immersion, Engagement and Presence," 63.

analogous taxonomies of immersion and have attributed it to creative engagement, empathy, game addiction, and flow states where gameplay feels intuitive. Additionally, scholars sometimes call attention to how immersion occurs in a range of complexity and intensity.[3] As this shows, immersion remains a plural-disciplinary catch-all topic that requires the analyst to create their own taxonomy in order to theorize it.

The immersion underpinning this paper's analysis is the emotional, kinesthetic impression of virtual experiences as real. The chief symptom of players immersed in this way is that they nostalgically recall virtual actions in a game as lived experiences in autobiographical memory.[4] The following gameplay features generally create this type of immersion. First, interactive gameplay calls attention to a player's existence in a virtual space. Players present themselves in a virtual world by interacting with virtual props, bodies (eating, washing, sleeping), and agents. Next, for a videogame to be recalled as a lived experience, it must disguise the simulation and minimize reminders that players are, in fact, playing a game. Developers achieve this impression by removing menus and designing natural, intuitive ways to interface with the virtual landscape. Immersive videogames also simulate agency and self-expression by demanding thoughtful choices from the gamer with dynamic consequences. Last, graphical and auditory realism are powerful contributors to this form of immersion, while hardware limitations are liable to distract from it.

Videogame music can either bolster or inhibit this type of immersion. Designers often use music as a storytelling tool to highlight plot events or make virtual settings feel more realistic. For example, the *Red Dead* videogame series (2004–present) is widely praised for immersive gameplay. The series is set in the Wild American West and creates a sense of realism with a soundtrack comprised of period appropriate instruments and imitations of the soundtracks of popular western films. Next, games featuring a high degree of player choice often employ *adaptive soundtracks* or collections of musical compositions that individually trigger in response to player action or narrative events.[5] An adaptive soundtrack can punctuate a player's choices and make them feel more meaningful. The *Red Dead*

[3] Glassner's *Interactive Storytelling* argues that immersion results from curiosity, sympathy, and empathy in a game. Ermi and Mäyrä assert in "Fundamental Components of the Gameplay Experience" that immersion depends on sensory experiences, meaningful challenges, and a game's ability to engage the imagination.

[4] For a neurological explanation of immersion's relationship to autobiographical memory, see Rone and Vitalino's "A Player's Guide to the Psychology of Nostalgia and Videogame Music" in this volume.

[5] For a fuller exploration of adaptive soundtracks, see Collins, *Game Sound*.

games also employ an adaptive soundtrack—peaceful situations are accompanied by peaceful music, while gunfights trigger intense compositions reminiscent of Sergio Leone films such as *The Good, the Bad, and the Ugly* (1966). Yet such techniques bolster immersion only if they are subtle. If the musical accompaniment becomes repetitive or heavy-handed, or if the fidelity of recordings is poor, players may become aware they are playing scripted simulations. As these variables suggest, personal taste does influence the impression of immersion. Yet series like *Red Dead, Elder Scrolls* (1994–present), *Grand Theft Auto* (1997–present), and *Far Cry* (2004–present) have all have been praised for using such techniques to make the virtual feel real to players.

While the immersive quality of a videogame has always drawn gamers to play, modern audiences also desire to feel nostalgia while playing a game. In *Postmodernism, or The Logic of Late Capitalism* (1991), Frederick Jameson explains that all future-oriented technological development prompts individuals to idealize the past. Scholars have many names for this feeling. Sandra Garrido and Jane Davidson term it *historical nostalgia*, a yearning for "simple rustic lifestyles that [an individual] may never have personally experienced."[6] Svetlana Boym terms this *reflective nostalgia*, a "longing for the slower rhythms of the past"[7] and a mental "rebellion against the modern idea of... progress" in *The Future of Nostalgia* (2001).[8] Gaming's rapid evolution creates similar rebellions. While the advent of gaming's brave new world is exciting to behold, gamers also experience their arrival as a form of loss. For example, games were once exclusively experienced via a controller connected to a console that was hardwired to a TV. Now "controllers" can be anything from buttons to motion-capture sensors, and screens can be located on one's face, wall, or desk or in the palm of one's hand. James Newman explains that the accumulation of such innovations forcibly replaces beloved titles as "platforms are superseded and eventually rendered obsolete... by newer, faster, "better" version[s]."[9] Sean Fenty describes this as causing a longing to return to the "past where the new technology does not exist... the pain of being caught between two worlds."[10] In sum, a gamer's objects of fondness are quickly rendered artifacts of the past. This loss can be experienced as a trauma, one that causes gamers to cease looking forward and begin nostalgically yearning for the simplicity of the past.

[6] Garrido and Davidson "Music, Nostalgia & Memory," 37.

[7] Boym, *The Future of Nostalgia*, 16.

[8] Boym, *The Future of Nostalgia*, xv.

[9] Newman, *Best Before*, 9.

[10] Fenty, "Why Old School Is 'Cool'," 21.

Videogame developers profit from this by creating retro-styled videogame memorabilia, musical concerts,[11] and game genres that actively reference nostalgia in gameplay. These genres exist in a spectrum of less-to-more intervention by modern technology. On one end of this spectrum lie re-released games. These are classic titles released on new consoles in approximately their original form. Examples include Nintendo's Wii Virtual Console games, compilations of "classic" games, and stand-alone "Plug-and-Play" consoles dedicated to a preloaded set of classic games. On the other side of this spectrum are re-mastered games. A remastered game updates a classic game with modern graphics, music, and gameplay. An example of this is the Nintendo Switch update of *Legend of Zelda: Link's Awakening* (2019, originally released in 1993).[12] In the middle of this spectrum lie nostalgia games: videogames that imitate the past using modern technology, hybridizing anachronistic formats with modern design. Examples include *Blasphemous* (2019), *Stardew Valley* (2016), and *Super Meat Boy* (2010). In "Playing the Déjà-New: Plug it in and Play TV Games and the Cultural Politics of Classic Gaming" (2008), Matthew Payne explains how these games market the opportunity to recover the lost objects of the past, referencing a monolithic affection for the "classic" gaming era of the 1980s and 1990s signaled by "low-resolution graphics, limited sound effects and music, and... elementary physical interface."[13] These games cut and paste nostalgic imagery together, sometimes engendering "a longing for a past that never was."[14] Overall, these games package nostalgic references into easy-to-consume gaming novelties.

Will these nostalgic genres be as fun to play now as they were back then? Perhaps not. Nostalgic players may discover that they now find the low-resolution graphics, antiquated gameplay, or low-fidelity sound of fondly remembered games currently annoying. Bothered in this way, players will become conscious of biases in their nostalgic memory. The disappearance of game-over penalties (death and loss of all progress) illustrates this. The ability to save one's game progress to console-hosted memory became standard in the late 1990s, training players to expect to master a game through trial and error and to experience all of its content. As audiences became literate in this technology, games that used game-over penalties

[11] Refer to Hunt's "My Childhood Is in Your Hands: Video Game Concerts as Commodified and Tangible Nostalgic Experiences" in this volume for another exploration of how video game nostalgia is commoditized in concerts.

[12] This is just one of several updates the Zelda series has received; *Twilight Princess*, *Ocarina of Time*, and *Majora's Mask* have all have been remastered.

[13] Payne, "Playing the Déjà-New," 53.

[14] Payne, "Playing the Déjà-New," 63.

were suddenly rendered annoying. Accordingly, despite the nostalgia gamers may now feel for the high-stakes drama of game-over, most modern audiences lose patience if game-over frequently interrupts play or a player's access to the larger story. A conflict like this puts the gamer's romance with the past uncomfortably on trial. It begs the question: is the "classic" format actually as fun as I remember it? Such questions detract from the player's ability to immerse in the virtual world presented by the game. Immersion is difficult when players are stuck evaluating the accuracy of their nostalgic memories.

The Angry Videogame Nerd (*AVGN*) web series embodies how current annoyance with archaic games puts biased nostalgic memory on trial. In it, James Rolfe plays the bespectacled, titular "Nerd" who satirically reviews games from his childhood. Each episode critiques nostalgic memory in varying degrees. *AVGN* episodes usually begin with a historical presentation of a classic game, interspersed with Rolfe's personal experiences playing the title as a child.[15] In his *Ninja Gaiden* episode, Rolfe explains that it has been "over 20 years, and I still can't beat this sonofabitch... I've wanted to beat that game all my life."[16] Rolfe's *Ghosts 'n Goblins* episode similarly blames said videogame for an "eternal frustration that scarred us all since childhood."[17] Episodes then transition to footage that lingers on sadistic gameplay that is often the result of archaic formats. The Nerd groans with profanity in these scenes, delivering trademark lines like "what were they thinking?" and "what a piece of shit!" Each episode usually ends in a cathartically profane rant where the Nerd derides the "nostalgic" game, then physically destroys the offending game cartridge. *AVGN* performs a gamer confronting the inaccuracies of nostalgic memory. Rolfe represents players who, as adults, are now equipped to critically evaluate nostalgically remembered videogames. Despite his reliance on profanity, the Nerd actually wields a sophisticated, modern technological vocabulary when criticizing the broken features of classic games. As such, by examining the "bad" in classic games, the Nerd symbolically invites his audience to challenge their biased nostalgic memory of a "good" classic videogame.

This clash with nostalgic bias is an obvious danger to a company seeking to market a classic game to modern audiences. Accordingly, re-released classics often take precautions to ensure their appeal to the nostalgic gamer's evolved tastes.

[15] In some episodes, Rolfe even presents footage of himself as a child playing the games he reviews.

[16] Cinemassacre. "Ninja Gaiden (NES)."

[17] Cinemassacre. "Ghosts N' Goblins (NES)." *Ninja Gaiden* (1988) and *Ghosts 'n Goblins* (1985) are two games infamous for their punishing difficulty, born of unfair, sadistic gameplay mechanics.

FIGURE 4.1: *Sega Genesis Classics* Home Screen—a simulated 1990s childhood bedroom.

Developers edit out annoyances to preserve entertainment value to current audiences, nostalgic or otherwise. *Sega Genesis Classics*, a collection of fifty Sega Genesis games (re-)released on the PlayStation 4, Xbox One, and Nintendo Switch in 2018, exemplifies this editing. The game box makes several artless nostalgic references to gaming's classic era. It commands players to "GET INTO THE CLASSICS" and fondly remember the Genesis of their youth. Within the box, players find a game disc and a double-sided poster for *Streets of Rage* (1991) and *Golden Axe* (1989)—replicas of promotional posters gamers received as children in print magazines like *Nintendo Power* or *Gamepro*. After booting up the game, players are assaulted with a modern techno song that samples sound effects from famous Sega games. These bluntly intentional nostalgic references continue in the game's hub screen (Figure 4.1): a virtual space styled to resemble a child's bedroom, replete with toys like an original *Super Soaker* water gun (1990). Players access *Classics'* games from a virtual shelf, triggering an animation of a cartridge loaded into a console hooked up to an analog TV for play, all of which remains visible during play as a framing device. Borrowing Boym's words, this nostalgic interface forces players to quite literally rebuild "the lost home" of childhood before playing anything.[18] It also performs Payne's assertion that re-releases create "a longing for a past that never was" in their references to a generalized affection for 1990s-era

[18] Boym, *The Future of Nostalgia*, 41.

gaming.[19] One does not even *need* to play the games to be entertained by such blunt references to an idealized representation of 1990s childhood.

This virtual room outwardly seems very immersive. In it, gamers "exist" in a virtual space and interact with props. Yet, this effect fades as *Classics* forces players to acknowledge they may now find nostalgic games annoying. *Classics* includes modern features intended to make its titles more playable to modern audiences. These include saving, upgraded graphics and sound, remastered music, online connectivity, achievements, and the ability to rewind or fast-forward a game at will. These hi-tech tools lessen modern annoyance with antiquated gameplay. Is something tedious? Fast-forward it. Fall into a pit? Rewind and jump again. Cannot finish a game in one sitting? Save your progress. However, the choice to erase these annoyances also prompts players to curate their own nostalgic play— meta-level thinking that keeps gamers self-consciously aware of positive bias in their nostalgic memories. The availability of these tools demands that players assess whether they still enjoy the videogames of their nostalgic past. They consequently ensure that players are always aware that they are playing a game and never fully perceive it as the reality of the present. This immersion-hampering outcome also helps explain why videogame *music* is widely acknowledged as a powerful trigger for nostalgia. Nostalgic gamers often listen to videogame music *separately* from the original games themselves. Music consequently can provoke nostalgic memories of a game without provoking this evaluation of the *accuracy* of said memories.

Like re-releases, *nostalgia games* also edit retro gameplay to entertain players with nostalgic references, further reducing the genre's immersive potential. In "Nostalgia Videogames as Playable Criticism" (2016), Robin Sloan defines the *nostalgia game* as a contemporary game "that explicitly incorporates past aesthetics, design philosophies, or emulated technical limitations."[20] Examples include *Owlboy* (2016), *Fez* (2012), and *Spelunky* (2008). Each game was produced to look, sound, and/or feel like those of 1980s and 1990s. Small development teams with crowd-funded budgets often create nostalgia games. They sometimes use antiquated features to signal what Andra Ivănescu terms in *Popular Music in the Nostalgia Videogame: The Way It Never Sounded* (2019) "an 'indie' ethos that values artistic prowess over production value."[21] Yet, nostalgia games rarely commit wholesale to antiquated styling, as faithfully reproducing retro architecture could create an un-fun clash between biased nostalgic memory and inflexible

[19] Payne, "Playing the Déjà-New," 63.

[20] Sloan, "Nostalgia Videogames as Playable Criticism," 35.

[21] Ivănescu, *Popular Music in the Nostalgia Videogame*, 14.

modern tastes. Nostalgia games instead curate retro features for modern consumption. For example, they often simulate the distinctive "bleep-bloop" sound of classic game music. Yet these games do not use antiquated technology to generate these sounds.[22] Instead, the bleep-bloops are replicated in high definition and (as exemplified in *Owlboy's* "Vellie") are sometimes played with crisply recorded accompaniment. Many nostalgia games also temper game-over with saving technology and cultivate faux "pixelated" graphics actually packed with colors and animations that could not have been processed on old consoles. In this way, these titles incorporate nostalgic reminders into game architecture without faithfully re-creating the annoyances of the past. Echoing Jean Baudrillard's *hyperreal*, nostalgia games are neither modern nor historical objects.[23] Instead, they obscure our ability to distinguish the reality of the past from its simulation in the present.

A large part of a nostalgia game's appeal stems from players' appreciation of what each chooses to emulate from the past. This genre performs what Boym terms as *Jurassic Park syndrome*: when "modern science is used for the recovery of the prehistoric world."[24] Like Spielberg's dinosaurs, nostalgia games entertain players by utilizing modern tech to reanimate DNA fragments of nostalgic memory. Sloan continues in this vein, explaining that a nostalgia game's "selection, exaggeration, and concentration of traits from past games"[25] expresses what designers felt was valuable in the past. Similar to the contemporary remix of an old videogame theme, this genre samples splinters of gaming popular culture (pastiche), sometimes to critique dead genres (parody) or to express affection for them (homage). Yet, observing and appreciating the novel ways nostalgia games reference history ultimately distracts from each game's ability to immerse. Entertaining with nostalgic references forces gamers to reflect on the nature of their own nostalgia. The gamer again asks questions like "does this game feature reflect my fondness for the past?" "Is it a faithful representation of classic games?" Such questions force players to evaluate biases in their memory and acknowledge that they are playing a game. How can one immerse in alternative realities with such distractions?

A nostalgia game's performance of how rose-colored nostalgic memory clashes with immersion is demonstrated in Mark Brown's video essay "Shovel Knight and Nailing Nostalgia" (2016). Brown produces *Game Maker's Toolkit*, a YouTube journalism channel on game design. In "Shovel Knight and Nailing Nostalgia,"

[22] Specifically, frequency modulation (FM) and musical instrument digital interface (MIDI) technology.

[23] Baudrillard, *Simulacra and Simulation*, 75–78, 121–28.

[24] Boym, *The Future of Nostalgia*, 35.

[25] Sloan, "Nostalgia Videogames as Playable Criticism," 43.

Brown asserts that *Shovel Knight*'s emulation of NES-era platform games typifies a good nostalgia game. He explains that *Shovel Knight* assembles nostalgic features from several NES games "to make a game reminiscent of 8-bit games in general."[26] The platforming is reminiscent of *Mega Man* (1987) and the protagonist's attacks are similar to *Ninja Gaiden* (1988), *Duck Tales* (1989), and *Castlevania* (1986). Game towns are reminiscent of *Zelda II* (1987), and *Shovel Knight* even borrows the map system from *Super Mario Brothers 3* (1988). Brown also explains that "old games look better, sound better, and feel better in our heads... we remember the epic moments but forget about the grinding. We remember the thrill of beating a tricky level, but block out the one hit kills that had us breaking controllers."[27] Accordingly, *Shovel Knight* uses modern technology to fix these annoyances that otherwise would spotlight our "cognitive bias of what retro games, in general, were like to play."[28] The game offers technical features that were impossible on an old Nintendo: saving, sound effects layered with high-fidelity music, and vivid, colorful, widescreen "pixelated" graphics. Brown concludes by stating that *Shovel Knight* is good because it tricks you into thinking "you are playing an NES game, without you fully realizing that you are playing one without the limitations of that console."[29] While "Shovel Knight and Nailing Nostalgia" stops here, note that, as a player, Brown likely had difficulty immersing in *Shovel Knight* as an alternative reality. The author's insights result from his intensely self-aware critical thinking that questioned why *Shovel Knight*'s nostalgic architecture is so entertaining. The video is Brown's preoccupation with determining if the game's nostalgic references felt entertaining, crystalized into visual format. Such meta-textual reasoning calls excessive attention to the game as simulation, which makes immersion difficult.

In sum, games that commodify nostalgic references encourage players to evaluate biases in their own nostalgic memories. When this process is separated from leitmotifs, it causes players to have difficulty immersing in virtual worlds. Re-released games, remastered games, and nostalgia games offer players the opportunity to indulge in experiences idealized by nostalgic memory. This return can provoke a bittersweet confrontation with annoying, outmoded features in classic games. Nostalgic genres anticipate this and omit such annoyances using modern technology. Yet, this editing also forces gamers to become aware that they are playing a game. These genres cannot disguise that they are simulating the past, as such is the ultimate source of their appeal. Even with the aid of nostalgic music, games

[26] Game Maker's Toolkit, "Shovel Knight and Nailing Nostalgia."

[27] Game Maker's Toolkit, "Shovel Knight and Nailing Nostalgia."

[28] Game Maker's Toolkit, "Shovel Knight and Nailing Nostalgia."

[29] Game Maker's Toolkit, "Shovel Knight and Nailing Nostalgia."

that entertain with nostalgic references hamper their potential to make the gamers feel as if they exist *within* the game world. Nostalgic references force players instead to fixate on biases in their own memories.

Part 2: *Leitmotifs as immersive nostalgic references in Final Fantasy*

However, nostalgic references *increase* immersion when leitmotifs are their vehicle. Leitmotifs resolve the usual tension between nostalgic references and videogame immersion. To approach this, remember that music can amplify the impact of immersive gameplay. As discussed in Part 1, music can highlight the interactions immersive games use to evince a player's existence in the virtual world. This can take a diegetic format (players create or manipulate sound in game) or a non-diegetic format (music highlights player actions from the background).[30] As Isabella van Elferen explains in "Analyzing Game Musical Immersion: The ALI Model" (2016), music can evoke emotions that "help assess gameplay situations: dangerous situations for instance, have to be immediately identifiable as such, and should therefore be sonically announced by recognizably frightening music."[31] The compositional style of a game's music can also explain the game's setting or the significance of characters and narrative events. Finally, music can help simulate agency and self-expression in gameplay. Changes in music can punctuate the consequences of a player's actions or call attention to changes in the game world the player has wrought. In these ways, game sound bolsters feelings of immersion in a game's world as the reality of the present.

Does music retain this immersive potential if it also entertains by provoking nostalgia? Or does this musical nostalgia hurt immersion by forcing the gamer to evaluate biases in their memory? *Final Fantasy* games provide a rich case study that answers this question. First released in 1987, *Final Fantasy* is a franchise of role-playing games fans regard as both highly immersive and nostalgic. To date, there have been fifteen numbered and titled installments, plus re-releases, sequels, spin-offs, and films. Natasha Whiteman explains how fandom akin to *FF* enthusiasts only culturally adheres to objects that are "fixed in some way, or the allegiance would not be held."[32] Although the games are not narratively linked, fans recognize

[30] A clear example of diegetic sound is playing the magical ocarina in *The Legend of Zelda: Ocarina of Time* (1998). In this game, the player uses a virtual ocarina to play enchanted songs that magically influence the in-game setting.

[31] Van Elferen, "Analyzing Game Musical Immersion," 35.

[32] Whitman, "Homesick for Silent Hill," 47.

FF games via their shared traits. All are set in virtual worlds with countries, politics, and local inhabitants. Players usually control a party of heroes who oppose a world-threatening villain. Each game also explores each hero's history and rich social relationship with the team. Finally, a web of recurring narrative motifs including airships, earth energy, magic crystals, monsters, and game mascots like the chocobos and moogles all knit *Final Fantasy* videogames together as a series.

A defining feature of the *Final Fantasy* series is how each videogame utilizes the same leitmotifs. A leitmotif is a short melody that has been symbolically associated with a person, thing, or concept in a multi-media work. Unlike symbolic songs (like an anthem or theme song), leitmotifs do not exist in isolation. As Matthew Bribitzer-Stull helps explain in *Understanding the Leitmotif: From Wagner to Hollywood Film Music* (2015), leitmotifs are utilized in multi-media narrative works, ranging from Wagnerian opera to contemporary film music. Although videogames are not films, Karen Collins explains in *Game Sound: An Introduction to the History, Theory, and Practice of Video Game Music and Sound Design* (2008) that game soundtracks are "very similar to film sound production."[33] Both play short melodies when audiences see particular narrative elements as a clarifying gesture. For example, *Star Wars* videogames and films both play "The Imperial March" in conjunction with antagonists to help audiences identify the "bad guys."[34] Films and videogames also use leitmotifs to explain plot, clarify emotions, or create new dramatic contexts. For example, permutations of "The Imperial March" sometimes announce to audiences that the film's *heroes* are gravitating towards evil. This is observable in *Star Wars: The Phantom Menace*'s "Anakin's Theme." Portions of song re-contextualize melodic and rhythmic components from "The Imperial March." In doing so, "Anakin's Theme" foreshadows Anakin's inevitable transformation into Darth Vader. Finally, a leitmotif's association can be cultivated over a long franchise. *Star Wars* encompasses multiple films, TV series, videogames, and even theme parks, all of which play "The Imperial March" to signal antagonists of all forms. Fans heavily exposed to a leitmotif perceive it as an independently operative storytelling device.

Videogame series deploy leitmotifs in didactic ways to explain the rules of gameplay unobtrusively. A game can use the same melodies over a long series to mark and explain the gameplay events or narrative events. Prominent examples of this repetition include *The Legend of Zelda* (1986–present), *Mario Bros* (1983–present), and *Sonic The Hedgehog* (1991–present) franchises. These series

[33] Collins, *Game Sound*, 5.

[34] For more information on leitmotifs in Star Wars, see Lehman, *Complete Catalogue of the Themes of Star Wars*.

repeat the same leitmotifs to clarify how each title functions. This paper focuses on the *Final Fantasy* series because it features a rich canon of leitmotifs, deployed consistently over 33 years of games. *FF* worlds are complex and rely on these leitmotifs to explain how gameplay functions. An *FF* game will likely feature a fully realized world, layered plots, dense menus, and gameplay that abruptly shifts between exploration, battle, and cinematics. Play demands a high degree of literacy in these varying game systems. Yet, excessively pausing gameplay to educate players (e.g., an unskippable tutorial) would create ludonarrative dissonance: clunky gameplay that clashes with *FF*'s narrative offerings. Accordingly, *FF* games use leitmotifs that subtly explain gameplay without interrupting the plot. Most games are set to wall-to-wall non-diegetic music composed by Nobuo Uematsu, and all locations, menus, and events are clarified by melodic cues. Characters also have themes that remind players of each's identity (heroic characters have "heroic" songs, comedic characters have lighthearted "funny" songs).[35] Leitmotifs also aurally announce if locations are safe or dangerous and abrupt changes in underscoring signal when the game shifts between battle and exploration. For example, *FF*'s "Victory Fanfare" leitmotif is a series of "sharp triplet rhythms… typical of fanfares… in actual military trumpet and horn calls,"[36] played at the end of all battles. As Julianne Grasso explains in "Music in the Time of Video Games: Spelunking Final Fantasy IV" (2020), this leitmotif is "a clear signaling device that marks the… oncoming return of the player's exploration."[37] Leitmotifs like this use their emotional associations with gameplay events to subtly increase the player's literacy with *FF*'s systems, without taking the spotlight off of *FF*'s immersive interactions.

Since *FF* videogames share gameplay mechanics and similar plots, the series has deployed the same leitmotifs to explain them. This repetition clarifies the mechanics of future titles for the longtime fan. For example, in all *FF* games, the aforementioned "Victory Fanfare" leitmotif marks a player's victorious moments. *FF*'s "Prelude" (a series of arpeggios) leitmotif often plays during the game's home screens, menus, and exit gestures to frame the fantasy world with an ethereal atmosphere. The upbeat, bouncy "Chocobo Theme" models the game's playful chocobo characters (adorable ostrich-like birds ridden like horses). Next, the

[35] For example, the theme of *FFVII* protagonist Cloud begins with a somber, melancholic figure orchestrated for brass instruments that transitions into an uplifting melody in the strings. This music thematically suggests the character's emotional reluctance to shoulder the weight of heroism and his later acquisition of courageous purpose.

[36] Grasso, "Music in the Time of Video Games," 109.

[37] Grasso, "Music in the Time of Video Games," 109–11.

"Final Fantasy Theme," a processional composition reminiscent of an awards ceremony, reminds players to celebrate beating the game during the ending. Each *FF* installment also features its own version of the "Boss Theme," a battle march comprising dissonant chords that mark the antagonist as a threat. An "Airship Theme" ("Highwind Takes to the Skies" in *FFVII*) leitmotif punctuates the thrill of flying in an airship with ascending arpeggios supporting a sweeping melody. As this list demonstrates, the didactic power each leitmotif has to clarify gameplay is intensified by *FF*'s repetition of them. Accordingly, the history surrounding *FF*'s consistent use of leitmotifs has transformed them into an aural tool that fluidly explains how gameplay works.

FF leitmotifs have become potent nostalgic triggers as a consequence of this repetition. The *FF* devotee returns to a pleasantly familiar soundscape with each new title. To ardent fans, these leitmotifs also remind them of positive and significant experiences with past *FF* games. As a franchise, producers of *Final Fantasy* content are not above making references to this nostalgia to commodify nostalgia for fan consumption. Several satellite productions related to the *FF* series have a similar design ethos of re-released and nostalgia games: they entertain with nostalgia references. Fans consume *FF* leitmotifs as orchestral music (*Distant Worlds* concert tours), rock music (Uematsu's rock band, *The Black Mages*), and even in stand-alone rhythm games like *Theatrhythm Final Fantasy* (2012), in which players tap out button combinations in rhythmic alignment with the notes of *FF*'s leitmotifs while miniaturized scenes from various *FF* games play in the background. Orbiting *FF* productions like these do not use leitmotifs to explain gameplay. Instead, they make blunt references to the nostalgia they invoke to delight audiences. These productions are consequently not very immersive, as they again provoke self-conscious evaluation of biases in a fan's nostalgic memory.

Yet the effect is curiously opposite when *FF* leitmotifs re-appear in numbered *Final Fantasy* role-playing games. In these titles, leitmotifs transform nostalgia into something that increases immersion. When players first encounter a familiar *FF* leitmotif in a contemporary iteration of the series, they initially experience something similar to the delight of re-releases and nostalgia games. Discovering a familiar leitmotif in a new *FF* game feels like discovering a fun reference to a nostalgic memory. Yet the leitmotif's role as a gameplay tutorial also remains active during this process. The leitmotif's reuse in new games prompts the player to use nostalgic memory to recall information about how past *FF* games work. Players experience this as the impression of returning to a familiar *FF* world governed by already known rules. With the rules remembered, the gamer can then cognitively focus on interactive, immersive elements of gameplay. In other words, *FF* use of leitmotifs as a vehicle to present nostalgic references circumvents the distracting meta-textual analysis of nostalgic game architecture. Unlike nostalgia games and

re-releases, references in leitmotifs do not prompt the reader to ask distracting questions like "is this game as good as I remember?" *FF* leitmotifs instead aid immersion in present virtual experiences by reminding players of how *FF* games normally function.

Final Fantasy XV (2016) and *Final Fantasy VII Remake* (2020) both feature leitmotifs that command this form of nostalgic immersion. This article focuses on these installments of the *FF* franchise because *XV* and *VII Remake* are modern games that have radically departed from traditional *FF* gameplay and thus use nostalgic leitmotifs to remind players that they are still *FF* games. Past *FF* games traditionally consisted of three gameplay phases: exploration, battle, and cinematics. In the exploration phase, players control a team of heroes, explore settings, gather items, and interact with non-player characters. While exploring dangerous areas, the party encounters unseen enemies. Battle forcibly interrupts exploration and initiates a separate gameplay space that displays combatants and battle statistics. Here, players select battle commands from menus and passively watch their party heroes carry them out. Last, *FF* games also frequently pause for expositional cinematics. These are interactive films; players passively watch plot events and sometimes contributes actions, or dialogue choices. Hardware limitations in early *FF* titles demanded this splitting of gameplay among battle, exploration, and cinematics. The scope of an *FF* adventure would often eclipse the memory or processing capacity of earlier systems. Since battle, story, and exploration could not be presented simultaneously, developers split them into three interwoven gameplay phases.

Modern *FF* titles face a design conundrum about whether or not to retain this structure. The battle-exploration-cinematic trichotomy is deeply engrained in a fan's awareness of *Final Fantasy*. Yet it is also undoubtedly antique. By 2021, gamers have had several opportunities to play massive open-world role-playing games where exploration, battle, and plot events occur seamlessly within the same virtual space. This technological achievement makes possible a new level of immersion in gameplay: one can socialize, explore, fight, all at once without the adventure being artificially partitioned. Accordingly, retaining divided gameplay states in new *FF* titles runs the risk of appearing old fashioned. Modern audiences likely expect a complex level of immersion only achievable when players participate in *all* aspects of gameplay. Yet, if *FF* games revise their core functionality to provide this, will long-time fans be able to identify them as *FF* games?

FFXV and *VII Remake* navigate this conundrum. *XV* and *VII Remake* are recognizably *Final Fantasy* in plot. In *XV*, players control Noctis, a deposed prince who wins back his throne, balances the world's cosmic energies, and averts a global catastrophe. *FFVII Remake* is a modern updating of *Final Fantasy VII* (1994). The game is the first title in a planned mini-series that divides the original story

of eco-terrorists opposing a corporation that destructively exploits the earth into episodes. However, the games are not recognizably *Final Fantasy* in gameplay. They have eliminated the three gameplay states and instead focus on interactivity with a seamless virtual world. Perspective shifts from the first to the third person, and the player frequently undertakes mundane actions to illustrate virtual presence: eating, sleeping, walking, driving, washing a car, and even pumping gas! Enemies are now spotted from miles away and fought in the same space. Battle menus have also been greatly reduced. Similar to an action game, players instead fight by moving characters dexterously in real time. Both *XV* and *VII Remake* have departed from the traditional *FF* mold to better cultivate player immersion in a realistic feeling space.

These revisions of traditional *FF* gameplay extend to the player's interactions with non-player characters. *XV* and *VII Remake* still feature traditional casts of heroes. Yet the player newly takes the perspective of an individual (usually protagonists Noctis and Cloud). Friends accompany the player but are controlled by computer A.I.s. As such, both games immerse the player in social interactions with A.I. companions. Players are tasked with socializing, and their choices affect future events in the game. *FFXV* does this by cultivating a realistic atmosphere of taking a road trip with friends. Act friendly, and the companions grow closer. Act dismissively, and the gang will later shun the player. Noctis's friends also express their personality, unprompted by player input. Prompto is a photographer and shoots whatever he encounters. Every night, Gladiolus sets up camp with Coleman camping gear. Before going to bed, Ignis cooks a photorealistic dinner while Prompto shares his photos, many of which will be selfies! *FFVII Remake* features a similar emphasis on realistic socializing. The game depicts a love triangle with Cloud and the two female leads, Tifa and Aerith. The game continually asks the player subtle questions that demand preference for one of the women. The A.I. companions also react to these choices, and gameplay subtly shifts around said preferences.[38] In short, both *XV* and *VII Remake* are also friendship simulators. They both offer groups of A.I. companions and build immersion through repetitive social interactivity. In short, *XV* and *VII Remake* are radically altered *FF* landscapes.

XV and *VII Remake* need *FF*'s historically invested leitmotifs to explain their dynamically altered landscapes. Deploying familiar leitmotifs could leverage a fan's nostalgic memory to label modern offerings as *FF* productions. The emotional cues

[38] In one example, early game Tifa suggests that she and Cloud (the player's protagonist) go out to celebrate, then asks what style dress would suit her. Hours of gameplay later, Tifa dons a dress that reflects what the player had said.

embedded in these compositions could also clarify the mechanics of these altered features. Yet, the sudden appearance of short melodies in the background of these games would also create ludonarrative dissonance. Leitmotifs need a realistic, interactive reason to appear in these realistic, interactive virtual worlds. Accordingly, the developers have transformed *FF* leitmotifs from non-diegetic background music into diegetic objects that players interact with. For example, Prompto (in *XV*) and Barrett (in *VII Remake*) both sing the "Victory Fanfare" when celebrating victory in battle, prompting snide remarks from teammates. *XV*'s Ignis and Prompto also hum the "Chocobo Theme" after riding one, suggesting that they might have the infectious melody stuck in their heads. In both examples, companions diegetically sing leitmotifs that are fundamentally non-diegetic—there is no in-game explanation for how they learned these songs. As such, initially only the longtime fan will grasp how these melodies explain gameplay events. *XV* and *VII Remake* also diegetically reinvent leitmotifs as objects in the virtual world. Leitmotifs that were once background music in earlier titles can now be purchased from in-game stores or vending machines as albums. The gamer plays these on their virtual car radio, phone, or jukebox, or can turn off the music and experience only sound effects. The presence of these leitmotivic albums reminds fans that they are still in a beloved, *FF* world. These clever diegetic transformations of *FF*'s leitmotifs explain the dynamically altered flow of gameplay without contradicting each game's new focus on immersive interactivity. Their inclusion in these new titles ultimately reminds fans that despite the radically altered landscape, they are still playing a loved *FF* game with familiar rules.

These leitmotifs act as potent nostalgic triggers because they have appeared in 33 years of prior games. As such, our prior explorations indicate that they could distract from *XV* and *VII Remake*'s effort to immerse in present virtual worlds. Yet, curiously, the inverse occurs. These diegetic transformations of leitmotifs initiate a chain of nostalgic associations that culminates with heightened immersion. Initially recognizing the creative ways contemporary *FF* games deploy leitmotifs feels like discovering a fun secret intended to delight an exclusive club of nostalgic players. Yet, while fans delight in their recognition of the nostalgic reference, the leitmotif also assures the audience that contemporary *FF* games are still a recognizable part of the series. Despite contemporary updates to the traditional formula, future *FF* games still follow rules that players nostalgically recall. These leitmotifs transform heavy-handed nostalgic references into a mnemonic, prompting the fan to recall their existing literacy in *FF* gameplay. Without calling attention to its own systems, the game uses leitmotifs to quietly resolve immersion-breaking questions and increase literacy in game systems. They help the player fluidly resolve questions like "what is this for?," "where am I?," and "what am I doing?" all from the background of gameplay. Accordingly, this invocation of a player's nostalgic

memory aids the player in focusing on immersive storytelling. In sum, the *FF* series uses leitmotifs as the vehicle of nostalgic references and also as a means to convey immersive gameplay instructions to the fan.

Conclusion

This paper's core contribution lies in its theorization of how leitmotifs reverse the anti-immersive effects of nostalgic references in videogames. When leitmotifs are used to convey such references, the nostalgia they provoke transforms from an immersion-compromising variable into something that bolsters it. Scholars interested in this topic should pay attention to future installments of the *FFVII Remake* series. As the first installment of a mini-series, the game currently utilizes musical nostalgia to absorb narrative ambiguity created by separating *FFVII* into episodes. *Remake* offers a remastered (and sometimes remixed) soundtrack of the original game's entire soundtrack. Longtime fans familiar with the music likely grasp the narrative associations it has with characters and plot events not yet represented in the series and thus perceive it as a storytelling device. Yet, *Remake* cannot leverage this musical nostalgia to carry the weight of its storytelling with new players. As such, many new players have critiqued the game for its fragmented storytelling.[39] As new episodes arise, these musical references will evolve into repeated, nostalgic leitmotifs themselves. They will become fertile ground upon which to theorize how nostalgic leitmotifs can act as *storytelling* devices that supplement or bind together videogame narratives to one. This is an obvious companion to this article's work with immersion.

Also note that that the leitmotif's immersive transformation of nostalgia is not limited to *Final Fantasy* series. Analogous series exist that consistently use leitmotifs over several titles. One prominent example would be *The Legend of Zelda* series.[40] There, several leitmotifs (like the "Secret Sound," an eight-note

[39] Readers can observe this reaction in the "Final Fantasy VII Remake" episode of *Girlfriend Reviews*. *Girlfriend Reviews* is a YouTube video essay series where Shelby (a novice gamer) reviews the games her veteran gamer boyfriend plays from the perspective of a newcomer. In this episode, she critiques *FFVII* Remake's "jarring" storytelling as "complete nonsense and I have no idea what is going on." She then affectionately deems the game "100% certified bananas, especially if you're new to the story like me."

[40] Vincent Rone's "Twilight and Faërie: The Music of Twilight Princess as Tolkienesque" has a comprehensive list of *The Legend of Zelda*'s leitmotifs and explains their in-game functionality, 87–92.

leitmotif played whenever the player discovers something) also invoke a player's nostalgic memory to increase game literacy and heighten immersion. *FFXV* and *VII Remake*'s transformation of leitmotifs into gameplay props simply demonstrates a leitmotif's power to use nostalgia as a mnemonic device uncommonly clearly. Accordingly, this paper's core contribution is to spotlight leitmotifs, and music in general, as creating an anomaly concerning nostalgia and immersion. Perhaps this is because it is not essential for game music to demand the player's conscious attention while communicating to them. This makes music an ideal tool to transform a nostalgic reference into an instructive element. The leitmotif's nostalgic reminder takes place in the subconscious, freeing the conscious mind to focus on a game's immersive systems. Finally, this work participates in a larger effort to theorize nostalgia as a creative force driving the development of new games. To borrow a well-known phrase from poet Ezra Pound, this essay tracks the decline of gaming's modernist desire to "make it new." It also studies the rise of postmodern game genres, generous in their offerings of meta-textual commentary on themselves *as* genres (via gameplay rich in homage, pastiche, and parody). Like the games they are housed in, leitmotifs also frustrate the modernist push to make completely new games. The deliberate, self-conscious associations these leitmotifs have to the past interrupt the normally future-oriented acceleration of game production. Ultimately, both nostalgic references and leitmotifs exemplify how the "new" in gaming is progressively decoupling from a single genre, game, or category.

LUDOGRAPHY

Blasphemous. The Game Kitchen. Nintendo Switch. Team 17, 2019.

Castlevania. Konami. Nintendo Entertainment System. Konami, 1986.

Duck Tales. Capcom. Nintendo Entertainment System. Capcom, 1989.

Fez. Polytron Corporation. Xbox 360. Trapdoor, 2012.

Final Fantasy VII. Square Enix. PlayStation. Square Enix, 1997.

Final Fantasy VII Remake. Square Enix. PlayStation 4. Square Enix, 2020.

Final Fantasy XV. Square Enix. Xbox One. Square Enix, 2016.

Ghosts 'n Goblins. Capcom. Nintendo Entertainment System. Capcom, 1985.

The Legend of Zelda: Link's Awakening. Nintendo. Nintendo Game Boy. Nintendo, 1993.

The Legend of Zelda: Link's Awakening. Grezzo. Nintendo Switch. Nintendo, 2019.

The Legend of Zelda: Ocarina of Time. Nintendo. Nintendo 64. Nintendo, 1998.

Megaman. Capcom. Nintendo Entertainment System. Capcom, 1987.

Ninja Gaiden. Tecmo. Nintendo Entertainment System. Tecmo, 1988.

Owlboy. D-Pad Studio. Nintendo Switch. D-Pad Studio, 2016.

Red Dead Redemption. Rockstar San Diego. Xbox 360. Rockstar Games, 2010.

Red Dead Redemption II. Rockstar Games. Xbox One. Rockstar Games, 2018.

Sega Genesis Classics. Sega. Xbox One. Sega, 2018.

Shovel Knight. Yacht Club Games. Microsoft Windows, Nintendo 3DS, and Wii U. Yacht Club Games, 2014.

Spelunky. Derek Yu. Xbox 360. Microsoft Studios, 2012.

Stardew Valley. Eric Barone. Nintendo Switch. Nintendo, 2016.

Streets of Rage. Sega. Sega Genesis. Sega, 1991.

Super Mario Bros. III. Nintendo. Nintendo Entertainment System. Nintendo, 1988.

Super Meat Boy. Team Meat. Nintendo Switch. Blitworks, 2018.

Theatrhythm Final Fantasy. Square Enix. Nintendo 3DS. Square Enix, 2012.

Zelda II: The Adventure of Link. Nintendo. Nintendo Entertainment System. Nintendo, 1987.

BIBLIOGRAPHY

Baudrillard, Jean. *Simulacra and Simulation*. Ann Arbor: University of Michigan Press, 1994.

Bribitzer-Stull, Matthew. *Understanding the Leitmotif: From Wagner to Hollywood Film Music*. New York: Cambridge University Press, 2015.

Boym, Svetlana. *The Future of Nostalgia*. New York: Basic Books, 2001.

Calleja, Gordon. *In Game: From Immersion to Incorporation*. Cambridge: MIT Press, 2011.

Cinemassacre [James Rolfe]. "Ninja Gaiden (NES)—Angry Video Game Nerd (AVGN)." Uploaded June 14, 2011. https://youtu.be/6t2YvyLqw3c.

Cinemassacre [James Rolfe]. "Ghosts N' Goblins (NES)—Angry Video Game Nerd (AVGN)." Uploaded October 23, 2012. https://youtu.be/94Y6y1MOoEo.

Collins, Karen. *Game Sound: An Introduction to the History, Theory, and Practice of Video Game Music and Sound Design*. Cambridge: MIT Press, 2008.

Ermi, Laura, and Mäyrä Frans. "Fundamental Components of the Gameplay Experience: Analyzing Immersion." In *Changing Views: Worlds in Play. Selected Papers of the 2005 Digital Games Research Associations' Second International Conference*, edited by S. De Castell and J. Jenson. Accessed June 3, 2020. http://www.digra.org/wp-content/uploads/digital-library/06276.41516.pdf.

Fenty, Sean. "Why Old School Is 'Cool': A Brief Analysis of Classic Video Game Nostalgia." In *Playing the Past: History and Nostalgia in Video Games*, edited by Zach Whalen and Laurie Taylor, 18–31. Nashville: Vanderbilt University Press, 2008.

Game Maker's Toolkit. "Shovel Knight and Nailing Nostalgia." Uploaded August 31, 2016. https://youtu.be/rHhX5GtWNr8.

Garrido, Sandra, and Jane Davidson. *Music, Nostalgia and Memory: Historical and Psychological Perspectives*. Cham: Palgrave Macmillan, 2019.

Gibbons, William. "Remixed Metaphors: Manipulating Classical Music and Its Meanings in Video Games." In *Ludomusicology: Approaches to Video Game Music*, edited by Michiel Kamp et al., 198–222. Bristol: Equinox Publishing, 2016.

Girlfriend Reviews. "Final Fantasy VII Remake." Uploaded April 30, 2020. https://www.youtube.com/watch?v=EMPF40-5rb0.

Glassner, Andrew. *Interactive Storytelling: Techniques for 21st Century Fiction*. Boca Raton: CRC Press, 2004.

Grasso, Julianne. "Music in the Time of Video Games: Spelunking *Final Fantasy IV*." In *Music in the Role-Playing Game: Heroes and Harmonies*, edited by William Gibbons and Steven Reale, 97–116. New York: Routledge, 2020.

Ivănescu, Andra. *Popular Music in the Nostalgia Videogame: The Way It Never Sounded*. London: Palgrave Macmillan, 2019.

Jameson, Frederick. *Postmodernism, or The Logic of Late Capitalism*. Durham: Duke University Press, 1991.

Lehman, Frank. *Complete Catalogue of the Themes of Star Wars, A Guide to John Williams's Musical Universe*. Last modified March 12, 2021. https://franklehman.com/starwars/.

McMahan, Alison. "Immersion, Engagement, and Presence: A Method for Analyzing 3-D Video Games." In *The Video Game Theory Reader*, edited by Mark Wolf et al., 67–86. London: Routledge, 2003.

Newman, James. *Best Before: Videogames, Supersession and Obsolescence*. London: Routledge, 2011.

Payne, Mathew Thomas. "Playing the Déjà-New: Plug It in and Play TV Games and the Cultural Politics of Classic Gaming." In *Playing the Past: History and Nostalgia in Video Games*, edited by Zach Whalen and Laurie Taylor, 51–68. Nashville: Vanderbilt University Press, 2008.

Rone, Vincent E. "Twilight and Faërie: The Music of *Twilight Princess* as Tolkienesque Nostalgia." In *Mythopoetic Narrative in The Legend of Zelda*, edited by Anthony Cirilla and Vincent E. Rone, 81–100. New York: Routledge, 2020.

Sloan, Robin. "Nostalgia Videogames as Playable Criticism" *Game 5* (2016): 35–45.

Summers, Tim. *Understanding Video Game Music*. Cambridge: Cambridge University Press, 2016.

Summers, Tim. "Analyzing Video Game Music: Scores, Methods and a Case Study." In *Ludomusicology: Approaches to Video Game Music*, edited by Michiel Kamp et al., 8–31. Bristol: Equinox Publishing, 2016.

Taylor, Laurie, and Zach Whalen. "Playing the Past: An Introduction" In *Playing the Past: History and Nostalgia in Video Games*, edited by Zach Whalen and Laurie Taylor, 1–18. Nashville: Vanderbilt University Press, 2008.

van Elferen, Isabella. "Analyzing Game Musical Immersion: The ALI Model." In *Ludomusicology: Approaches to Video Game Music*, edited by Michiel Kamp et al., 32–51. Bristol: Equinox Publishing, 2016.

Whiteman, Natasha. "Homesick for Silent Hill: Modalities of Nostalgia in Fan Responses to *Silent Hill 4: The Room*." In *Playing the Past: History and Nostalgia in Video Games*, edited by Zach Whalen and Laurie Taylor, 32–50. Nashville: Vanderbilt University Press, 2008.

5

The Sounds of 8-Bit Nostalgia: The Resurgence of Chiptune Music in Contemporary Film-Based Videogames

Jonathan Waxman

In December 1982, Atari released the infamous videogame *E.T. The Extraterrestrial* for the Atari 2600. Released earlier that year, the film *E.T.* was a commercial success, grossing close to $800 million worldwide. Executives at Atari's parent company, Warner Communications, optimistically assumed that a videogame adaptation would reap the benefits of association and paid Universal Pictures $25 million for the film's rights.[1] Atari was less confident. This was the first time so much was paid to make a videogame and developers were unsure if it would be successful.[2] *E.T.* the game was a failure, due in part to the game's confusing, tangential relationship to the film. Most of the game's sparse references to the film are on the title screen. There, the smiling titular character appears with the letters "E.T." above him, accompanied by a looped chiptune rendition of the two phrases of John Williams's iconic theme. Yet, the gameplay only offers sound effects, and the graphics only approximate the friendly alien.[3] This, in addition to poor gameplay mechanics, made *E.T.* the game such a failure that Atari dumped excess stock in a New Mexico landfill. The game is also blamed for the videogame crash from 1983 to 1985, and for why Atari never recovered as a company.[4] Like *E.T.*, 1980s and

[1] Pollack, "Game Turns Serious at Atari."
[2] Kent, "The Ultimate History of Video Games," 237–39.
[3] Montfort and Bogost, *Racing the Beam*, 127.
[4] Montfort and Bogost, *Racing the Beam*, 127; USA Today, "Diggers Find Atari's E.T. Games in Landfill." Although it was often a rumor that ET cartridges were buried in a New Mexico landfill, an excavation done in 2014 found these unsold items.

1990s games based on movie franchises, such as *Back to the Future*, *Ghostbusters*, *Friday the 13th*, and *A Nightmare on Elm Street*, frequently bore little relationship to their source material. Today, YouTube commentators such as James Rolfe (the "Angry Video Game Nerd") lambast glitches, poor design, and repetitive music, common to adaptations, particularly those made by the videogame company LJN. Rolfe even created a feature-length film about his frustrations with Atari's *E.T.*

It is unexpected that players remember this genre fondly considering these severe shortcomings.[5] Yet, 30 years later, new videogame adaptations are being released in the style of the failed adaptations of the 1980s and 1990s. The kinds of films that are now being converted into 8-bit games would not have been obvious candidates for adaptation in the past. Films such as *Manos: The Hands of Fate* and *The Room* are being adapted into retro-styled games. These independent films garner a cult rather than mainstream following and are dramas instead of action movies. Furthermore, the plots of each film do not divide easily into levels, nor would the music be ideal for a platforming adventure game. Nevertheless, the absurd scenes that comprise these bad movies relate to the basic, poorly executed 8-bit film game. *Manos: The Hands of Fate* and *The Room* have cult followings in part because audiences appreciate bizarre scenes that likely resulted from the "indie" constraints under which each film was produced. Contemporary game developers see these scenes as analogous to how movie-based games of the 1980s were churned out quickly without much regard to quality. Accordingly, they use the antiquated game genre to represent these contemporary films. This connection relies both on nostalgia for the movie and for these old games.

This chapter will begin by exploring factors that led to the retro game movement during the mid-2000s. It first illustrates characteristics of music from videogames based on movies by comparing the audio of 1980s and early 1990s Nintendo games to the sounds for re-creations from the past ten years. Finally, the article analyzes two contemporary videogames derived from movies as case studies—*Manos the Hands of Fate* and *The Room*. Unlike 8-bit games adapted from successful movie franchises, these games are based on films derided by critics and feature slow-moving plots that are difficult to translate into 8-bit game conventions. However, the music of these games transforms the film's original score so that they adhere to the conventions of 1980s chiptune videogame composition. In this way, players still recognize the score from the film and recall the game adaptations of films from decades ago. Additionally, these games are not as frustrating as games from the past. Instead they improve on the genre with a more direct

[5] James Rolfe's videos have spurred other game commentators including one defending these games who releases videos by the name "The LJN Defender."

relationship to the original film, better controls, and varied music. Overall, the nostalgia provoked by these games relates to Svetlana Boym's concept of "yearning for a different time—the time of our childhood" since these games are marketed to those who played them as children.[6] This contemporary transformation of an 8-bit genre provokes this nostalgia both in their fidelity to the original film's score and to conventions of 8-bit gameplay and audio. Thus, they both comment on the games of the past and the contemporary movies on which they are based.

Nostalgia and the retro movement of 8-bit gaming

These new movie-based 8-bit games are a recent phenomenon spurred by the resurgence of retro videogames. Retro videogaming during the last two decades has been dominated by three distinct genres of these games: newly developed games meant to imitate older ones, re-mastered games with updated graphics and music, and direct re-releases of older games. The first videogame emulator MAME was released in 1997 allowing enthusiasts to replay classic arcade games, but MAME was not mainstream and of questionable legality.[7] In 2006, Nintendo launched the "Wii Shop Channel" simultaneously with the Nintendo Wii, a highly popular Nintendo console. At its inception, the "Wii Shop Channel" only allowed users to download re-releases of classic Nintendo games. David Heineman cites the creation of the Wii Shop Channel as an important moment in the retro movement of gaming and argues that it has "coincided with what seems to be a larger and growing interest by consumers for playing older games."[8] Competitors also developed similar on-line stores such as the Xbox Games Store, and PlayStation Store, but their on-line marketplaces lacked Nintendo's catalogue of classic games. For succeeding consoles, the Wii U and the portable 3DS, the Wii Shop Channel was replaced by the similar "Nintendo E-Shop."[9] As retro videogaming gained in popularity through the late 2000s and early 2010s, Nintendo found other ways to sell older games to players such as The Nintendo Classic, a miniaturization of the Nintendo Entertainment System that contained 30 pre-loaded games. Matthew Payne in his article about "plug in and play" TV games—small miniature gaming consoles that allow users to play a single classic game such as *Frogger* or *Pong*—cites the immense popularity of the systems, but their popularity was dwarfed by

6 Boym, "The Future of Nostalgia," xv.
7 Payne, "Playing the Déjà-New," 52.
8 Heineman, "Public Memory and Gamer Identity," 1–2.
9 Nintendo, "Virtual Console Games."

the Nintendo Classic.[10] Stores quickly ran out of the product, and while Nintendo has been known in the past to create a scarcity of their games and systems, it is more likely that Nintendo did not properly anticipate the sheer number of game-players who would want an item that could play decades old Nintendo games.

In subsequent years, the "Wii Shop" released several "Wii Ware" titles that were either remakes of previous games with updated graphics or completely new games meant to imitate older 8-bit games. Several of the best sellers were newly created installments of older games' franchises: *Bomberman Blast*, *Dr. Mario Online Rx*, *My Pokémon Ranch*, *Final Fantasy: Crystal Chronicles: My Life as a King*, *Final Fantasy IV: The After Years*. Other games were re-releases of previous games with updated graphics: *Castlevania: The Adventure ReBirth*, *Contra: ReBirth*, and *Gradius: ReBirth*. In both cases, these new games also appeal to nostalgia in their similarities to earlier installments of the franchise. Notably though, none of the "Wii Ware" titles were based on movies, perhaps because the process to get authorization for a game was arduous, having to adhere to Nintendo's precise specifications.[11] Even on the most recent iteration of Nintendo sponsored retro-gaming, the Nintendo Switch Online, no titles were those related to films.[12]

The appeal of these new games is not only the gameplay, but the entire experience including sound effects and chiptune music, a style of synthesized music used in 1980s videogames. In the early 1980s, when the original Nintendo Entertainment System (NES) was released, game consoles began to have a dedicated sound chip. The music that could be created for these systems was very limited since systems had only four or five different voices or channels in order to play more than one note at a time with three different waveforms in order to change the kind of audio that could be heard.[13] The NES's sound chip was a custom five-channel programmable sound generator (PSG) chip designed by Yuiko Kaneoka. It consisted of two pulse waves (rectangular waves,) a triangle wave, a noise channel, and a sample channel. The pulse waves (rectangular waves) were primarily used for melodies while the triangle wave imitated basslines since it can produce only one voice with one volume, and the noise channel functioned as percussion. The last channel was the sample channel that could also be used for percussion. With these five channels, chiptune has often been compared to a band with two

[10] Payne, "Playing the Déjà-New," 52.

[11] Plothe, "The Princess Doesn't Leave the Castle," 42–44.

[12] See Nintendo, "Virtual Console Games," for a list of released Wii Ware games.

[13] For a more comprehensive examination of 1980s sound chips in videogames, see Collins, *Game Sound*.

guitar melodies (pulse waves), a bass (triangle wave), and drums (noise or sample). Despite these limitations, composers used several techniques to create engaging music.[14]

Along with retro gaming, composing chiptune music in the last decade has experienced a resurgence, and now anybody with a PC can create chiptune music with an open source chip emulator. One such emulator called the Famitracker can accurately reproduce the sound channels and thus the music of a Nintendo. Leonard Paul in his essay "For the Love of Chiptune" gives a detailed explanation of how an NES sound chip functions as well as the Famitracker, a program named after the Japanese equivalent of the NES, the Famicom. The Famitracker allowed chiptune musicians to compose music that used the audio capabilities of both the NES and the Famicom systems.[15] The ability to create this music had multiple appeals as Paul contends in his essay: "where the first generation has a nostalgia for the original systems, the new generation is attracted to the old sound as a way to generate something new."[16] This underscores the importance of chiptune music to the overall appeal of these games. Nostalgia is clearly at least part of the appeal since synthesized audio has since become more sophisticated.

Other recent scholarship supports the contention that chiptune music is at least part and in some cases a major factor in the appeal of these retro games. Rone and Vitalino examine the subjective nature of nostalgic experiences by noting that certain games appeal to the memories of certain players.[17] Paul and McAlpine explore how the chiptune audio itself generates nostalgia for past games. For children who grew up in the 1980s and 1990s, McAlpine goes as far as to call chiptune "as much a part of teenage life as were Iron Maiden and Depeche Mode." Other studies focus on how videogame music evokes nostalgia for specific game series; however, they often focus on a single series that was popular with gameplayers.[18] Schartmann, for instance, shows how Koji Kondo's melodies for the Super Mario Bros. franchise evoke nostalgia and how those melodies are reincorporated into new games.[19] Kizzire's study shows how Nobuo Uematsu's music for *Final Fantasy IX*, while not reusing specific melodies, allows the user to recall the earlier

[14] Collins, *Game Sound*, 25–26.

[15] The two systems have similar but not identical audio capabilities. For more information, see Elkins, "'Music Minus One'" and Elkins, "The Well(?)-Tempered Famicom."

[16] Paul, "For the Love of Chiptune."

[17] Vitalino and Rone, "A Player's Guide to the Psychology of Nostalgia and Videogame Music" earlier in this volume.

[18] Paul, "For the Love of Chiptune," 508–9. And McAlpine, *Bits and Pieces*, 2.

[19] Schartmann, "Koji Kondo's Super Mario Bros. Soundtrack," 2–4.

mid-1990s installations of the franchise.[20] The concern of this chapter is distinct from studies such as Schartmann and Kizzire that examine new installments of popular franchises that evoke nostalgia rather than nostalgia through games that seek to recall a genre or even an entire decade of gaming. The category that is the main concern of this study are retro games which "appropriate the esthetic style of games of the past," in particular those based on films. Ivănescu classifies this as a different category from "nostalgia games," although for games based on films, the categories are not mutually exclusive. According to Ivănescu, "nostalgia games" do not need to refer to an original game or group of games, but must "appropriate their signifying system [...] through the lens of popular culture past."[21] By these definitions, retro film-based videogames, as a category, are both nostalgia games because they signify a genre that has particular social context for the player, and retro games, because they adapt the esthetics and common tropes of older games. Thus, they represent a category distinct from games based on established franchises or newly created games that have no references outside of themselves.

Creating 8-bit audio for retro games

There are several ways that pre-existing chiptune music can be used to evoke nostalgia for gameplayers. Svetlana Boym in her article "Nostalgia and its Discontents" and her book *The Future of Nostalgia* identifies two types of nostalgia—restorative and reflective. For Boym, restorative nostalgia attempts a "transhistorical restoration of one's home," recreating a past that may or may not have existed. Reflective nostalgia is about "the longing itself" and is characterized by acknowledging the past's differences and wistfully remembering them. While both kinds of nostalgia are relevant when discussing the nostalgia of chiptune music, updated "remixed" versions of music from previous games in a series is a form of Boym's restorative nostalgia. In these cases, the music is updated and meant to sound like the older music. *Castlevania: The Adventure ReBirth*, a game that is based loosely on the 1989 Gameboy title *Castlevania: The Adventure*, offers an example of this. The popular *Castlevania* game series, a gothic horror genre, began with the release of the first game for the Nintendo in 1986. The updated title takes the same music from the original title attempting what Boym would deem a "restoration" of the music.

[20] Kizzire, "'The Place I'll Return to Someday.'"

[21] Ivănescu, "Popular Music in the Nostalgia Video Game," 17.

While the music for *Castlevania ReBirth* is not chiptune music, but rather remixed versions from previous games with digitized samples, newly produced games for other series do use original chiptune music. *Mega Man 9* and *Mega Man 10*, released as "Wii Ware" titles, use originally composed chiptune music to accompany the various stages. Like *Castlevania*, each game in the original Mega Man series follows the same basic story: the android hero Mega Man must battle against the evil Dr. Wily and his army of evil robots. The first game was released in 1987 and then a subsequent Mega Man was released on a nearly yearly basis. The series was extraordinarily popular with subsequent spinoffs including a 16-bit "Mega Man X" series, *Mega Man Legends* for the PlayStation, and the *Mega Man Battle Network*. However, the 8-bit series, originally for Nintendo, released its last game, *Mega Man 8*, in 1996 for the PlayStation and Sega Saturn. In 2009, thirteen years after the last game, another installment, *Mega Man 9*, was available to download from the Wii Shop Channel. The producers and the development team wanted to make the game in the 8-bit style that gameplayers remember. To achieve this, the graphics, controls, and sound are similar to the older games. There is even an option to add "flicker," which occurred when the NES processor was overloaded and the game had to slow down, a problem that should not be present with contemporary systems. The "flicker," along with the gameplay and chiptune music, contributes to engaging the player in an older experience.

The musical score and sound effects for *Mega Man 9* were created by Ippo Yamada who wanted to create music similar to those for the earlier games in the series. During an interview he claims that

> strictly speaking the soundtrack of *Mega Man 9* is not NES music, but to its very core, it has been created in the spirit of NES music. We made use of a program that closely resembles the consoles sound source, producing very similar waveforms and thereby were able to make music tracks that sound just like the original. In the days of Mega Man 1-6, you were challenged to manipulate the audio signals produced by the sound card within the range designated by the restrictions of the hardware. Naturally in making this game we had no hardware restrictions, but we stuck to the formula of three pulse wave channels and one noise channel. Within this framework, we freely went about composing music.[22]

Yamada's clear delineation that the music is "not NES music," but in the "spirit" of the music is an important distinction. Rather than composing music because of the technology's functional limitations, Yamada composed in this style to make the

[22] Siliconera, "Mega Man 9 Music Interview."

score appear "retro." He further explains how he "worked with a sense of nostal-gia" and that the sound director Yu Shimoda spent months analyzing the audio for the previous *Mega Man* titles before beginning the music for the ninth installment. The clear goal was for the game's music to sound indistinguishable from the music of the franchise's previous installments.[23] The trailer to advertise the game, first shown at the 2008 E3 conference, incorporates not just the gameplay but also the music in order to sell the "classic Mega Man." The beginning of the two-minute advertisement uses the opening Mega Man theme present in almost all other games from the series. It then transitions into a video alternating between cut scenes and gameplay from the levels. During the entire advertisement, the newly composed music of *Mega Man 9's* "Tornado Man" stage plays throughout the video.[24] The trailer does not want the player only to recall the gameplay but also to remember the entire experience of playing other games from the franchises decades earlier.

Although *Mega Man 9* was a commercial success, not all reviews of the game were positive. IGN accused the creators of pandering to nostalgia concluding that "you're left with a game that if it featured any other mascot or title, would almost certainly be panned as shallow and featureless."[25] The implication of the reviewer is clear: the game does not have the depth of games for contemporary systems. Despite the negative reviews, *Mega Man 9* and other games based on existing franchises were commercially successful.

Retro videogames based on movies

Following the success of the retro games linked to existing franchises, other producers also attempted to capitalize on nostalgia and produce games that imitate the ones that players remember. One genre that independent developers began exploring is videogames based on movies. Game developers released movie-based videogames as early as 1983 with *E.T.* and *Raiders of the Lost Ark* for the Atari. While movie-based games were released for later 1980s home systems such as the Commodore 64 and Atari systems, the sheer number released for the NES made it one of the iconic genres that players remember.[26] When discussing retro games,

[23] Siliconera, "Mega Man 9 Music Interview."

[24] Engadget, "Mega Man 9 Trailer to Share with Everyone."

[25] Infendo, "Capcom Selling Mega Man 9."

[26] Hall, "'You've Seen the Movie.'" Hall's dissertation includes a comprehensive list of movie to videogame adaptations including the companies that created the games and the relation-ship with their respective films.

Ivănescu argues that these games "are used as opportunities to critique aspects of games of the past, providing commentaries and opportunities for reflection on the part of the players."[27] These new movie-based games accomplish this by not only evoking the memories of the past games but also the sometimes frustrating experience of playing them.

Selling games based on movies started in the 1980s and the videogame companies that created them often had direct relationships to film studios. In the 1980s, North American games based on movies were predominantly created by the developer LJN. LJN Toys was originally a company that sold action figures and other merchandise based on films and television shows. In 1986, Sydney Scheinberg, the head of MCA, the parent company of Universal Pictures, bought LJN and began to release videogames based on their recent movie releases.[28] With this vertical integration, the relationship between the film and their respective videogames was solidified. However, after some particularly poor years, LJN was sold to the videogame developer Acclaim Entertainment that used the LJN license to sell games based on film and television shows to circumvent Nintendo's limit on the number of games any one company could release per year.[29] These games were created quickly and are remembered for their poor quality and often tangential relationship to the film.

Contemporary videogame critics such as "The Angry Video Game Nerd," an enthusiast who releases videos of him playing older games, critiques these games' shortcomings in his videos. His review for the LJN movie-based game *Back to the Future* cites the irritation with the controls, the enemies not drawn from the film, and the difficulty of extending time by collecting clocks, something that he indicates bears no resemblance to what happens in the movie. He also references the repetitive music in the game, which is a common topic during his reviews of LJN movie games such as *Friday the 13th, Bill and Ted's Excellent Adventure, Jurassic Park, Hook*, and *Beetlejuice*. Because of the cost incurred in music licensing, many games based on movies, especially when the music is not particularly memorable, contain little music from their respective films. LJN's game *Back to the Future* (1989), based loosely on the 1985 movie, for example, does not incorporate any of Alan Silvestri's original music from the film and instead twelve measures of music looped for the entire game was composed. However, for other LJN videogame adaptations, such as *Ghostbusters* (1984), an 8-bit chiptune version of Elmer

[27] Ivănescu, "Popular Music in the Nostalgia Video Game," 14.

[28] Fabrikant, "MCA Turns Hand to Acquisitions," D1.

[29] LJN often subcontracted the development of games to other companies and had these companies sign strict non-disclosure agreements, so it is often impossible to determine which company created a particular game.

Bernstein's iconic theme with pulse waves for the melody is used throughout the game. However, it can easily grow tiresome, as it is repeated during the entire game from the opening scene to the ending boss battle as the only piece of music.

In the 1980s, a game's release for the most part coincided with the movie's release, so there was not an opportunity to engage gameplayers' nostalgia since the movie was only years if not months old.[30] However, creating a new game based on a movie from the past creates two instances for gameplayers' nostalgia: one through recollection of the 8-bit style of the game, and the other through recalling the original movie, now decades old. This is both a form of Boym's reflective nostalgia and restorative nostalgia. It is reflective nostalgia because these games represent a past era in videogames and are based on older films that players fondly remember, and restorative nostalgia, since developers are creating new games with better mechanics that are more faithful to the original film on which they are based. To engage both kinds of nostalgia, game developers often choose a decades old film with a cult appeal and create a retro game based on it. The movies that are chosen are what Margulies and Rebello term "good bad" rather than one that is just bad.[31] These games can be seen as examples of the positive creative products that emerge from the fandom community of cult films.[32] These games also represent a multi-layered nostalgic response through a game based on a poor-quality movie meant to evoke substandard LJN games from the 1980s. In this way, gaming enters a nostalgic, postmodern moment. While the modernist movement in videogames focuses on state-of-the-art technology and hyper-realistic graphics and sounds, the post-modern movement relies instead on parody, collage, and representing older forms in an often ironic way.

One of these movies with a cult appeal that spurred a videogame release was the 1966 film *Manos: The Hands of Fate*. This independent film was popularized in a 1993 episode of *Mystery Science Theater 3000*, a show based around commenting on bad films.[33] The Mystery Science Theater episode led to renewed interest in the film and even inspired a documentary *Hotel Torgo*

[30] For example, the videogame based on *Back to the Future* was released in September 1989, which coincided instead with the premiere of the sequel *Back to the Future Part 2*, and not the first film in the series, which was in theaters four years earlier. The videogame *Ghostbusters* also coincided with the premiere of *Ghostbusters II* in June 1989 even though the action of the videogame *Ghostbusters* more closely conforms to that of the original 1984 movie.

[31] Margulies and Rebello, *Bad Movies We Love*, xviii.

[32] Mathijs and Sexton, *Cult Cinema*, 57.

[33] Benshoff, "A Companion to the Horror Film," 287–88.

FIGURE 5.1: (*Top left*) *Gyromite* box art; (*top right*) *Manos: Hands of Fate* box art. (*Middle left*) Scene from *Manos: Hands of Fate*; (*middle right*) cut scene from the videogame. (*Bottom left*) *Castlevania 2* overworld; (*bottom right*) *Manos: The Hands of Fate* stage 4. Screen captures by the author.

(2004) that consisted of interviews of the surviving cast and crew members.[34] The film's creator, Harold Warren, published the film without a copyright notice, and it is therefore in the public domain. Because no royalties had to be paid to the film's creator, several enthusiasts have created stage plays and other creative works based on the film. In 2012, FreakZone Games developed an 8-bit game based on the film that uses aspects of the film's story and also the original music.

[34] Hicks, "Resurrecting the Dead," 57–58.

The developers take several opportunities to evoke nostalgia even before playing a level. The advertisement FreakZone uses for the game clearly tries to recall 8-bit Nintendo games of the 1980s. The advertisement for the Manos videogame looks strikingly similar to the box art of Nintendo games from the 1980s. Both use 8-bit drawings from their respective games along with similar diagonal text along with a picture of the game type in the lower left. Instead of the "Nintendo Seal of Approval," the Manos Game has the "Master Seal of Disapproval" as a reference to the common line from the film "The Master would not approve." Additionally, the game's website clearly shows that the producers are striving for a nostalgic appeal to players. It states that "Manos will take you back to the fantastically absurd games of the past."[35] These "fantastically absurd games" no doubt refer to the movie videogame adaptations produced by companies such as LJN. Like these games, the levels in *Manos* range from regular platforming to side-scrolling either horizontal or vertical. The creators also use cut scenes, common from games from that era, between the levels to recreate the scenes from the movie, and frequent direct allusions to popular 8-bit Nintendo games such as the "Day/Night" text box transition from *Castlevania 2*. With obvious allusions to the loose relationship of a film based videogame and the actual movie typical of the games from the 1980s, there are ridiculous levels and boss fights of the game that do not represent anything that occurred in the actual movie. For example, the game requires the player to fight a giant ostrich in an underground cavern, shoot UFOs and zombies in a graveyard, and fly a propeller plane during a side scrolling level. These non-sensical quests are an allusion to the similarly bizarre levels of the earlier LJN games.

Likewise, the film score is memorable for being distinct and incongruous for a horror movie, consisting of mostly cool jazz with only piano, drums, and saxophone. On the surface, jazz would not be appropriate for the action of a platforming game. However, in an effort for gameplayers to recall the original film, the music for the game draws upon several cues from the film's score. Because of the score's distinct sound, the developers had an opportunity to use music that a fan of the movie would instantly recall. The videogame score is mostly restricted to three cues from the film that recur the most. The use of these cues adds to the experience of playing the game while simultaneously recalling the film.[36]

[35] FreakZone Games, "Manos: The Hands of Fate."

[36] For another example of how the music of older media is used in a modern retro game, see Wissner, "You Unlock This Game with the Key of Imagination: *The Twilight Zone: The Game* (2014), Musical Parody, and the Sound of Nostalgia" in this volume.

While the music for the videogame is very similar to the movie, there are some adjustments that were made to convert the jazz score for use in a retro game. 8-bit videogame music cannot handle multiple changes in tempo, so the music had to be more metrical. For instance, the chiptune conversion for "Portrait of Evil" leaves the melodies intact, but the videogame rendering adds a steady bass part along with drum samples to ensure a steadier beat while the version for the movie often has the melody alone. The use of the triangle wave for the bass part, common in Nintendo games of the 1980s, also gives the level the feel of a platforming game. However, the melody is transposed to a higher register, up an octave from the film version. That melody is used in one pulse wave while the bass chords from the film are also brought up an octave and assigned to the second pulse wave. A similar key change, moving the melody up slightly, also occurs later during the same levels, but the arranger adjusts the melody because the melodic line would reach notes that would be impossible for the chiptune sound card. These changes allow the game to have the platforming feel of 1980s games while enabling the player to experience the same music from the film. For most cues the same pattern is followed, the melody is kept the same, but a bass part and percussion are added. This creates a score that relates to both the movie and 8-bit videogames.

Another example of a developer choosing to re-create a movie with a cult following was *The Room*. Released in 2003, *The Room*, a film written, directed and starring the eccentric Tommy Wiseau, follows Johnny, a successful banker, who lives in San Francisco with his fiancée Lisa. Lisa becomes bored of Johnny and begins an affair with Johnny's best friend Mark. It has been called "the Citizen Kane of bad movies," frequently criticized for plot holes, poor acting, and inconsistent narrative structure.[37] However bad the movie was, it became a phenomenon. It has had midnight screenings around the country since its release, sometimes with a question and answer period with Tommy Wiseau. The film also spurred a book, *Disaster Artist*, detailing the creation of the movie. The book was adapted into a movie by the same name, which was nominated for both Golden Globes and Academy Awards. The film is celebrated for its shortcomings and like *Manos: The Hands of Fate* has garnered a cult following.

Like *Manos: The Hands of Fate*, the score has become an iconic and beloved part of the movie. The music for *The Room* was composed by Mladen Milicevic, a composer and professor of music at Loyola Marymount University. While there are several different musical cues throughout the film, the score is dominated by the theme that plays from the main title. In an interview, Milicevic recounts the requests he receives for the score's sheet music, and that his students are excited

[37] Collis, "The Crazy Cult of *The Room*."

when they find out that he is the composer for the film. The Loyola Marymount student newspaper even conducted an interview with him about his film composition for *The Room* in 2018, fifteen years after the movie's initial release.[38] For the film's devoted followers, the score is an important part of the experience of watching *The Room*.

The Room Tribute Game, released in 2010 by the game publisher Newgrounds, is another example of the nostalgic movie-based game based on a cult film. The game has a 16-bit feel in the graphics, gameplay, and music. In the adaptation, the player controls Johnny who goes to different places in his San Francisco world finding items and going on various side quests. Milicevic's theme is used as background for almost all the action and melodically it is kept intact. The original theme is relatively simple; it consists of long phrases with mostly straightforward consonant harmonies while the bass plays arpeggiated chords that change approximately every measure. Like the music for a videogame, which is repeated as long as the player is on a specific stage or environment, the melody is heard consistently throughout the movie and unsurprisingly becomes the basis for the videogame score based on the film.

While the score for the game is the main theme of the movie played on a loop, there are some prominent exceptions. This music is often interrupted by other audio from the film depending on areas the player enters. These sections relate to the scenes of the movie, allowing the player freedom to explore the world, but, on the other hand, following the plot and events of the movie. Another is the battle theme that is meant to evoke the random battles of role-playing games from 1980s and 1990s, in particular those from the *Final Fantasy* and *Dragon Quest* series released for the Nintendo. Unlike the RPGs of the 1980s and 1990s, the theme that repeats is an up-tempo version of the Room theme, not an original battle theme but uses similar musical tropes from RPG battle music. For example, the music begins with a short introductory fanfare, typical of early Nintendo games in popular role-playing series, which interrupts the action and draws the player into the battle. To convert the film's theme to battle music, the flowing original melody was changed to short staccato notes, and bass and percussion were added. Like other battle music for role-playing games, the music is played on a repeated loop in a fast tempo with a prominent bass part. By transforming the Room theme instead of creating an original battle theme that would imitate 8-bit battle themes of role-playing games from the Nintendo, the game both references the original movie as well as 8-bit game conventions.

[38] Brogan, "12 Burning Questions with Mladen Milicevic."

Conclusion

These new 8-bit games add a critical dimension to nostalgia studies in videogame music. They offer much more than a return to one's childhood. Instead these titles allow players to create new experiences that feel like old memories of a past era, even if those old memories were not positive in the first place. Why then are we so nostalgic for the 8-bit videogames based on movies to the extent that there is now a market for these games even though the titles on which they were based were generally of poor quality? When referring to the "nostalgic game," Ivănescu contends that a game "does not simply appropriate the image, or the soundscapes, of media past, but can emphasize the sociopolitical undertones of the genres, styles, and individual works referenced, and that the category of games functions not as a mirror but rather "a magnifying glass, often revealing the disconcerting underbelly behind the glossy finish."[39] While the games on which they are based are reviled by critics both in the past and today, the videogame versions of *The Room* and *Manos: The Hands of Fate* receive positive reviews from players. While people can have nostalgia for places that they have not been or time periods they have not experienced, the market for these games was primarily those who grew up with the emergent videogame culture as children and viewed these games as their generational identity.[40] Thus, replaying older games is akin to replaying their childhood, and playing these newer games feels like going back to a familiar place. According to the Entertainment Software Association, the average videogame player in 2019 was 33 years old, so those who began playing videogames as children in the 1980s are nostalgic for their childhood.[41] As the children born in the 1980s grew up, the sophistication of games, including the music, also exponentially improved and can lead to one yearning for the simplicity of the games from one's childhood. One can also apply Masahiro Mori's "uncanny valley hypothesis" that to make a robot that is up to 95% realistic is great, but a 96% lifelike robot makes us think that there is something seriously wrong.[42] Games today on contemporary systems

[39] Ivănescu, "Popular Music in the Nostalgia Video Game," 16.

[40] Hutcheon and Valdés, "Irony, Nostalgia, and the Postmodern."

[41] Zackariasson and Wilson, "Marketing of Video Games," 57–58. "Essential Facts about the Video Game Industry." The average age of the videogame player trended upward over the last decade but in recent years tended to trend downward owing to the popularity of the recent home consoles by the younger generation.

[42] Mori, "The Uncanny Valley [From the Field]." For a discussion of the "Uncanny Valley" hypothesis in videogames, see Tinwell, *The Uncanny Valley in Games and Animation*, 7–9.

are able to portray the world realistically, so it makes sense that gameplayers, who grew up playing games in the 1980s, find comfort in 8-bit games that do not.

Perhaps the appeal is a reaction against the digital revolution, what Walter Benjamin deemed "revolutionary nostalgia"—holding on to the past as a revolt against the current political order or in this case more technologically advanced gaming systems. Ivănescu agrees that this could be the case because retro games are not "a passing fad" in gaming, but now an established genre.[43] Is it because today's society is more complex or is it a nostalgia for the childhood absence of responsibility? Sean Fenty argues that videogames offer not only a return to the past but also a past in which players can participate.[44] While this can explain the popularity of retro games for game series such as *Mega Man* and *Castlevania*, it does not explain the popularity of new retro games based on movies. These new creations are more than games based on films but rather both a parody of the original film and an evocation of a genre that gameplayers found frustrating. While the absurd levels of the videogames based on other movies were seen as lazy videogame creations intending to churn out a game quickly, the ones created for *Manos: The Hands of Fate* and *The Room* are intentional. The creators want the game to appear absurd since they are based both on a low-quality film that is frequently mocked as well as games from the past that are ridiculed today. In these ways, they create multiple levels of nostalgia for the player: nostalgia for the films, the larger genre of 8-bit videogames, and the specific genre of games based on films.

LUDOGRAPHY

Back to the Future. Beam Software. Nintendo Entertainment System. LJN, 1989.
Castlevania: The Adventure ReBirth. M2. Nintendo Wii. Konami, 2009.
Castlevania 2: Simon's Quest. Konami. Nintendo Entertainment System. Konami, 1988.
E.T. The Extra Terrestrial. Atari, Inc. Atari 2600. Atari Inc., 1982.
Ghostbusters. Activision. Nintendo Entertainment System. Activision, 1988.
Manos: The Hands of Fate. FreakZone. Microsoft Windows. FreakZone, 2012.
Mega Man 9. Inti Creates. Nintendo Wii. Capcom, 2008.
The Room Tribute Game. Newgrounds. Adobe Flash. Newgrounds, 2010.

BIBLIOGRAPHY

Benshoff, Harry M. *A Companion to the Horror Film*. Hoboken: John Wiley & Sons, 2014.

[43] Ivănescu, "Popular Music in the Nostalgia Video Game," 14.

[44] Fenty, "Why Old School Is 'Cool'," 20.

Boym, Svetlana. *The Future of Nostalgia*. New York: Basic Books, 2002.

Brogan, Kayla. "12 Burning Questions with Mladen Milicevic." *Los Angeles Loyolan*. February 7, 2008. http://www.laloyolan.com/news/burning-questions-with-mladen-milicevic/article_a2ab60d6-cb5e-5614-8930-74cf09b6d441.html.

Collins, Karen. *Game Sound: An Introduction to the History, Theory, and Practice of Video Game Music and Sound Design*. Cambridge: MIT Press, 2008.

Collis, Clark. "The Crazy Cult of *The Room*." *Entertainment Weekly*. December 12, 2008. https://ew.com/article/2008/12/12/crazy-cult-room/.

Elkins, Alan. "'Music Minus One': Timbral Adjustments and Compromises in First-Party FDS-to-NES Conversions." Paper presented at the North American Conference on Video Game Music, Davidson, NC, January 2016.

Elkins, Alan. "The Well(?)-Tempered Famicom: Variations Between Tuning Systems in Famicom/NES Games." Paper presented at the North American Conference on Video Game Music, Ann Arbor, January 2018.

Engadget. "Mega Man 9 Trailer to Share with Everyone." Accessed November 12, 2019. https://www.engadget.com/2008/07/10/mega-man-9-trailer-to-share-with-everyone/.

"Essential Facts about the Video Game Industry." Entertainment Software Association, 2019.

Fabrikant, Geraldine. "MCA Turns Hand to Acquisitions." *New York Times*. February 9, 1987. https://www.nytimes.com/1987/02/09/business/mca-turns-hand-to-acquisitions.html.

Fenty, Sean. "Why Old School Is 'Cool' A Brief Analysis of Video Game Nostalgia." In *Playing the Past: History and Nostalgia in Video Games*, edited by Zach Whalen and Laurie N. Taylor, 19–31. Nashville: Vanderbilt University Press, 2008.

FreakZone Games. "Manos: The Hands of Fate." Accessed November 13, 2019. https://freakzonegames.com/post/21375637553/manos- the-hands-of-fate.

Hall, Stefan. "'You've Seen the Movie, Now Play the Video Game': Recoding the Cinematic in Digital Media and Virtual Culture." PhD diss., Bowling Green State University, 2011.

Heineman, David S. "Public Memory and Gamer Identity: Retrogaming as Nostalgia." *Journal of Games Criticism* 1, no. 1 (January 2014). http://gamescriticism.org/articles/heineman-1-1.

Hicks, Cheryl. "Resurrecting the Dead: Revival of Forgotten Films through Appropriation." In *In the Peanut Gallery with Mystery Science Theater 3000: Essays on Film, Fandom, Technology and the Culture of Riffing*, edited by Robert G. Weiner and Shelley E. Barba, 55–65. Jefferson: McFarland, 2014.

"Hot Toy Alert: Toys 'R' Us to Get New Shipment of Hatchimals, NES Nintendo Classic." Accessed November 13, 2019. http://malled.blog.palmbeachpost.com/2016/12/01/hot-toy-alert-toysrus-to-get-new-shipment-of-hatchimals-nes-nintendo-classic/.

Hutcheon, Linda, and Mario J. Valdés. "Irony, Nostalgia, and the Postmodern: A Dialogue." *Poligrafías* 3 (1998–2000): 18–41. http://revistas.unam.mx/index.php/poligrafias/article/viewFile/31312/28976%20.

Infendo. "Capcom Selling Mega Man 9 with Minimal Effort and Maximum Fanfare." July 11, 2008. https://infendo.com/capcom-selling-mega-man-9-with-minimal-effort-and-maximum-fanfare/.

Ivănescu, Andra. *Popular Music in the Nostalgia Video Game: The Way It Never Sounded.* Palgrave Studies in Audio-Visual Culture. Cham: Palgrave Macmillan, 2019.

Kent, Steven L. *The Ultimate History of Video Games: From Pong to Pokemon—The Story Behind the Craze That Touched Our Lives and Changed the World.* Roseville: Three Rivers Press, 2001.

Kizzire, Jessica. "'The Place I'll Return to Someday': Musical Nostalgia in *Final Fantasy IX.*" In *Music in Video Games: Studying Play,* edited by K. J. Donnelly, William Gibbons, and Neil Lerner, 183–98. London: Routledge, 2014.

Margulies, Edward, and Stephen Rebello. *Bad Movies We Love.* London: Marion Boyars, 1995.

Mathijs, Ernest, and Jamie Sexton. *Cult Cinema: An Introduction.* Chichester: Wiley-Blackwell, 2011.

McAlpine, Kenneth B. *Bits and Pieces: A History of Chiptunes.* Oxford: Oxford University Press, 2018.

Montfort, Nick, and Ian Bogost. *Racing the Beam: The Atari Video Computer System.* Cambridge: MIT Press, 2009.

Mori, Masahiro. "The Uncanny Valley [From the Field]." Translated by Karl F. MacDorman and Norri Kageki. *IEEE Robotics Automation Magazine* 19, no. 2 (June 2012): 98–100.

Nintendo. "Virtual Console Games." Game Store. Accessed August 5, 2020. https://www.nintendo.com/games/virtual-console-games/.

Paul, Leonard J. "For the Love of Chiptune." In *The Oxford Handbook of Interactive Audio,* edited by Karen Collins, Bill Kapralos, and Holly Tessler, 507–30. New York: Oxford University Press, 2014.

Payne, Matthew Thomas. "Playing the Déjà-New 'Plug It in and Play TV Games' and the Cultural Politics of Classic Gaming." In *Playing the Past: History and Nostalgia in Video Games,* edited by Zach Whalen and Laurie N. Taylor, 51–68. Nashville: Vanderbilt University Press, 2008.

Plothe, Theo. "The Princess Doesn't Leave the Castle: How Nintendo's WiiWare Design Imprisons Indie Game Design." In *Video Game Policy: Production, Distribution, and Consumption,* edited by Steven Conway and Jennifer deWinter, 42–53. Milton: Taylor & Francis, 2015.

Pollack, Andrew. "Game Turns Serious at Atari: After an Explosive Rise, the Company Has Been Shaken by Executive Turmoil and Faltering Sales. The Game at Atari Gets Serious as Profits Drop and Top Executives Fall." Business, *New York Times.* December 19, 1982. https://www.nytimes.com/1982/12/19/business/the-game-turns-serious-at-atari.html.

Schartmann, Andrew. *Koji Kondo's Super Mario Bros. Soundtrack.* New York: Bloomsbury Academic, 2015.

Siliconera. "Mega Man 9 Music Interview with Inti Creates Ippo Yamada." Accessed March 19, 2014. http://www.siliconera.com/2008/10/04/mega-man-9-music-interview-with-inti-creates-ippo-yamada.

Tinwell, Angela. *The Uncanny Valley in Games and Animation*. Boca Raton: CRC Press, 2014.

USA Today. "Diggers Find Atari's E.T. Games in Landfill." April 26, 2014. https://www.usatoday.com/story/tech/2014/04/26/diggers-find-ataris-et-games-in-landfill/8232609/.

Zackariasson, Peter, and Wilson, Timothy. "Marketing of Video Games." In *The Video Game Industry: Formation, Present State, and Future*, edited by Peter Zackariasson and Timothy Wilson, 57–75. London: Routledge, 2012.

PART 3

SUBJECTIFYING NOSTALGIA AND VIDEOGAME MUSIC

6

A Link between Worlds:
Nostalgia and Liminality in Musical
Covers of *The Legend of Zelda*

Alec Nunes

For many players, *Ocarina of Time's* (*OoT* 1998) virtual representation of musical performance sparked their love of *The Legend of Zelda* franchise. Its cinematic sequences expanded players' conceptualization of how videogames (VGs) could tell stories. *OoT* begins with young Link's arrival at Hyrule Castle. There he witnesses Zelda throw a magical ocarina into a stream. Once players retrieve Zelda's ocarina, a musical staff appears on-screen, and the game prompts players to play an enchanted melody, "The Song of Time." Players then "perform" music on the ocarina by pushing buttons on the controller, which automatically translates to "The Song of Time"'s notated pitches that gradually appear on the musical staff. This interactive approach to music left an indelible mark on players. It occurs in a space between the input of players and Link's musical performance in the virtual world. It, therefore, exemplifies the concept of *liminality*: the threshold of real and virtual. Similar moments of liminality have become a defining feature of the series since *OoT* and draw players into the *Zelda* franchise. *OoT*'s liminal musical moments create an itchy nostalgia that transcends the context of the original game. Later musical covers and arrangements provide a salve to this itch. They have inspired the creation of several online communities whose members produce and consume *OoT*'s music for nostalgic purposes. Such arrangements rework or extend the game's original musical composition, usually set in a different medium. Furthermore, these covers sometimes constitute songs initially performed or recorded by another performer and do not specify deviation or adherence to the original. The multitude of these *Zelda* music cover titles, filed under subcategories relating to nostalgia, evinces how this exchange of music alleviates a pain associated with nostalgia. Listeners treat them as nostalgic "artifacts" that evoke a

128

soothing emotional response that eases the pain of lost pasts. Within this context, nostalgia is not solely a form of memory that remains in the past. Instead, it is a problem that demands action in the present

I argue that *Zelda*'s musical interaction enters a disembodied space of liminality. This liminality produces nostalgia for the series that demands action in the present. The action, in turn, is relieved in musical covers, themselves nostalgic expressions. Expressed differently, the liminal quality of music in *Zelda*'s gameplay creates a nostalgic itch, scratched by the dissemination of musical covers in online communities. I first establish how musical immersion in *Zelda* enables liminality, particularly in *OoT* and musical covers of its music using the work of Stephanie Lind, Tim Summers, and Kiri Miller. The musical activity demanded by and almost uniquely particular to *Zelda* allows players to enter a liminal space that strengthens their potential to forge nostalgic memories. Next, I examine how Svetlana Boym and Natasha Whiteman's perspectives on nostalgia operate in *OoT*'s musical covers. Here, I establish how nostalgia associated with the game's liminal experiences can be painful and demand an action in the present to soothe this pain. Finally, I demonstrate how different online communities identify, enact, and assuage this demanding form of nostalgia through case studies of *Zelda* covers. Ultimately, although this article examines mostly *OoT* examples, its larger contribution lies in its theorization of the relationship between a disembodied performance within the liminal space of VG play and the embodied nostalgic practice of online VGM covers.

Zelda's musical literacy and liminality

Fantasy and adventure games like *Zelda* cultivate immersion or the fading away of real-world sensory information in favor of what is happening in the game. Action-adventure and fantasy games like it offer vast, developed virtual worlds and extensive musical soundtracks. *OoT*'s direct musical engagement, however, is an immersive technique other games have not employed. *OoT* introduces players to many songs that appear across multiple titles. Players assume musical agency and engage more deeply with Hyrule because of the music. For example, in *OoT*, players perform songs directly to influence gameplay in the way one might expect a magical spell to function. One of the first songs players learn in *OoT* is "Zelda's Lullaby." Players memorize and perform this piece on their controller by playing a specified button combination. After the song is played, it opens secret passages marked by the Triforce or the Royal Crest of Princess Zelda's family. Stephanie Lind argues that songs like "Zelda's Lullaby" generate layers of meaning within *OoT* by "directly engag[ing] the player in a fully participatory role: The game is not

possible to complete if the player does not *initiate* these leitmotifs, each a thematic event."[1] Lind calls *OoT*'s playable ocarina songs leitmotifs for two reasons. First, they reappear to solve puzzles or advance the game. Second, they are associated with particular zones, areas, characters, and gaming contexts. In short, music is inextricably linked with *Zelda*, as players must exercise musical agency through the controller.

The leitmotif's contribution to *Zelda*'s immersive experience is crucial in the development of nostalgia. The player's musical performances fix associations within gameplay. The moments of musical literacy in *OoT*, amplified by the associative power of leitmotifs, prime players to experience nostalgia. *OoT*'s leitmotifs must be performed multiple times to complete the game. Most players consequently memorize each song's sequence of buttons and notation patterns. This repetition codes such moments into the player's long-term memory.[2] Ludomusicologist Tim Summers describes this action as more than merely button pressing. He argues that the game encourages players to think of the button-pressing action as a melody rather than a code.[3] In other words, players remembering "Zelda's Lullaby" likely will recall the music's rhythm and melody before the sequence of buttons. In other words, the player remembers the buttons as the notes of an instrument that can produce a melody. The controller acts as a ludic instrument, whose manipulation results in a musical performance.[4] This experience of music learning underpins musical nostalgia in *Zelda*.

The musical learning in *Zelda* momentarily takes players out of the game world. It interrupts the player's immersive state by demanding players take embodied action.[5] For example, when Zelda's guardian Impa first teaches players "Zelda's Lullaby," they see a music staff appear on the screen. Pressing the correct sequence of buttons translates to notated pitches on the staff. Rather than drawing gamers into the virtual narrative, the musical staff projects into the real world. Note that this musical event never projects fully into the real world. Nevertheless, it extends just far enough to provide a space where players can enter the threshold of the virtual through performance. It is a *liminal* event. As described by Isabella van Elferen, this space

[1] Lind, "Active Interfaces and Thematic Events," loc. 1819 of 6683, Kindle.

[2] See the second section of Michael Vitalino and Vincent Rone's "VGM Inducing Emotion: How It Happens" earlier in this volume.

[3] Summers, "Understanding Video Game Music," 179.

[4] Summers, "Understanding Video Game Music," 179.

[5] This idea is not unlike one of Can Aksoy's central premises about the leitmotif's interruptive function in his essay "Remembering The Rules: Immersive Nostalgia in *Final Fantasy* Leitmotifs" elsewhere in this volume.

in-between the real and virtual enables players to build musical literacy through repeated gaming practices.[6] As such, learning exists both in-game and in the real world. William Cheng elaborates, explaining that to "grasp the real-virtual divide is to acknowledge that what happens in game worlds rarely stays in game worlds—that the sounds and simulations of games can resonate well beyond the glowing screen."[7] Cheng's observation of what he calls "sound play" resonates in *Zelda*. While he considers it "the ways in which individuals play with sound via video games," players receive concrete examples of sounds moving beyond the speakers and screens.[8] In a way, the liminality of this musical performance generates a special kind of immersion. It transcends the virtual and relies on interactions between musical literacy and the associative power leitmotifs to trigger intensely personal memories in players. This liminality is the crux of the nostalgic experience in *OoT*. It creates a desire not only to return to Hyrule but also to experience it as the site of musical contact. This desire motivates the game's outward projection into the real world.

Liminality functions similarly in other games, prized for their musical qualities. The *Grand Theft Auto* and *Guitar Hero/Rock Band* series present, as Kiri Miller writes, design choices that foster a musical bridge between the real and virtual worlds.[9] The *Grand Theft Auto* (*GTA*) series offers immersion by way of criminal activity, which ranges from minor traffic infractions to multiple hit-and-runs or shootings. Players must steal a car to advance the game, which opens a panoply of musical options. Players can skim presets on the radio, complete with genre-specific stations, real-world music, and hosts. On the other hand, the *Guitar Hero/Rock Band* franchises build player skill without immersion in a virtual reality. The scrolling nature of their musical interface allows players to cultivate skills in rhythm, entrainment, and note recognition. Also, players can customize their characters and story modes. Such options let them unlock more songs and lets their list of songs evolve. The music extends into the real-world contexts of gamers and thus invites them deeper into the fantasy of the game.

However, *GTA* and *Guitar Hero/Rock Band* do not integrate music into the immersive experience as comprehensively as in the *Zelda* series. In *GTA*, musical moments are focused around their specific cultural practices and social context rather than the playing of music. No one becomes more skilled at theft from listening to music. Many actions in the *GTA* series require different physical abilities for

[6] Van Elferen, "Analyzing Game Musical Immersion," 32–39. See also Vitalino and Rone's essay for further discussion about van Elferen's "ALI Model."

[7] Cheng, *Sound Play*, 14.

[8] Cheng, *Sound Play*, 6.

[9] Miller, *Playing Along*, 149.

which neither controller nor music prepare players. Also, the music does not advance *GTA*'s plot, as players can opt to turn off the radio and play without music. Players, however, *may* emerge from the game with greater knowledge of the pop-music repertoire. Despite providing an immersive experience curated by real-world music, *GTA*'s immersion does not develop player skills outside the game. The opposite effect occurs in the *Guitar Hero* and *Rock Band* franchises. Although the game's progression depends on the acquisition and performance of some musical skill, these games do not give the player interactive agency over music. Their musical content might inspire players to extend their musical journey to actual instruments. However, in the process, they likely will not express the same nostalgia for the games. *Guitar Hero* and *Rock Band* nurture musical learning in players. Yet, they lack the spaces to foster liminality against the backdrop of a developed virtual world and narrative.

Unlike these games, music is a constitutive facet of *Zelda*, especially for *OoT*. Players cannot progress without participating in musical performances. These performances do not amount to random button mashes but are leitmotifs players perform as they trek through Hyrule. The combination of integrated, responsive music and the requirement of musical literacy throws into relief the importance of liminal spaces, the "betweenness" of real and virtual worlds where players may connect with the game in meaningful ways. Because of this, the disembodied space as the site of musical performance allows players to forge powerful memories and can prime for nostalgia.

Nostalgia: *The itch created by Zelda's liminality*

Liminality forges a new type of immersion within *OoT*. Player input projects inwards toward the game world in the form of performance on the ludic instrument, the controller. The game simultaneously projects outward into the real by urging players to perform music on digital musical staff notes. Both actions meet in the disembodied liminal space. This liminal intersection creates a robust nostalgic response that manifests beyond their initial gaming experiences. It also inspires the creation of subcultures whose constituent members upload and disseminate musical covers within online communities to sate their yearnings for the past. This section argues that musical covers of VGM scratch or satisfy the itchy nostalgia. To that end, I theorize liminal nostalgia as an emotional longing for the past to demonstrate its capacity to act as a treatable ailment.[10] In other words, the longing

[10] Nostalgia as ailment originates in the seventeenth century with Dr. Johannes Hofer, who used it to diagnose the homesickness of Swiss soldiers. Nostalgia was treated with leeches, emulsions, opium, stomach purges, and a return to the Alps—a return to the homeland—the most effective method.

produces a "virtual" itch that needs scratching or an addiction that needs a fix. Within this broader historical context, I show how performances of *Zelda* musical covers provide two things. First, they embody liminality. Second, they offer a medicinal remedy for nostalgic fans longing to engage with VGM outside the original context of gameplay. The work of nostalgia historian Svetlana Boym and Natasha Whiteman help demonstrate the emotional states that originate when this nostalgic itch begins. I then follow with how members of online communities, content creators, and fans alike, express their nostalgia—how they scratch.

The liminal experience of musical literacy creates a liminal nostalgia and an unending itch. Returning to the player's first encounter with "Zelda's Lullaby" in *OoT*, it introduces players to button presses not as a code sequence but as a memorable melody. Each repetition of this leitmotif further engrains it within the player. Furthermore, subsequent releases in the *Zelda* series alter or build upon this foundation and musical performance becomes an integral aspect of gameplay. These games remind players of this liminal experience of musical literacy and desire a return to this state. Sean Fenty argues that nostalgia for VGs often manifests in the attempt to recapture the emotional reaction of initial playing experiences,[11] fans and creators of covers try to recapture something more subtle. Fans, players, and creators want to return to this first encounter with liminality, but such a literal return is impossible. Boym's restorative and reflective nostalgia both address the "aches of temporal distance" but differ that the former wants to rebuild the lost home while the latter savors the distance.[12] For *Zelda*, and liminal nostalgia, both of Boym's nostalgia inform liminal nostalgia. The physical manifestation of nostalgia informs the nostalgic's response as a need to satiate the desire or cure the aches. With no immediate or obvious vent for liminal nostalgia, the "itch" develops. The fan addresses this through musical engagement as a salve to the nostalgic itch.

With no channel for these embodied skills, the nostalgic fan fashions musical covers and arrangements to scratch the itch. *Zelda* predicates nostalgia through liminal gameplay, but fans cannot satiate their nostalgia through gameplay. Their desire stems from the first encounter with musical literacy as agency in the game world. Waiting for a future *Zelda* release may assuage their yearning, but its musical gameplay might underwhelm their musical expertise and no longer fulfill their desire. For these fans, the only salve left requires creating and seeking out fan-made content. Discussing fan responses to game world building, Whiteman theorizes diachronic nostalgia. Diachronic nostalgia, Whiteman writes, "involves some transformation of the textual universe." A fan of the game who did not

[11] Fenty, "Why Old School Is 'Cool'," 20–22.

[12] Boym, The Future of Nostalgia, 44.

participate in developing the original can implement changes to a given piece.[13] While Whiteman writes here about fan responses to *Silent Hill* canon, *Zelda* fan-creators contribute not for control over the game world but as a way to re-experience liminality as a place of musical learning. The creation of *Zelda* covers fulfills the desire for musical growth in the context of *Zelda*. This growth takes the form of online communities that help to produce, critique, and spread content.

The online communities that produce and disseminate *Zelda* covers offer such mitigation. More precisely, communal engagement functions as the therapeutic activity to the ailing or yearning brought about by nostalgia with the understanding that fans no longer are situated in their original playing contexts but can share their experiences.[14] As this section has framed nostalgia as an ailment and also a means to contextualize how VGM covers can function as nostalgic practice, the following section examines specific case studies that demonstrate the transference from disembodied liminal spaces to embodied practice motivated by nostalgia. The communities that comprise these online sites constitute their desire, in the words of Fenty, "for liminality itself—for that moment of transition" between the virtual and real.[15] The following case studies layout the process of an embodiment of initial musical literacy in *Zelda*'s liminal spaces to the channeling of their emotional responses and memories through nostalgic practice, combined with the reception this process creates.

Fan music: "Scratching the Itch" with fan covers

Sites including YouTube, OCRemix, Zelda Dungeon's blog posts, and Zelda Universe's hosted *ZREO* project all accommodate localized spaces for fans who share nostalgia for VGM and provide effective scratches for such itches. So far, this chapter has focused on the importance of liminality created by *OoT*, followed by how nostalgia motivates the desire among fans to embody that liminality fuelled by nostalgia. This section continues with *OoT* examples but also applies this chapter's theoretical framework to other games within the *Zelda* franchise. Each example in this section manifests the liminal nostalgia discussed earlier through examination of fan reception, user commentary that places nostalgia for *Zelda*'s music in the foreground. Such commentary suggests how everyday fans express nostalgia for

[13] Whiteman, "Homesick for Silent Hill," 43–45.

[14] This point resonates analogously to the concept of *unisonance*, a form of collective knowledge concerning a musical piece, as described by Sebastian Diaz-Gasca in this volume.

[15] Fenty, "Why Old School Is 'Cool'," 23.

the *Zelda* series. Across these sites, fans participate in communal discourse that encourages others among the sites' fandom to make and contribute music. This activity and discourse together fuel a self-sustaining enterprise, which generates the nostalgic itch while simultaneously supplying the metaphorical scratch.

YouTube and Zelda nostalgia

YouTube allows anyone to post virtually any form of media, which targets a broad fan base and consequently allows *Zelda* fans to scratch their nostalgic itches. However, YouTube lacks a centralized discussion venue, such as a forum, for community analysis, offering only a general comment section for each upload. Therefore, people who identify with subcultures dealing with musical covers or nostalgia-based music must search for channels, usernames, or titles that might fit their interests. For example, Erik C 'Piano Man' offers numerous piano covers on his YouTube channel. He covers various videogame tunes, music form television film, and anime. He currently hosts a specific playlist for all of his *Zelda* covers. He creates all of these arrangements "to show the power and diversity of the piano through [his] covers."[16] One such cover is his "Zelda: Ocarina of Time Piano Medley (Extended) Nostalgia Edition," which emphasizes the prevalence of piano covers with the intention to create a nostalgic space.[17]

The title, of course, invites nostalgic commentary, which relies on liminal nostalgia. Some commenters focus on a specific narrative or gameplay moment, the most notable being *OoT's* (in)famous Water Temple. A commenter on the video, Michael Potticary, for example, refers to the temple's difficulty. This user's response generates a 126-message reply chain debating the difficulty of the level! On the other hand, users provide general nostalgic appeals, such as by user Christian Baeza who describes the music cued a significant memory between his father and him, where the former watched the latter play the game as he grew up. Blizz 4041 provides a meta-reflection on the nature of the comment section itself, as they describe themselves being moved to tears by the video and music.[18] Comments

16 C' Piano Man, Erik, "(31) Erik C 'Piano Man' – YouTube."

17 C' Piano Man, Eric, "Ocarina of Time Piano Medley," 2020. This medley incorporates several songs from *OoT*: "Title Theme," "Song of Storms," "Serenade of Water," "Great Fairy Fountain," "Saria's Song," "Zelda's Lullaby," "Minuet of Forest," "Bolero of Fire," "Lon Lon Ranch," "Nocturne of Shadow," "Gerudo Valley," "Title Theme (Reprise)," "Kakariko Village," and the item-discovery theme.

18 Blizz 4041, March 20, 2020, comment on Erik C 'Piano Man,' "Ocarina of Time Piano Medley."

like Blizz's tap into the emotional satisfaction musical covers of VGM supply to relieve the nostalgic itch. This cover appeals to liminal nostalgia as the arrangement does not follow the original, but listeners still can satisfy their longing. The reference to "Zelda's Lullaby" further taps into the significance of the song to *OoT*. Players must perform the song to advance through the game multiple times; each performance becomes a liminal moment of musical literacy. These discrete moments of beginning musicianship further cement these specific moments for these fan commenters. Without liminal nostalgia, the listeners miss out on these specific nostalgic connections enfolded into the experience of ludo-musicality. However, content creators can further "scratch" liminal nostalgia and help alleviate the "itching" of others in community spaces like OCR.

OCRemix: Covers, remixes, re-orchestrations

OCRemix functions as a communal space primarily for composers or other music makers interested in covering, rearranging, or remixing ("mashing up") VGM. None of the videos are hosted on-site but instead on YouTube. However, it does host a forum with pages for games, music, people, and workshops. Most importantly, OCR provides a platform for remixes to undergo a review process before being uploaded to a YouTube page, which then is embedded to a site page with an evaluation panel. This review process involves commentary and moderation of the remixes by a panel before they are posted to the site or uploaded to the YouTube page. Additionally, OCRemix sponsors, publishes, and publicizes full albums.[19] The uploads also include an explanation from the arrangers and performers, as well as commentary from one of the judges. One such offering is an arrangement of "The Ballad of the Wind Fish" from *Link's Awakening* (1993, *LA*).

Users Chris~amaterasu & waltzforluma's arrangement "Dreams of Home" scratches their and others' liminal nostalgia. Their arrangement of the "Ballad of the Wind Fish" transforms the chiptune sounds of *Link's Awakening* into a piano-violin duet that invites nostalgic engagement.[20] In the evaluation panel, for example, Amaterasu says, "Aivi [waltzforluma] thought of the name 'Dreams of Home,' and we chose it because it is relevant to the game's storyline and she thinks of home when she listens to the song."[21] The title and thought processes of the creators connote the historical roots of nostalgia.[22] The arrangement and title

[19] OCRemix published Songs of the Sirens: Link's Awakening ReMixed in September of 2019.

[20] Chris~amaterasu and waltzforluma, "Remix."

[21] djpretzel, 2013, evaluation of Chris~amaterasu and waltzforluma, "Remix."

[22] Comprised two Greek roots, *nostos* and *algia*, "nostalgia" literally means longing to return home.

unintentionally play off of homesick variant of nostalgia. The recollection of home and the bittersweet emotions that often follow surface in kind within the OCR comment section. One user writes how "Dreams of Home" captured the general feel he received whenever he heard the song while playing the game, a form of "home" within original gaming contexts. This song brings back so many memories. "Such a bittersweet feeling."[23] Joshua Hook writes how the cover reminds him of cherished memories of his past laced with a "strong sense of sadness." The liminal experience necessary for nostalgic engagement appears in a different context in *LA*. The 1993 Gameboy title lays the foundation for *OoT*'s musical performance. Link's first performance on an ocarina and his learning songs in *LA*. Much like in *OoT*, *LA*'s character Marin teaches Link the BWF by singing the tune first and having him repeat it. Although there is no staff and no player input to approximate a musical instrument, it must be played to complete the game. After gathering eight musical instruments, each within a dungeon, BWF plays during a cut scene where the player/Link opens the Wind Fish's egg before the final boss and again at the game's end as Link awakens. This musical interaction alone is not enough to evoke the same liminal experience as in *OoT* and future titles. However, it suggests a microcosm of liminality aided by the premise of the game. Since *LA* takes place in Link's dreams, Link himself experiences a liminal experience of sorts with the entanglement of his dream and the waking world. He has the experience of the BWF, which results in his waking to his reality, and thus, he can return home. Similarly, the music here transmediates liminal experience from Link to our interaction with virtual and real worlds. Listeners scratch their nostalgic itch with "Dreams of Home" and, like Link, can escape their liminal experience until the itch surfaces again.

Zelda Dungeon's blog posts

Zelda Dungeon and Zelda Universe both market themselves as fan sites for the game series. Each offers blog posts, editorials, news, daily Q/A posts, and other catered contents for their respective communities. Regarding the former, the front page sidebar displays recent events such as (at the time of this chapter's writing) the 2020 Musical March Madness that allows community members to rank 64 *Zelda* songs.[24] One of the former staples of the site was a weekly music editorial

[23] Wvlfpvp, 2013, comment on Chris~amaterasu and waltzforluma, "Remix."

[24] The Musical March Madness parodies America's March madness basketball tournament. The 2020 winner was *Wind Waker*'s "Dragon Roost Island" with *Skyward Sword*'s "Ballad of the Goddess" taking second.

titled the "Windmill Hut" (2012–13) and "Weekly Music Spotlight"/"Fan Music Spotlight" (2015). Contributing authors of the "Windmill Hut" series post and review YouTube videos of music covers from various *Zelda* games. Even after the demise of this weekly editorial format, the community continues the endeavor more sporadically as individual users post music covers for other fans to respond and engage with each other.

The Zelda Dungeon post "Let the Goddess Serenade You with the Bardic Ballad from *Skyward Sword*" showcases the musician Reven's cover of the "Ballad of the Goddess." The reception for her cover emphasizes nostalgic engagement built on musical literacy. The author of the post, Kat Vadam, provides an embedded link to Reven's cover and BandCamp page. Vadam waxes nostalgic in her praise of the cover writing:

> Remember the first time you saw her, Goddess Incarnate. Think of the song she sang, and feel the smile cross your face once more. Now, you can relive that moment once more with this absolutely amazing cover of the "Ballad of the Goddess." Like a bard in a tavern, stringing stories of old, musician Reven pours her heart into this simple, yet melodic tune, backed by the gentle pluckings of her harp and lively beats to keep pace. A song that traverses time itself. This is your call, hero. Unite earth and sky. What do you think of Reven's cover? Let us know in the comments below![25]

In her quote, Vadam calls the reader/listener to hear these nostalgic sounds in Reven's cover. Vadam's cover opens with an English translation of the lyrics to the song. Reven begins her rendition of the "Opening theme" from *Skyward Sword*, which is a slow arrangement of "Ballad of the Goddess" like the lyrical version from the game-opening, which she accompanies on herself on a harp. "Ballad of the Goddess" itself references "Zelda's Lullaby" by reversing the latter's melody, which is supposed to imply the connection between Zelda and the Goddess Hylia. Later in Reven's arrangement, she adds an electric-acoustic guitar and what sounds like a cajón. The addition of these instruments brings the listener to a faster version of BG. Reven's cover satisfies the nostalgic itch that Vadam so clearly calls out in her post.

The inclusion of the harp recalls the original tune and the goddess harp, the ludic instrument of *SS*. Players use both the ballad and the goddess's harp to advance in the game and builds on the ideas of musical literacy and liminality introduced in *OoT*. The player strums this song on top of the Light Tower in Skyloft to reveal the path into the Thunderhead and advance further into the game.

[25] Vadam, "Let the Goddess Serenade You."

To play the harp in the game, the player manipulates the Wii-mote to pluck the harp. The circles of light, which pulsate on the ground, indicate the tempo at which the player should strum the harp. If performed correctly, Link's companion, Fi, will sing along. *Skyward Sword's* ludo-musical interactions provide more sensory engagement for the player than *OoT* but still evokes the same liminal nostalgia in the fans as evidenced by Vadam's post. The reference to earlier *Zelda* songs, the liminal experience, and musical literacy heighten the nostalgic engagement of fans, especially those who have played titles before *SS*.

Zelda universe and the ZREO project

In addition to Zelda Dungeon, Zelda Universe also dedicates its existence to the game series but with more emphasis on its musical section and preserving the arrangements of the *Zelda* Re-orchestrated (ZREO) project. The opening page contains a menu option titled "Media," wherein music is a subcategory that contains links for *every song* of every soundtrack from the original *Legend of Zelda* (1986) to *SS* in addition to re-orchestrated and rearranged versions of several songs within the series.[26] The music menu also features audio recordings of several live covers of the games, including the now-disbanded ZREO. ZREO's website remains accessible with all their albums; however, the website Radio Hyrule now maintains the community. ZREO comprised members who devoted themselves to the music because of their connections to the series. The group tasked itself with updating the series' music with improved digital instruments and expanding some of the material into longer pieces.

Before disbanding in 2013, ZREO endeavored to compose *Twilight Symphony*, a 50-track album spanning almost three-and-a-half hours of music dedicated to the themes of the eponymous title. *Twilight Princess* (*TP*, 2006) is interpreted to be a spiritual successor to *OoT*, which we will see in the upcoming description of its opening menu screen.[27] YouTube commenters on the track clamor for these

26 In order: SS Original Soundtrack (OST), Spirit Tracks (2009) OST, Phantom Hourglass (2007) OST, Twilight Princess (TP 2006) OST, Nintendo of Europe's (NOE) TP, The Minish Cap (TMC 2004) OST, Zelda: The Music, NOE's Melodies of Time, TWW OST, Mario & Zelda Big Band Live, Super Smash Bros. Live!, Oracle Series OST, MM Orchestrations, MM OST, OoT Rearranged, Hyrule Symphony, OoT OST, LA OST, Sound and Drama (ALttP remix album), ALttP Rearranged, ALttP OST, and LoZ OST.

27 Serrels, "Twilight Princess." Mark Serrels compares the initial reception of WW and TP. The former's art style and gameplay left many fans uncertain on release, whereas the latter was return to the beloved OoT and MM. For Serrels, and he seems to claim for others, not

in-between experiences intimating the desire to recreate the initial conditions of the opening cutscene of *Twilight Princess*. As the music plays, Link and Epona ride throughout Hyrule field and eventually veer off-screen. Once the screen catches up to them, Link has transformed into his wolf form, and a howl overlays the musical accompaniment. As Vincent Rone argues, this opening scene establishes "self-references to established *Zelda* tropes." It inverts the *OoT* title screen to reintroduce the player to Hyrule while recalling the one of eight years prior.[28]*TP* contains moments of musical interaction that deepen these nostalgic bonds, as Wolf Link interacts with the game world to advance the plot by howling tunes similar to *OoT*'s ocarina system. To advance into the Sacred Grove, the player howls "Zelda's Lullaby" at a Howling Stone with the triforce symbol, which again references playing the lullaby in *OoT* at triforce symbols. Other songs that the player howls to gain hidden skills are "Song of Healing" (*Majora's Mask*, 2000) "Requiem of Spirit," "Prelude of Light," two unnamed songs, and *TP* "Title Theme."

Listening to the track "Overture,"[29] which uses *TP*'s title theme, itself an elaboration on the first ten seconds of the *LoZ* title theme, several commenters express a sentiment similar to Vapidbobcat, who writes, "Now if only they made a true HD Twilight Princess [...]. Not that cheap remaster they gave us for the Wii U."[30] On the ZeldaUniverse forums in a post titled "Your Zelda Beginning," board moderator EzloSpirit writes, "I am still awed by [*Twilight Princess*], and it holds a very special place in my heart, as does its soundtrack."[31] Such replies have a distinctive nostalgic charge toward the music's capacity to move people emotionally or appeal to their memories of *TP*. Nevertheless, as the excerpts indicate, many reactions also point toward the desire to see a remake of the original 2006 game, a hope that a remake might match the quality fans accorded with ZREO's symphony. The lackluster reaction among fans toward Nintendo's 2016 *Twilight Princess* remake enabled them now to evaluate and assess ZREO's symphony on its merit. The satisfaction embedded in fan reception regarding ZREO's monumental undertaking alone provides a productive liminal nostalgia. The original 2006 *Twilight Princess* created the itch or the ache and *Twilight Symphony*, the scratch,

only did the TP HD remake fail to please fans, it never had a chance. As of July 2020, WW is hailed as one of the greatest Zelda titles because of its art style and gameplay. TP, while not a bad game, relied too much on past titles, had confusing quests, and unintuitive controls. TP could only have succeeded at the time it did—it is a relic of the past.

28 Rone, "History and Reception in the Music of *The Legend of Zelda* Peritexts," 44–67.

29 ZREO, "Overture," 2013.

30 Vapidbobcat, 2017, comment on ZREO "Overture."

31 EzloSpirit, reply to "Your Zelda Beginning," ZeldaUniverse, July 8, 2018.

or the relief. The invitation in *Twilight Symphony* to nostalgize necessitates an interstitial interaction with the game. Had people not played this game like these commenters, then they could not understand how the HD remaster failed to please its audience. However, even the audience fails to see the satisfaction, they receive from the musical covers that they still clamor for a worthwhile remake. Perhaps their reaction is a desire to wean themselves off of musical covers as a temporary stop gap and that somehow a perfectly realized remake will cure their incessant itch. Regardless, ZREO's *Twilight Symphony* poses perhaps the most fascinating case study as to the complex interactions and intersections of liminal nostalgia.

Conclusion

All four case studies demonstrate the often unnoticed but shaping role liminality plays when listening to or viewing *Zelda* adaptations and arrangements. Despite stylistic shifts, additional musical content, or intentional flagging of nostalgia, the creative output of content creators provides opportunities for nostalgic engagement in their covers and arrangements. The music helps fans conjure specific memories or experiences associated with their time in the liminal space. If music has the potential to strengthen nostalgia resulting from gameplay, then other musical aspects of *Zelda* require further investigation for their nostalgic potentials such as theme variations across game and fan reaction and recognition of these themes. Furthermore, these communal spaces run counter to a commodified nostalgia as our last example has pointed out. *TP* had difficulty engaging fans to the degree Nintendo had hoped, despite embodying a direct, traditional appeal to nostalgia. The democratization of these fan sites and their efforts to stave off the nostalgic itch warrant further investigation about what such efforts might imply with regard to intellectual, creative, and other types of ownership and methods of dissemination.

Of course, no player can return to the Hyrule they first encountered. Part of that longing to do so makes the impossibility more attractive, more fantasy-like, and perhaps even more addictive. Nevertheless, musical and online communities, as well as the individuals who participate in them, offer a supportive scratch to this itch. Their artistic media satisfies the nostalgic itch that typically follows the realization that attempting to revisit an irretrievable past is futile. The *Zelda* franchise contains many immersive qualities, but its method of musical immersion has created a musical literacy in its players that have transcended the confines of the original game. Players nostalgic for their virtual experiences with musical creativity play the music outside of gameplay in exceptionally creative ways. Players and musicians together combine genres, styles, and melodies of *Zelda* songs to

make something new but familiar enough to scratch the itch of nostalgic longing. Players afflicted by this nostalgia discover they are not alone. There are communities dedicated to creating new remixes and inspiring new cover artists that cure this audience's longing for the past.

LUDOGRAPHY

The Legend of Zelda: Link's Awakening. Nintendo. Gameboy. Nintendo. 1993

The Legend of Zelda: The Ocarina of Time. Nintendo. Nintendo 64. Nintendo, 1998.

The Legend of Zelda: Skyward Sword. Nintendo. Wii. Nintendo. 2011.

The Legend of Zelda: Twilight Princess. Nintendo. Wii/GameCube. Nintendo. 2006

BIBLIOGRAPHY

Boym, Svetlana. *The Future of Nostalgia*. Basic Books, 2008.

Cheng, William. *Sound Play: Video Games and the Musical Imagination*. Oxford: Oxford University Press, 2014.

Chris~amaterasu [Chris Woo] and waltzforluma [Aivi Tran]. "Remix: *The Legend of Zelda: Link's Awakening* 'Dreams of Home.'" OC ReMix. February 15, 2013. https://ocremix.org/remix/OCR02608.

Erik C 'Piano Man.' "About." Accessed August 10, 2020. https://www.youtube.com/c/Piano-ManArrangements/about.

Erik C. "Zelda: Ocarina of Time Piano Medley (Extended) Nostalgia Edition." Premiered February 16, 2020. https://www.youtube.com/watch?v=bUMS8Ut9ybA.

FamilyJules. "Legend of Zelda: Ocarina of Time Guitar Medley—YouTube." Uploaded September 28, 2010. https://www.youtube.com/watch?v=waIBSXxkdPg.

FamilyJules. "The FamilyJules Ultimate Q&A Part 1: Covers—YouTube." Uploaded January 25, 2018. https://www.youtube.com/watch?v=AngBZXuWM0w.

Fenty, Sean. "Why Old School Is 'Cool': A Brief Analysis of Classic Video Game Nostalgia." In *Playing the Past: History and Nostalgia in Video Games*, edited by Zach Whalen and Laurie N. Taylor, chapter 9. Nashville: Vanderbilt University Press, 2008. Kindle.

Garrido, Sandra, and Jane W. Davidson. *Music, Nostalgia, and Memory: Historical and Psychological Perspectives*. Cham: Palgrave Macmillan, 2019.

Lind, Stephanie. "Active Interfaces and Thematic Events in *The Legend of Zelda: Ocarina of Time*." In *Music Video Games: Performance, Politics, and Play*, edited by Michael Austin, chapter 3. Bloomsbury Academic, 2016. Kindle.

Miller, Kiri. *Playing along: Digital Games, YouTube, and Virtual Performance*. Oxford: Oxford University Press, 2012.

Reven. "Ballad of the Goddess." Uploaded October 5, 2018. https://revenmusic.bandcamp.com/track/ballad-of-the-goddess.

Rone, Vincent E. "History and Reception in the Music of *The Legend of Zelda* Peritexts." *Journal of Sound and Music in Games* 1, no. 2 (April 2020): 44–67.

Serrels, Mark. "Twilight Princess Is A Game Out Of Time." Kotaku Australia, March 7, 2016. https://www.kotaku.com.au/2016/03/twilight-princess-is-a-game-out-of-time/.

SilvaGunner. "Windmill Hut—The Legend of Zelda: Ocarina of Time—YouTube." Uploaded May 14, 2016. https://www.youtube.com/watch?v=iXG8ttP1IPk&t=1s.

Summers, Tim, and James Hannigan. *Understanding Video Game Music*. Cambridge: Cambridge University Press, 2016.

Vadam, Kat. "Let the Goddess Serenade You With This Bardic Ballad from Skyward Sword." *Zelda Dungeon* (blog), October 6, 2018. https://www.zeldadungeon.net/let-the-goddess-serenade-you-with-this-bardic-ballad-from-skyward-sword/.

van Elferen, Isabella. "Analysing Game Musical Immersion." In *Ludomusicology: Approaches to Video Game Music*, edited by Michiel Kamp, Tim Summers, and Mark Sweeney, 32–52. Sheffield: Equinox Publishing, 2016.

Whalen, Zach, and Laurie N. Taylor. "Playing the Past: An Introduction." In *Playing the Past: History and Nostalgia in Video Games*, edited by Zach Whalen and Laurie N. Taylor, chapter 1. Nashville: Vanderbilt University Press, 2008. Kindle.

Whiteman, Natasha. "Homesick for Silent Hill: Modalities of Nostalgia in Fan Responses to *Silent Hill 4: The Room*." In *Playing the Past: History and Nostalgia in Video Games*, edited by Zach Whalen and Laurie N. Taylor, chapter 3. Nashville: Vanderbilt University Press, 2008. Kindle.

Zzyxal. "101—Overture Twilight Symphony." Uploaded April 3, 2013. https://www.youtube.com/watch?v=WyyD08VQswU&list=PLrm56KQs1y6ZCwIjjhs2XaY8-qYQAE-l.

7

You Unlock This Game with the Key of Imagination: *The Twilight Zone: The Game* (2014), Musical Parody, and the Sound of Nostalgia

Reba A. Wissner

On September 17, 2014, Legacy Interactive released a PC game based on *The Twilight Zone* (1959–64). Set in the most famous scenes of the original series, the player takes on the role of a new character, seeking hidden objects and encountering well-known figures along the way. The game recreates the settings of several episodes in level environments. The music and sound effects also channel the aural esthetic of the original television series. Electric guitars play the famous four-note repeated phrase by Marius Constant over the game's title card. Quickly thereafter come the dissonant clusters among the brass and high-pitched woodwind figures, tapered off by a rhythmic pattern on the bongos. One of the most iconic musical excerpts of the twentieth-century television, Constant's main-title theme conveys the eerie, unsettling sound that things are not what they seem. In addition, Legacy Interactive's game uses newly composed music in the style of many of the episode scores and with modified themes from the original series to present an alternative reality that places the viewer-as-actor in *The Twilight Zone*.

This essay examines how music in *The Twilight Zone: The Game* (TTZTG) creates inter-media nostalgia for players by maintaining the aural esthetic of the television series. By creating modified versions of some of the most prominent musical motives and sound effects from the series' scores, *TTZTG* is much more than a point-and-click videogame: it immerses the player in the world of the series and allows them to absorb several elements through osmosis. They consequently experience nostalgia for a television show through specific musical markers within the game. This article first presents the history, intended format, and gameplay

mechanics of *TTZTG*. Second, it theorizes how nostalgia is provoked by its use of music and sound effects by considering the role of inter-media nostalgia and nostalgic play. Importantly, this section draws upon personal fieldwork interviews with *TTZTG*'s composer, Aditya Gaikwad, that describe his process of writing the game's music. Finally, the article situates how *TTZTG* use of iconic music provokes inter-media nostalgia within broader gaming contexts through comparative musical case studies of similar videogame adaptations including *Alien: Isolation* and *Murder, She Wrote* games.

This chapter offers an ironic perspective on nostalgia's relationship to videogame music. Many other studies focus on player immersion within developed virtual worlds as the prime apparatus for nostalgia. As such, dynamic, adaptive music is usually posited as a vehicle for this phenomenon. This argument, however, studies a nostalgia that results from static, non-dynamic music of a point-and-click game. The nostalgia in *TTZTG* stems from its direct quotation of or strong reference to the music of its model, *The Twilight Zone* series. As such, this argument details how nostalgia can surface across media. It takes a first step at theorizing inter-media nostalgia within videogames by pointing out musical relationships within a genre and the cultural models on which they are based.

Setting the stage for inter-media nostalgia: TTZTG's history, format, and gameplay

Legacy Interactive conceived *The Twilight Zone, The Game* as part of their Hollywood Hits game series, announcing their signing of a licensing agreement with CBS Consumer Products on June 3, 2011.[1] The game's producer, Jamar Graham, wrote that he intended to create new stories rather than retell ones from classic episodes for fear of making the retelling weak.[2] In a press release, Legacy Interactive similarly described how since the series is "beloved by baby boomers worldwide, Legacy hopes to bring the same chilling intelligence, social relevance, and supernatural themes to our *Twilight Zone* videogame."[3] Developers intended for *TTZTG* to be a role-playing game but produced a hidden object game instead.[4]

[1] "Announcing Upcoming Twilight Zone TV Series Game for PC/Mac."
[2] "Twilight Zone Game Announced."
[3] "Announcing Upcoming Twilight Zone TV Series Game for PC/Mac."
[4] *TTZTG* was likely intended to be structured like Legacy's games modeled after television series such as *Murder, She Wrote* (CBS, 1984–96), in which players solve mysteries with twists and turns as the series protagonist Jessica Fletcher, which I discuss below.

Hidden object games task players with solving puzzles imbedded in a pictorial background or setting. The player uses a mouse cursor to point to elements in this setting—items, people, doorways, and so on—then clicks to initiate a range of interactions including talking, accessing a location, or taking, combining, then applying items as necessary. Therein lies the puzzle-solving aspect of a hidden object game—the player must create plot associations and recall details in order to decide what actions to take. This sometimes leads to some cryptic puzzles, but they are all grounded in specific episodes of the original *Twilight Zone* series. The hidden object genre is well matched to the *The Twilight Zone's* source material, as the mechanics of such games are suited to detective fiction plots, infused with mystery, discovery, and adventure.

As Table 7.1 indicates, *TTZTG* has 15 levels, each based on an episode of the series. The game's levels are organized arbitrarily. They do not match the order of the episode's original airing nor increase in difficulty. Instead, levels are gradually unlocked as players accrue items, experience, and sanity points. The starting premise for each level is stated in the beginning. For example, the game describes "Invaded Cabin" level as "a relaxing vacation in a cabin [that] goes awry with unexpected visitors." This scenario is based on *The Twilight Zone* episode "The Fear" (1964), in which an overworked fashion magazine editor rents a cabin off the beaten path to avoid a nervous breakdown. In each level, players seek mystery objects as their goal. Clues like shadows, silhouettes, clouded images, or scrambled names aid in this quest. The player decodes these corrupted clues, often using the mouse to cast literal light on portions of the shady images.

Flaws in *TTZTG's* game design force the player into repetitive game-play. The game demands players to play the same level multiple times to accrue enough sanity points to advance. In every play-through, all the objects remain the same locations, so players rely on trial and error and memorization to win (the developer's strategy guide acknowledges this[5]). Yet, after training the player in this gameplay, the *TTZTG* then confusingly contradicts this formatting. As players advance into later levels, new discoverable objects suddenly appear in prior scenes, contradicting the player's memorized knowledge. This consequently demands more repeat play. Finally, discoverable objects often are "hidden" in plain sight, defying the logic of uncovering something hidden and ultimately frustrating players. For example, an exit sign is "hidden" on the top of a door and an antenna hidden on top of a television set. Finally, side quests repeat but with new, increasingly abusive challenges,

[5] "*The Twilight Zone* Tips and Tricks Guide."

Game level title	Corresponding episode
Solitary Space	"The Lonely"
Captured Spaceship	"Third from the Sun"
Invaded Cabin	"The Fear"
Bombed Library	"Time Enough at Last"
Lost Plane	"The Odyssey of Flight 33"
Terminal Terminus	"Mirror Image"
Suspicion Stop	"Will the Real Martian Please Stand Up"
Horror Hospital	"Eye of the Beholder"
Wealthy Estate	"The Masks"
Dark Hamlet	"The Monsters Are Due on Maple Street"
Scheming Station	"To Serve Man"
Isolated Town	"Where Is Everybody?"
Cruel Courtroom	"The Obsolete Man"
Permanent Prison	"Escape Clause"
Unsafe House	"Night Call"

TABLE 7.1: Game levels and their corresponding episodes.

such as banishing a character first ten times, then *thirty* times. This repetition is even expressed aurally in gameplay: a limited repertoire of musical cues punctuates the actions players repeatedly undertake while they replay each level.

The framework of inter-media nostalgia in TTZTG

The Twilight Zone connects to *TTZTG* in content, style, and context of their musical cues. The game's composer absorbed the framework of *TTZTG's* music from the television series. This relationship between show and game thus allows players to tap into nostalgia that operates on multiple levels due largely to the musical cues. Nostalgia here occurs as a consequence of personal connections players have with the show. It also surfaces from the player's historical imagination of *The Twilight Zone's* 1950s and 1960s American setting. Like many cultural artifacts of the 1950s and 1960s, *The Twilight Zone* has become a pervasive part of American cultural memory through its dissemination in the mass media.[6]

To begin theorizing this, realize that even now, people know about *The Twilight Zone* and its famous musical theme. The series aired on CBS from 1959 to 1964 with a 30-minute runtime for the first through third and fifth seasons, as well as an hour-long runtime during its fourth season. Billed as both science fiction and fantasy, the show was famous for its wildly entertaining twist endings that usually resulted in the comeuppance of a nefarious character or the revelation that things were not what they seemed. This format garnered fans of all ages, much to the chagrin of some parents during its original run, who felt it was too scary for their children. Nevertheless, *The Twilight Zone*, and its musical theme entered the American pop-culture imaginary. Its decades of reruns on televisions ensured its ability to provoke nostalgia among fans.

The nostalgia that *TTZTG* creates is grounded in inter-media nostalgia, in which the nostalgia created by one medium—in this case, television—can be elicited by the videogame. The game, therefore, is a way of "(re)inventing the past."[7] In videogames, especially those based on pre-existing media, "nostalgia is a key factor in game construction and marketing, extending beyond simply fulfilling a player's desire to (re)visit and interact with times, places, and

[6] Sprengler, *Screening Nostalgia*, 40.
[7] Niemeyer, "Introduction: Media and Nostalgia," 2.

characters from the past."[8] This is especially true with cult classics like *The Twilight Zone*, which has a large fan base. Nostalgia migrates into culture, especially popular culture, and in this case, the use of material from a single television show into a new medium permits nostalgia to become a pervasive part of popular culture through our inter-media consumption.[9] The result is nostalgia for pop culture of the 1950s and 1960s through transmediated signifiers within the game, such as the visuals, graphics, and musical cues. These signifiers within the game both belong to and derive from the show and, as such, can elicit nostalgia across media. Thus, the type of nostalgia created through game play is what Anna Reading and Colin Harvey term nostalgic-play, in which memory is a crucial component of the nostalgia present in videogame play, especially for games based on pre-existing media such as television series.[10] Nostalgic-play is how the past is invoked to create meaning in the present.[11]

Nostalgia for *The Twilight Zone* series refers to the emotional reaction that accompanies one's attempt to return to or visit the past. The show consequently channels two types of nostalgic engagement distributed among three kinds of fans. According to Davis, one type of nostalgia emerges from a personal experience of an object or event, which contributes to the store of one's memories.[12] The first group of fans who fit this description includes those who remember and watched the series in the original run as either children or adults. The show channels nostalgia in these viewers through collective memory.[13] The other type, Lowenthal writes, refers to one's ability to long for times, places, and objects before their lifetimes.[14] This kind of nostalgia is shared by the two remaining fan groups: those who came to it later in syndication as adults, and those who came to it later as children. For instance, I fall into the third category: I saw my first rerun episode of the series at age 6 in the late 1980s and fell in love with it. I could not get enough of *The Twilight Zone* and became an even more avid fan as I grew older, equating watching the series with both my own childhood and longing for the "better days" of the 1950s and 1960s. When I began this

[8] Reading and Harvey, "Remembrance of Things," 166.

[9] Niemeyer, "Introduction," 6:11.

[10] Reading and Harvey, "Remembrance of Things Fast," 177.

[11] Reading and Harvey, "Remembrance of Things Fast," 168.

[12] Davis, *Yearning for Yesterday*, 8.

[13] See Justin Sextro, "'This Game Stinks': Musical Parody and Nostalgia in *EarthBound*," in this volume.

[14] Lowenthal, *The Past Is a Foreign Country*, 4–6.

project in 2016, I asked an online community of fans who comprised each of the three categories above if they had ever heard of *TTZTG* or even played it. Although none had, all expressed interest in it, even those of the baby boomer generation. This is related to what Elizabeth Hunt notes is a way to return to one's past "by purchasing items that sell us the idea of return and, in doing so, give the intangible feeling of nostalgia some sense of tangibility."[15] *The Twilight Zone* can channel both personal and historical types of nostalgia, yet fans can become nostalgic for the television by specific features presented in the game. For these reasons, the relationship between show and game offer inter-media nostalgia. Indeed, as Michael Vitalino and Vincent Rone write, when memories have "emotional associations an autobiographical significance," they become easier to retrieve.[16]

 TTZTG was created, in large part to tap into the *Twilight Zone's* nostalgia, thereby making it relatively easy to market to fans. This consumerist nostalgia is quite common in games. Many genres use inter-media references that seek to reorient players in the world of a fondly remembered, bygone era of a television show, book, or film.[17] Such games, Henry Jenkins specifies, "depend on our familiarity with the roles and goals of genre entertainment to orientate us to the action, and in many cases, game designers want to create a series of narrative experiences for the player."[18] Jessica Kizzire further explains how this mixing of the past and present "in a single moment can relive intense emotions, making it a powerful motivator."[19] This overall creates what Jenkins terms as evocative spaces where players "have visited many times before in their fantasies" or, in this case, through repetitive watching of the television show.[20]

 Music channels the nostalgia of the viewer for the medium to which the game refers. Tim Summers notes that such nostalgic games use music to "realize, render

[15] Elizabeth Hunt, "My Childhood Is in Your Hands: Video Game Concerts as Commodified and Tangible Nostalgic Experiences," this volume.

[16] Michael Vitalino and Vincent Rone, "A Player's Guide to the Psychology of Nostalgia and Video Game Music," this volume.

[17] The essays of Brent Ferguson and T. J. Laws-Nicola and of Sebastian Diaz-Gasca elsewhere in this volume discuss the commodification of and consumerist perspectives about nostalgia within the VG industry.

[18] Jenkins, "Game Design as Narrative Architecture."

[19] Kizzire, "The Place I'll Return to Someday," 183.

[20] Jenkins, "Game Design as Narrative Architecture."

or project the virtual universes."[21] Yet, as Mark Rowell Wallin indicates, "the very notion of adaptation demands change—of mode, of message, of address, etc. Thus, as the medium shifts, so we must expect the constraints to alter the plot."[22] Roger Moseley also expresses this sentiment, stating "within (and against) the constraints that regulate it, ludomusical play fluctuates between the preordained and the unforeseeable, emerging in relation both to the performance of familiar cultural scripts and to the imperative to improvise."[23] This merging of "old and new elements in the same game"[24] encourages fans to relive an element of the past while presenting something "new" for novice audiences. Depending on the experience level of the fan, *The Twilight Zone* and its game adaptation both indeed trigger one's inter-media nostalgia through repeated exposure to cultural tropes, historical markers, and the series' distinctive sonic profile.

Inter-media nostalgia also occurs as a product of influence of one composer's music on another. The influence is nothing new.[25] As game composer Winifred Philips notes, when she and other game composers need to write music for a game, they often study other games in that genre. She writes, "when we study the musical styles of other representative games in the genre of our current project, we're likely internalizing demographically inspired choices."[26] As opposed to an intentional move, some composers unconsciously write music that sounds like it came from a specific place merely by listening to music in that style.[27] Musical lineage also can be traced to an identifiable source. In this case, the television show inspired *TTZTG*'s composer and sound designer Aditya Gaikwad of Apar Games in India. In an email correspondence, I asked Gaikwad if the show's music influenced his composing for the game. He responded, "Yes, *Twilight Zone* is one of my favorite TV series. When I was told to design the music for the game, I was very excited. I did a re-run of the episodes and understood every mood of the character. I mostly make spacey, atmospheric and dark music. That's something I really enjoy."[28] Such influence usually occurs to game composers subconsciously.[29] Given Gaikwad's

[21] Summers, *Understanding Video Game Music*, 86.

[22] Wallin, "Myths, Monsters and Markets."

[23] Moseley, *Keys to Play*, 16.

[24] Kizzire, "The Place I'll Return to Someday," 183.

[25] See, for example, McNaught, "On Influence and Borrowing" and McNaught, "On Influence and Borrowing: A Sequel."

[26] Phillips, *A Composer's Guide to Game Music*, 77.

[27] Phillips, *A Composer's Guide to Game Music*, 77.

[28] E-mail correspondence with Aditya Gaikwad, May 26, 2016.

[29] Phillips, *A Composer's Guide to Game Music*, 77.

rewatching of the series before creating the music and sound design, his hearing certain cues multiple times informed his composing music for the game that sounds like those cues.

When asked if there was a reason he chose to write only two pieces of music for the game, Gaikwad answered, "not really, but when we play tested the game, we were pretty sorted with 2 sounds for all levels. So we stuck to the idea of making 2 killer background sounds which are playing in the levels."[30] I also asked him what his approach was to writing the music and sound effects to the game. He responded:

> To be honest I didn't expect the game to flow in the Hidden Object genre. I had a different picture of sound design but later on after playing the prototype and general gameplay I jotted down the sounds I needed for the game and started working on it. I had made up my mind while playing the game without the BG [background] and SFX [sound effects] that whenever I get my hands-on music-making, I would keep the music subtle, dark and eerie and that's how *TZ* music was done.[31]

Thus, Gaikwad visualized the game differently than its final version. Accordingly, he adjusted his vision and compositional practices to align with the generic change in the game from that of RPG to Hidden Object (point-and-click). This adjustment prompted him to focus more on the emotional content of the songs, in lieu of direct references to the show. Yet, despite these alterations, the differences did not affect the music's function: it sonically connected *TTZTG* to *The Twilight Zone* and thus provoked nostalgia in the game's fan audience.

Gaikwad's compositional process and the tiered categories of fans outlined here suggest inter-media nostalgia plays an important part between *The Twilight Zone* and *TTZTG*.[32] Gaikwad constructs the game's music by using MIDI, software that aurally recalls older, low-budget games, given the game's production in 2014. The music in *TTZTG*, based on music from the original series, creates a set of memorable tunes, serves a similar purpose.[33] As William Gibbons has written, "when a game uses a musical work that's closely associated with a different media product—most commonly a film or film series—players receive multiple levels of signification."[34] *TTZTG* uses music in a variety of ways. We first hear Constant's

[30] E-mail correspondence with Gaikwad.

[31] E-mail correspondence with Gaikwad.

[32] For more on this, see Wissner, "No Time Like the Past."

[33] Cheng, *Sound Play*, 77.

[34] Gibbons, *Unlimited Replays*, 52.

title theme for the television series, heard over the game's Title Card. Then a modified version of Constant's theme plays during the opening cut scenes. The music for Menu Screens A and B then follows, which echoes Bernard Herrmann's title theme for the television series before it was replaced by that of Constant. Players also hear several cues during gameplay: one related to Jerry Goldsmith's "Mysterious Storm" used in the second season of the television series and another related to Constant's theme, "Milieu #1." Within a short span after turning on *TTZTG*, players hear a number of themes bearing melodic and stylistic similarities to those of *The Twilight Zone*.

The repeated exposure to these sonic markers strengthens the relationship between the two media. Because the music of the game recalls the music of the series, it induces nostalgia in the player by eliciting a sound from the past in the present within the context of a new medium. The game thus generates inter-media nostalgia by continually playing music that sounds as if it is from the older television series. Gaikwad's absorption and adoption of the music from the television series therefore contributed a powerful apparatus by which players of TTZTG might experience inter-media nostalgia.

Hearing inter-media nostalgia in TTZTG: Player as viewer

As the previous section gave a framework to observe how inter-media nostalgia for *The Twilight Zone* is provoked by *TTZTG*, this section now analyzes the motivic and melodic relationships of music within the series and game. These relationships optimize the conditions for fans to experience inter-media nostalgia as a matter of course. The kind of non-interactive musical immersion *TTZTG* offers allows players to envision themselves as if they were in the show itself. To begin, *TTZTG*'s music is non-interactive and not dynamic, but virtually situates players as viewers of the show. Unlike many games in which the music changes depending on the player's maneuvers, the cues here remain static and function as atmospheric music. This aligns with what Nacke and Grimshaw call "imaginative immersion," or the "absorption in the narrative of a game or identification with a character which is understood to be synonymous with feelings of empathy and atmosphere."[35] The music of *TTZTG* is not tied to the rules of its gameplay; it neither provides information about gameplay, nor does it respond to player interaction. Rather, *TTZTG*'s music functions independently and serves an ecological

[35] Nacke and Grimshaw, "Player-Game Interaction through Affective Sound," 272.

purpose, a sound environment where players can locate themselves.[36] Importantly, the game's non-dynamic music resembles a television episode whereupon control lies with the composer rather than with players/viewers. *TTZTG* lies at the intersection between the gaming and televisual experiences. This idea is not new, since, according to Papazian and Sommers, "in an effort to sate players who crave immersive, interactive narrative experiences, the VG industry has increasingly borrowed from the film industry."[37] *TTZTG's* strange and otherworldly music is reminiscent of *The Twilight Zone* thus provoking inter-media nostalgia for the series.

From the onset of the game, the combination of visual and musical information places players within this T.V. viewing context. They turn on the game and virtually begin to watch an episode of *The Twilight Zone*, which invites the type of "imaginative immersion" described by Nacke and Grimshaw. For example, the game logo of *TTZTG* first appears in black and white, placed over the famous starry night backdrop seen in the title screen of the series. In this moment, a splash screen presents *The Twilight Zone's* iconic black-and-white door featured at the start of most episodes. In this moment, players symbolically enter the game's "door" and become game participants, instead of T.V. viewers. They do this, first looking through *Twilight Zone* door, then symbolically "entering" the show by walking through. In this moment, the game continues in color to further signal that viewers are now inside this T.V. game and can assume the role of players. When asked whether the game would be in color or black and white, Graham stated that Legacy Interactive is "leaning towards color right now, to bring as vibrant and exciting a world to life as possible. We do believe, however, that there's something magical about the black-and-white aesthetic, so we're trying to add some of that feel as well to select sections of the game."[38] Indeed, these visual techniques immerse players in the context of the show first, triggering inter-media nostalgia as they begin to play. Thus, this element of nostalgic-play allows the player to reorient themselves in the past through the game's sonic markers that create meaning. In a sense, this allows the players to also become viewers and permits player nostalgia to cross media thresholds.

Strengthening the imaginative immersion and nostalgic impact of these visual markers are the familiar music in two versions. First, Marius Constant's iconic theme plays in its original instrumentation, presumably either re-recorded or used from a production recording. The excerpt plays during the title card, which contains a still of the floating icons of the series, such as

[36] For more on VGM ecology, see Kamp, "Musical Ecologies in Video Games."

[37] Papazian and Sommers, "Introduction," 11.

[38] "Twilight Zone Game Interview with Jamar Graham."

FIGURE 7.1: *The Twilight Zone* theme (*top*) and the stylized version (*bottom*).

doors, single eyes, and so forth. All these recall the commercial bumper of the series. The music then fades away from the loading screen, which takes players into the game and the levels. The accompanying loading graphic is the famous *Twilight Zone* black-and-white spiral found at the opening of almost every episode's title sequence from the second season onward. A second stylized version of Constant's theme music occurs during the first bedroom fire scene. This is the *only* cutscene in the game, a step in establishing the players as T.V. characters. The musical material from the cutscene occurs during gameplay and reinforces its non-adaptive quality. Rather than signifying one entity, the motif serves to create connections between entities, binding together the disparate elements of the game.

The stylized theme in the bedroom fire scene is analogous with Constant's *Twilight Zone* theme, as both consist of a four-note repeating motive. As Figure 7.1 indicates, both motives show the prominence of a descending perfect fourth, A–E in the original and F–C in the stylized version. The stylized theme also is an inversion Constant's theme.

This stylization creates a geographic specificity that places the player squarely in the game environment. Even the title card is stylized, but the music playing is Constant's theme, complete with electric guitars. In sum, the visuals and the static music of the opening cutscene of *TTZTG* bear a close relationship to the show. They allow players to situate themselves in almost a dual role as viewers and then as players and ultimately provoke inter-media nostalgia among players.

Once the cutscene with Constant's music ends, the gameplay of *TTZTG* begins, and the music remains unresponsive to player interaction, once again taking on the properties of the television score. One of two randomly chosen pieces play at the beginning of a level. Both work to situate players in the game environment and set the show's spooky mood. According to Collins, such recurrent themes "situate the player in the game matrix, in the sense that various locales or levels

155

are usually given different themes."[39] This is not the case in *TTZTG*. The music cues always begin at the beginning of a scene without introductory gestures. Cues stop at the end of the loop before a period of silence, and they begin again. This pattern repeats with unwavering regularity until players complete a level. Such stasis may give players a feeling of being trapped with no way out, while also having a hypnotic effect on them. As such, the music here is additive and experiential rather than indicative: it contributes to the context, mood, and atmosphere of a scene instead of directing the attention of players.[40]

In sum, the music of *TTZTG* functions similarly to that of the stock music in *The Twilight Zone* in that it is not context specific.[41] But the reuse of recognizable themes from the series in the game musically signifies the original television shows by, according to Summers, "importing associations that can support signification on the visual level, or [...] fill[ing] in gaps left on the visual (or dialogue, or other textual levels)."[42] In other words, *TTZTG* provides sites of identification and offers players a recognizable semiotic system to create signification.[43] This context of "players as viewers" therefore contributes to the nostalgia woven into the musical fabric of the game. This facilitates nostalgic play in that the players are able to orient themselves in the past television series through the present videogame.

Further permutations of *TTZTG's* sonic model in other games

Other VGs have forged aural relationships with the former media they are based similar to *TTZTG*. *MediEvil 2* (2002), those based on the *Alien* film franchise, the *Battlestar Galactica* game that is based on the television series of the same name, and two *Murder, She Wrote* games all establish "imaginative immersion" and inter-media nostalgia. In each of these cases, nostalgia is elicited across the televisual and videogame media by virtue of visual, topical, and sonic markers, creating a sense of nostalgic-play. These case studies expand our understanding of this intersection between cultural consciousness of popular media and the nostalgia it evokes. The element of non-adaptive music characteristic of *TTZTG* appears in these games. David Bessell describes the music of *MediEvil 2* and *Alien*

[39] Collins, *Game Sound*, 130.

[40] Kassabian, "The End of Diegesis as We Know It?" 97.

[41] Wissner, *A Dimension of Sound*, 10.

[42] Summers, "Epic Texturing in The First-Person Shooter," 133.

[43] Kassabian, "The End of Diegesis as We Know It?" 96.

Trilogy (1996) as Hollywood-style film underscore.[44] In *MediEvil 2*, for example, some loops continuously play until the level ends. This non-dynamic music is not synchronized with the game's action. It results in what Bessell calls a "rather generic nature of the soundtrack," in which the sound and gameplay bear no correspondence to one another.[45] In *Alien Trilogy*, the lines between sound effect and musical underscore can often be blurred. Similarly, there are gaps of hard silence between each loop iteration.[46] The emulation of specific musical styles from Hollywood films and television shows allow games such as these, according to Summers, to "invoke narrative genres and their associated tropes to contextualize gameplay."[47] Thus, as in *TTZTG*, this music also situates the player in an aural landscape that evokes the former medium.

The function of *TTZTG*'s soundtrack as a mood-setter within a science-fiction genre also has precedent in these models. Sega released *Alien: Isolation* for Xbox 360, Xbox One, PlayStation 3, and PlayStation 4. The game features two adventures inspired by the film *Alien* (1979) and its score by Jerry Goldsmith, but it is much more than that. The game's composers, Joe Henson and Alexis Smith, known collectively as The Flight, had a method of composition not unlike Gaikwad's for *TTZTG*:

> We watched [*Alien*] many times, and studied Jerry Goldsmith's score. It has a very iconic sound and we wanted to work out what were the most important aspects of it for our score to feel authentic without just copying. As well as the main themes, there are certain sounds like the 'Alien whale,' or the delayed orchestral snaps that are key. The atonal and aleatoric approaches used also work hand in hand with building a tense, even terrifying at times, atmospheric score. [...] The overall idea was to start quite true to the original, and then to explore some different directions as the game goes on—but making sure they sound right for the game's overall aesthetic.[48]

Like *TTZTG*, composers for *Alien: Isolation* also focused on maintaining the show's esthetic for the game's ambient music and sound. In both games, the score predominantly consists of parody music. These pieces deliberately change the original while retaining recognizable elements of the pre-exiting piece.[49] In this

44 Bessell, "What's That Funny Noise?" 137.

45 Bessell, "What's That Funny Noise?" 138.

46 Bessell, "What's That Funny Noise?" 139.

47 Summers, *Understanding Video Game Music*, 149.

48 Usher, "*Alien: Isolation* Interview."

49 Hutcheon, *A Theory of Parody*, xx.

way, composers for film, television, and games can take identifiable elements of a piece of music and rework it, so players can easily identify its cinematic source material. As Isabella van Elferen points out, "Even if the soundtrack to a *Lord of the Rings* game does not quote directly from Howard Shore's film score, employing the epic scoring conventions evident therein is enough to create immersive game music."[50] Indeed, the iconicity of the musical style can allow the player to identify its source. Musical affect unsurprisingly contributes to collective meaning. This is especially true for iconic music like that of *The Twilight Zone*, which has a collective meaning in popular culture and American cultural consciousness in general.[51]

An even better analog to *TTZTG* exists, one even produced by Legacy Interactive: two games based on the television show *Murder, She Wrote*. These games have everything one might imagine *TTZTG* might have had if the game developer's original vision had been realized. The games feature dialogue prompting players to find objects to help solve a case. Players here do not have an on-screen avatar, but they still have a virtual identity in a virtual world.[52] In both games introduce players to a host of characters who help solve the mystery, most notable of which is Jessica Fletcher, the show's famous writer-turned-detective protagonist, in scenarios akin to the original series. The game is aurally linked to the show via Fletcher's actress, Angela Lansbury, providing voice acting. Each game also has five individual cases for players to solve by finding clues like a torn card or a knife hilt to help them solve the case. Such markers in *Murder, She Wrote* strongly parallel those identified as inter-nostalgic markers in *TTZTG*.

Also like *TTZTG*, the music of the *Murder, She Wrote* games borders more on ambient sound than underscoring. The music comprised MIDI cues, likely compiled from the library of sound designer, Clement Samson Correya of ChaYoWo Games. The sound effects in this game exemplify, as Cheng writes, of "the big stories that little sounds tell."[53] In the first *Murder, She Wrote* game, music only plays only during the introduction to the individual stories in the style of the TV series cues. Unlike in *TTZTG*, however, the actual object-finding scenes in the first *Murder, She Wrote* game do not contain music, just the ambient diegetic sound effects triggered by the discovery of objects. This structure changes in the second game, *Murder, She Wrote 2: Return to Cabot Cove*, which uses music during cut scenes and gameplay.[54] In these object-finding scenes, the music functions as it does

[50] Van Elferen, "Analyzing Game Musical Immersion," 37.

[51] Van Elferen, "Analyzing Game Musical Immersion," 35.

[52] Gee, *What Video Games Have To Teach Us*, 49.

[53] Cheng, *Sound Play*, 63.

[54] See YouTuber Gamer, "Murder, She Wrote 2: Return to Cabot Cove."

in *TTZTG*: the cues loop with a short period of silence between loops, though the silence is longer than that in *TTZTG*. Since looping was a staple of 1960s minimalist music and a technique found in many well-known cues from *The Twilight Zone* television series, Gaikwad may have did this deliberately.[55] Finally, like *TTZTG*, both *Murder, She Wrote* games feature the actual recorded theme song from the television show, used at the outset during the title screen. The parallels between *TTZTG* and its models, especially regarding its music, provide ample evidence for a network of games to provoke inter-media nostalgia. While these musical functions and melodic references occur most clearly in *TTZTG*, they also take place in several other film and T.V. videogame adaptations.

Conclusion

In the words of Henry Jenkins, "game designers don't simply tell stories; they design worlds and sculpt spaces."[56] The composition of sound worlds in videogames is particularly crucial in this arena. The music in *TTZTG* does not serve as part of the game's narrative component; some even may argue that the game does not have any narrative. While, according to Moseley, "the computer can both visualize auditory data and 'sonify' visual data," it does not always do this.[57] In this case, *TTZTG*'s repetitive music, which does not contribute to any tension, release, or climax, merely serves as aural wallpaper. This point becomes clearer upon examination of its models. Yet the "music-as-wallpaper" becomes a stylistic feature of such games and becomes a point of nostalgic contact between the game and the various films or shows upon which they are based.

The musical repetition reinforces the overall concept of being "stuck" in the TV show—the music is stuck on a few simple cues rather than creating a cinematic score. It also, however, serves as a sonic reminder of a beloved television show, creating a sense of inter-media nostalgia for a time when the player would sit by their television set and watch. This examination of nostalgia in *TTZTG*, as fostered through *The Twilight Zone* television series, can illuminate how inter-media nostalgia becomes present in ludomusicology. Of course, games that are based on pre-existing television series are not new, but our understanding of how they are not completely separate entities, and one can create nostalgia in a player through the reference of another.

[55] Collins, *Game Sound*, 36.

[56] Jenkins, "Game Design as Narrative Architecture."

[57] Moseley, *Keys to Play*, 48.

The episodic nature of the television series offered viewers predictability and grounded them within a specific context of time and place, strengthened by its musical cues. The game, which is also episodic in that each level is based on a different episode, offers the same predictability for fans of the show and the game's sonic profile, which is similar to that of the television series, also lends itself to predictability for fans. The music of the game also serves to ground players in the game's fictional space through relative aural continuity. As such, the role of players in each game level becomes less disparate and more connected, creating one overarching locale with fifteen smaller ones, keeping the player oriented squarely in...*The Twilight Zone*.

LUDOGRAPHY

Alien: Isolation. Creative Assembly and Feral Interactive. Xbox 360, Xbox One, PlayStation 3, and PlayStation 4. Sega, 2014.

Alien Trilogy. Fox Interactive. PlayStation, Sega Saturn and Windows. Acclaim Entertainment, 1996.

MediEvil 2. SCE Cambridge Studio. PlayStation. Sony Computer Entertainment, 2000.

Murder, She Wrote. Legacy Interactive. Microsoft Windows and Mac OS X. Focus Multimedia, 2009.

The Twilight Zone: The Game. Legacy Interactive. PC. Spark Plug Games, 2014.

BIBLIOGRAPHY

"Announcing Upcoming Twilight Zone TV Series Game for PC/Mac." IGN. Updated May 6, 2012. http://m.ign.com/articles/2011/06/03/announcing-upcoming-twilight-zone-tv-series-game-for-pcmac.

Bessell, David. "What's That Funny Sound? An Examination of the Role of Music in *Cool Boarders 2*, *Alien Trilogy* and *MediEvil 2*." In *Screen Play: Cinema/Videogames/Interfaces*, edited by Geoff King and Tanya Krzywinska, 136–44. London: Wallflower Press, 2002.

Cheng, William. *Sound Play: Video Games and the Musical Imagination*. Oxford: Oxford University Press, 2014.

Collins, Karen. "An Introduction to Procedural Music in Video Games." *Contemporary Music Review* 28 (2009): 5–15.

Collins, Karen. *Game Sound: An Introduction to the History, Theory, and Practice of Video Game Music and Sound Design*. Cambridge: MIT Press, 2008.

Collins, Karen. *Playing with Sound: A Theory of Interacting with Sound and Music in Video Games*. Cambridge: MIT Press, 2013.

David Fred. *Yearning for Yesterday: A Sociology of Nostalgia*. New York: Free Press, 1979.

Gee, James Paul. *What Video Games Have to Teach Us About Learning and Literacy*. New York: Palgrave Macmillan, 2003.

Gibbons, William. *Unlimited Replays: Video Games and Classical Music*. Oxford: Oxford University Press, 2018.

Hart, Iain. "Meaningful Play: Performativity, Interactivity, and Semiotics in Video Game Music." *Musicology Australia* 36, no. 1 (2014): 273–90.

Hutcheon, Linda. *A Theory of Parody: The Teachings of Twentieth-Century Art Forms*. Urbana: University of Chicago Press, 2000.

Jenkins, Henry. "Game Design as Narrative Architecture." *Electronic Book Review* 3 (2004). Accessed June 1, 2018. https://electronicbookreview.com/essay/game-design-as-narrative-architecture/.

Kamp, Michiel. "Musical Ecologies in Video Games." *Philosophy & Technology* 27, no. 2 (2014): 235–49.

Kassabian, Anahid. "The End of Diegesis as We Know It?" In *The Oxford Handbook of New Audiovisual Aesthetics*, edited by John Richardson, Claudia Gorbman, and Carol Vernalis, 89–106. Oxford: Oxford University Press, 2013.

Kizzire, Jessica. "'The Place I'll Return to Someday': Musical Nostalgia in *Final Fantasy IX*." In *Music in Video Games: Studying Play*, edited by K. J. Donnelly, William Gibbons, and Neil Lerner, 183–98. London: Routledge, 2014.

Lowenthall, David. *The Past Is a Foreign Country*. New York: Cambridge University Press, 2003.

McNaught, W. "On Influence and Borrowing." *The Musical Times* 90 (1949): 41–45.

McNaught, W. "On Influence and Borrowing: A Sequel." *The Musical Times* 91 (1950): 173–77.

Moseley, Roger. *Keys to Play: Music as a Ludic Medium from Apollo to Nintendo*. Oakland: University of California Press, 2016.

Nacke, Lennart E., and Mark Grimshaw. "Player-Game Interaction through Affective Sound." In *Game Sound Technology and Player Interaction: Concepts and Developments*, edited by Mark Grimshaw, 264–85. Hershey: Information Science Reference, 2011.

Niemeyer, Katharina. "Introduction: Media and Nostalgia." In *Media and Nostalgia: Yearning for the Past, Present and Future*, edited by Katharina Niemeyer, 1–23. New York: Palgrave Macmillan, 2014.

Papazian, Gretchen, and Joseph Michael Sommers. "Introduction: Manifest Narrativity—Video Games, Movies, and Art and Adaptation." In *Game On, Hollywood: Essays on the Intersection of Video Games and Cinema*, edited by Gretchen Papazian and Joseph Michael Sommers, 8–18. Jefferson: MacFarland, 2013.

Phillips, Winifred. *A Composer's Guide to Game Music*. Cambridge: MIT Press, 2014.

Reading, Anna, and Colin Harvey, "Remembrance of Things Fast: Conceptualizing Nostalgia-Play in the *Battlestar Galactica* Video Game." In *Playing the Past: History and Nostalgia in Video Games*, edited by Zach Whalen and Laurie N. Taylor, 164–79. Nashville: Vanderbilt University Press, 2008.

161

Sprengler, Christine. *Screening Nostalgia: Populuxe Props and Technicolor Aesthetics in Contemporary Film*. New York: Berghahn Books, 2011.

Summers, Tim. "Epic Texturing in The First-Person Shooter: The Aesthetics of Video Game Music." *The Soundtrack* 5, no. 2 (2012): 131–51.

Summers, Tim. *Understanding Video Game Music*. Cambridge: Cambridge University Press, 2016.

"Twilight Zone Game Announced." Cult Labs. Accessed May 5, 2016. https://www.cult-labs.com/forums/original-1960s-show/5996-twilight-zone-game-announced-2012-a-2.html.

"Twilight Zone Game Interview with Jamar Graham." June 15, 2011. https://web.archive.org/web/20130519052504/http://www.horror-video-games.com/features-1047-Twilight_Zone_game_interview_with_Jamar_Graham.html.

"*The Twilight Zone* Tips and Tricks Guide." Legacy Games. Accessed May 1, 2016. https://www.legacygames.com/help/walkthroughDetailTheTwilightZoneWalkthrough/.

Usher, William. "*Alien: Isolation* Interview: How Composers Evolved a Legacy." *Cinema Blend*. October 28, 2014. http://www.cinemablend.com/games/Alien-Isolation-Interview-How-Composers-Evolved-Legacy-68091.html.

van Elferen, Isabella. "Analyzing Game Musical Immersion: The ALI Model." In *Ludomusicology: Approaches to Video Game Music*, edited by Michel Kamp, Tim Summers, and Mark Sweeney, 32–52. Yorkshire: Equinox, 2016.

Wallin, Mark Rowell. "Myths, Monsters and Markets: Ethos, Identification, and the Video Game Adaptations of *The Lord of the Rings*." *Game Studies* 7, no. 1 (2007). http://gamestudies.org/07010701/articles/wallin/.

Wissner, Reba. *A Dimension of Sound: Music in The Twilight Zone*. Hillsdale: Pendragon Press, 2013.

Wissner, Reba. "No Time Like the Past: Hearing Nostalgia in *The Twilight Zone*." *The Journal of Popular Television* 6, no. 1 (2018): 59–80.

Youtuber Gamer. "Murder, She Wrote 2: Return to Cabot Cove." Uploaded April 3, 2015. https://www.youtube.com/watch?v=5wOEMomGHyI.

8

"This Game Stinks": Musical Parody and Nostalgia in *EarthBound*

Justin Sextro

EarthBound (1995) begins like so many role-playing games (RPGs) before it: a prophesied hero gathers a party of underdogs and confronts an apocalyptic evil. However, in lieu of knights and mages, the story follows child protagonist Ness and three of his friends who traverse destinations from American suburbs to a dinosaur safari zone to defeat the invading alien Giygas. The gameplay features a curious mix of the mundane juxtaposed against the bizarre. Ness wields household items and psychic powers to face down enemies like hippies, piles of puke, and nuclear robots. Yet *EarthBound*'s most peculiar trait may be the score by Keiichi Suzuki and Hirokazu "Hip" Tanaka. Throughout the game, the composers reference various cultural touchstones such as *The Blues Brothers*, B horror movies, 8-bit videogames, the Beach Boys, and John Philip Sousa.

In this chapter, I posit that *EarthBound*'s music parodies contemporaneous JRPG conventions with nostalgic references, quotations, and samples of popular music and culture. My argument draws on the scholarly fields of musical parody and nostalgia, especially Carolyn Williams's framework of parody as simultaneously comic and serious, critical yet affectionate, and Jessica Kizzire's methodology that identifies musical nostalgia through aural signifiers of an idealized past and lived experience.[1] After demonstrating the general nostalgic and parodic nature of the game, I offer an audio–visual analysis of three key scenes. By incorporating musical pop culture references as generic subversive elements, *EarthBound*

[1] Williams, *Gilbert and Sullivan*. See also Jessica Kizzire, "The Place I'll Return to Someday," 183–98.

utilizes elements of both parody and nostalgia.[2] Read between these two concepts, the hodgepodge soundtrack coalesces to create an imaginary American suburban soundscape, one in which nostalgia plays an important role in the game narrative and which directly engages with players' lived experiences.

EarthBound is the second game in the loosely connected *Mother* trilogy, released in Japan in 1989, 1994, and 2006.[3] Developed for the Super Nintendo Entertainment System (SNES), *EarthBound* was the only game in the trilogy to land on North American shores. In the late 1980s, famous copywriter Shigesato Itoi approached Nintendo's Shigeru Miyamoto with a potential RPG based on *Dragon Quest* but set in suburban America.[4] Itoi's original conception questioned the then-standardized medieval European fantasy RPG: "I was wondering why all RPGs were set in medieval Europe. Of course, the origin of RPGs is *The Lord of the Rings*, and then they made a [pen-and-paper] game called *Dungeons and Dragons*, but those are not the indispensable elements."[5] Itoi tapped the musical talent of Keiichi Suzuki and Hip Tanaka to write the score for his modern RPG drama. Suzuki worked as a popular songwriter and a member of the rock band The Moonriders.[6] Tanaka was a veteran game composer credited with many of Nintendo's early Famicom hits, including *Metroid* (1986), *Super Mario Land* (1989), and *Tetris* (1989).[7] Itoi's *Mother* found sales success in Japan with its modern premise and kooky cast of characters and carved out a space next to JRPG mainstays like the *Dragon Quest* (Enix) and *Final Fantasy* (Squaresoft) series.

Pleased with the result, Nintendo greenlit a sequel and planned for the series' first international release in North America. The sequel's development time inflated to five years but was able to get back on track thanks to the last minute efforts

2 Credit for uncovering these musical references goes to several online fan communities, especially starmen.net, earthboundcentral.com, and *Earthbound Wiki*. The contributors and designers of these sites have collected a host of interviews, news stories, fan discussions, and trivia, without which this chapter would not have been possible.

3 The original Japanese titles are *Mother*, *Mother 2*, and *Mother 3*. *Mother 2* was recast as *Earth-Bound* for its North American release. The original *Mother* was Japan-only until Nintendo rereleased the game on the Wii U Virtual Console under the title *EarthBound Beginnings*. Nintendo has not released an official *Mother 3* localization outside of Japan despite lobbying from fans for over a decade. In this chapter, I use the English 1995 title *EarthBound*.

4 For an in-depth discussion of RPG genres and definitions, see Gibbons and Reale, "Prologue," 1–4.

5 Quoted in Kawada, Jimbo, and Kaneko, "Family Computer 1993–1994," 59.

6 "Keiichi Suzuki Profile."

7 Brandon, "Shooting from the Hip."

by Hal Laboratory and future Nintendo president Satoru Iwata, who stepped in as a last-minute producer and programmer.[8] Anticipating the North American release of *EarthBound*, Nintendo of America attempted to broaden the appeal with parodic and somewhat ill-advised advertising elements. The North American marketing campaign infamously featured the tagline "This Game Stinks" and included unpleasant scratch-and-sniff cards with magazines such as *Nintendo Power*.[9] The campaign failed to generate mainstream interest, and some sources report *EarthBound*'s original run sold fewer than 150,000 units.[10] Despite disappointing sales numbers, a dedicated cult following formed and helped to sustain interest.

Suzuki and Tanaka once again helmed the music during *EarthBound*'s development, joined by sound staff members Hiroshi Kanazu and Toshiyuki Ueno for select compositions. The composers employed the SNES's increased storage capacity and improved sound sampling capabilities to craft an eclectic, even disjointed score. In addition to numerous original tunes, *EarthBound*'s soundtrack incorporates references, quotations, and samples of popular music and culture. This study examines these granules of musical pop culture in the context of scholarly discussions surrounding nostalgia. Historian David Lowenthal was one of the first scholars to theorize about nostalgia's impact on modern life. According to Lowenthal, nostalgia has a variety of intertwining effects, both positive and negative. He conceptualized the past as "once virtually indistinguishable from the present" but now "an ever more foreign realm, yet one increasingly suffused by the present."[11] Put another way, the past, and nostalgia for that past, has become increasingly commodified and identified by its relationship to the present. This viewpoint does have some benefits, a few of which include affirmation of identity and guidance for the future.[12] However, Lowenthal cautions that the negatives of a past-oriented present may quickly overcome the positives, the most notable of which is a stunting of innovation at the hands of tradition.[13]

Some nostalgia scholars have acknowledged the dangers of the concept yet seek to reexamine nostalgia's positive effects. Recasting nostalgia through the lens of videogames, Zach Whalen and Laurie N. Taylor also acknowledged the possible drawbacks of nostalgia but claimed that it "can also be understood in constructive

[8] Tanaka, "Shigesato Itoi."

[9] See, for example, the leaflet in *Nintendo Power* 74 (July 1995).

[10] Meyer, "Octopi! Spinal Tap!"

[11] Lowenthal, *The Past Is a Foreign Country*, xix.

[12] Lowenthal, *The Past Is a Foreign Country*, 40–47.

[13] Lowenthal, *The Past Is a Foreign Country*, 69.

terms, as the process by which knowledge of the past is brought to bear on the present and the future."[14] *EarthBound* provides a rich case study for the interactions between nostalgia and videogames, as it is historically situated amidst the height of many iterative RPG series like *Dragon Quest* and *Final Fantasy*, which both released their sixth entries around the time of *EarthBound*'s development. *EarthBound* demonstrates the positive creative capabilities of nostalgia by combining elements of the past and present, not in an effort to recreate the past but to acknowledge its contributions.

Memories of Mother

EarthBound tells the story of Ness, a thirteen-year-old silent protagonist from Onett. One night, he awakens to the sound of a crashing meteorite near his house. Ness sneaks out of the house and discovers an alien named Giygas has invaded, turning people and objects evil. A time-traveling fly, Buzz Buzz, informs Ness his only hope lies in collecting eight pieces of a melody. These melodic fragments represent Magicant, Ness's personal sanctuary and a reflection of his mind from which he may draw the necessary strength to face Giygas. During the adventure, Ness recruits Paula, a psychic girl next door; Jeff, a boy genius toting bottle rockets and airguns; and Poo, a crown prince and martial artist from the floating island Dalaam. Together, the heroes overcome a variety of obstacles standing between them and the melody fragments.

Fans of the original *Mother* may notice obvious similarities to *EarthBound*. In *Mother*, a young hero from Podunk named Ninten resists the forces of the invading alien Giegue.[15] To aid him in saving the world, the amnesiac Queen Mary of Magicant tasks Ninten with the collection of eight melody fragments. Like Ness, Ninten encounters friends who will join his quest: Ana, the psychic girl; Lloyd, the genius toy-weapon smith; and the gang leader, Teddy. *EarthBound*'s preliminary subtitle, "Giygas Strikes Back," suggests that the game began as a direct sequel to *Mother*. However, Itoi stated in an interview before *EarthBound* released that he wanted players to decide for themselves if the game continued *Mother*'s plot since the player could now rename the main characters.[16] The decision to make

[14] Whalen and Taylor, eds., *Playing the Past*, 3.

[15] Both Ninten and Ness derive their names from similar Nintendo puns: Ninten from Nintendo and Ness from NES (Nintendo Entertainment System).

[16] "Weekly Famitsu: 19 June 1992," *Yomuka!*

the sequel status ambiguous was most likely enacted to allow North American players easy entry into the series.

Though both *Mother* and *EarthBound* require a collection of eight melody fragments during the adventure, their respective narrative purposes indicate key differences that strengthen the importance of nostalgia in the latter game. In *Mother*, Ninten returns his eight melody fragments to Queen Mary of Magicant. Upon hearing the full song, Mary recovers from her bout of amnesia and reveals that she is Ninten's grandmother, Maria. Long ago, Maria adopted an abandoned Giegue and often sang the melody to him as a lullaby. Armed with this knowledge, Ninten and his friends sing the melody during the final confrontation to awaken Giegue's memories and ultimately force his retreat. In contrast, *EarthBound*'s eight melody fragments do not relate to Giygas but instead represent parts of Ness's own childhood memory. After collecting each fragment, Ness receives a vision from his past. When Ness retrieves the seventh melody fragment, for instance, an in-game text box tells us that he sees "a vision of his father holding him." When all the fragments have been collected, the full melody allows Ness to access Magicant, or "Your World." Magicant is not a physical place as it was in *Mother* but instead reflects Ness's mind. In Magicant, Ness embarks on a journey of self-discovery, encountering familiar faces from his journey and battling his worst nightmares to realize his full potential. In essence, then, *EarthBound* recounts Ness's quest to recover and recreate his memories through music.

These plot points in *EarthBound* recall some of the core concepts in nostalgia studies. Nostalgia is remembrance, involving feelings of loss for an idealized past that never or only partially existed. Feelings of nostalgia often result in the reinterpretation of events. For example, ethnomusicologist Gage Averill draws a direct connection between nostalgia and the barbershop quartet revival of the 1930s, which expunged the important role that African Americans played in barbershop's creation.[17] Folk music scholar Noora Karjalainen argues for an additional type of nostalgia she terms "horizontal nostalgia," which occurs when feelings of nostalgia become "directed not toward the past but sideways toward parallel reality."[18] *EarthBound* and videogames in general add another layer to the construction of nostalgia thanks to player interactivity. Ness's journey has the player guide him through a parallel reality of 1990s suburban America. The apparent similarity

[17] Averill, *Four Parts, No Waiting*, 4. See also Sarah Pozderac-Chenevey's chapter in this volume, which analyzes some intersections between anti-Black racism and nostalgia through the lens of *BioShock Infinite* (2K Games, 2013).

[18] Karjalainen, "Place, Sound, and Tradition," 3.

between Ness's world and the United States does not matter to its inhabitants, but it can matter to *EarthBound's* players.

Scholars have also argued that collective memory plays a significant role in the formation of nostalgia. Svetlana Boym claimed that nostalgia represents "an intermediary between collective and individual memory."[19] Matthew Thomas Payne argues that videogames offer a unique medium for nostalgic collective memory due to interactivity. Following James Wertsch's outline, Payne explains that collective memory arises around shared texts within a community and that the *act* of remembering these texts contributes more to the creation of collective memory than memories alone.[20] Further, the interactive nature of videogames readily fosters collective memory. In other words, videogames create opportunities for players to form similar memories through common in-game events: Ness is the character on the journey of rediscovery, but it is the players who guide him through the process. Boym and Payne's separate observations on the construction of nostalgia may be found in *EarthBound's* visual esthetic and narrative described above, but the soundtrack also has a part to play.

The nostalgic evocations of popular music throughout *EarthBound's* soundtrack engage with both individually lived experience and collective memory. In her chapter examining *Final Fantasy IX* (Squaresoft, 2000), Jessica Kizzire created a framework composed of two different types of ludo-musical nostalgia, which she calls "series-specific cues" and "signifiers of an idealized past."[21] The first category draws on a player's own experiences with earlier games by alluding to musical cues from past games in the *Final Fantasy* franchise. Kizzire explains that the series-specific cues foster comparisons between *Final Fantasy IX* and its predecessors, and it is comparison that creates a space in which musical nostalgia arises. To create a sense of nostalgia, series-specific cues depend on player perception and therefore the player must be familiar with the music from previous games. The second category, signifiers of an idealized past, creates a sense of nostalgia through culturally encoded meaning rather than personal experience. For example, *Final Fantasy IX's* introductory sequence alludes to a vague Renaissance style of music with sonic markers like pavan form, modality, and period instrumentation. Since *Final Fantasy IX's* players may not be familiar with the stylistic characteristics of Renaissance works, recorders and modal melodic materials create a sense of

[19] Boym, *The Future of Nostalgia*, 54. For further discussion on the connections between nostalgia and collective memory, see Pickering and Keightley, "The Modalities of Nostalgia," and Wilson, *Nostalgia*, 38–52.

[20] Payne, "Playing the Déjà-New," 54.

[21] Kizzire, "The Place I'll Return To Someday," 187.

estrangement when compared to contemporary musical procedures. *EarthBound*'s composers utilize both of Kizzire's categories but with slight twists that blur the definitions. Rather than relying on series-specific cues (although those still appear), *EarthBound* invites comparison between itself and other RPGs by parodically evoking generic hallmarks. Under the second category, Suzuki and Tanaka do not rely entirely on general signifiers of an idealized past (instrumentation, harmonic schemes, etc.) but instead use specific musical material from the twentieth-century American pop music and culture, including quotes, samples, and references.

Parody at play

In many ways, *EarthBound*'s gameplay mechanics match those found in mainstream JRPG series such as *Dragon Quest* and *Final Fantasy*. The player guides Ness and his party as they explore dungeons and towns, battle enemies to gain experience, and purchase items that increase stats. *Dragon Quest* players may find *EarthBound*'s battle system particularly familiar. When the player enters battle, a screen wipe transports Ness to a different diegetic space where only the enemy appears on the screen. The player chooses actions from a static square menu in the first person, that is, from Ness's point of view.

Beyond these core systems, however, *EarthBound*'s visual and narrative design create a large separation between itself and *Dragon Quest*. Ness travels through Eagleland, a thinly veiled reference to the United States. Like other JRPGs, the player navigates a mixture of towns and dungeons in a set order, though in *EarthBound* the developers highlight this progression with a humorous town naming scheme: Onett, Twoson, Threed, etc. The towns' scenarios become increasingly bizarre as the story progresses; at times, Ness may struggle against members of the Happy Happyist cult or travel to an alternate reality in Fourside to save Paula. The battle mechanics maintain *Dragon Quest*'s structure but stray just far enough to draw attention. Like *Dragon Quest*, Ness battles enemies by choosing actions from text boxes. However, *EarthBound* sets its battles against psychedelic backgrounds rather than relating to the in-game environment. Ness does not utilize potions or antidotes to heal himself; instead, he devours hamburgers, pizza, and fries—and adding condiments provides bonus health points. Outside of battle, enemy sprites appear on the field, giving the player the ability to engage in combat at will. To my knowledge, *EarthBound* is the first game in which the *enemies* run away from the player if Ness's level is too high.

Unique to *EarthBound* is the status ailment "homesickness." After winning a battle, Ness may become homesick, causing him to reminisce about home, his favorite meal, or his mom. The status effect may cause Ness to skip a turn in

subsequent battles, leaving him vulnerable to enemy attacks. Though there are a few other options, calling home to Ness's mom is the best way to cure homesickness. Homesickness certainly contains parodic implications when compared to other RPGs (it's hard to imagine the stoic characters in *Dragon Quest* succumbing to homesickness) and the status ailment also reaffirms the nostalgic thread running through *EarthBound*. The name "homesickness" invites a direct comparison to nostalgia's origins as a disease, first identified by Johannes Hofer in 1688.[22] Hofer's diagnosis attempted to explain a variety of symptoms but primarily targeted the strong emotions felt by people displaced from their homeland by work or war. There is little doubt that if Ness's yearnings for home were presented to Hofer, he would readily diagnose the young lad with a severe case of nostalgia.

All these peculiar narrative and esthetic choices, from homesickness to humorous naming schemes, combine to create a game that parodies the conventions of RPGs. In her book on Gilbert and Sullivan, Carolyn Williams argues that parody does not simply mean derisively aping preexisting elements but may involve a variety of attitudes for both producers and consumers. She continues, saying,

> At one extreme of the spectrum lies critique, but at the other lies a kind of homage. In any particular instance, these attitudes can be mixed, and thus a parody can make fun of its object, humorously indicating that it is old-fashioned or long past, while affectionately, ruefully—or with any other attitude—preserving its memory.[23]

To qualify as parodic, the newly created text may exaggerate certain generic aspects of the original text. Williams claims, for example, that Gilbert and Sullivan parodied opera and English theater by incorporating operatic conventions, including arias, ensembles, and choruses.[24]

Musicologist Karen Cook makes similar arguments for videogames and further theorizes that music can have as much parodic power as game mechanics. She demonstrates that *The Bard's Tale* (InXile 2004) contains many of the hallmarks of an action RPG but that the music parodies RPG conventions with lyrical pop culture references in the guise of a loose medieval musical style. In Cook's estimation, the subversion of expectations simultaneously mocks and honors RPG conventions.[25] *EarthBound*'s developers pull a similar move by dressing *Dragon Quest*'s game mechanics in wacky modern trappings. Here, too, the composers

[22] Boym, *The Future of Nostalgia*, 3.

[23] Williams, *Gilbert and Sullivan*, xiv.

[24] Williams, *Gilbert and Sullivan*, 24–26.

[25] Cook, "The Things I Do for Lust," 31.

write music with the conventions of RPGs in mind, choosing at times to heighten or directly subvert those conventions.

EarthBound differs from parodical games such as *The Bard's Tale* due to its use of preexisting material, whose presence in the soundtrack engages with the collective memory while simultaneously parodying JRPGs. John P. Thomerson wrote an in-depth framework for the uses of preexisting material in the twentieth- and the twenty-first-century vernacular American music. Under the typology and methodology laid out by J. Peter Burkholder, Thomerson posits that three techniques dominate parody in popular music: "contrafacta, stylistic allusion, and quotation."[26] The latter two categories can be found in *EarthBound*; stylistic allusion (what I refer to as references) borrows general characteristics of parodied music such as melody or timbre while quotations incorporate small portions of preexisting music. Using an analysis of over 700 songs, Thomerson concludes that one reason parodists use stylistic allusion is to create an association with the parodied source. Quotations also often function to create a musical characteristic according to their extra-musical associations. Unlike stylistic allusion, quotations tend to be less integral to a parody piece's structure but *do* highlight impactful moments in the musical form.

Those unfamiliar with the quotations may not appreciate their inclusion as intended. Phillip Tagg calls this disconnect between intended musical vocabulary and audience *codal incompetence* and *codal interference*. Codal incompetence arises when an audience does not know the intended meaning of materials used by the author. Codal interference occurs when the audience knows the materials but interprets them differently due to differing cultural systems.[27] In other words, the disparate musical allusions found in *EarthBound* may fail to generate nostalgia for those unfamiliar with the cues. Nevertheless, the two regions in which *EarthBound* was originally released, Japan and North America, have a history of cultural exchange that may enable the translation of cultural signifiers as found in *EarthBound*. E. Taylor Atkins argues that popular music from the United States in particular played a formative role in many facets of Japanese cultural production and consumption.[28] Acknowledging Tagg's caveats, my chapter assumes some level of awareness of American pop culture for the audience.

In summary, *EarthBound* creates a fertile space for comparison by parodying contemporary JRPGs. One game composer may choose to parody a genre

[26] Thomerson, "Parody as a Borrowing Practice in American Music," 43. For more discussion on uses of pre-existing music, see Burkholder, *All Made of Tunes*.

[27] Tagg, *Music's Meanings*, 179–85.

[28] Atkins, "Can Japanese Sing the Blues?" 28–29.

simply by amplifying the expected characteristics, as Gilbert and Sullivan did with their use of aria forms in their operas. *EarthBound*'s composers go further by incorporating preexisting music that functions like Kizzire's signifiers of an idealized past but also directly engages with the lived experience of those familiar with the tunes. Following Thomerson's reasoning, the preexisting music often functions to create associations beyond the game's diegesis. Suzuki and Tanaka add another category, sampling, to join Thomerson's stylistic allusion and quotations. These disparate musical references, quotes, and samples, then, function simultaneously as agents of parody and nostalgia. The result is a nostalgic American landscape crafted with familiar scenes and sounds but twisted to merge with the fictitious world. The next section describes in detail how music contributes to the parody with nostalgic signifiers in the form of references, quotes, and samples.

Adventures in Eagleland

In a 2014 interview, Hip Tanaka offers insight into his mindset when he composed *EarthBound*, saying,

> I had to compose music to fit the story. I wasn't as limited by hardware. It was about composing and staging music as part of the game's story. *EarthBound* was a game with a contemporary drama. I couldn't create music that I'd never heard before, so there were influences from rock, or pop, or even world music. I littered that throughout the score.[29]

Tanaka alludes to the presence of references or extra-textual musical works within *EarthBound*'s score and explains that the upgraded Super Nintendo hardware afforded the opportunity to expand *EarthBound*'s musical integration. Why then choose such a strange hodgepodge of musical influences? Some insight may be found by looking at Tanaka's work on the original *Mother*. Tim Summers observes that Suzuki and Tanaka juxtaposed two musical styles in *Mother*: music characterizing aliens or foes and music associated with the human characters, which employs what Summers calls the "aesthetic of naïveté."[30] Summers argues that *Mother* uses the reoccurrence of the eight melodic fragments and the simplistic esthetic of naïveté to evoke nostalgia for "our own

[29] Red Bull Music Academy, "Hip Tanaka."

[30] Summers, "*Mother/EarthBound Zero* and the Power of the Naïve Aesthetic," 45.

musical histories and childhoods."[31] In *EarthBound*, the composers exchange the esthetic of naïveté for "real-world" musical references that collectively engage with personal musical histories.

Frank

The composers waste little time presenting musical influences originating outside the game world. Battle themes comprise some of the most frequently heard pieces in an RPG soundtrack, and many contemporaneous RPG composers relied on one theme to accompany most encounters. In stark contrast, Suzuki and Tanaka included twelve separate battle themes for *EarthBound*, each linked to specific enemies. This represents a huge expansion from *Mother*, which already boasted four unique battle themes.

Two early battle themes contain recognizable pop music references. Ness's first task in Onett sees him confronting the Sharks, a gang terrorizing the town. On his way to challenge their leader, Frank, Ness may face enemies to the sounds of "Battle Against a Weak Opponent."[32] The track opens with a brief riff that mimics "Tequila" by The Champs. Plucked guitar lines, punctuated by maracas and dotted rhythms in the bass, alternate between two chords in a loop lasting only thirty seconds. Having defeated a horde of opponents blocking his path, Ness challenges Frank at the Sharks headquarters, the local videogame arcade. The soundscape changes drastically upon entering the arcade; electronic beeps, buzzes, and scattered 8-bit melodies combine to recreate the sounds of a typical 1980s arcade. One melody, a fast scalar figure, resembles a similar motive found in Namco's 1983 arcade cabinet game, *Xevious*. After traversing the town and defeating Frank's minions, Ness must face off against the man himself. Yet another familiar tune accompanies this boss fight. His battle theme is a slightly altered quotation of Chuck Berry's "Johnny B. Goode" (1958), complete with opening guitar solo and R&B bass ostinato. Frank (seen in Figure 8.1) wears a red double-breasted suit complemented by greased back hair, resembling Berry's style in the 1950s.

Ness's struggle to rid Onett of Frank and his thugs occurs during the first few hours of gameplay, yet Suzuki and Tanaka already display a willingness to twist JRPG soundtrack expectations. William Gibbons posits that JRPG

[31] Summers, "*Mother/EarthBound Zero* and the Power of the Naïve Aesthetic," 47.

[32] Many of the battle tracks do not have official titles. The names for tracks are fan creations, listed on "Mother 2/EarthBound Music."

FIGURE 8.1: The battle against Frank. Screenshot captured by the author.

musical expectations derive from the model set up by the *Dragon Quest* composer Koichi Sugiyama, which Patrick Gann termed the "eight melodies template."[33] Gibbons explains that, though the style may vary, players can reasonably expect music of a certain length and mood based on game contexts such as location or game-state. Locations such as a castle or dungeon usually contain music that demonstrates the "nature (and relative safety) of each setting" while game-state music occurs in different situations, such as battles or title screens.[34]

Following this archetype, many RPG composers choose to aurally indicate a battle with exciting or tense musical cues. For example, revered videogame music composer Nobuo Uematsu's main battle theme for *Final Fantasy III* (Squaresoft 1994) features a fast-paced minor-mode melody accompanied by driving bass and percussion. Since players spend a lot of time fighting in the game, *Final Fantasy III*'s battle theme also contains a contrasting section to avoid annoyance by repetition. However, in *EarthBound*, "Battle Against a Weak Opponent" and "Frank's Theme" utilize a bright, bouncy major mode, and the former even forgoes

[33] Gann, "The 'Eight Melodies' Template."
[34] Gibbons, "Music, Genre, and Nationality," 418.

a clear melody, deriving most of its material from the "Tequila" riff, repeated *ad nauseum*.[35]

Similar effects occur during Frank's dungeon theme and boss battle. According to Gann, these moments call for musically distinct themes, but Frank's dungeon, a videogame arcade, forgoes distinct melodies in favor of an electronic videogame soundscape, bolstered by the *Xevious* theme's presence. "Frank's Theme" should deliver a suitably bombastic culmination leading to the boss battle but instead undercuts tension with a humorous resemblance to Chuck Berry. Adding another layer to the parody, "Frank's Theme" represents one of the few tracks to reappear from *Mother*, where it played for only one enemy, the Hippie. When the track from *Mother* made the jump to *Earth-Bound*, the composers gave the theme to two enemies: Frank and the New Age Retro Hippie. Suzuki and Tanaka thus offer a clever meta-commentary for players familiar with *Mother* by associating it with a boss whose domain consists entirely of old videogames.

The references and quotations previously identified push these songs beyond simply parodying JRPG conventions. Their presence certainly speaks to the composers' tastes but also functions as a nostalgic signifier. As described above, Kizzire explains that music qualifies as a nostalgic signifier of the past due to player imagination and culturally encoded meaning.[36] Hearing "real-world" tunes in a videogame engenders player interaction with the soundtrack, and even individuals unfamiliar with the music may feel a sense of nostalgia thanks to the culturally encoded sonic markers used by the cues. Other scholars of musical nostalgia convey similar views. In the same article in which she describes horizontal nostalgia, Karjalainen studies female folk singers and postulates that hallmarks of folk music can create a nostalgic sense even without first-hand experience.[37] Applying this line of thinking to "Frank's Theme," even players unfamiliar with the sounds of 1980s videogame arcades or Chuck Berry may still associate those sonic markers with texts outside of *Earth-Bound*. Further, as both Kizzire and Karjalainen describe, a sense of nostalgia can still arise even without the ability to name the nostalgic cause, that is, "Johnny B. Goode."

[35] My argument holds some similarity to Reba Wissner's discussion, as seen elsewhere in this volume, of repetitive quotations as a source of parody and inter-media nostalgia in *The Twilight Zone: The Game* (Legacy Interactive, 2014).

[36] Kizzire, "The Place I'll Return to Someday," 189.

[37] Karjalainen, "Place, Sound, and Tradition," 8.

The Runaway Five

Many scenes in *EarthBound* feature pop culture references like those in the battle themes. After defeating Frank, Ness hears a psychic call from a girl in the next town over. Ness travels to Twoson and finds himself at the Chaos Theater. Here, he encounters the Runaway Five, a down-on-their-luck band unable to leave town thanks to the enormous debt they owe to the theater owner. By a happy circumstance, Ness previously purloined money from a thief nearby and offers to pay off the debt. In gratitude, the Runaway Five offers Ness tickets to their last show in Twoson.

The Runaway Five's esthetic and musical style mimic characters from the *Saturday Night Live* (SNL) sketch and 1980 film *The Blues Brothers*. The Runaway Five's two front men, Gorgeous and Lucky, lead the group in red and green suits; in the original Japanese release, however, the group wore black suits like Jake and Elwood from *The Blues Brothers*. Even more similarities appear when the Runaway Five plays the show in Twoson. Like the Blues Brothers, the Runaway Five perform with stylistic hallmarks from the R&B, funk, and soul genres. After a slow introduction, Gorgeous and Lucky dance around the stage to an upbeat modified 12-bar blues riff featuring a call and response exchange between the electric piano and brass. Though not an exact imitation, the Runaway Five echo some specific elements from the Blues Brothers sketches and film: the rhythmic, arpeggiating bass line recalls the same found in the film's song by Aretha Franklin, "Think," and the call and response instruments adhere closely to the SNL recreation of "Soul Man" by the vocal duo Sam and Dave.

Much of Ness's interaction with the Runaway Five occurs in cinematic scenes, segments of noninteractive content that usually play out like short movies. Giles Hooper claims that music in videogame cinematic scenes generally serves to reiterate or reflect important story beats and reinforce emotional narrative high points. Hooper also positions music as the "binary distinction between 'gameplay' and 'cutscene.'" [38] Using Hooper's reasoning, Cook examines *The Bard's Tale*, explaining that the game's cinematic scenes are parodic since they do not further the story or fit stylistically within the musical context. [39] The Runaway Five sequence goes one step further: their show sticks out in the musical context and does little for the main story but also takes time to rehash *The Blues Brothers*. Like the battle themes described above, the Runaway Five's stylistic characteristics do not exactly recreate but heavily allude to the artists they mimic.

[38] Hooper, "Sounding the Story: Music in Videogame Cutscenes," 128.

[39] Cook, "The Things I Do for Lust," 28.

With the addition of *The Blues Brothers*, Suzuki and Tanaka add yet another extra-textual musical reference. Combining Berry with videogames like *Xevious*, the musical allusions span a time period from the 1950s to the late 1980s. Similar to the way "Weird Al" Yankovic frequently uses allusion to create parody in his music, the Runaway Five does not use specific Blues Brothers quotations but instead borrows their general esthetic and musical style.[40] By borrowing Blue Brothers material, Suzuki and Tanaka create connections between *EarthBound* and media outside the game world. In contrast to Weird Al's approach, Suzuki and Tanaka choose to parody a parody, creating a nonsensical atmosphere that sets up an expectation for humor. In combination with the suburban imagery of Eagleland, scenes like the Runaway Five show form a horizontally reimagined version of the United States. The scenes draw inspiration from the twentieth-century American pop culture as filtered through the Japanese development team's viewpoint, all couched in JRPG mechanics. Reflecting on *EarthBound*'s larger narrative scheme reveals a mundane, everyday picture of American life overlaid with imaginary scenarios and filled with a faintly familiar soundtrack.

The battle against Giygas

I have so far described instances in which Suzuki and Tanaka chose to quote or allude to pop culture music icons. However, *EarthBound*'s most well-known musical feature may be the direct samples of preexisting music implemented throughout the score. Nintendo's previous console, the Nintendo Entertainment System (NES), included limited sampling capabilities. With the SNES's Sony SPC-700 sound chip, composers had access to eight channels equipped with ADPCM sampling and a preset stock of MIDI instruments.[41] Suzuki and Tanaka took advantage of the expanded capabilities not only by including various samples but also increasing the typical file size for an SNES soundtrack. Itoi reported in an interview that the composers' "broad" and "disorderly" tastes ballooned the music storage requirements to eight megabits, a third of the 24-megabit game cartridge.[42]

The final dungeon and subsequent battle against Giygas exemplify the composers' use of sampling and pop culture references. The dungeon's esthetic also includes heavy symbolism connected to nostalgia and parody. Upon collecting the eighth fragment of Ness's melody, the heroes descend upon Giygas's lair, the Cave of the Past. A desolate place framed by grey cliffs and populated with powerful enemies,

[40] Thomerson, "Parody as a Borrowing Practice in American Music," 50.

[41] Collins, *Game Sound*, 45–48.

[42] "Weekly Famitsu: 9 September 1994," *Yomuka!*.

the Cave of the Past features a sparse cue consisting entirely of a sample of "La Marseillaise." Suzuki and Tanaka use only the first three chords of the anthem, applying an echo effect while decreasing the volume. They then repeat the process but shift the march to different pitch levels. "La Marseillaise" bounces around the walls of the Cave of the Past, like a snippet of a song half-remembered.

Since the party cannot find Giygas, their venture comes to naught, but hope is renewed when Dr. Andonuts, Jeff's inventor father, hatches a plan to send the heroes back in time when Giygas still resided in the Cave of the Past. Since time travel in *EarthBound* destroys human bodies, Ness and friends transfer their minds to robots and travel to the final location. In this time period, "La Marseillaise" gives way to a sample of "Deirdre" by the Beach Boys. The track begins recognizably enough but the composers quickly alter the melody by transposing it upward in pitch until it is almost indiscernible.

More horrifying sights and sounds await Ness and the party in Giygas's lair. Deep in the Cave of the Past lies the Devil's Machine, a contraption covered in snaking tubes that contains Giygas's power. Ness's annoying next-door neighbor Pokey awaits the heroes at the Devil's Machine. Besides Giygas, Pokey is *EarthBound*'s primary recurring antagonist, and he appears one last time to reveal his true allegiance to Giygas in the Cave of the Past. Pokey comes to the battle well armed in a spider exoskeleton suit; he is the only obstacle left between the heroes and Giygas. As opposed to a tense final boss theme characteristic of contemporary JRPGs, the sounds that greet the player during the fight with Pokey conform to those found in soundtracks from the NES. Instead of sampled instruments, Suzuki and Tanaka employ a four-voiced arrangement composed of a noise channel underneath melodic square and triangle waves. In addition to using the same sound capabilities as the older console, arpeggiating accompaniments, contrapuntal textures, and fast-paced rhythms in Pokey's theme allude to techniques used by NES composers to sidestep the system's five voice limit and small timbral range.[43] Yet the quaint blips and bloops of yesterday's gaming soon recede; in the next section of Pokey's theme, the composers maintain the same melodic and harmonic material but change the timbre. Hard-driving heavy metal instruments roar into action and increase the tension.

After Pokey's defeat, the group moves on to face Giygas. The tone again changes drastically: facing a red and black void, Ness fights to the sounds of amelodic

[43] See Jonathan Waxman's contribution to this volume for more discussion on 8-bit sound and its use in other game genres. Waxman examines retro film-based videogames and the ways in which the recreation of music from film to chiptune invokes nostalgia.

electronic noise. While battling Pokey, the player could rely on tactics learned throughout the game: attacking, using items, and casting spells. Against Giygas, however, the player can effectively do nothing to fight back and instead must concentrate on healing party members to stay alive. The stark contrast in the transition from Pokey to Giygas highlights the over-the-top parody of NES RPGs that was Pokey's boss fight. A "pray" option in Paula's menu, previously an unhelpful action, now becomes the only hope for victory. By employing Paula's pray ability, the player reaches out to characters encountered throughout the game. These characters, including Frank and the Runaway Five, then appear in vignettes in which each offers prayers for the party's victory. The scenes serve a gameplay function but also encourage the player to reflect on preceding characters and events. Tonal music resurges during the vignettes—an organ, playing unresolved and homorhythmic chords, provides a glimmer of hope after Giygas's electronic nightmare. If the player can survive through nine rounds of prayers, Giygas will die and the world is saved.

The ending stays true to the parodic and nostalgic framework found throughout the game. By first appropriating hallmarks of NES music textures in Pokey's battle and then stripping them away when facing Giygas, the *EarthBound* composers create a point of parody with an impactful emotional climax. The textures and sounds in Pokey's battle, which function as a parody of JRPG conventions, simultaneously act as agents of nostalgia for those conventions. Pokey's battle is juxtaposed with the subsequent battle against Giygas. Gone are the comforts of understandable battle mechanics, visible characters, and melodic music, leaving the player with a feeling of hopelessness which can only be overcome with the help of friends met during the journey in *EarthBound*.

Conclusion

The final confrontation with Giygas marks a tense ending to a seemingly silly game in which the heroes adventure through neighborhoods clutching baseball bats and frying pans. After defeating Giygas, Ness goes home to find his mom ready with his favorite meal as if nothing has changed. It's almost as if the whole story took place entirely inside Ness's mind; some, in fact, read the game in this fashion. For example, games critic and journalist Jeremy Parish makes room for interpreting the original *Mother* in this way, writing,

Mother [sic] forever leaves players wondering what's presented literally and what's simply an invention of its young protagonist Ninten. While other RPGs cast players

as a hero like in Dragon Quest, Mother at times feels more like you're taking the role a child *pretending* to be a hero like in Dragon Quest.[44]

Parish pinpoints the nostalgic allure of *Mother*, and his comments are equally true for its sequel. *EarthBound* offers a nostalgic trip through a faux-American landscape that incorporates elements of real-world pop culture superimposed on the structure of a JRPG. Read the opposite way, JRPG elements may be superimposed onto the American landscape through the power of childhood imagination, all appropriately accompanied by eclectic snatches of pop culture references. If Ness's imagination informs the soundtrack, it also serves as another point of connection between player and narrative. Gamers playing through *EarthBound* may well recognize the snatches of real-world music or recognize the culturally encoded musical references. *EarthBound* invites the player to become an integral part of the narrative by creating explicit connections between fiction and reality—a point that Itoi emphasizes at the end of the game by listing the player's name as the final entry in the credits.

EarthBound continues to impact the videogame musical landscape. In some ways, it serves as a proof of concept for parodic videogames. Recent game developers such as Toby Fox, the creator of *Undertale* (2015), cite *EarthBound* as a primary inspiration for their non-conforming takes on the RPG genre.[45] *EarthBound* also owes much of its impact to the small cult following it generated during the otherwise unsuccessful release. Thanks to active online communities and never-ceasing petitions for an English localization of *Mother 3*, *EarthBound* continues to enjoy promotion as one of Nintendo's favored franchises. In 2017, Nintendo included it on the plug-and-play Super Nintendo Classic, alongside games featuring company mascots Mario and Link. Fan nostalgia also drives support for the *Mother* series, as active online communities continue to keep these games in the gaming milieu even a decade after the last release. *EarthBound*'s continued success attests to the power of both fan and in-game evocations of nostalgia.

LUDOGRAPHY

Dragon Quest. Chunsoft. Famicom. Enix, 1986.
EarthBound. Ape Inc. and Hal Laboratory. Super Nintendo Entertainment System. Nintendo, 1995.
Final Fantasy. Square. Famicom. Square, 1987.
Final Fantasy III. Square. Super Nintendo Entertainment System. Square, 1994.

[44] Parish, "Daily Classic."

[45] Nintendo Everything, "Undertale Creator on the Games that Served as Inspiration."

Final Fantasy IX. Square. PlayStation. Square, 2000.

Metroid. Nintendo. Famicom. Nintendo, 1986.

Mother. Ape Inc. Famicom. Nintendo, 1989.

Mother 3. Brownie Brown and Hal Laboratory. Game Boy Advance. Nintendo, 2006.

Super Mario Land. Nintendo. Game Boy. Nintendo, 1989.

Tetris. Nintendo. Game Boy. Nintendo, 1989.

The Bard's Tale. InXile. PlayStation 2 and Xbox. InXile, 2004.

Undertale. Toby Fox. PC and Mac. Toby Fox, 2015.

BIBLIOGRAPHY

Atkins, Taylor E. "Can Japanese Sing the Blues? 'Japanese Jazz' and the Problem of Authenticity." In *Japan Pop! Inside the World of Japanese Popular Culture*, edited by Timothy J. Craig, 27–59. Armonk: M. E. Sharpe, 2000.

Averill, Gage. *Four Parts, No Waiting: A Social History of American Barbershop Harmony*. Oxford: Oxford University Press, 2003.

Boym, Svetlana. *The Future of Nostalgia*. New York: Basic Books, 2001.

Brandon, Alexander. "Shooting from the Hip: An Interview with Hip Tanaka." Gamasutra. September 22, 2002. https://www.gamasutra.com/view/feature/131356/shootingfromthe-hipan.php.

Burkholder, J. Peter. *All Made of Tunes: Charles Ives and the Uses of Musical Borrowing*. New Haven: Yale University Press, 1995.

Collins, Karen. *Game Sound: An Introduction to the History, Theory, and Practice of Video Game Music and Sound Design*. Cambridge: MIT Press, 2008.

Cook, Karen M. "'The Things I Do for Lust…': Humor and Subversion in *The Bard's Tale*." In *Music in the Role-Playing Game: Heroes & Harmonies*, edited by William Gibbons and Steven Reale, 21–34. New York: Routledge, 2020.

Gann, Patrick. "The 'Eight Melodies' Template: How Sugiyama Shaped RPG Soundtracks." RPGFan, November 29, 2008. http://www.rpgfan.com/editorials/2008/11-29.html.

Gibbons, William. "Music, Genre, and Nationality in the Postmillennial Fantasy Role-Playing Game." In *The Routledge Companion to Screen Music and Sound*, edited by Miguel Mera, Ronald Sadoff, and Ben Winters, 412–27. New York: Routledge, 2017.

Gibbons, William, and Steven Reale, eds. *Music in the Role-Playing Game: Heroes & Harmonies*. New York: Routledge, 2020.

Gibbons, William, and Steven Reale. "Prologue: The Journey Begins." In *Music in the Role-Playing Game: Heroes & Harmonies*, edited by William Gibbons and Steven Reale, 1–7. New York: Routledge, 2020.

Hooper, Giles. "Sounding the Story: Music in Videogame Cutscenes." In *Emotion in Video Game Soundtracking*, edited by Duncan Williams and Newton Lee, 115–41. Cham: Springer International Publishing, 2018.

Karjalainen, Noora. "Place, Sound, and Tradition: Origin Narratives Constructing Nostalgia in the Media Representations of Female Folk Singers." *Journal of Popular Music Studies* 29, no. 3 (September 2017).

Kawada, Kikuji, Kyoko Jimbo, and Ryuichi Kaneko. "Family Computer 1993–1994." In *Tokyo Metropolitan Museum of Photography*, 59. Tokyo: Ohta Books, 2003. Translated in Chris Kohler, *Power-Up: How Japanese Video Games Gave the World an Extra Life*, 89. Indianapolis, IN: BradyGames, 2005.

"Keiichi Suzuki Profile." KeiichiSuzuki.com. Accessed November 6, 2019. http://www.keiichisuzuki.com/profile/.

Kizzire, Jessica. "'The Place I'll Return to Someday': Musical Nostalgia in *Final Fantasy IX*." In *Music in Video Games: Studying Play*, edited by K. J. Donnelly, William Gibbons, and Neil Lerner, 183–98. New York: Routledge, 2014.

Kohler, Chris. *Power-Up: How Japanese Video Games Gave the World an Extra Life*. Indianapolis: BradyGames, 2005.

Lowenthal, David. *The Past Is a Foreign Country*. Cambridge: Cambridge University Press, 1985.

Meyer, John. "Octopi! Spinal Tap! How Cult RPG EarthBound Came to America." *WIRED*, July 23, 2013. https://www.wired.com/2013/07/marcus-lindblom-earthbound/.

"Mother 2/EarthBound Music." Starmen.net. Accessed September 25, 2019. http://starmen.net/mother2/music/.

Nintendo Everything. "Undertale Creator on the Games that Served as Inspiration, Changes During Development, and More." October 27, 2018. https://nintendoeverything.com/undertale-creator-on-inspiration-changes-during-development-and-more/.

Parish, Jeremy. "Daily Classic: 25 Years Ago, Mother (aka EarthBound Zero) Skewered JRPGs, and America." USGamer. August 22, 2014. https://www.usgamer.net/articles/daily-classic-25-years-ago-mother-skewered-japanese-rpgs-by-satirizing-america.

Payne, Matthew Thomas. "Playing the Déjà-New: 'Plug It In and Play TV Games' and the Cultural Politics of Classic Gaming." In *Playing the Past: History and Nostalgia in Video Games*, edited by Zach Whalen and Laurie N. Taylor, 51–68. Nashville: Vanderbilt University Press, 2008.

Pickering, Michael, and Emily Keightley. "The Modalities of Nostalgia." *Current Sociology* 54, no. 6 (November 2006): 919–41.

Red Bull Music Academy. "Hip Tanaka." Uploaded November 22, 2014. http://www.redbullmusicacademy.com/lectures/hip-tanaka.

Summers, Tim. "*Mother/EarthBound Zero* and the Power of the Naïve Aesthetic: No Crying Until the Ending." In *Music in the Role-Playing Game: Heroes & Harmonies*, edited by William Gibbons and Steven Reale, 35–54. New York: Routledge, 2020.

Tagg, Philip. *Music's Meanings: A Modern Musicology for Non-Musos*. New York: Mass Media Music Scholars' Press, Inc., 2012.

Tanaka, Keiichi. "Shigesato Itoi." Wakage no Itari, episode 5. October 26, 2017. http://news.denfaminicogamer.jp/english/180109.

Thomerson, John P. "Parody as a Borrowing Practice in American Music, 1965–2015." PhD diss., University of Cincinnati, 2017.

"Weekly Famitsu: 19 June 1992." Yomuka! Accessed October 15, 2019. https://yomuka.wordpress.com/2009/04/30/famitsu-06191992/.

"Weekly Famitsu: 9 September 1994." Yomuka! Accessed October 25, 2019. https://yomuka.wordpress.com/2009/06/21/weekly-famitsu-september-9-1994/.

Williams, Carolyn. *Gilbert and Sullivan: Gender, Genre, Parody*. New York: Columbia University Press, 2011.

Wilson, Janelle L. *Nostalgia: Sanctuary of Meaning*. Lewisburg: Bucknell University Press, 2005.

Whalen, Zach, and Laurie N. Taylor, eds. *Playing the Past: History and Nostalgia in Video Games*. Nashville: Vanderbilt University Press, 2008.

PART 4

CONFRONTING NOSTALGIA
AND VIDEOGAME MUSIC

9

Playing Music Videos:
Three Case Studies of Interaction
between Performing Videogames
and Remembering Music Videos

Brent Ferguson and T. J. Laws-Nicola

Several videogames (VGs) feature music videos, a medium within a medium, which can immerse players in a variety of ways. For instance, players must control the musical performance of their avatar in a music video in "Love Rap," a call-and-response musical minigame in *Rhythm Heaven Fever* (*RHF*, 2011). Similarly, *Yakuza 0* (*Y0*, 2015) features a karaoke minigame in which the avatar begins to sing in a bar before transporting players into a music video within the character's imagination for the song's duration. Finally, *Omega Quintet* (*OQ*, 2014) tasks players with directing, arranging, and choreographing a promotional performance video of the titular musical ensemble. These VGs immerse players into music videos through the performative control required for a successful playthrough, carefully directed camera movements, and the intricate choreography of the background characters. Yet, more importantly, these music videos within VGs immerse players through nostalgia, a marketing strategy common to the popular-music industry.

We argue the use of music videos within VGs produces two results. First, the cases demonstrate the activation of different types of immersive nostalgia for players and game characters. Second, the different types of nostalgia present VG developers with ways to appeal to buyers, evidenced by advertising, streaming, and related products. We organize this chapter into three case studies with the following order. First, we theorize the kind of nostalgia operative in each game. We then analyze how the nostalgia manifests in each case study through visual and musical markers. Finally, we describe how the nostalgia of the game presents

developers with marketing opportunities. "Love Rap" features a mise en scene referencing popular hip-hop videos between the 1990s and 2000s to elicit a *retro nostalgic* esthetic.[1] Retro nostalgia is an emotion that manifests as a longing for a specific era that may or may not have existed. *Y0*'s karaoke game deploys retro nostalgia of the 1980s in its video, but it is brought about by the avatar's *episodic nostalgia*. Also called Proustian nostalgia, episodic nostalgia refers to a physiological experience prompted by memory rather than emotion. Although *Y0*'s karaoke minigame does not sell a product, real advertisements and multimedia associated with the *Yakuza* series deploy these musical moments in their marketing. While the first two games feature past settings, *OQ* takes place in a dystopian future in which music functions as both a magical weapon and a utilitarian source of entertainment to boost the morale of humanity. The *future nostalgia* encountered in *OQ* projects an idealized future that fetishizes the past, focusing on the idol pop genre, which is itself another manifestation of the retro-nostalgia esthetic.[2] *OQ* straddles the line between virtual and real marketing by focusing on a music group that creates videos for promotional purposes both in the diegesis and as a selling point for the game itself. Retro nostalgia acts as the common thread among all three games, but it surfaces differently in each.

Recognizing music–video esthetics and nostalgic connections in VGs relies on the cultural experiences and prior knowledge players bring to the game being activated by their immersion in the games' music videos. Developers highlight these nostalgic connections to increase sales and revenue, either within the *RHF*'s narrative economy, in reality through marketing and producing the karaoke songs of *Y0*, or both inside and outside *OQ*'s diegesis. Consequently, our three case studies illuminate three different practices of marketing musical nostalgia in VGs.

Rhythm Heaven Fever

Nintendo Wii's *RHF* is a collection of music minigames played by pressing the A or B buttons on the remote in accordance with a beat pattern or cued calls

[1] A music–video mise en scene includes all elements of its production including the setting, costumes, makeup, characters, narrative, sound mixing, dialogue, choreography, and any other element players see and hear.

[2] The Japanese word for "idol" is アイドル (*aidoru*), and idol pop is a genre popular throughout East Asia since the 1970s. It often centers around a solo or group act that functions as both a musical act and marketing mechanism.

and responses. *RHF* organizes the minigames in groups of increasing difficulty, each concluding with a cumulative game termed a "remix." Many minigames within *RHF* relate to nostalgia, but we focus on the retro nostalgia evoked by the music–video esthetics from the 1990s and 2000s in "Love Rap." Simon Reynolds defines retro nostalgia as "the self-conscious fetish for period stylization (in music, clothes, design) expressed creatively through pastiche and citation."[3] He names this type of nostalgia as "one of the great pop emotions," often related to emotional capital.[4] We rely on Holly Tessler's definition of emotional capital as emotionally charged intellectual property that forges connections.[5] "Love Rap" achieves retro esthetics first through settings and costumes and second via repeated rhythmic performances of the song lyrics. Repeated performances of lyrics from an artist's library connote self-referencing, a staple in rap music of the past and present.[6] The settings, costumes, rhythmic difficulty, and self-quoting all constitute emotional capital. Both popular music and VGs, in turn, manipulate emotional capital through established connections or retro nostalgia.

Regarding settings and costumes, "Love Rap" presents iconography that refers to the pop culture of the past. While many minigames throughout *RHF* feature culturally nostalgic signs such as masked wrestlers and a samurais, "Love Rap" employs a retro-nostalgic glance back to a specific moment of popular culture, a generic low-budget hip-hop video from the 1990s or 2000s. "Love Rap" features MC Adore leading the trio Love Posse in front of an airport fence as a plane takes off with a straight-shot camera angle (shown in Figure 9.1). MC Adore sits on the hood of a lowrider car while the two backup singers stand on either side of the vehicle. Each member of Love Posse is casually dressed, and they wear accessories such as headphones, sunglasses, and gold chains.

This setup resembles classic rap videos, such as Ice Cube's "Steady Mobbin" and "It was a Good Day," Mack 10 and Nate Dogg's "Like This," and Cypress Hill's cover of War's "Lowrider." The airport setting recalls Dr. Dre's video for "Keep Their Heads Ringin," as well as other videos popular in the latter half of the 1990s and the early 2000s.[7] The evaluation screen players see after playing

[3] Reynolds, *Retromania*, xii–xiii.

[4] Reynolds, *Retromania*, xxviii.

[5] Tessler, "The New MTV," 13.

[6] Stoia et al., "Rap Lyrics as Evidence," 331.

[7] Popular videos with airport settings include U2's "Beautiful Day," Maroon 5's "Makes Me Wonder," and Backstreet Boys' "I Want It That Way," to name a few.

FIGURE 9.1: Screen capture from "Love Rap."

"Love Rap" measures Love Posse's commercial success on the basis of players' accuracy. Another version of the minigame, "Love Rap 2" visually conveys the group's success with the more elaborate mise en scene featuring a mansion setting and new accessories such as costume jewelry and wigs. Such visual and costume markers within the video suggest a retro-nostalgia esthetic of 1990s and 2000s pop culture.

Moreover, the gameplay contributes to the retro-nostalgia esthetic. "Love Rap" incorporates three basic call-and-response motifs and metrically manipulates them. As MC Adore leads the Love Posse by supplying the calls, players control one of the backup singers. The avatar responds correctly by players pressing the A button on the eighth note after MC Adore finishes her call. Figure 9.2 provides a transcription of the three motives in the format of music theorist Kyle Adams's rhythmic transcriptions of hip-hop lyrics.[8] The rhythm is broken into eighth-note divisions, and we bold the lyric of the beat (or upbeat) on which players must push the button. If players are too early or late, the avatar stumbles over the words and earns irritated glances from their bandmates. After completing the minigame, the camera zooms out to reveal everything occurring on a television set with several characters from other minigames watching this music video. Players also perform

[8] Adams, "Aspects of the Music/Text."

Motive A

Beat	1	+	2	+	3	+	4	+
MC Adore	In-		to	you				
Player Character					In-		to	you

Motive B

Beat	1	+	2	+	3	+	4	+	1	+	2	+	3	+	4	+
MC Adore			Cra-	zy	in-		to	you								
Player Character									Cra-	zy	in-		to	you		

Motive C

Beat	1	+	2	+	3	+	4	+
MC Adore	Fo'		sho'					
Player Character			Fo'		sho'			

FIGURE 9.2: Rhythmic motives in "Love Rap."

as their avatar in Love Posse during several remixes.[9] Players progressing through *RHF* also advance the success of Love Posse by helping to market using the retro esthetic.

Through the multiple references to the music–video format during players' encounters with Love Posse, *RHF* utilizes retro nostalgia as a *diegetic*—that is, within the game's narrative world—marketing tool. Jessica Kizzire claims the VG industry profits from nostalgia through simultaneously working "to attract new audiences and to allow longtime fans to revisit the games of their youth."[10] In order to cater to the various audiences, she continues, "game designers strive to merge old and new elements in the same game."[11] *RHF* achieves a synergy between old and new by introducing minigames and characters from previous entries in the franchise while simultaneously providing new ways to play the games as players progress. While "Love Rap" is original to *RHF*, it activates and forges connections

[9] Chronologically, players see the Love Posse performing at a carnival in "Remix 6" after the first "Love Rap" and in a sleek black and red video setting in "Remix 9" shortly after "Love Rap 2." Players encounter Love Posse one more time in their original video format during "Remix 10"—the final review of all minigames in their original form.

[10] Kizzire, "The Place I'll Return to Someday," 183.

[11] Kizzire, "The Place I'll Return to Someday," 183.

with past characters from the franchise in combination with the retro-nostalgic music video.

Consequently, the music videos of "Love Rap" and its other iterations market the group within the *RHF*'s narrative economy. Players' participation in the rising fame of their avatar allows Love Posse to capitalize on nostalgic effects in their various music videos as players progress within the sequence of minigames. At the same time, *RHF* capitalizes on the personal experience of players by adopting music–video styles from the 1990s and 2000s, as well as other characters from within the franchise. The cover art and advertisements for *RHF* also feature these characters, eliciting connections with players familiar with the series. While retro nostalgia functions in *RHF*'s internal economy, the other minigames and intra-texts provide further emotional capital for players. Therefore, music videos work in *RHF* as commercially nostalgic multimedia stimulating memories of players with reminders of past decades, in conjunction with characters and situations from within the game and previous entries in the *Rhythm Heaven* series.

Yakuza 0

Released by SEGA in 2017, *Y0* is the sixth installment in the *Yakuza* VG series, though its setting in 1988 Osaka and Tokyo places it as a prequel to the first five installments. Players switch between two avatars, both *yakuza*, as they become embroiled in a conspiracy to consolidate power: Kazama Kiryu (the main protagonist of the series) and Majima Goro.[12] Most of the narrative has the protagonists engaging with an intricate plot that deals with intraorganizational power struggles and conspiracies, and players often fight their way through the story in the fashion of the brawler genre of VGs. *Y0* also includes several minigames identifying with retro nostalgia such as playable classic arcade VGs, and, most relevant to our research, karaoke. *Y0* attempts to capture the period of late 1980s Tokyo, down to the atmosphere of a smokey karaoke bar and stylistic conventions of the decade's music videos. The karaoke minigames combine two types of nostalgia: retro and episodic. The following section examines how these types of nostalgia surface in the format and general content of the karaoke minigame itself, as well as in two examples of karaoke songs in *Y0*, "Judgement -Shinpan-" and "Bakamitai."

[12] Yakuza are known in Japan as ヤクザ, among other names. Though the form of Japanese organized crime that they belong to has existed since the Edo period (*c.*1600–1868), yakuza have generally taken a more semi-legitimate, corporate approach to their enterprises in the modern Reiwa era (2019–present).

While retro nostalgia denotes a longing for a past that did not exist, *episodic nostalgia* refers to phenomena in which people experience transcendental moments activated by their memories. Philosopher Scott Howard claims nostalgia operates episodically by reliving an experience of a particular moment.[13] This moment, he continues, "is targeted in episodes of nostalgia are memory representations of the unrecoverable past, seen, at least in the moment, as meriting desire."[14] Episodic nostalgia is also called Proustian nostalgia, named for the French novelist and critic Marcel Proust whose work *In Search of Lost Time* provides the archetype. Howard describes Proustian nostalgic episodes as "nostalgic involuntary autobiographical memories triggered by a stimulus."[15] This definition applies to the episodes in the karaoke minigame. Cognitive psychologists Dorthe Berntsen and Nicoline Hall study Proustian nostalgia in their research on involuntary memory, and they conclude these episodes "influence the mood of the rememberer to be consistent with the emotional content of the memory and often come with a distinctive bodily reaction."[16] *Y0* shows a bodily reaction to a Proustian episode through Kiryu's participating in the music video in the second half of each karaoke song. Therefore, each karaoke song serves as a catalyst for Kiryu to experience a nostalgic episode.

The format and content of the karaoke minigame invite an episodic reading of *Y0*. Karaoke has been in the series since *Yakuza 3* (*Y3*, 2009), and each song experience has a similar structure. After entering the karaoke bar, players pick a song, and a musical introduction begins. Lyrics in both kanji (Chinese and Japanese characters) and romaji (Roman letter transliterations) are set as chyrons above button prompts on a horizontal line representing time (see Figure 9.3). After players successfully complete the first verse of the song, as the bottom image of Figure 9.3 shows, the karaoke bar disappears, the screen flashes white behind the visible control prompt, and the singer appears in a music video while singing the chorus and finally finishes the song. Once the song ends, the screen fades white again to bring the avatar back to the bar before players receive a score for their attempt. Behind the chyron, each song positions the avatar to sing first at the karaoke bar before transporting players into the avatar's episode of nostalgic imagination.

The episodic nature of the game is reinforced further because, due to players' immersion in Kiryu's imagination, the video's exact location in the diegesis of *Y0* during these moments is unclear. Jesper Kaae claims that certain sounds in VGs

[13] Howard, "Nostalgia," 641.

[14] Howard, "Nostalgia," 647.

[15] Howard, "Nostalgia," 644.

[16] Berntsen and Hall, "The Episodic Nature," 791.

FIGURE 9.3: Two screen captures of "Judgement -Shinpan-" from *Yakuza 0*. (*Top*) Kiryu performs in the karaoke bar. (*Bottom*) Kiryu experiences episodic nostalgia during the minigame.

have the potential to trigger players to "see" an image in a "quasi-synesthesia."[17] In this case, both players and Kiryu experience an exclusive fantasy due to a song. Negotiating these karaoke fantasies softens the image of Kiryu players sees throughout *Y0*, an unstoppable gangster who often solves problems with his fists. Another, perhaps better, way to explain this fantastical negotiation is Laurie Taylor's concept of *telepresence*. Telepresence is "based on the subject's presence in separate simultaneous areas that are based on differing spatial domains, but not necessarily differing geographical areas."[18] In other words, Kiryu exists both in the imaginative plane and in the karaoke bar. Recognizing the concept

[17] Kaae, "Theoretical Approaches," 87.

[18] Taylor, "When Seams Fall Apart."

of telepresence for players, Kaae observes this to be a special plane of conscious-ness between the "player outside the diegesis" existing on a "physical space of the players within the real world."[19] The effect layers on itself by way of episodic compartmentalization in *Y0* as the virtual entity of Kiryu meets players on this plane through his transcendence. Through this digital meeting, the karaoke minigame realizes Melanie Fritsch's concept of believing "that players of a game are 'immerses'—immersed in meaning…[taking] part in a complex interplay."[20] While the song in the karaoke bar is diegetic, Kiryu exists both in the narrative reality of the karaoke bar and in the space between game diegesis and the real world or a metadiegesis.

Although there are many such karaoke songs throughout the *Yakuza* series, we focus our attention on the two songs featuring Kiryu, both of which exem-plify the retro and episodic nostalgia operating in *Y0*: "Judgement -Shinpan-" and "Bakamitai."[21] In the former, Kiryu imagines himself as the frontman of a rock group, clad in leather with a red bandana wrapped around his head (as seen in the bottom image of Figure 9.3). Lighting rafters stand tall behind a chain link fence, and the band is set on a checkered stage in front of the fence. Kiryu is singing and playing guitar with supporting characters Akira Nishikiyama on guitar and Shintaro Kazama on keyboards. The three have a lengthy backstory dating back to the first game in the series, loading this scene with layers of meaning for both Kiryu and players familiar with earlier entries in the series. In contrast, the episode in "Bakamitai" takes Kiryu to a different bar with a soft filter. Kiryu sits alone, holding a photograph of the Sunshine Orphanage where he and Nishikiyama grew up in one hand and a drink in the other hand. Both videos include characters and events from previous installments in the series.

Retro nostalgia operates on several levels within the two karaoke songs. Both songs further reflect the game's retro-nostalgic milieu of 1980s Tokyo by employing esthetics from music videos from that era. Shelton Waldrep writes about the idea of attempting to capture another period as the attempt is "a simulacrum of the period, a[n] […] eighties album as it might exist in or for the [2000s]."[22] On the one hand, the costumes and setting of "Judgement" could allude to American videos such as Toto's "Rosanna," but it more likely refers to the video for "Heavy Chains" by 1980s Japanese metal group Loudness. In "Heavy Chains," the band, clad in leather and headbands, performs in front

[19] Kaae, "Theoretical Approaches," 114.

[20] Fritsch, "Beat It," 167.

[21] 馬鹿みたい, literally "I've been a fool."

[22] Waldrep, *Future Nostalgia*, 55.

of a chain link fence. The musical and clothing style of "Judgement" relating to "Heavy Chains" aligns the karaoke video with a retro esthetic centering on 1980s rock videos. On the other hand, rather than featuring an intertext to a particular video, "Bakamitai" features a music–video trope in the 1970s and 1980s featuring a singer drinking alone in a bar.[23] Examples of videos showing a singer alone at a bar includes George Thorogood's "I Drink Alone," Kenny Loggins's "Meet Me Halfway," and Vicente Fernandez's "Volver Volver;" all songs share the lyrical theme of sorrow or regret. While relating to the American examples in these ways, "Bakamitai" shows a distinctly Japanese bar with traditional lamps adorning the ceiling. In either case, both songs deploy recognizable imagery from a retro 1980s Tokyo setting.

Episodic nostalgia initiates with the music-video portion of the karaoke game, which enables players to witness Kiryu's nostalgic memory. In the case of "Judgement," the episode unfolds as a fantasy of leading a rock band with their close friends. The video portion features only Kiryu and Nishikiyama in the leather clothing, but Kazama is wearing his normal suit. This clothing glitch could signify an imperfect episode for Kiryu. Alternatively, there is a possibility that Kiryu cannot imagine his father figure (Kazama) in leather clothing; the protagonist's memory overrides the costume for his keyboardist. In contrast, "Bakamitai" activates and interacts with Kiryu's memory. Players see a music video of Kiryu sorrowfully drinking while staring at a photograph of his childhood home. "Bakamitai" could also be a recent memory, causing the photograph to become a memory within a memory—or metanostalgia. This experience in Y0 concentrates on prior events to the franchise's narrative and has extra nostalgic baggage for players familiar with previous installments of Yakuza. The song "Bakamitai" first appeared in Yakuza 5 (Y5, 2012) with a similar video, but with Kiryu's pet dog named Rex appearing in the photograph. In Y3, Kiryu found Rex roaming the now rebuilt orphanage, called the Morning Glory Orphanage, and at the end of Y3, Rex became the official pet for the orphanage. Thus, players familiar with Y3 are treated to a callback to Rex in Y5's "Bakamitai," and players familiar with Y5 will recognize the similar episode in Y0's version. Furthermore, Yakuza Kiwami (2016),[24] a remake of the original Yakuza (Y, 2005), contains a remix of "Bakamitai" with the same mise en scene, but with a side character unique to Y0, Pocket Circuit Fighter, on the photograph. Thus, "Bakamitai" follows Kiryu throughout his life from remembering the

[23] This is similar to the concept of stylistic allusion described by Justin Sextro in his chapter earlier in the volume, "'This Game Stinks': Musical Parody and Nostalgia in EarthBound."

[24] English title, known in Japan as 龍が如く極 (Ryū ga Gotoku: Kiwami, literally "Like a Dragon: Extreme").

innocent days of the Sunshine Orphanage in *Y0*, to missing his friend in *Kiwami*, and finally to recalling Rex and the events of *Y3* in *Y5* (set in 2012). Each of these karaoke experiences features characters and events relevant to Kiryu, each with their own strong emotional attachment to the protagonist. Kiryu's memories of these characters and events bind to a specific song within the karaoke catalog of each game. Therefore, karaoke songs in the *Yakuza* series work as a catalyst for episodic nostalgia at various points in Kiryu's memory.

Developers since *Y3* have capitalized on the nostalgia built into the karaoke minigame. Even *Y0*'s website advertises:

> Belt Out the 80's! The popular karaoke mini-game returns! This game's karaoke bar is made to match karaoke of the 80's era. Sing passionately with friends, or put in original interjections to add some excitement to the song. You can also invite girls here on a date or just have a drink.[25]

The developers of *Y0* are well aware of the nostalgic connection between karaoke and previous installments of the series. *Kiwami* features two more songs for Kiryu, and the nostalgic episodes reminisce on Kiryu and Nishikiyama's friendship in *Y0* ("Tonight -restart from this night-") and Kiryu's ten-year jail sentence in the events of *Y* ("Ijisakura 2000"). Each of these songs is featured on albums that are available to stream via Spotify or are available to purchase.

Y0's success, like "Love Rap," depends on the activation of nostalgia in both preexisting fans and newcomers. The developers of *Y0* take advantage of this emotional capital affiliated with karaoke through marketing its musical media in the form of compilation albums featuring versions of the karaoke songs.[26] *Y0* and "Love Rap" envelop their music videos in a retro esthetic centering around a particular decade. The karaoke minigame uses episodic nostalgia as a vehicle for its music–video presentation. Both minigames immerse players in the video performance, and *Y0*'s albums allow players access to the karaoke songs outside of the game. Thus, the karaoke minigame and its related commercial media are prime examples of marketing both immersive retro and episodic nostalgia. The next example changes the role of players from performers to directors while simultaneously immersing them in both retro and future nostalgia or an idealized future focusing on the past pop culture.

[25] Sega, "Yakuza 0" (website).

[26] Sebastian Diaz-Gasca writes more on multimedia based on videogame in his chapter "And the Music Keeps on Playing: Nostalgia in Paraludical Videogame Music Consumption" earlier in this volume.

Omega Quintet

Our final case study differs from the previous two in gameplay mechanics and therefore in analysis. The narrative content of *OQ* offers a critique of some oppressive structures extant in the Japanese music industry through a lens of future nostalgia and the historical contextualization of idol culture. Because of the comparative complexity of this case, our final section theorizes future nostalgia as the means to frame this critique, explains how retro and future nostalgias operate within the game, and contextualizes idol pop culture within Japan. Whereas the nostalgias of the previous sections allowed us to examine the marketing strategies of games, the framework here broadens our understanding of the role marketing plays in Japan's larger economic and gender structures.

The Japanese role-playing game *OQ* was released in 2014 for the PS4, and it depicts future nostalgia as its characters dream of an ideal future in a dystopian present alongside elements glorifying the past.[27] Reynolds describes future nostalgia as "an archaic and sometimes comically ossified idea of what the future is going to be like," projecting "those sensations of wistfulness, mixed with irony, amazement, offset by amusement."[28] He suggests that future nostalgia emerged prominently in the mid-twentieth century science-fiction film and popular music. Both media tended to include themes of what life could be like in either utopian or dystopian futures. Examples of the former include the *War of the Worlds* (1953/2005), *Invasion of the Body Snatchers* (1956/1978), and the *Planet of the Apes* (1968). Reynolds also identifies examples in the works of British music groups The Focus Group, Belbury Poly, and The Advisory Circle.[29] Not unlike retro nostalgia, future nostalgia can long for alternative (ideal) futures, imagined futures, or, as in the case of *OQ*, long for an ideal past while situated in a dystopian future.

OQ's narrative and use of music set the stage for future nostalgia, as they draw heavily on Japan's past (and present) cultural activities. First, *OQ* is set in a dystopian futuristic Tokyo in which most of the world has been affected by the Blare, an aural phenomenon that possesses organisms, breaks their minds, and transforms them into monsters. *OQ*'s "ossified" trope common to dystopian science-fiction stories is the threat humanity faces in the future posed by an evolved, sinister entity. Second, the sensations Reynolds identifies—amazement,

[27] *OQ* could also fall into the anime game genre, or a VG with an art style resembling Japanese animation; *OQ* features other paratextual elements common in anime such as an opening and closing credit sequence between each of its episodic chapters.

[28] Reynolds, *Retromania*, 370.

[29] Reynolds, *Retromania*, 330.

amusement, and perhaps irony—that accompany dystopian futures rest with the idol group called the "Verse Maidens." The group comprises young women who use sound weapons to harness song and dance to eliminate the Blare and its monsters, and they draw their musical power from the responses of their fan base. The term *idol*, according to Patrick Galbraith and Jason Karlin, "refer[s] to highly produced and promoted singers, models, and media personalities [...] [who] tend to be young, or present themselves as such."[30] Idols are expected to make daily contact with their fans through the marketing power of their management company, or *jimusho*. The Verse Maidens tap into these traditions by featuring idol pop music, a genre of Japanese popular music since the 1970s. In *OQ*, Idol pop music is the music of the future as well as humanity's only defense against the Blare. Moreover, the Verse Maidens must stay in frequent contact with their fans because they draw musical power to combat the Blare from the audience's responses. Finally, the Verse Maidens interact with their audiences through Takt, their *jimusho* and the player-controlled character. *OQ's* narrative and weaponization of idol pop music thus offer a powerful apparatus for nostalgia to appear within its Japanese dystopian future.

While most of the gameplay follows JRPG conventions, *OQ* also features the Promotional Video System (PVS), a music video editor minigame that puts players into the director's seat, that the player must use once to progress the story. Despite the game narrative revolving around the five powerful women idols, players mostly control the teenage male protagonist and manager of their *jumisho*, Takt. Early in the story, Takt participates in a quest to create a new promotional video to introduce fans to the new Verse Maidens. After selecting a song, players are given a template they can alter (seen in Figure 9.4), allowing them to choose several options: which Verse Maidens perform, their vocal assignment to certain parts of the song, the group's placement on stage, what they wear, how they dance, and how the camera moves. Eventually, Takt may add all five Verse Maidens of the Omega Quintet to the playable party. Only Verse Maidens who have joined the party of players are available to make a video, and new songs become available through the narrative as Verse Maidens join the party. Players only need to make one video to advance the narrative, but they can return any time to make more.

Both retro and future nostalgia activate through the PVS by way of the music–video presentation. On the one hand, retro nostalgia manifests through the connections with the real idol industry. The videos of *OQ* adopt the simple mise en scene of the daily videos idols release to keep in contact with their fans and maintain

[30] Galbraith and Karlin, "Introduction," 2.

FIGURE 9.4: Two screen captures of the PVS in Omega Quintet.

their popularity, which occurs often through stage performances or low-budget videos limited to a single setting. In *OQ*, a variety of dance moves are available that would be nostalgic to players familiar with the genre. Two actual idol producers, Lantis and WILL, compose and produce the songs and score for *OQ*. The soundtrack pages for the *OQ* website boast the actual voice actors of the Verse Maidens as the singers of each track, adding a personal touch for fans of *OQ* that

are also fans of specific voice actors.[31] Through relating to generic idol videos, the PVS videos channel future nostalgia from players' ideal idol performance. The developers capture the retro esthetic of idol pop through dance and outfits, and players present an idealized idol performance in *OQ* through the PVS. On the other hand, future nostalgia for the idols in *OQ* surfaces closely in the game's endings. Of the two possible endings players can experience when they beat the final boss, the typical ending of *OQ* seems like the ideal future for Takt, since he maintains his control over the Verse Maidens.[32] The "normal" ending of the first playthrough has one Verse Maiden perish, and the Blare remains; therefore, the *jimusho* does not lose its purpose. On the other hand, the "True" ending seems to be the ideal future for the Maidens as well as the rest of the world. To achieve the "True" ending, players must start the story over while retaining their statistics and inventory in a New Game + mode to achieve the prerequisites for the second ending. The "True" ending presents an alternative future nostalgia—a future without the Blare where all the Verse Maidens survive to live out their ideal future—achievable only after multiple playthroughs.

The types of nostalgia inherent to the alternative endings reveal the marketing strategies of *OQ*'s developers. While the best ending is the goal for players and the idols, the regular game world and the normal ending is the ideal future for the developers since it is what sells *OQ* and has players replay it additional times. Christophe Thouny provides an analysis for the Miyadai Shinji concept of the "never ending everyday" (*owarinaki nichijō*) which he translates and explains as normalizing Armageddon. Thouny states the "apocalypse has become the imperative to reproduce the social structure, at the very level of everyday life [...] everyday is now the critical moment."[33] Through the never-ending everyday, dystopia and utopia exist in the same diegetic sphere due to a desire for a constant crisis. Thus, the never-ending everyday is a type of future nostalgia. In this sense, *OQ* is a reflection on the idol industry within a postapocalyptic world. The normal ending results in a perpetuation of the never-ending everyday focusing on future nostalgia since the world would be the same. Achieving the best ending progresses a different never-ending everyday through the lens of retro nostalgia by returning idols to their original economic purpose of entertainment.

[31] Compile Heart, "Omega Quintet: Music" (website).

[32] There are five different ending scenes for the best ending serving as a conclusion on your relationship with each member of the quintet. The ending scene does not affect the content of the best ending. A player also achieves a bad ending, or game over, when the avatars lose a battle.

[33] Thouny, "Waiting for the Messiah," 114; Miyadai, *Owarinaki nichijō o ikiro*, 111.

Moreover, these nostalgic readings of *OQ's* endings illuminate more broadly the role of marketing in the Japanese idol industry, as well as the country's oppressive economic power structures. Both endings for the woman musicians result in their sustained oppression—each another never-ending everyday. Recalling the definition of Galbraith and Karlin, idols serve entertainment purposes, a disposable commodity valuing celebrity spectacle, and they are a large part of the hypercapitalist market in Japan.[34] The *jimusho*, W. David Marx argues, seeks commodities of visual consumption and allows "big stars to be poor actors, bad singers, and unskilled dancers, but they can certainly not be controversial, unattractive or otherwise disruptive."[35] *OQ's* idols are not real idols; they are virtual idols voiced by real singers. While most idols are flesh-and-blood, virtual idols such as Hatsune Miku and the ones within the game *THE iDOLM@STER* (2005) give the consumer full control of their performance. Daniel Black, discussing *THE iDOLM@STER*, states the following:

> The game thus caters to fantasies of ownership over idols, reflecting the real-life gendered power relations between male music producers and the disposable, commodified young girls in which they deal. In playing the game, the fan consumes a fantasy of production: rather than being cast as consumer of the idol text, the fan experiences [...] [directing] idols to produce texts for the consumption of others.[36]

Black describes the PVS in *OQ* as well as the mechanics of *THE iDOLM@STER*. *OQ* features the power dynamic between the male producer (Takt) and the disposable quintet, the ability to participate in a production fantasy, and the player can share their videos with other players or consumers. For this reason, *OQ* also can be classified as an idol simulator genre, as well as a metonymic music game, as the music video immerses players further into the power structure within the *jimusho* rather than that of a performer. The *jimusho* are relentless and oppressive in their tactics for controlling their idols, and *OQ* places players in the role of the *jimusho* for the titular group.

The PVS in *OQ* relays the power struggles present in the idol industry while progressing the Verse Maidens towards their ideal future. While idols have become an important product in the Japanese economic system, *OQ's* idols are the *only* commodity in the game's dystopia—they are essential to human survival in its never-ending everyday. The best ending, impossible on the first playthrough, shifts

[34] Galbraith and Karlin, "Introduction," 2.

[35] Marx, "The *Jimusho* System," 51.

[36] Black, "The Virtual Idol," 220.

the purpose of idols from survival back to entertainment. Due to the "economic" system in the best ending, the idols are not free from oppression. Their commodification and consumption shift from one of necessity to luxury. Related to this, feminist theorist bell hooks claims the "positive impact of liberal reforms on women's lives should lead to the assumption that they eradicate systems of domination."[37] While the best ending only shows celebration after the Blare's defeat, idols are the now only commodity responsible for entertainment. Due to this, Takt and the *jimusho* benefit either way; they still exert power over the women idols to produce capital. The best ending is just a different type of never-ending everyday.

In sum, *OQ*'s narrative encapsulates future nostalgia. Idols are the only glimmer of hope for civilization, an idealized conception of an industry that, in real life, is exploitative and capitalizes on the power imbalance between producers and products inherent in the commodification of people. The expectations of the idealized conception turn out to be unrealistic due to the impossibility to achieve the best ending. Thus, *OQ* interprets the current idol industry as perpetually unsustainable through the normal ending; an idol must live a literal second life to achieve their ideal ending. In *OQ*'s future, idols are so entrenched in the idealized market, their effect is exponential to the point they reach a "savior" status. As part of the never-ending everyday, the Verse Maidens connect directly to the concept of future nostalgia through fetishization of dystopia. They are the sole market, and the Omega Quintet is the only commodity within the market producing survivability. *OQ* and the normal ending prolong the future nostalgic world while the best ending reverts to the retro nostalgia role of idol as entertainer. The goal of the promotional videos is to increase fan support, allowing the Verse Maidens to move towards the ending. Each ending presents two versions of future nostalgia: the normal ending enforcing the status quo and the best ending permanently benefitting both the idols and the rest of humanity. Therefore, the PVS encapsulates future nostalgia by showing a preview of this ideal future—singing in performance rather than battle—while also serving as the primary vehicle for reinforcing the never-ending everyday through its idealized production of idol music videos in its unsustainable economy.

Conclusions

Immersive nostalgia operates on different levels through music videos in VGs. In *RHF*, the "Love Rap" minigame refers to the esthetic of hip hop in the 1990s–2000s. *YO*, already saturated with retro nostalgia due to its setting,

[37] hooks, *Feminist Theory*, 21.

immerses players in an avatar's nostalgic episode through the presentation of a music video in the karaoke minigame. *OQ* situates players as directors of idol music videos to realize an idealized future of the game characters, a mode of future nostalgia. While *RHF* channels retro nostalgia and *OQ* employs future nostalgia, *Y0* propels players into Kiryu's nostalgic episode. Immersive nostalgia operates as a feeling of fondly looking towards the past, an episodic phenomenon of reliving a memory, prophesying the ideal future, or combinations of the three.

Each game publisher advertises the music–video components in their marketing campaigns. Many minigames in *RHF* already resemble music videos in their mise en scene, and minigames featuring vocals include paratextual chyrons identifying the vocalist at the beginning of the video. The *Y0* marketing team knew about the nostalgic attachment preexisting players have with the karaoke minigame and attempted to attract new consumers by emphasizing the minigame's retro nostalgia of the 1980s. The publishers of *OQ* make its commodities widely available for consumption due to the sharing aspect of the PVS and availability through physical recordings. The nostalgic markers of each game therefore presented VG the opportunity to increase revenue.

Each example in our chapter purposes nostalgia as a marketing tool either in real-life advertisement campaigns or in the narrative economy of games, as in *RHF* and *OQ*. Each case study has another layer of nostalgic music–video practice superimposed on its musical esthetic. Publishers' capitalization on immersive nostalgia suggests a cost-efficient method to strengthen a brand, and it activates emotional investment to create new connotations between VGs and player–avatar relationships. Music videos, a postmodern byproduct of capitalist marketing for a musical artist, produce emotional capital in VGs by importing its practices and tropes that culturally sensitive players might recognize, reflected in the response of the avatars in music videos. Kiryu remembers and rebuilds these practices in his nostalgic imagination, the Love Posse fictionally capitalizes on nostalgia, and *OQ* provides nostalgic commentary on a cultural and musical industry.

LUDOGRAPHY

Hatsune Miku: Project DIVA. Sega, Crypton Future Media, and Dingo. Sony Playstation Portable. Sega, 2009.

Omega Quintet. Galapagos RPG. Sony PlayStation 4. Compile Heart, 2014.

Rhythm Heaven Fever. Nintendo SPD and TNX Music Recordings. Nintendo Wii. Nintendo, 2011.

THE iDOLM@STER. Metro and Namco. Microsoft XBOX360. Namco, 2005.

Yakuza 0. Ryu Ga Gotoku Studio. Sony PlayStation 4. Sega, 2015.

Yakuza 3. Sega CS1 R&D. Sony PlayStation 3. Sega, 2009.

Yakuza 5. Ryu Ga Gotoku Studio. Sony PlayStation 3. Sega, 2012.

Yakuza Kiwami. Ryu Ga Gotoku Studio. Sony PlayStation 4. Sega, 2016.

BIBLIOGRAPHY

Adams, Kyle. "Aspects of the Music/Text Relationship in Rap." *Music Theory Online* 14, no. 2 (May 2008): http://www.mtosmt.org/issues/mto.08.14.2/mto.08.14.2.adams.html.

Backstreet Boys. "I Want It That Way." Uploaded October 25, 2009. 3:39. https://youtu.be/4fndeDfaWCg.

Berntsen, Dorth and Hall, Nicoline. "The Episodic Nature of Involuntary Autobiographical Memories." *Memory & Cognition* 32, no. 5 (2004): 789–803.

Black, Daniel. "The Virtual Idol: Producing and Consuming Digital Femininity." In *Idols and Celebrity in Japanese Media Culture*, edited by Patrick Galbraith and Jason Karlin, 209–25. Chippenham: Palgrave Macmillan, 2012.

Cypress Hill. "Cypress Hill—Lowrider." Uploaded November 23, 2009. 4:06. https://youtu.be/mMWBh0B9F0M.

Fritsch, Melanie. "Beat It!: Playing the 'King of Pop' in Video Games." In *Music Video Games: Performance, Politics and Play*, edited by Michael Austin, 153–76. London: Bloomsbury Academic, 2016.

Galbraith, Patrick, and Jason Karlin, eds. *Idols and Celebrity in Japanese Media Culture.* Chippenham: Palgrave Macmillan, 2012.

Gibbons, William. *Unlimited Replays: Video Games and Classical Music.* New York: Oxford University Press, 2018.

hooks, bell. *Feminist Theory: from Margin to Center.* Boston: South End Press, 1984.

Howard, Scott. "Nostalgia." *Analysis* 72, no. 4 (October 2012): 641–50.

Ice Cube/Cubevision. "Ice Cube—It Was a Good Day (Official Video)." Uploaded February 24, 2009. 5:12. https://youtu.be/h4UqMyldS7Q.

Ice Cube/Cubevision. "Ice Cube—Steady Mobbin." 1991. Uploaded March 4, 2009. 2:17. https://youtu.be/tMxXtOU09tM.

Kaae, Jesper. "Theoretical Approaches to Composing Dynamic Music for Video Games." In *From Pac-Man to Pop Music: Interactive Audio in Games and New Media*, edited by Karen Collins, 75–92. Aldershot: Ashgate, 2008.

Kenny Loggins. "Kenny Loggins—Meet Me Halfway." Uploaded October 4, 2013. 3:33. https://youtu.be/3pYNd0MSVXs.

Kizzire, Jessica. "'The Place I'll Return to Someday' : Musical Nostalgia in *Final Fantasy IX.*" In *Music in Video Games: Studying Play*, edited by Kevin J. Donnelly, William Gibbons, and Neil W. Lerner, 183–98. New York: Routledge, 2014.

Kunkle, Sheila. "Psychosis in a Cyberspace Age." *Othervoices: The (e)Journal of Cultural Criticism* 1, no. 3 (1999). http://www.othervoices.org/1.3/skunkle/psychosis.html.

Laurel, Brenda. *Computers as Theatre.* Reading: Addison-Wesley Publishing Company, 2014.

Maroon 5. "Maroon 5—Makes Me Wonder (Official Music Video)." Uploaded December 13, 2009. 3:43. https://youtu.be/sAebYQgy4n4.

Marx, W. David. "The *Jimusho* System: Understanding the Production Logic of the Japanese Entertainment Industry." In *Idols and Celebrity in Japanese Media Culture*, edited by Patrick Galbraith and Jason Karlin, 36–56. Chippenham: Palgrave Macmillan, 2012.

Miyadai, Shinji. *Owarinaki nichijō o ikiro! Oum kanzen kokufuku manyuaru* [Live an endless everyday: A manual for completely overcoming Aum]. Tokyo: Tsikuma Shobō, 1995.

Omega Quintet. "Music" (website). Accessed October 30, 2019. http://ideafintl.com/omega-quintet/#/sound.

PacoThrashammer. "Loudness—Heavy Chains (Official Video) [HD]." Uploaded April 17, 2011. 4:25. https://youtu.be/Pl1vhqaRvTM.

RedDome1995. "Mack 10 ft. Nate Dogg—Like This (Official Music Video) HD." Uploaded May 18, 2011. 3:44. https://youtu.be/HbdWIJjzBgE.

Reynolds, Simon. *Retromania: Pop Culture's Addiction to Its Own Past*. London: Faber, 2012.

Stoia, Nicholas, Kyle Adams, and Kevin Drakulich. "Rap Lyrics as Evidence: What Can Music Theory Tell Us?" *Race and Justice* 8, no. 4 (2017): 330–65.

Taylor, Laurie. "When Seams Fall Apart: Video Game Space and the Player." *Game Studies: The International Journal of Computer Game Research* 3, no. 2 (December 2003). http://www.gamestudies.org/0302/taylor/.

Tessler, Holly. "The new MTV?: electronic arts and 'playing' music." *From Pac-Man to Pop Music: Interactive Audio in Games and New Media*, edited by Karen Collins, 13–26. Aldershot: Ashgate, 2008.

Thergothon1. "I Drink Alone—George Thorogood and the Destroyers." Uploaded October 2, 2016. 4:32. https://youtu.be/4E9ydw_aDMg.

Thouny, Christophe. "Waiting for the Messiah: The Becoming Myth of *Evangelion* and *Densha otoko*." *Mechademia 4: War/Time*, edited by Frenchy Lunning, 111–30. Minneapolis: University of Minnesota Press, 2009.

TotoVEVO. "Toto—Rosanna (Official Music Video)." Uploaded January 10, 2013. 5:27. https://youtu.be/qmOLtTGvsbM.

U2. "U2—Beautiful Day." Uploaded December 23, 2009. 4:10. https://youtu.be/co6WMzDOh1o.

Unearthed Sound. "Dr. Dre.—Keep Their Heads Ringin' (Dirty) Music Video." Uploaded August 16, 2010. 5:11. https://youtu.be/1yFfQtd-A5A.

Vincentefernandez. "Vincente Fernández—Volver Volver." Uploaded December 5, 2008. 2:59. https://youtu.be/ugNQ5uIN09Q.

Waldrep, Shelton. *Future Nostalgia: Performing David Bowie*. New York: Bloomsbury Academic, 2016.

Yakuza 0. "World" (website). Last updated in 2018. https://yakuza.sega.com/yakuza0/world.html#.

10

Remembering Tomorrow: Music and Nostalgia in *Fallout*'s Retro-Future

Jessica Kizzire

In the post-apocalyptic setting of Bethesda's *Fallout 3* (*F3*, 2008), players explore an inhospitable retro-future grounded in the esthetics of mid-twentieth century America. Players inhabit the ruins of Washington, DC, now dubbed the Capital Wasteland, approximately 200 years after conflicts between the United States and China over scarce resources resulted in global nuclear destruction. Amidst the rubble of familiar monuments, they contend with mutated creatures, hostile forces, and irradiated food, fighting for survival in the harsh environment. Taking the development of the atomic bomb as the point of departure, *Fallout* projects an alternative timeline in which "technology progressed at a much more impressive rate, while American society remained locked in the cultural norms of the 1950's. [*sic*] It was an idyllic 'world of tomorrow,' [...] [until] it all went to hell in a globe-shattering nuclear war."[1] As a result, the ruins and artifacts strewn throughout the rubble of the Wasteland reflect the art, architecture, and values of mid-century American society.

Situating its analysis within the broader context of alternative histories and nostalgia studies, this chapter examines the use of nostalgic aural signifiers in *F3*, addressing the careful selection of licensed music heard on the game's diegetic radio stations and exploring the often ironic function these elements assume within the gameworld.[2] It begins by bringing together these two overlapping areas of research, advocating for

[1] This description comes from the official booklet included with *Fallout 3*. The Fallout 3 Team, *Vault Dweller's Survival Guide*, 5.

[2] Ivănescu also examines the significance of nostalgia in the licensed music of the *Fallout* games, exploring several musical selections that this chapter will examine in detail. However, while

the consideration of alternative histories as a form of nostalgic engagement. It then offers a close look at the use of nostalgic audio tropes as a critical part of *F3*'s overall esthetic before concluding with an investigation of the radio's diegetic appeals to NPC and player nostalgia using Svetlana Boym's categories of reflective and restorative nostalgia.[3] By examining the multi-faceted ways *F3*'s licensed music engages with nostalgia, this study demonstrates the ways in which nostalgia can participate in a sophisticated process of reflection and act as a form of historical consciousness.

Alternative pasts and nostalgic possibility

When scholars address games in the *Fallout* franchise, particularly *F3*, most examine its presentation of an alternative history. Karen Hellekson's exhaustive taxonomy of the alternative-history genre in science fiction identifies narratives like *F3*'s as "true alternate histor[ies]" because the events of the game take place many years after the fictional timeline diverged from our own.[4] Hellekson further argues that works in this genre inherently invite their audiences to question their foundational assumptions about history, thus reshaping their relationship with and understanding of it.[5] In studies focusing on alternative history videogames, the emphasis turns to issues of player agency. William Uricchio concludes historical simulation games "thriv[e] upon the creative interaction of the user" and as a result encourage "a more abstract, theoretical engagement of historical process."[6] By giving players the ability to change the outcomes of history in concrete and meaningful ways, alternative history games provide an opportunity for them to rethink the historical narratives familiar to them in new contexts.

Historians' explorations of *F3*'s alternative history primarily focus on the implications of its narrative and setting. Tom Cutterham highlights the ways *F3* simultaneously plays on and plays with gamers' knowledge of US history—a feature that encourages critical engagement.[7] By preserving recognizable monuments and

Ivănescu's work effectively describes the nostalgic quality of the music heard on in-game radio stations, it largely overlooks the significant ironic commentary the music produces in the game. Ivănescu, Popular Music in the Nostalgia Video Game, 110–25.

[3] NPC stands for non-playable character.

[4] Hellekson calls this point of departure a "nexus event." Hellekson, "Toward a Taxonomy of the Alternate History Genre," 253.

[5] Hellekson, "Toward a Taxonomy," 255.

[6] Uricchio, "Simulation, History, and Computer Games," 328–30.

[7] Cutterham, "Irony and American Historical Consciousness in *Fallout 3*," 321.

addressing historical narratives like slavery in a fictional dystopian context, *F3* invites players to question the ideological basis for the narratives that underlie their historical consciousness. Joseph November looks more specifically at the ways *F3* uses irony to emphasize the political and social tensions inherent to US Cold War society. In giving them agency to preserve or destroy society's remnants, *F3* invites players to confront mid-century American fears that technological utopia might come at the expense of American democratic values.[8] Through their actions, players choose which vision of American society ultimately triumphs, giving them a unique way to engage the anxieties of a previous era in American history within the context of their own experiences.

Although these studies include extensive discussions of the ironic imagery and narrative context in *F3*, they take for granted the way the visual and aural signifiers of mid-century American life operate within the game because they fail to address the role of nostalgia. In describing the setting of *F3*, November indicates the way social norms in the game deviate from players' everyday experiences:

> Looking to the future, [Americans in the 1950s] observed the changes in their own lives and projected those changes ahead. In many ways, *Fallout* captures that projection —the game's future is in line with 1950s norms and expectations, rather than our own.[9]

While this description of the game accurately represents its values and esthetics, it also stops short, failing to acknowledge that the idea of the 1950s at the heart of that process is itself a nostalgic representation.

In *F3*, nostalgia operates as the lens through which players engage the game's alternative historical setting; it brings mid-century American society into a distant retro-future. At its core, nostalgia is a form of historical engagement that connects a perceived past (lived or otherwise) with the present moment.[10] Originally limited to a sense of homesickness, the term has taken on broader meanings in modern times. Svetlana Boym describes it simply as a "[way] of giving shape and meaning to [our sense of] longing."[11] We engage with nostalgia in many ways, for many different reasons, and subjects of nostalgia run the gamut from things or places

[8] November, "*Fallout* and Yesterday's Impossible Tomorrow," 298.

[9] November, "*Fallout*," 299.

[10] Justin Sextro's chapter within this volume also addresses nostalgia as a form of historical consciousness, describing the ways in which culturally coded meanings and player recognition of stylistic references influence our perception of game sounds as nostalgic elements.

[11] Boym, *The Future of Nostalgia*, 41.

we have experienced personally in the past to those we have never encountered. Ekaterina Kalinina provides a comprehensive exploration of the many disciplinary perspectives on nostalgia and the ways our understanding of it have changed over time.[12] Nostalgia is multifarious; it can be a feeling, an emotion, a sense of cultural awareness, an act of memory, or a vehicle of ideology. In all of these capacities, nostalgia's mingling of past and present opens the door to critical reflection on the relationship between the two.

When nostalgia operates as a form of historical engagement, as it does in *F3*, it encourages the contemplation of different historical possibilities. Much like the invitation of alternative histories to ask what if, nostalgia empowers us to pursue unexplored outcomes through revisiting the past.[13] Taken together with positive psychology's view that it serves a useful function for maintaining our self-identity during times of uncertainty, nostalgia also serves a crucial role in our projections of the future.[14] In the words of cinema scholar Christine Sprengler, "the past envisioned today functions as a blueprint for a better tomorrow."[15] The nostalgic explorations that bring the past into the present unlock the possibilities of both alternative pasts (as we remember them or as they might have been) and the potential futures that could have resulted from them. When November describes the ability of *F3*'s alternative history to explore the fears and anxieties of a previous time in American history, he describes a nostalgic engagement with our historical consciousness. Looking back to that historical moment and re-envisioning it through the lens of an alternative timeline forces audiences to re-engage with the past in new ways, bringing our history into our present.

Going beyond this ability to entertain other historical possibilities, *Fallout* relies on nostalgic aural and visual tropes to create its carefully crafted retro-future. The cultural artifacts that litter the Capital Wasteland and resound across its radio airwaves invoke the Fifties, while the ruins and destruction of the desolate landscape signal a distant future.[16] November aptly points out that this "paradoxical sense that the game is set both in the future and in the past" is "central to the player experience."[17] Indeed, this unusual esthetic defines *Fallout* and lies

12 Kalinina, "What Do We Talk About?" 6–15.

13 Chrostowska, "Consumed by Nostalgia?" 55.

14 Kalinina, "What Do We Talk About?" 11.

15 Sprengler, *Screening Nostalgia*, 74.

16 Here I use Sprengler's distinction between the historical period of the 1950s and the "mythic, nostalgic construct" that represents that period in popular culture. Sprengler, *Screening Nostalgia*, 39.

17 November, "*Fallout*," 301.

at the heart of analyses on its use of irony, including Cutterham's exploration of the game's questioning of American historical consciousness.[18] Yet questions of how these visual and aural signifiers of the past rely on nostalgia to create *F3*'s retro-future remain largely unexplored.

Sounds of a retro-future

The game achieves its retro feel because it successfully taps into the nostalgic details that best signify the Fifties, relying on myriad visual and aural cues. Because nostalgic cinema widely uses objects such as tail-finned cars, jukeboxes and colorful home appliances to capture the esthetic of what Sprengler calls the "Populuxe Fifties," these images have become ubiquitous with our historical conception of the period in popular culture.[19] As she notes, these images go beyond a simple representation of the consumerism of the period, also signaling the broader social and political values associated with it.[20] *F3* relies on players' recognition of these visual and aural details, using these signifiers of the Fifties as the springboard for the game's dystopian retro-future. Of the game's many diegetic radio stations, Galaxy News Radio (GNR) contributes most strongly to the overall Fifties esthetic through its musical programming.[21] As Boym observes, music and nostalgia share a close relationship: "The music of home, whether a rustic cantilena or a pop song, is the permanent accompaniment of nostalgia."[22] As Michael Vitalino and Vincent Rone describe in Chapter 1, the close links our brains perceive between music, emotion, and memory give music an incredible nostalgic power when coupled with the immersive experience of videogames. Music can take us back—back to a time we may or may not have experienced.

Although many visual details play a critical role in creating *F3*'s retro-future, the game's licensed music provides verisimilitude in a way that the visuals of the game cannot. Barbara Stern observes the importance of verisimilitude for nostalgia, calling it "the key that unlocks the imagination" because it creates "the illusion

[18] Cutterham, "Irony," 313–26.

[19] Sprengler, *Screening Nostalgia*, 58.

[20] Sprengler, *Screening Nostalgia*, 49.

[21] This chapter will primarily focus on the nostalgic implications of the music on GNR and Enclave Radio. For a summary of the musical content and nostalgic implications of Agatha's Station, which plays classical music, see Cheng, *Sound Play*, 31–34.

[22] Boym, *The Future of Nostalgia*, 4.

of reality conveyed by faithfully depicted details."[23] While the architecture, styles of dress, consumer goods, and advertisements of the Capital Wasteland clearly rely on the esthetics popular during the 1950s, these artifacts are also tailored to the *Fallout* universe. For example, a cola advertisement in the 1950s might have advertised Coca Cola, while the poster in *F3* advertises its fictional equivalent, Nukacola. By contrast, the music heard on GNR escapes this tailoring process, existing in the same form in-game as it does outside of it. In the end, this distinction does not make an appreciable difference in our perception of the visuals—we still perceive them as Fifties-ish—but the music's concrete links to our historical awareness help legitimize the retro feel the game strives to achieve.

 F3 embeds these Fifties nostalgic references within a broken dystopian future, and as a result, these artifacts (musical and otherwise) take on new ironic meanings. Presented alone the retro Fifties esthetics might offer a celebration of the consumerist culture that spawned them, but instead *F3* scatters their remains across the desolate Wasteland. Tattered advertisements and broken consumer products litter the rubble of crumbling buildings, and what little music can be heard on the radio is understood to be all that remains. This juxtaposition of Populuxe past and dystopian future destroys the images and sounds of the consumerist utopia, creating a scathing criticism of the gameworld's misguided history.[24] Marcus Schulzke addresses the ironic effect of this dynamic, arguing that *F3*'s destruction of the utopian vision serves as a warning that invites players to learn from the past.[25] November, Cutterham and Schulzke have all examined the ironic role of *F3*'s Fifties visual esthetics, but less attention has been paid to the ironic role of GNR's musical selections. As players venture into the Capital Wasteland, the Pip-Boy 3000, a personal information device that doubles as the in-game menu allows them to pick up various radio signals. Main frequencies heard anywhere in the Wasteland include popular music station GNR, hosted by DJ Three Dog, and the patriotic Enclave Radio, hosted by President John Henry Eden.[26] While the use of the radio is entirely optional (players can tune in or tune out at any time), active radios appear throughout the Wasteland, meaning some degree of contact

[23] Stern, "Historical and Personal in Advertising Text," 16.

[24] Sprengler observes a similar ability of Fifties artifacts to provide deep criticism of consumer culture in filmic contexts. Sprengler, *Screening Nostalgia*, 64.

[25] Schulzke, "Refighting the Cold War," 267–68.

[26] Galaxy News Radio is only heard from any point in the Wasteland with the completion of the mission "Galaxy News Radio" offered by DJ Three Dog. Without the completion of this mission, it is limited to the downtown area and has poor signal quality.

with the music on these stations is inevitable. For players who choose to tune-in frequently, this diegetic audio becomes the primary soundtrack for the game.

GNR's musical selections typically provide ironic commentary in one of two ways: through general stylistic characteristics or via deliberately ironic lyrics. With selections of popular music from the 1930s and 1940s by artists including The Ink Spots, Cole Porter, Ella Fitzgerald, and Billie Holiday, the songs on GNR's play-list stand in stark contrast to the barren landscape and violent encounters of the Wasteland (Table 10.1).[27] The upbeat sounds of the station's instrumental tracks feel particularly ironic, pulling the lighthearted sounds of pre-apocalypse American life squarely into the combat of the Wasteland. The vast majority of tracks on the station include lyrics, which engage ironically with the game's setting and events through general societal commentary or more specific ironic language.

The most telling (and unavoidable) instance of intentionally ironic musical nostalgia happens in the opening moments of the game. Players see a retro radio hum to life, and The Ink Spots' popular hit, "I Don't Want to Set the World on Fire," begins to play. The camera slowly pans back, revealing the interior of a decrepit Fifties-style bus, complete with peeling retro advertisements. As the camera continues to back away from the retro-radio at the front of the bus, players see broken windows and eventually that only the front half of the bus exists. The diegetic music begins to fade, transitioning into the dark low-brass chords of the game's main theme as the ruins of the Washington monument and a soldier in full mechanized armor come into view. The song tells us "I don't want to set the world on fire," but as the reality of the Capital Wasteland comes into focus, players see just that—a world destroyed in the fire of a nuclear apocalypse.

Other songs featured on the station offer a darkly humorous commentary on the dystopian setting. For example, Cole Porter's "Anything Goes" becomes a description of life in the Wasteland, where people will do anything to stay alive. Roy Brown's "Butcher Pete (Part I)" uses a violent surface text about "whacking" and "hacking" meat as a cover for sexual innuendo. When placed in the context of the game, this brutal imagery takes on new meanings as players navigate raider hideouts that use dismembered bodies as decorations.[28] Stylistically these songs share the upbeat tempo, major harmonies, and swing rhythms of other selections on the station, making the correlation between their lyrics and the dystopian setting

[27] Although the selections on GNR invoke the Fifties, many of the songs come from the preceding era of the 1930s and 1940s. As is often the case with nostalgia, historical accuracy is less important than the "feel" these songs provide. For more, see Chapman, "Privileging Form Over Content."

[28] For more on players' responses to this ironic function, see Cheng, *Sound Play*, 36–39.

Ironic songs

The Ink Spots	"I Don't Want to Set the World on Fire"	1940
Tex Beneke	"A Wonderful Guy"	1949
Roy Brown	"Butcher Pete (Part I)"	1949
Billie Holiday	Crazy He Calls Me"	1949
Billie Holiday	"Easy Living"	1937
Jack Shaindlin (composer)	"I'm Tickled Pink"	1952
Bob Crosby and the Bobcats	"Happy Times"	1949
Jack Shaindlin (composer)	"Let's Go Sunning"	1954
Roy Brown	"Mighty Mighty Man"	1949

Nostalgic Songs

Cole Porter	"Anything Goes"	1934
Danny Kaye with The Andrews Sisters	"Civilization"	1947
The Ink Spots	"Maybe"	1935
Ella Fitzgerald and The Ink Spots	"Into Each Life Some Rain Must Fall"	1944
Bob Crosby and the Bobcats	"Way Back Home"	1935

Instrumentals		
Sid Philips	*Boogie Man*	Unavailable
Gerhard Trede (composer)	*Fox Boogie*	Unavailable
Billy Munn (composer), Charles Brull's Dance Orchestra	*Jazzy Interlude*	1950
Gerhard Trede (composer)	*Jolly Days*	Unavailable
Eddy Christiani and Frans Poptie (composers), Charles Brull's Dance Orchestra	*Rhythm for You*	Unavailable
Allan Gray (composer), Charles Brull's Dance Orchestra	*Swing Doors*	1950

TABLE 10.1: Complete list of licensed tracks on Galaxy News Radio from game credits. Selections are indicated by artist/composer, title, and year recorded. For tracks with no credits given, dates and performers have been included where they can be added with reasonable certainty.

all the more striking. Even the songs' titles contribute to the ironic commentary, with Three Dog's frequent introductions before they play on the radio highlighting the ironic lyrics before the songs even begin.

Most commonly GNR's ironic musical commentary comes through songs that exude the blind optimism and frivolity of the consumerist utopia that existed before the world fell apart. The majority of these songs, like Billie Holiday's "Crazy He Calls Me" or Jack Shaindlin's "Let's Go Sunning" portray the promises of a world without conflict.[29] As William Cheng notes, romantic love takes center stage and song lyrics often speak to "problems that impoverished, irradiated survivors in 2277 probably *wish* they had" (emphasis original).[30] In Jack Shaindlin's "I'm Tickled Pink," a lover reflects on a perfect relationship and anticipates the rosy future ahead of the couple. Bob Crosby and the Bobcats' "Happy Times" offers a

[29] Sarah Pozderac-Chenevey addresses the ironic and nostalgic functions of several examples from GNR. Pozderac-Chenevey, "A Direct Link to the Past."

[30] Cheng, *Sound Play*, 31.

similarly blind optimism about the future, telling listeners that someday they will have "happy, happy times."[31] When these musical artifacts appear in the Wasteland, however, their messages ring hollow. The promises and dreams so many of these songs espouse disappeared with the apocalypse, and the desolation of the Wasteland becomes a biting commentary on the naiveté of the past.

Through these musical selections, *F3* offers a critique on the tendency of nostalgia to gloss over the dark spaces of history, using irony to highlight the anxieties of the Cold War era. The sterilized messages of the Populuxe Fifties and superficial lyrics evidenced in the popular songs on GNR largely overlook the very real fears of atomic destruction that came with the development of nuclear technology. In the *Fallout* universe, they achieved a technological consumerist utopia in which nuclear energy was a safe and accepted part of everyday life. It powered cars, operated robots, and laced their colas as a special ingredient. *F3* invites players to imagine what this consumerist utopia could have been, while simultaneously presenting it long after its destruction. By incorporating the remains of naively optimistic consumerist imagery and song lyrics into a game world blasted by nuclear war, *F3* concretizes these anxieties and draws attention to their conspicuous absence in the cultural artifacts that players encounter.

Restoring the Wasteland

The diegetic, nostalgic appeals of *F3* to NPCs and players compliment the general nostalgic esthetics that create its retro-future. The game effectively layers nostalgic meanings, relying on both a passive form of nostalgic recognition in the general Fifties feel, but also implementing active, deliberate nostalgic messaging within the gameworld. This nostalgic messaging heard on the two main radio stations targets the historical consciousness of NPCs and becomes an integral part of the game's ideological and power structures. At the diegetic level, the two primary political factions within the game wield nostalgia as a tool to persuade residents of the Wasteland and players to join their side. The open-ended world of *F3* leaves players free to determine their allegiances through the acceptance and completion of missions—a feature that gives players the ability to alter the balance of power in the game dramatically. Through the radio, the opposing factions in

[31] Ivănescu highlights "I'm Tickled Pink" and "Happy Times" as examples meant to encourage optimism for a "better tomorrow" in players and NPCs, but the stark contrast between the tone of these examples and the realities of the Wasteland also clearly contribute to the ironic commentary of the game. Ivănescu, *Popular Music*, 121.

the game reinforce their own political agendas by appealing to different aspects of pre-apocalypse culture and music. GNR, closely allied with the Brotherhood of Steel (BoS), and Enclave Radio, associated with the military force known as the Enclave, perform the crucial task of persuading the hearts and minds of the Wasteland's citizens, as well as the player's. Although the BoS does not oversee the broadcasting on GNR the way the Enclave maintains Enclave Radio, the two are closely associated throughout the game. Brotherhood missions liberate the radio station plaza, giving access to the interior of the station for the first time, and they maintain an outpost on the lower level of the building. Within the Citadel, formerly the Pentagon and the BoS's main base, the active radio in the courtyard tunes to GNR automatically. Furthermore, DJ Three Dog speaks out against Eden frequently and repeatedly praises the BoS in his news broadcasts.

The BoS and Enclave both rely on nostalgic messaging on their associated radio stations, but the artifacts they choose to highlight and the historical constructs they try to re-envision as a promising future differ significantly. GNR uses popular music to engage in what Boym terms reflective nostalgia, which focuses "not on [the] recovery of what is perceived to be an absolute truth but on the meditation on history and the passage of time."[32] It takes comfort in the cultural products of the past while also acknowledging the realities of the present. By contrast, Enclave Radio's patriotic music attempts to consolidate the Enclave's power within the Wasteland through restorative nostalgia. Rather than simply take comfort in the remains of the past, restorative nostalgia strives to rebuild a lost home in the present, according to Boym.[33] The past becomes the ideal, and its restoration becomes the Enclave's promise for the future. In his analysis of F3's music, Cheng has argued that in the wake of the apocalypse the artistic products of the Wasteland have become ahistorical for the people who live there. Cheng describes the process by which this lack of historical meaning developed:

> The world [of F3] suffers from a crisis of memory wherein history persists only as a web of competing fictions invented for propagandistic ends. Due to such mass amnesia, the few surviving musical recordings, endlessly iterated on the radio, can scarcely be understood to have any historical significance in the gameworld. To the ears of the wasteland's NPCs, these tunes ostensibly evoke no more than a blurry sense of a distant past.[34]

[32] Boym, *The Future of Nostalgia*, 49.

[33] Boym, *The Future of Nostalgia*, 41.

[34] Cheng, *Sound Play*, 23.

For Cheng, this "blurry sense of a distant past" does not provide sufficient detail for a sense of historical consciousness. While Cheng makes an excellent point—the citizens of the Wasteland are likely not envisioning the 1940s—nostalgia as a form of historical consciousness does not require the level of historical truth Cheng desires. The vague sense of historicity (the time before the apocalypse) conveyed by the musical selections on GNR and Enclave Radio sufficiently engages the historical consciousness of the Wasteland's residents. That these stations select different cultural artifacts from the past and use different forms of nostalgia to reach their audiences reinforces this idea.

GNR: *"Bringing you the truth, no matter how bad it hurts."*

The reflective nostalgia of the BoS and GNR manifests in their collection of artifacts from the past. The BoS takes the acquisition of pre-war technology as its primary mission, and the player has the option to help by collecting pre-war books in exchange for experience points and money. GNR itself is a relic from the pre-war period that Three Dog and his technician Margaret have resurrected, as evidenced by the deteriorating pre-apocalypse advertisement for the station that appears during the game's loading screens. The musical recordings curated by GNR also contribute to this sense of preservation; although limited in variety, Three Dog explains that the musical selections heard on GNR are the only recordings in playable condition that he has been able to find.[35] In all these cases, the BoS/GNR attempts to salvage the remains of the past and use them to influence the present moment.

The musical artifacts preserved by GNR provide a sense of cultural normalcy and appeal to Wastelanders' nostalgic ideas of the past while also fully engaging with the realities of the present. In contrast to the ironic music discussed in the preceding section, Three Dog's public-service announcements and news updates on the exploits of the player-character emphasize the very real and very present dangers of the Capital Wasteland. His frank descriptions of mutated wildlife, bloodthirsty raiders, and hazardous radiation make the dreamy, ironic lyrics of the station's musical artifacts all the more powerful. GNR does not shy away from the realities of the Wasteland's present moment when it shares the songs of its past but rather views them through the lens of time.

[35] As Cheng observes, Three Dog's explanation at once justifies the repetition of the station's offerings, but also saves the audio designers and players from having to imagine "what music hundreds of years from now will sound like." Cheng, *Sound Play*, 35.

A handful of songs on the station double their nostalgic power, operating not only in the aforementioned ways but also containing intentionally nostalgic lyrics that highlight the anxieties of modern experience. In Cole Porter's "Anything Goes," the lyrics that take on new ironic meanings in *F3* originally addressed social anxieties that modernity was causing moral decay: "In olden days a glimpse of stocking/was looked on as something shocking/but now, God knows/anything goes." Similarly Danny Kaye and The Andrews Sisters' "Civilization" speaks directly to Cold War fears about nuclear weapons, using a noble-savage trope to depict the perspective of an indigenous person in the Congo.[36] The singer describes the drawbacks of the civilization that missionaries to the village are advocating, pointing out that film subjects and recreation activities of civilization are the singer's everyday life. The song's final lines, "They have things like the atom bomb, so I think I'll stay where I am Civilization, I'll stay right here," offer the only direct musical reference to the threat of nuclear arms in the entire game.

Other songs exhibiting this double nostalgia take a different approach, reflecting on nostalgic feelings for past experiences. In both The Ink Spots' "Maybe" and "Into Each Life Some Rain Must Fall," which features Ella Fitzgerald, the lyrics look back with bittersweet emotion on past relationships. Bob Crosby and the Bobcats' "Way Back Home" looks back with positive nostalgic feelings at the singer's hometown, where "the dogs are the yappiest" and "the folks are the happiest." The combination of this rose-colored reflection on a lost home and the sense of sadness conveyed by the lyrics "Don't know why I left the homestead/I really must confess/I'm a weary exile/Singing my song of loneliness" capture the bittersweet essence of nostalgic feelings.[37] In the broader context of the Capital Wasteland, the lyrics of this song represent not necessarily a return to a hometown but rather a return to the time before the apocalypse.

The reflective nostalgia on GNR focuses on sharing the relics of the past, sometimes deliberately invoking the bittersweet emotions associated with nostalgia. For citizens of the Wasteland, these musical references act as reminders of the time before, and individual artifacts from the past become the focus of memory and nostalgic feeling in an unpleasant present. For players, the tension between the optimistic artifacts of the past and Three Dog's unvarnished truth-telling creates an ironic commentary on their experiences in the Wasteland. Put simply, GNR

[36] Sarah Pozderac-Chenevey addresses the potential for codal interference, which may result in this song invoking disgust for its racist lyrics, rather than nostalgia for mid-century America. Pozderac-Chenevey, "A Direct Link."

[37] Pozderac-Chenevey, "A Direct Link."

filters the past through the present moment, giving both players and Wastelanders the ability to reflect on what is, what was, and how we got here.

Enclave radio: *"God bless the USA. And nowhere else."*

In contrast, Enclave Radio's messaging and music use restorative nostalgia to promise a return to past greatness and cultural supremacy. Eden models his frequent radio speeches on Franklin D. Roosevelt's fireside chats of the 1930s and 1940s, replicating their format and often including quotes from past presidents.[38] A patriotic musical collection complements this nostalgic reference to mid-century American life, further reinforcing *F3*'s overall sense of Fifties-ness through the station's strong sense of national pride.[39] On Enclave Radio, Eden describes a nostalgic vision of a unified America and attempts to unify the people of the Wasteland (and the player) under the authority of that vision.

Eden's many radio speeches depict pre-apocalyptic visions of the United States as a utopian society unified by national pride, usually promising its restoration by the Enclave in the future. Eden's chat about the children of the Wasteland illustrates this process clearly, beginning with a nostalgic appeal to childhood adventure:

> Sweet America, hello again, this is your President Eden. I'd like to have a chat. When I was a child, growing up in rural Kentucky, I had the best friend a boy could hope for—my dear old dog, Honey. Oh, the adventures we had! From Knob Creek to Hodgenville we roamed, carefree and courageous, irresponsible and completely inseparable. It was, for a little boy, the perfect existence.

This nostalgic description of personal memory encourages Wastelanders and players to look back to fond memories of their own childhoods, but it quickly gives way to harsh criticism of the realities of the present.

> So let me ask you, America: how many of your children can say the same? How many of this nation's youth are truly happy, truly carefree? Well, we both know the answer, don't we? None. America's children live in a terrifying, meaningless existence. There is no hope. No happiness.

[38] Cheng, *Sound Play*, 28.

[39] As Gary Gerstle observes, the 1950s were a time when the prevailing cultural consciousness focused on the success of American industry and the victory of democracy over fascism in WWII. Gerstle, "The Working Class Goes to War," 105.

At this point, Eden gets to the crux of the matter, making promises to restore American society to its former glory through the might of the Enclave.

> That changes! Right here, right now! From this moment onward, the children of this great nation are its highest priority. The Enclave will restore every American school, reinstate every youth program, and offer counseling and financial assistance to any family in need. We will match up the destitute, orphaned children of the Capital Wasteland with qualified, eligible adults. We will rebuild the American family, as it was, as it was meant to be. The values of our past shall be the foundation of our future. We've got to part now, you and I, but don't be sad, America. The Enclave is working tirelessly to rebuild this great nation, so you don't have to.

In this final passage, Eden repeatedly uses language that intentionally invokes the time before the apocalypse as a model to be achieved in the future—the Enclave will "restore," "reinstate," and "rebuild" America.

The patriotic music on Enclave Radio serves a similar nostalgic function, using instrumental arrangements of songs closely associated with the armed forces to suggest links with the pre-apocalypse military might of the United States. These arrangements often feature instrumental combinations with long-standing military associations; for example, "Battle Hymn of the Republic," the "Marine's Hymn," and "Dixie" feature a flute and drum combination, which recalls the drum and fife corps used during the Revolutionary and Civil Wars. Other pieces offer traditional band arrangements of well-known John Philip Sousa marches, such as "Stars and Stripes Forever" and "The Washington Post." The strong sense of rhythmic regularity and prominent use of percussion in many of these selections further associates them with a military context, thus aligning the Enclave symbolically with major achievements in US military history. Enclave Radio's overtly patriotic music relies on these military associations to create a strong sense of national pride in listeners, which in turn breeds support for the Enclave and their mission of restoration. If players converse with NPC Nathan Vargas in the city of Megaton, they are given the opportunity to question his support of the Enclave:[40]

> Player: "Why do you support the Enclave?"
> Nathan: "Because America is the greatest country on Earth ... actually ... it might be the only country on earth now."

[40] Nathan is a citizen of Megaton and a staunch supporter of the Enclave. He can be heard humming selections from Enclave Radio as he wanders the town of Megaton.

Nathan supports the Enclave solely out of a sense of national pride and an appreciation of their radio broadcasts. He shows no clear understanding of their governmental policies during this conversation, and late in the game when Nathan appears in a prison cell in Enclave headquarters, his warning to the player, "They're not who they say they are," suggests a change of heart.

The songs on Enclave Radio also contribute to the game's proclivity for ironic commentary, with titles standing in stark opposition to the realities of the Wasteland. Even though they appear in instrumental versions, songs like "America the Beautiful" contain lyrics widely familiar to American audiences, and recognition of the song's melody suffices to invoke the language and meanings associated with its text. On Enclave Radio, "America the Beautiful" shares the same dark humor as GNR's "Anything Goes." Similarly, the title of Sousa's march, "Stars and Stripes Forever," exudes a certainty about the future of the United States akin to the blind optimism of "Happy Times." But America is no longer beautiful, and despite Nathan's optimistic viewpoint in Megaton, it ceased to be a country long ago. These song titles simultaneously create ironic commentary for players and reinforce the utopian image of the past that the Enclave wants to restore. By selecting these songs, Eden presents a sanitized vision of the past—a beautiful, eternal, and culturally dominant United States—as an escape from the unpleasant complexities of the present.[41] Eden relies on the imagery and military associations of these songs to paint a picture of the past and make promises for the future, but for players who see the destruction of the Wasteland, this nostalgic propaganda also acts as a critique of the failures that led to the apocalypse.

By greatly emphasizing the rebuilding of America's past in the Wasteland's future, Enclave Radio's restorative nostalgia threatens to destroy *F3*'s present when this nostalgic impulse becomes a justification for mass violence. Nostalgia attempts to recall the past, bringing it into the present moment, but the two can never truly coexist.[42] As the game progresses, Eden's rhetoric begins to demonstrate conspiratorial thinking, and the actions the Enclave takes to restore the past

[41] Scholars in many fields have criticized nostalgia's tendency toward superficiality, describing it as a sanitizing act and an attempt at escapism that glosses over the negative aspects of a given period. See Stern, "Historical," 20. Kalinina, "What Do We Talk About," 11. Pickering and Keightley, "Retrotyping and the Marketing of Nostalgia," 87–89.

[42] S. D. Chrostowska states "nothing can really be recovered, only re-collected, re-imagined." Chrostowska, "Consumed by Nostalgia?" 54. Boym makes a similar observation that it "breaks the frame" when we try to merge the two images into one. Boym, *The Future of Nostalgia*, xiv.

increasingly involve the destruction of any in opposition to his nostalgic vision.[43] Late in the game's main narrative, players discover that Eden, a sentient Enclave computer, plans to restore America by cleansing the Capital Wasteland of anyone with genetic mutations. In other words, the longed-for home—a thriving pre-apocalypse consumerist utopia—can only be achieved by eliminating the irradiated residents of the Wasteland. Ultimately, players choose whether or not to proceed with Eden's plans, leaving the fate of the Wasteland and its survivors in their hands.

A better tomorrow

When players enter *F3*'s Capital Wasteland, they encounter a dystopian retro-future blasted by nuclear war and clinging to fragments of its past. The two main political factions vie for power, persuading residents with radio messages and military force alike. The Enclave weaponizes nostalgia, wielding its appeals to national identity and patriotism as part of an extensive propaganda machine that promises a restoration of the good old days. By contrast, GNR firmly acknowledges the dangers and realities of post-apocalyptic life but turns nostalgically to songs of the past as a source of comfort and hope. Both promise a better tomorrow for the Wasteland based on these appeals to a long-destroyed past.

In this dystopian world, players hold the power to shape that better tomorrow, deciding the balance of power and narrative outcomes in the game. Not only do players decide which faction to support, but they also have a critical hand in deciding the musical landscape created by the game's radio stations. As Cheng notes, player decisions during various quests control whether or not the radio stations play across the Wasteland.[44] By deciding what music the Wasteland preserves (popular, patriotic, both, or neither), players become an integral part of the curating process and active participants in shaping the nostalgic messages heard on the game's airwaves. Because players control the radio, they also control (to some degree) the amount and kinds of nostalgic messages they receive. Beyond its general Fifties esthetic, their experiences of the game's nostalgic historical consciousness are up to them.

The distinctive esthetics of *Fallout* that afford such rich material for the study of nostalgia have only grown in the time since *F3*'s release. Subsequent games have expanded the musical selections included in the *Fallout* universe, incorporating increasingly diverse selections from the 1950s and 1960s. Most notably, *Fallout 4*

[43] For more on conspiratorial thinking and nostalgia, see Boym, *The Future of Nostalgia*, 43–45.

[44] Cheng, *Sound Play*, 24.

includes several examples of newly composed music, written in the gameworld by a popular lounge singer in the town of Good Neighbor. These expansions open the door to further inquiries on nostalgia, music, and the ways their intersection can shape our historical consciousness, whispering the promise of a better tomorrow.

LUDOGRAPHY
Fallout 3. Bethesda Game Studios. PlayStation 3. Bethesda Softworks, 2008.

BIBLIOGRAPHY

Boym, Svetlana. *The Future of Nostalgia*. New York: Basic Books, 2001.

Chapman, Adam. "Privileging Form Over Content: Analysing Historical Videogames." *Journal of Digital Humanities* 1 (2012): 1–2. http://journalofdigitalhumanities.org/1-2/privileging-form-over-content-by-adam-chapman/.

Cheng, William. *Sound Play: Video Games and the Musical Imagination*. New York: Oxford University Press, 2014.

Chrostowska, S. D. "Consumed by Nostalgia?" *SubStance* 39 (2010): 52–70.

Cutterham, Tom. "Irony and American Historical Consciousness in *Fallout 3*." In *Playing with the Past: Digital Games and the Simulation of History*, edited by Matthew Wilhelm Kapell and Andrew B. R. Elliot, 313–26. New York: Bloomsbury Academic, 2013.

Gerstle, Gary. "The Working Class Goes to War." In *The War in American Culture: Society and Consciousness During World War II*, edited by Lewis A. Erenberg and Susan E. Hrisch, 105–27. Chicago: University of Chicago Press, 1996.

Hellekson, Karen. "Toward a Taxonomy of the Alternate History Genre." *Extrapolation* 41 (2000): 248–56.

Ivănescu, Andra. *Popular Music in the Nostalgia Video Game: The Way It Never Sounded*. London: Palgrave Macmillan, 2019.

Kalinina, Ekaterina. "What Do We Talk About When We Talk About Media and Nostalgia?" *Medien und Zeit: Kommunikation in Vergangenheit und Gegenwart* 31 (2016): 6–15.

Kapell, Matthew Wilhelm, and Andrew B.R. Elliott, eds. *Playing with the Past: Digital Games and the Simulation of History*. New York: Bloomsbury Academic, 2013.

November, Joseph A. "Fallout and Yesterday's Impossible Tomorrow." In *Playing with the Past: Digital Games and the Simulation of History*, edited by Matthew Wilhelm Kapell and Andrew B. R. Elliot, 297–312. New York: Bloomsbury Academic, 2013.

Pickering, Michael, and Emily Keightley. "Retrotyping and the Marketing of Nostalgia." In *Media and Nostalgia: Yearning for the Past, Present, and Future*, edited by Katharina Niemeyer, 83–94. New York: Palgrave Macmillan, 2014.

Pozderac-Chenevey, Sarah. "A Direct Link to the Past: Nostalgia and Semiotics in Video Game Music." *Divergence Press* 2 (2014). http://divergencepress. net/2014/06/02/2016-11-3-a-direct-link-to-the-past-nostalgia-and-semiotics-in-video-game-music/.

Schulzke, Marcus. "Refighting the Cold War: Video Games and Speculative History." In *Playing with the Past: Digital Games and the Simulation of History*, edited by Matthew Wilhelm Kapell and Andrew B. R. Elliot, 261–75. New York: Bloomsbury Academic, 2013.

Sprengler, Christine. *Screening Nostalgia: Populuxe Props and Technicolor Aesthetics in Contemporary American Film*. New York: Berghahn Books, 2009.

Stern, Barbara B. "Historical and Personal in Advertising Text: The Fin de siècle Effect." *Journal of Advertising* 21 (1992): 11–22.

The Fallout 3 Team. *Vault Dweller's Survival Guide*. Bethesda Softworks: 2008.

Uricchio, William. "Simulation, History, and Computer Games." In *Handbook of Computer Game Studies*, edited by Joost Raessens and Jeffrey Goldstein, 327–38. Cambridge: MIT Press, 2005.

11

Confronting Nostalgia for Racism in American Popular Music via *BioShock Infinite*

Sarah Pozderac-Chenevey

American society, as whole, does not do a very good job of honestly confronting history. Rather than making amends or learning from mistakes, its institutions generally prefer to forget any events that paint it in a bad light. Historian James Loewen has addressed how textbooks fail American students by white-washing history, glossing over any complexity in the lives of designated "heroes" and omitting the lives and stories of women, minorities, and the poor.[1] What frequently results from the dominant American culture's unwillingness to confront the realities of history is a nostalgia for the "good old days"—that is, without the uncomfortable bits. Svetlana Boym incisively identified this tactic, writing, "This is an American way of dealing with the past—to turn history into a bunch of amusing and readily available souvenirs, devoid of politics."[2] Take, for example, this two-star Google review of a southern plantation that went viral in 2019:

> My husband and I were extremely disappointed in this tour. We didn't come to hear a lecture on how the white people treated slaves, we came to get the history of a southern plantation and get a tour of the house and grounds.[3]

[1] Loewen, *Lies My Teacher Told Me*. Unfortunately, this is still a problem: see Goldstein, "Two States. Eight Textbooks."

[2] Boym, *The Future of Nostalgia*, 51.

[3] Quoted in Twitty, "Dear Disgruntled White Plantation Visitors, Sit Down."

These visitors clearly did not consider the enslaved people who constructed and maintained the plantation to be part of its history despite the fact that slavery is an inextricable part of every southern plantation's past. Instead, they wanted to enjoy the beauty of the house and grounds, perhaps indulge in a little *Gone with the Wind*-esque nostalgia for the antebellum South, without being confronted with the human cost of such pastoral grandeur. But as Michael W. Twitty, food historian and historical interpreter, put it, "The Old South may be your American Downton Abbey but it is our American Horror Story, even under the best circumstances it represents the extraction of labor, talent and life we can never get back."[4] Admiring the results of forced labor while ignoring the enslaved people who suffered and died is an abhorrently common product of white privilege. Confronting how this privilege hides historical accounts from sight and memory generally entails an unpleasant admission of cultural guilt, one many would prefer to avoid. Accordingly, privilege encourages one to forget historical racism on plantations and overlook racism in other parts of life and culture, including art, science, and music. Nostalgia for the past often becomes racist, whether by erasing Black personhood, labor, and pain or by cutting away racist objects and actions so that heroes and places can be celebrated without ambiguity. As the Yelp review shows, nostalgia for the antebellum South often encourages both—to discuss slave labor is to acknowledge Black suffering and plantation society's racism.

The 2013 videogame *BioShock Infinite* (*BI*) repeatedly forces the player to confront the racism endemic to the early twentieth century as well as the nostalgia it elicited and the nostalgia that conceals it. Rather than a brilliant vision of the future or an idealized version of the past, the game's fictional setting of Columbia is an allegory for American society—and the very nature of videogames, the fact that the player must participate for the story to progress, means the player cannot look away from what it reveals.[5] Virtual interactions in Columbia depict several kinds of racist violence and discrimination and call attention to the way nostalgia has erased them from our collective memories. The music of *BI* is a powerful contributor to this allegorical statement. *BI* depicts several different kinds of racist violence and discrimination, but in this essay, I will focus specifically on its musical depictions of anti-Black racism. I theorize a specific form of restorative nostalgia I term *idealizing nostalgia*, which is present in "real life" and satirized in *BI*. I begin by examining the historical roles of racism and nostalgia in *BI*'s music

[4] Twitty, "Dear Disgruntled White Plantation Visitors, Sit Down."

[5] For an analysis of nostalgia at play in a very different combination of past and future America, please refer back to Jessica Kizzire's "Remembering Tomorrow: Music and Nostalgia in *Fallout 3*'s Retro-Future."

before analyzing five case studies that demonstrate how *BI* calls attention to ideal-izing nostalgia through music. These analyses demonstrate how *BI* illustrates some of the most racist parts of American (musical) history in a way that exposes the comfortable fiction demanded by nostalgia for an idealized past.

Idealizing nostalgia in American popular music

Columbia is saturated, perhaps even motivated, by what Svetlana Boym terms "restorative nostalgia," about which she writes,

> The past for the restorative nostalgic is a value for the present; the past is not a dura-tion but a perfect snapshot. Moreover, the past is not supposed to reveal any signs of decay; it has to be freshly painted in its "original image" and remain eternally young [...] Restorative nostalgia evokes national past and future.[6]

This nostalgia takes the form of nostalgia for an idealized past, which I term *idealizing nostalgia*. Idealizing nostalgia arises from a nostalgia that is "freshly painted" without any signs of decay—the "perfect snapshot" is a retouched photo. However, what has been retouched varies. In some cases, what is erased is Black labor, expertise, and suffering. In others, it is overt racism. In all cases, however, idealizing nostalgia creates a version of history in which discomforting elements have been cleansed or perhaps just swept under the rug. There are many events and artifacts that could illustrate idealizing nostalgia, but this essay will use examples from American music history—specifically, a selection of music and musicians appearing in *BI*. First, this essay will discuss Polk Miller, whose idealizing nostalgia for the antebellum south requires the erasure of Black suffering. Next, this essay will provide a brief history of blackface minstrelsy, a racist genre that played on anti-Black stereotypes, became the object of nostalgia, and was ultimately erased by idealizing nostalgia. Racism has shaped both the history and historiography of American music, and idealizing nostalgia has played a substantial role in how we remember—or do not remember—the musical past.

Polk Miller's connections to both the antebellum South and the Confederate States of America (CSA) were at the core of his performing career, and his cele-bration of nostalgia for them was a major part of his appeal. The South, the CSA, and ultimately the institution of slavery were important objects of nostalgia for many white Americans in the early twentieth century—and, as continuing conflicts

[6] Boym, *The Future of Nostalgia*, 49.

over the removal of Confederate statues, names, and flags show, many twenty-first century Americans too. Born in 1844, Miller grew up on a plantation and served in the Confederate Army during the Civil War. He learned to play banjo from slaves on his father's plantation as a child,[7] and in 1893, he left a successful career as a pharmacist in order to travel and perform "sketches of the old-time Negro."[8] His early performances included "banjo songs, dialect stories and lecture, without the use of blackface,"[9] but around the turn of the century, he assembled "quartettes" of African-American men to "illustrate [his] work."[10] The intended historical connection was made clear in advertisements: "This entertainment is in no sense a lecture, but is an evening of story and song on 'Old Times Down South.'"[11] In 1909, Polk Miller and his Quartette were recorded by the Edison company, who sent a recording team to Richmond.[12] Three of these recordings are heard in *BI*: they are rare examples of contemporaneous recordings, not just contemporaneous compositions, included in the game.

Miller's musical career models how idealizing nostalgia can be nostalgia for racism and racist artifacts. Here, what must be purified from the past is not anti-Black racism but awareness of Black people's essential personhood. If Black people are not people, then they can be reduced to caricatures such as Toms and Mammies, happy to serve their white masters and mistresses.[13] The past can be reborn as a time of racial harmony, with everyone in their proper place—a view that Miller openly espoused.[14] Advertisements for the group's performances emphasize Miller's antebellum connection and play up the music's nostalgic appeal. Brochures explicitly positioned the African-American men as singing authentic versions of plantation songs:

> They do not try to let you see how nearly a Negro can act *the White Man* while parading in a dark skin, but they dress, act and sing like the real *Southern Darkey* in his "workin'" clothes [...] To the old Southerner it will be *"Sounds from the Old Home of Long Ago."*[15]

[7] Brooks, *Lost Sounds*, 216.

[8] Mark Twain, quoted in Seroff, "Polk Miller and the Old South Quartette," 29.

[9] Seroff, "Polk Miller," 29.

[10] Quoted in Seroff, "Polk Miller," 37.

[11] Quoted in Brooks, *Lost Sounds*, 218.

[12] Brooks, *Lost Sounds*, 221.

[13] Pilgrim, "The Tom Caricature," and Pilgrim, "The Mammy Caricature."

[14] See Brooks, *Lost Sounds*, 215–20 for more information about Miller's beliefs as a slavery apologist.

[15] Quoted in program brochure reproduced in Seroff, "Polk Miller," 35. Italicizations in original.

The accompanying image shows four Black men in suits, giving the lie to the "'workin' clothes" claim, but all four men look happy to perform, implying that the "real *Southern Darkey*" was a happy slave. Their voices are the true depictions of the antebellum South, the uncultivated voice of the slave who sings as he works. In his article charting the history and reception of Polk Miller and his ensemble, Doug Seroff concludes that Polk Miller shaped his ensemble into "an essentially 'backwards-looking' musical aggregation; designed to evoke fond memories of an earlier era."[16] Miller's music is an expression of nostalgia for the time of slavery, and in his staged performances, his ensembles are transformed from free Black men into living objects of that idealizing form of nostalgia.

While Polk Miller's relationship with idealizing nostalgia is straightforward, blackface minstrelsy's relationship with it is much more complicated.[17] Minstrelsy has its roots in the mid-nineteenth century, and it became the object of nostalgia for generations who grew up with it as entertainment before being erased by idealizing nostalgia. My hometown of Mount Vernon, for example, has celebrated The Dan Emmett Music and Arts Festival every August for more than 30 years in honor of its native son, born in 1815, who composed "Dixie."[18] However, it ignores the distressingly racist aspects of Emmett's career due to idealizing nostalgia. I performed in the festival as a child and visited it as an adult, and I never heard a single mention of Emmett's role in the Virginia Minstrels, one of the earliest and most successful minstrel troupes.[19] The racist performance customs that made my hometown's best-known progeny famous were rendered invisible at the festival celebrated "in his honor." Of course, while minstrelsy may be an embarrassment today, it was the object of nostalgia for many people for decades. While blackface imagery and minstrel sound have been carefully separated out from the "acceptable" parts of history, nostalgia for minstrelsy and the racism it perpetuated still simmer below the surface.

The iconography of minstrelsy remained fairly constant over the century it was popular. It caricatured what were seen as markers of Blackness: impossibly dark skin (colored with burnt cork), large red lips, and tightly curled hair. Figure 11.1 reproduces the cover of a set of Emmett's songs published in London (*left*) and the cover of a movie program from *The Jazz Singer* (*right*). Al Jolson's blackface

[16] Seroff, "Polk Miller," 38–39.

[17] What follows is, of course, an extremely condensed version of minstrelsy's history. For greater detail, see Lott, *Love and Theft*.

[18] "Dixie" may have been composed by Black musicians, as chronicled by H. Sacks and J. Sacks, *Way Up North in Dixie*.

[19] Grove Music Online, s.v. "Emmett [Emmit], Dan(iel Decatur)."

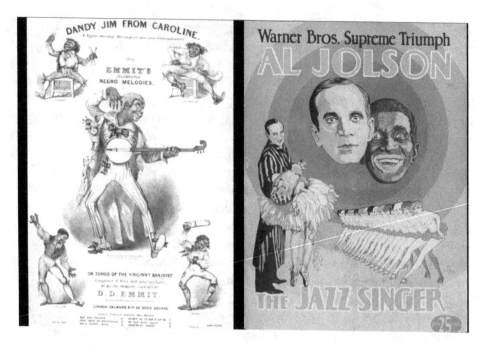

FIGURE 11.1: (*Left*) The cover of "Emmit's Celebrated Negro Melodies, or Songs of the Virginny Banjoist. Composed and Sung with Great Applause at All the Principal Theatres by D. D. Emmit." MS Thr 556 (59). Houghton Library, Harvard University. (*Right*) Program flier from *The Jazz Singer*. From The New York Public Library, https://digitalcollections.nypl.org/items/b15209a3-2498-39cf-e040-e00a1806058c.

appearance in *The Jazz Singer* (1927) has come to represent his entire career in the public's mind. Jolson was one of the most popular performers of the early twentieth century, making him one of the most chronologically appropriate musicians to include in *BI*, and his work was a contemporary iteration of minstrelsy, a genre that his generation grew up with as family entertainment. Emmett was one of the earliest professional minstrels; Jolson, one of the latest. Emmett (here spelled "Emmit") is depicted in his "Dandy Jim" persona, alongside engravings of other members of the troupe in costume and depictions of specific dances—note the exaggerated lips and teeth and the curly hair in each widely grinning portrait. Compare this with the program cover for *The Jazz Singer*, which foregrounds the transformative "blacking up" that was the crux of the film's plot. On Jolson's blackened face, the exaggerated lips persist, again surrounding an open, smiling mouth, and Jolson's hair has become tight curls. Though the artistic styles of the documents are different, the visual markers of minstrelsy remain remarkably consistent despite the decades separating Emmett's career from Jolson's.

As a result of minstrelsy's broad and long-lasting popularity, it evoked an idealizing nostalgic response even after it fell out of style, and its legacy in popular media continues well into the twenty-first century. Michael Rogin tracks how the sight and sound of minstrelsy were nostalgic and welcome up through the middle of the twentieth century. For example, Rogin analyzes *Babes in Arms*, a 1939 film in which Mickey Rooney and Judy Garland's characters perform in blackface, in light of minstrelsy's popularity that spanned generations. As an introduction to the show-within-a-show put on by the "Dixie Minstrels" at the climax of the film, Garland sings "My daddy was a minstrel man [...] I'd like to black my face [...] and go again down memory lane with an old-fashioned minstrel show,"[20] clearly linking blackface with nostalgia. Rogin writes that the movie itself, just like the show the Rooney and Garland put on within it, "offers all the pleasures of the traditional minstrel spectacle."[21] Blackface's populist history is reflected also in its persistence in television. Actors have appeared in blackface on major television networks well into the twenty-first century in shows such as *30 Rock*, *Mad Men*, *The Office*, and *Saturday Night Live*.[22] Minstrelsy had a long life on the stage as well: the University of Vermont featured a performance called the "Kake Walk" in which pairs of men competed in blackface as the central event of the university's annual Winter Carnival for at least 80 years. It was finally forbidden in 1969, to the dismay of many alumni.[23]

This minstrelsy was no historical blip; its descendants still linger in popular media. The Dan Emmett Festival was celebrated in my hometown until 2019— and I should note here that Mt. Vernon is located *in Ohio*, which remained part of the Union during the Civil War. The town square features a memorial statue for Union soldiers, but in 2006, members of the Ohio Division of the United Daughters of the Confederacy (UDC) re-dedicated the town's memorial to Emmett with "a rousing rendition of 'Dixie,'"[24] bringing the simmering idealizing nostalgia for minstrelsy and the CSA startlingly close to boiling up into consciousness. It was not until February 2020 that the town publicly acknowledged Emmett's minstrel history and removed his name from the festival. Unsurprisingly, people complained that this was due to political correctness run amok.[25] The celebration of Emmett and the sublimation of his music's racism and association with the CSA are part of

[20] Berkeley, *Babes in Arms*.

[21] Rogin, *Blackface, White Noise*, 125.

[22] Dessem, "Just How Many Recent Shows."

[23] Loewen, *Lies across America*, 425–29.

[24] Durbin, "Dan Emmett Memorial Re-dedicated."

[25] See Townsend, "Dan Emmett Festival Renamed."

the historical revision that erected monuments and romanticized the CSA around the turn of the twentieth century.[26] It is also symptomatic of idealizing nostalgia within American popular music, caught between its affection for racist music and musicians and its desire to excise the problematic parts of history and whitewash historical figures.

Past, present, and future intertwined by real music in a fictional city

BioShock Infinite satirically interrogates images of a racist past, transformed by idealizing nostalgic memory. Through gameplay, the player is empowered with the ability to look beyond this perfected veil and see the exploitation and racism that maintain Columbia's shining exterior. However, *BI* is far from an obnoxiously moralizing parable. Although it does include an impressive amount of historical information, *BI*'s commentary on racism in American racist history is superimposed over a first-person shooter game. Players control Booker DeWitt, a Pinkerton detective sent to retrieve Elizabeth Comstock from the fictional floating city of Columbia. Booker's past as a soldier and Pinkerton is reflected in the game's violence. As Booker investigates the city and unearths the connections between his history and Columbia's, residents who realize that he does not belong immediately attack him. The player dispatches these enemies with firearms, "Vigors," and a Sky-Hook melee weapon that also allows players to ride zip lines between the floating city's floating platforms.[27]

 BI creates in a virtual space a physical representation of the idealizing nostalgia it interrogates. *BioShock Infinite* satirically takes aim at several long-running American cultural values, including American exceptionalism, individualism, and manifest destiny, as well as the distinct strain of Christian fundamentalism that continues to this day. The first *BioShock* game satirized Randian Objectivism in much the same way, creating a libertarian "paradise" called Rapture below the sea.[28] In *BI*, even though Columbia has officially seceded from the United States, its cultural identity is still distinctly American. Columbia's stratified structure represents early twentieth-century America's segregation on the basis of both

[26] Loewen, *Lies across America.*

[27] This too provoked controversy: did the violence add to or detract from the game? See Plante, "Opinion," Hamilton, "*BioShock Infinite* Is Insanely, Ridiculously Violent," McLaughlin, "BioShock Infinite's Extreme Violence." I personally had no interest in the combat portion of the game but was engrossed in the narrative.

[28] See Perrotta, "'BioShock,'" and Robertson, "Why *BioShock.*"

race and class, with the topmost layer reserved for the privileged elite. Columbia literally floats above the rest of the world in a grand showcase of its technological expertise and moral superiority. The city credits its white majority with this technological achievement, and its citizens protect its hegemonic culture with religious fervor. This is reinforced visually as the player encounters larger-than-life representations of George Washington, Thomas Jefferson, and Benjamin Franklin swathed in religious imagery. Mechanical versions of Washington, Jefferson, Franklin, and a bald eagle monster even attack Booker directly! This appropriation and restyling of American founding fathers convey Columbia's brand of xenophobic, ultra-nationalist zealot patriotism.[29] Overall, there is no single "bad-guy" in *Bioshock Infinite*. Instead, the player must confront social institutions created by racist idealizing nostalgia and promulgated by an alternate version of himself.

Columbia's residents also seem deeply nostalgic for the antebellum South. Their desire for a similarly rigid race and class structure results in regular people suppressing anything of difference. Colombian residents deliberately preoccupy themselves with entertainments and blissfully ignore the oppression that keeps the city *literally* afloat. Despite the fact that only a select few occupy this literal castle in the sky, Colombia makes room for an enslaved working class to maintain the city. These laborers (who are mostly Black but also come from other minority groups, including Irish and Chinese immigrants) work out of the public's view. Columbia's privileged white class cannot tolerate anything that contradicts the pleasantness of their surroundings or the normative belief that they are special or superior. They attack Booker if he dares disturb the peace in an effort to keep the poor out of both sight and mind. Colombia endeavors to symbolically float "above" the slavery, exploitation, and oppression. In this way, *BI* furthers its satiric caricature of idealizing nostalgia by reminding players of the forced labor that literally built the antebellum South and established the United States as a global superpower.

When Booker first enters Columbia, it appears to be a city focused on the future—it is flying, after all—but this image is soon problematized. Elizabeth has the ability to open "tears" between alternate universes, resulting in an admixture of past and present and future. This collapsing of time is reflected in the music, as well. "God Only Knows" is the first in a collection of stylistic covers that are a mixture of past and future. As the narrative progresses, Booker and Elizabeth visit an upscale club and a rundown bar, where they hear Bessie Smith's "I'm Wild about That Thing" and a cover of "Tainted Love." They visit a beautiful beach where a

[29] For a very different nostalgic reimagining of the American past, see Justin Sextro's essay entitled "'This Game Stinks!': Musical Parody and Nostalgia in *EarthBound*." In it, he details how Ness's world is a Japanese depiction of an American past that never quite was.

calliope plays "Girls Just Want to Have Fun" and a shanty town where children perform Elizabeth Cotten's "Shake Sugaree."[30] In one alternate universe, the Vox Populi has revolted; as the battle rages, a Black woman sings "Fortunate Son." Each song carries with it meaning in its textual content, its "real world" history, and, in the case of the "covers," its transformation. These songs highlight the complicated relationships between Columbia's present and our past, our present and Columbia's future. They collapse the temporal distance between now and then.

Case study 1: "Goodnight, Irene"

The first unmistakable glimpse of Columbia's deeply held anti-Black racism occurs shortly after Booker enters the city, in the form of blackface imagery and appropriated music. Following the sound of an enthusiastically singing crowd, Booker arrives at a stage, the setting of a raffle. A young white woman gives Booker a numbered baseball, and the curtain rises to reveal a white man and Black woman bound to a grotesque set (seen in Figure 11.2). Booker and the player soon realize that they are attending a public stoning of an interracial couple composed of a white man and a Black woman. While the folksy, upbeat atmosphere may be jarring today, it refers to another popular form of now-forgotten entertainment: "The African Dodger," a carnival game also known as "Hit the Coon" or "Hit the Nigger Baby," also involved throwing baseballs at Black men's heads.[31] This scene introduces players to Columbia's dedication to white supremacy. Historian Peggy Pascoe writes, "The stronger white supremacy grew, the more likely it was that White men would be subject to the full range of the disabilities of miscegenation law [...] But the targeting of White men remained the hardest won—and most unstable—achievement in the history of miscegenation law."[32] The couple has violated the rules governing interracial relationships, and they are to be publicly stoned. In a twist of fate, Booker's number is called; he has "won" the raffle and is awarded the "privilege" of casting the first stone. The player must choose whether to throw the ball or refuse. Does Booker throw the ball and become complicit in the racist violence of the crowd, in hopes of maintaining his cover? Or does he refuse to participate, and draw attention (and danger) to himself? In short, BI immediately asks players to either participate in or confront racist violence.

[30] This is the only example I know of in which an existing recording (that is, not a recording produced for *BI*) is presented as being sung on-screen. All other recordings are heard issuing from some sort of device.

[31] Hughes, "The African Dodger."

[32] Pascoe, *What Comes Naturally*, 11.

FIGURE 11.2: Jeremiah Fink exhorts the player to throw the first ball at the bound couple. Screen capture by the author.

The set parodies marital iconography via the visual language of minstrelsy, supporting the racist violence taking place. Two monkeys swing from trees, one wearing a bowtie and top hat and holding a diamond ring, the other wearing flowers and holding a basket of petals with its tail. In addition to representing these wedding party figures, these images allude to the racist caricature of the "picaninny": the slave child depicted as more animal than human. These monkeys have not just been anthropomorphized—they have been painted with the exaggerated lips of blackface, just as Emmett and Jolson were (see Figure 11.1). Behind them stands what is presumably the celebrant, who sports burnt-cork-black skin, blood-red eyes and mouth, and white gloves while wearing a top hat (conventions of minstrel costuming) and holding an open book as though ready to begin the ceremony. Someone bangs out "Bridal Chorus" from *Lohengrin* on an unseen piano, linking the scene with music long associated with weddings as well as a composer tied to racism and antisemitism.[33] Thus the couple is publicly shamed: he is stripped of his privilege, she is dehumanized, and their relationship is mocked through this darkly stylized minstrel wedding. While Booker's entrance into Columbia allowed the player to step into an idealized past, here the player is confronted with the

[33] Gibbons analyzes the use of Wagner's "Bridal Chorus" within this scene at greater length. Gibbons, *Unlimited Replays*, 43–44.

racist violence integral to that past: the whitewashing of the past is but a thin layer concealing the nostalgia for racism.

This scene also depicts another, more insidious form of racism in American history: the erasure of Black artists.[34] As Booker approaches the scene of the raffle, he hears the all-white crowd enthusiastically singing "Goodnight, Irene." Jeremiah Fink, the owner of Finkton and its factories and thus a major beneficiary of Columbia's exploitative system, leads this chorus. By putting "Irene" into the mouths of white singers, *BI* erases the musical labor and expertise of Huddie "Lead Belly" Ledbetter. Ledbetter was a Black man born in Louisiana in 1888, the son of sharecroppers who hoped to someday own farmland. He was "discovered" by John and Alan Lomax, who were touring prisons looking for Black musicians to record.[35] Throughout Ledbetter's life, his career was constrained by the stereotypes held by his audiences and the restrictions society placed on him.

In this scene, the product of Ledbetter's musical labor is present, but Ledbetter himself is absent. "Irene" was Ledbetter's best-known song: Jeff Place, writing for the Smithsonian Folkways collection, described "Goodnight, Irene" as "Lead Belly's theme song, sung at the beginning and end of many of his radio programs" and "undoubtedly [his] most famous song."[36] The game's credits credit him for music and lyrics, but his voice is never heard. Just as Columbia's material wealth is based on exploiting Black labor and rendering it invisible, so too is much of Columbia's musical wealth. In *BI*, Ledbetter's music has been filtered through white mouths and voices as the crowd prepares for their violent pastime. His erasure in Columbia stands as a literalization of Columbia's whitewashing nostalgia—except here, instead of erasing anti-Black racism, the crowd erases a Black musician in order to claim this music as their own. That it is Blackness, not racism, that is the uncomfortable reality that needs to be excised in order to create a nostalgic, perfected version of itself is emphasized by the presence of blackface caricatures in the same scene. In Columbia, blackface is acceptable, while Black people are not.

[34] Many songs and genres recorded first by Black artists only became commercially successful when recorded and released by white singers. For example, "Hound Dog" is well known as an Elvis Presley hit, but before Elvis sang it, it was recorded and released by "Big Mama" Thornton. Rap and hip hop are modern incarnations of this process, as white rappers gain accolades and cash with genres pioneered by Black musicians. This is not limited to popular music, either. See Ewell, "Music Theory and the White Racial Frame" for a thoughtful analysis of racism in the discipline of music theory and Flannery, "Whose Music Theory?" for an overview of the backlash against Ewell's plenary address.

[35] Biographical information taken from Place, "Life and Legacy of Lead Belly," 20–21.

[36] Place, "Life and Legacy of Lead Belly," 30.

Case study 2: "Old Time Religion"

In contrast to how Black musician's music is commandeered by a crowd in Columbia, former plantation owner and CSA veteran Polk Miller's deliberately nostalgic music is preserved in racist Columbian institutions. Three of his 1909 recordings are heard at important locations within Columbia: the lighthouse that leads to the city, the headquarters of the "Fraternal Order of the Raven," and the city's museum. The first appearance of Polk Miller's music is the first diegetic song encountered in the game. "Old Time Religion" is played in a lighthouse, before Booker enters Columbia. The lighthouse contains a rocket ship to the city. This setting conflates Columbia with Eden and reminds the player that contradicting this idealized comparison will provoke violence. As Booker climbs the lighthouse, he encounters cross-stitched banners that read "FROM SODOM SHALL I LEAD THEE," "TO THINE OWN LAND I SHALL TAKE THEE," and "IN NEW EDEN SOIL SHALL I PLANT THEE" juxtaposed with dead bodies and bloody messages. After the rocket takes off, Booker passes through stormy clouds and suddenly emerges in the sunlit flying city while a recorded voice inside the rocket chants "Hallelujah." The music prefacing the player's ascension into Columbia attempts to induce nostalgia in those who enter the lighthouse by priming pilgrims to see Columbia's religion as an ongoing tradition rather than a new cult. "Old Time Religion" is also the first in-game example of white appropriation of Black music. A contemporaneous advertisement for the record reads, "This hymn is of negro origin, but owing to the fact that its words and melody stir the popular heart, the southern whites have introduced it into their church services."[37] The earliest written sources for the song were published in 1872, under the title "This Old Time Religion" in a collection of works sung by the Fisk Jubilee Singers.[38] The song was introduced to white Southern congregations by Charlie D. Tillman, who copyrighted it in 1891, but, as the Traditional Ballad Index page for the song points out, "this claim is obviously bogus."[39] Thus its use in the beginning of *BI* again erases Black musicians in order to create an idealized past, deliberately linking Columbia's theocracy to a nostalgic representation of "old time religion."

The second appearance of Polk's Miller's music, the horrifically racist song "The Watermelon Party," plays in the headquarters of the Fraternal Order of the Raven. *BI* situates this song in a similarly racist atmosphere. Booker encounters it when infiltrating the headquarters of The Fraternal Order of the Raven,

[37] *The Edison Phonograph Monthly*, 19.

[38] Seward and White Cravath, *Jubilee Songs*, 41.

[39] "That Old Time Religion," The Traditional Ballad Index.

a caricature of the Ku Klux Klan. Their building is riddled with iconography that announces how Colombia wishes to rewrite the past and racially purify the present, just like the Ku Klux Klan. Its courtyard features a statue depicting Colombia's leader fighting a hydra with three racially caricatured heads: an African face with a bone in its nose, a Jewish face with curled hair and a hooked nose, and an Asian face with a reed hat and slits for eyes. Inside resides a cult that seeks to rewrite the history of the Civil War, depicting Abraham Lincoln and the Union Army as a legion of demons and replacing Robert E. Lee with an angelic George Washington at the head of the Confederate Army. Booker finds a gramophone playing "The Watermelon Party" next to a heroic statue of John Wilkes Booth under a banner emblazoning "Sic Semper Tyrannis," the phrase Booth shouted after assassinating Lincoln.

"The Watermelon Party" symbolically fits this environment. It was a "coon song" composed by James L. Stamper, a Black member of the Quartette,[40] and as Miller added the Quartette to his show no earlier than 1899, the song antedates the game's events by no more than thirteen or fourteen years. The "coon song" was a genre of comic song that was popular between roughly 1890 and 1920, named after the "Zip Coon" caricature popularized by minstrel shows. One of the distinguishing characteristics of the genre was the use of stereotypical dialect and the inclusion of other demeaning stereotypes. The track in the game begins with the second instance of the refrain and continues to the end of the song. I have included a transcription of one verse below:

> Now to sing another verse
> Indeed we haven't got de time
> Oh, you darkies, won't you come along with me
> Why, don't you heard em bells a-ringin'?
> Dey are calling me to dine
> Oh, you darkies, won't you come along with me
> Now dey got all dem watermelons
> And cut in pieces of three
> And I'm savin' all de sweetest
> And de biggest pieces for me
> And if I stay away much longer den I
> Can't get in de line
> An' nothin' will be left for me
> But watermelon rind

[40] Brooks, *Lost Sounds*, 224.

As these lyrics demonstrate, "The Watermelon Party" plays on the stereotype of Black people as lazy and gluttonous. It achieves this with its emphasis on watermelons, a food commonly used in anti-Black racist artwork.[41] Brooks notes, "It is notable [...] given Miller's racist message, how restrained most of his material was in terms of overtly burlesquing blacks,"[42] but with its use of dialect and language like "darkies," "The Watermelon Party" was one of the few but important exceptions, and this uncomfortable excerpt is the tamer half of the work (the first two verses, omitted in *BioShock*, include the word "nigger"). Although Mark Twain declared "The Watermelon Party" to be a "musical earthquake,"[43] a historically literate modern listener would likely recognize the racist content of the text. Its unique history is significant to *BI*'s larger thematic commentary on idealizing nostalgia, specifically nostalgia for the antebellum South: it is an exemplar of a contemporaneous popular song genre based on racist stereotypes, composed by a Black musician, hailed by one of America's most beloved literary voices, and performed by a former Confederate soldier and an ensemble of free Black men.

Case study 4: "The Bonnie Blue Flag"

The third appearance of Polk Miller's music occurs in a Columbian museum that memorializes the city's racism. The "Hall of Heroes" level takes place in a museum that enshrines institutionalized racism. This section of the game reveals that Colombia's racism ranges beyond anti-Black prejudice to dehumanizing Native Americans and Chinese people by glorifying military actions against them. Here, the player interacts with twisted dioramas of the Wounded Knee Massacre and the suppression of the Boxer Rebellion that twist these events into celebrations of violence against indigenous and Chinese peoples. The museum's memorial to Lady Comstock also evokes the traditional personification of the South as a delicate, virtuous white woman that must be protected by white male patriots.[44] For the modern player, the Confederacy, the Massacre at Wounded Knee, and the Boxer Rebellion are likely distant history. Accordingly, this virtual space impresses upon the player that they have entered a hostile culture that openly advocates for slavery and white supremacy in its nostalgic re-writing of history.

Polk Miller's "The Bonnie Blue Flag" is heard outside the Hall of Heroes. Note that the game is set roughly 50 years after Lincoln issued the Emancipation Proclamation.

41 Woods, "Talking Race Over a Slice of Watermelon."

42 Brooks, *Lost Sounds*, 224.

43 Seroff, "Polk Miller," 37.

44 Loewen, *Lies My Teacher Told Me*, 159.

Accordingly, the player encountering this aural artifact of a Confederate veteran singing the CSA's anthem directly reveals that the object of Columbia's idealizing nostalgia is the antebellum South. The song chronicles the secession, state by state, of the eleven states that left the Union:

> We are a band of brothers,
> Native of the soil,
> Fighting for the property
> We gained by honest toil
> When first our rights were threaten'd
> And a cry rose near and far
> We raised on high the Bonnie Blue Flag, that bears a single star.

"The Bonnie Blue Flag," "sung with enthusiasm by Miller, accompanied by his own loudly strummed banjo,"[45] primes Columbian visitors to view the museum's contents through a lens of restorative nostalgia and romanticized Neo-Confederate revisionism. Hearing this song in the Hall of Heroes inclines players to reframe ugly visual imagery of the nineteenth-century military action as a patriotic defense of American culture. Again, *BI* juxtaposes the rosy nostalgia for the Lost Cause heard in Miller's voice with the racist reality of what that time was. With the Hall of Heroes' official sanction, the song destroys the illusion of distance between the nostalgia for an idealized past and the nostalgia for naked racism.

Case study 5: "Shiny Happy People"

While blackface imagery is evident from virtually the beginning of *BI*, the sound of minstrelsy is harder to track down in the game. In particular, Al Jolson, the son of a cantor turned the famous face of minstrelsy (as seen in Figure 11.1), is conspicuously absent from the game's soundtrack. But although his actual voice is never heard in game, there are connections to him in *BI*. Others sing for Jolson: a performance of his song "Little Pal" on the organ is heard multiple times, and several songs he performed or is credited as writing are included. Yet it is not until Booker and Elizabeth journey to the Comstock house that anything aurally resembling Joplin is heard by the player. There, players hear Tony Babino, singing in imitation of Jolson's vocal style, a song that Jolson (who died in 1950) could not have: R.E.M.'s "Shiny Happy People" (1991).

[45] Brooks, *Lost Sounds*, 224.

To explain, *BI* includes "Goodnight, Irene" and Polk Miller's music in relatively unaltered formats, as this music was historically produced in periods analogous to the game's setting. However, *BI* also features "covers" of contemporary music, reimagined to aurally fit into the 1910s. R.E.M.'s "Shiny Happy People" is one such cover. The diegetic explanation for these adaptations is that a game character, Albert Fink, has exploited an inter-dimensional tear to great commercial success. Through this portal, Fink listened to real-world music and then re-wrote it into a contemporaneous musical style. Appearing in the game an astounding seventy-nine years early, "Shiny Happy People" is Fink's most recently released song. It is the most anachronistic of all his covers and symbolically punctuates the game's puzzling narrative about dimensional portals, verb tenses and quantum physics. The original song's ambiguously cynical tone conflicts with Colombia's aggressively positive official face. Many listeners have interpreted the original "Shiny Happy People" as a critique of how autocratic states control the masses with an idealized image of peaceful co-existence. Yet its Columbia "cover" retools this message to reflect Columbia's unshakeable belief in its own superiority over the unenlightened people below: Native Americans, Chinese citizens, and, of course, African Americans.

The game's "Shiny Happy People" cover, arranged by Scott Bradlee, brings the song in line with Columbia's temporal setting. The text of "Shiny Happy People" is straightforward, requiring relatively little structural revision to turn it into something appropriate to 1912. The existing structure of the song lends itself easily to a cover in the style of an early (approximately 1900–20) Tin Pan Alley song, a genre that focuses on the refrain and usually includes two verses. R.E.M.'s original lyrics fit into this structure easily. Twelve of the twenty-four sung lines are simply "Shiny happy people holding hands," two more are "shiny happy people laughing," leaving just ten sung lines to say something. At face value, these lyrics are bubbly and optimistic. These shiny happy people are presumably the white, affluent residents of Columbia. The major addition is the spoken section before the final chorus:

> There was a time when people didn't laugh at us
> Now all that glitters is gold
> And every cloud has a silver lining
> Hey! Here we go!

This interpolation is a direct nod to Al Jolson and his performance of "Mammy" at the climax of *The Jazz Singer*, which featured Jolson speaking several lines of text before concluding the song. Here, Bradlee's allusion to the racist work makes a modern song appropriate to the *BI* setting that idealizes racist institutions. Throughout his performance of "Shiny Happy People," Babino further supports this connection by imitating Jolson's brash but heartfelt signature

sound. Jolson sang with the gusto of a pre-amplification performer unabashedly tugging on heartstrings. As W.T. Lhamon, Jr., put it, "Jolson seldom grades a gesture or hints at nuance in a word. His thoughts are sudden eruptions."[46] Yet while Jolson grapples with taking on the mask of blackface throughout *The Jazz Singer*, Columbia's performer accepts it, exhorting anyone struggling in Columbia to do the same—"there's no time to cry," after all. But while Babino's surface tone might match the city's public face, the song's satirical original reveals Columbia's rotten, racist, and exploitative nature. In adding references to blackface minstrelsy to a song that had none, *BI* demonstrates that racism is an inseparable part of its representation of American society. The nostalgia for Columbia's impossibly beautiful boulevards is also an idealizing nostalgia that erases the exploitation of Columbia's slums. In a virtual society nostalgic for slavery, minstrelsy is the logical result.

Conclusion

No matter how many times revisionist histories claim that the Civil War was just about states' rights, the fact remains that the primary right in question was the right to own humans as chattel slaves. No matter how many tourists want to visit plantations and admire the buildings and grounds, the fact remains that these are sites of stolen labor and lives. No matter how many times Black musicians are erased from the history of American popular music, the facts remain that Black musicians were essential to the creation of quintessentially American genres and that one of the most popular forms of music for nearly a century was the racist performance practice known as minstrelsy. And no matter how many people may want to believe that America is a post-racial society, the fact remains that American culture, including American music, still has an enormous problem with racism.[47]

The overt racism that has been forgotten and therefore rendered invisible in the "real world" can be encountered in Columbia, exposing the player to stories and perspectives they might never encounter in their day-to-day life. By doing so via the interactive medium of videogames, *BI* takes away the possibility of distancing oneself from the scene depicted. I grew up relatively sheltered from overt racism, and when I studied the Civil War in high school, I comforted myself with the fact that Ohio did not secede—we were the good guys! But the reality was that the homogenous makeup of Mt. Vernon (95.3% white, per the 2010 Census) meant

[46] Lhamon, *Raising Cain*, 103.

[47] See Morris, "Why Is Everyone Always Stealing Black Music?"

that there were few opportunities for overtly racist incidents. Instead, as the Dan Emmett Festival shows, racist legacies and structures are minimized by idealizing nostalgia and continue unnoticed. The interactive world of *BI* strips away the fog of idealizing nostalgia that conceals exploitation in the real world, illuminating past and present racism for the player.

LUDOGRAPHY

BioShock. 2K Boston and 2K Australia. Xbox 360 and Microsoft Windows. 2K Games, 2007.

BioShock Infinite. Irrational Games. Playstation 3, Xbox 360, and Microsoft Windows. 2K Games, 2013.

BIBLIOGRAPHY

Baudouin, Richard, ed. *Ku Klux Klan: A History of Racism and Violence*. 6th ed. Montgomery: Southern Poverty Law Center, 2011.

Berkeley, Busby, dir. *Babes in Arms*. Starring Mickey Rooney and Judy Garland. 1939. Burbank: Warner Archive Collection, 2018. DVD.

Boym, Svetlana. *The Future of Nostalgia*. New York: Basic Books, 2001.

Brooks, Tim. *Lost Sounds: Blacks and the Birth of the Recording Industry, 1890–1919*. Urbana: University of Illinois Press, 2004.

Dessem, Matthew. "Just How Many Recent Shows Featured Blackface, Anyway?" *Slate*, June 30, 2020. https://slate.com/culture/2020/06/blackface-tv-episodes-30-rock-scrubs-community-snl.html.

Durbin, Beth. "Dan Emmett Memorial Re-dedicated." *Mount Vernon News*, May 15, 2006. https://web.archive.org/web/20070929094306/http://www.mountvernonnews.com/local/06/05/15/dan.emmett.html.

The Edison Phonograph Monthly. "Special Record List." January 1910.

Ewell, Philip A. "Music Theory and the White Racial Frame." *Music Theory Online* 26, no. 2 (September 2020). https://doi.org/10.30535/mto.26.2.4.

Flaherty, Colleen. "Whose Music Theory?" *Inside Higher Ed*, August 7, 2020. https://www.insidehighered.com/news/2020/08/07/music-theory-journal-criticized-symposium-supposed-white-supremacist-theorist.

Gibbons, William. *Unlimited Replays: Video Games and Classical Music*. Oxford: Oxford University Press, 2018.

Goldman, Herbert G. *Jolson: The Legend Comes to Life*. New York: Oxford University Press, 1988.

Goldstein, Dana. "Two States. Eight Textbooks. Two American Stories." *New York Times*, January 12, 2020. https://nyti.ms/2QJK7zq.

Grove Music Online, s.v. "Emmett [Emmit], Dan(iel Decatur)." By Robert Stevenson. Accessed December 12, 2019. https://doi.org/10.1093/gmo/9781561592630.article.08773.

Grove Music Online, s.v. "Minstrelsy, American." By Clayton W. Henderson. Accessed January 14, 2020. https://doi.org/10.1093/gmo/9781561592630.article.18749.

Hamilton, Kirk. "*BioShock Infinite* Is Insanely, Ridiculously Violent. It's a Real Shame." *Kotaku*, April 4, 2013. https://kotaku.com/bioshock-infinite-is-insanely-ridiculously-violent-it-470524003.

Hughes, Franklin. "The African Dodger – October 2012." Jim Crow Museum of Racist Memorabilia, October 2012. https://www.ferris.edu/HTMLS/news/jimcrow/question/2012/october.htm.

Lahti, Evan. "Interview: Ken Levine on American history, racism in BioShock Infinite: 'I've always believed that gamers were underestimated'." *PC Gamer*, December 13, 2012. https://www.pcgamer.com/bioshock-infinite-interview-ken-levine-racism-history/.

Lhamon, W. T., Jr. *Raising Cain: Blackface Performance from Jim Crow to Hip Hop*. Cambridge: Harvard University Press, 1998.

Loewen, James. *Lies across America: What Our Historic Sites Get Wrong*. New York: The New Press, 1999.

Loewen, James. *Lies My Teacher Told Me*. 2nd ed. New York: The New Press, 2007.

Lott, Eric. *Love and Theft: Blackface Minstrelsy and the American Working Class*. Rev. ed. New York: Oxford University Press, 2013.

McLaughlin, Rus. "BioShock Infinite's Extreme Violence Is Completely Valid." Venture Beat, April 10, 2013. https://venturebeat.com/2013/04/10/bioshock-infinites-extreme-violence-is-completely-valid/view-all/.

Mooney, Katherine C. *Race Horse Men: How Slavery and Freedom Were Made at the Racetrack*. Cambridge: Harvard University Press, 2014.

Morris, Wesley. "Why Is Everyone Always Stealing Black Music?" The 1619 Project. *The New York Times Magazine*, August 14, 2019. https://www.nytimes.com/interactive/2019/08/14/magazine/music-black-culture-appropriation.html.

Pascoe, Peggy. *What Comes Naturally: Miscegenation Law and the Making of Race in America*. New York: Oxford University Press, 2009.

Perrotta, Anthony. "'Bioshock' and the Philosophy of Ayn Rand." *Entropy*, July 7, 2017. https://entropymag.org/bioshock-and-the-philosophy-of-ayn-rand/.

Pilgrim, David. "The Brute Caricature." Jim Crow Museum of Racist Memorabilia. Updated 2012. https://www.ferris.edu/jimcrow/brute/.

Pilgrim, David. "The Mammy Caricature." Jim Crow Museum of Racist Memorabilia. Updated 2012. https://www.ferris.edu/HTMLS/news/jimcrow/mammies/homepage.htm.

Pilgrim, David. "The Picaninny Caricature." Jim Crow Museum of Racist Memorabilia. Updated 2012. https://www.ferris.edu/HTMLS/news/jimcrow/antiblack/picaninny/homepage.htm.

Pilgrim, David. "The Tom Caricature." Jim Crow Museum of Racist Memorabilia. Updated 2012. https://www.ferris.edu/HTMLS/news/jimcrow/tom/homepage.htm.

Place, Jeff. "The Life and Legacy of Lead Belly." In *Lead Belly*, 16–28. Washington, DC: Smithsonian Folkways Recordings, 2015.

Plante, Chris. "Opinion: Violence limits BioShock Infinite's Audience—My Wife Included." *Polygon*, April 2, 2013. https://www.polygon.com/2013/4/2/4174344/opinion-why-my-wife-wont-play-bioshock-infinite.

Robertson, John. "Why *Bioshock* Still Has, and Always Will Have, Something To Say." *Ars Technica*, August 10, 2016. https://arstechnica.com/gaming/2016/08/bioshock-objectivism-philosophy-analysis/.

Rogin, Michael. *Blackface, White Noise: Jewish Immigrants in the Hollywood Melting Pot.* Berkeley: University of California Press, 1996.

Sacks, Howard L., and Judith Rose Sacks. *Way Up North in Dixie: A Black Family's Claim to the Confederate Anthem.* Urbana: University of Illinois Press, 2003.

Santelli, Robert. "Lead Belly: A Man of Contradiction and Complexity." In *Lead Belly*, 11–15. Washington, DC: Smithsonian Folkways Recordings, 2015.

Seroff, Doug. "Polk Miller and the Old South Quartette." *78 Quarterly* 1, no. 3 (1988): 27–41.

Seward, Theodore F., and George L. White Cravath, eds. *Jubilee Songs: As Sung by the Jubilee Singers, of Fisk University, under the Auspices of the American Missionary Association.* New York: Bigelow and Main, 1872.

"That Old Time Religion." *The Traditional Ballad Index.* Accessed May 28, 2017. http://www.fresnostate.edu/folklore/ballads/R628.html.

Townsend, Carly. "Dan Emmett Festival Renamed after Public Poll." *The Kenyon Collegian*, February 20, 2020. https://kenyoncollegian.com/news/2020/02/dan-emmett-festival-renamed-after-public-poll/.

Twitty, Michael W. "Dear Disgruntled White Plantation Visitors, Sit Down." *Afroculinaria*, August 9, 2019. https://afroculinaria.com/2019/08/09/dear-disgruntled-white-plantation-visitors-sit-down/.

Woods, Keith. "Talking Race Over a Slice of Watermelon." *Poynter.* July 28, 2003. https://www.poynter.org/reporting-editing/2003/talking-race-over-a-slice-of-watermelon/.

Contributors

CAN AKSOY is a professor of English at Los Angeles City College, where he teaches English literature and writing courses. His interests include writing instruction and pedagogy, American postmodern literature, financial culture, materialist esthetics, risk theory, and videogames. Can completed his PhD at the University of California, Santa Barbara. At the time of publication, he has been in academic for 13 years and a gamer and game music enthusiast for 30 years.

* * * * *

SEBASTIAN DIAZ-GASCA is an audio engineer, music producer, and lecturer in music industry at the School of Media and Communications at RMIT University. His research ranges from ludomusicology, musical narratology, videogame studies, music production, ethnomusicology, and Latin American social studies. Sebastian's ludomusicological research focuses on the relationships between audiences and videogame music, and the personal, social, and economic forces that surround these relationships. His current research examines the role of artificial intelligence in emerging musical narratives within interactive environments.

* * * * *

BRENT FERGUSON (PhD in music theory, University of Kansas, 2020) is assistant professor at the College of Southern Maryland. He teaches classical guitar, music theory, and general education courses in popular music and music in global cultures. His research interest is primarily in music for multimedia. Brent is also a videogame composer with his first Nintendo Switch release, *Mystiqa: Trials of Time*, currently in production.

* * * * *

ELIZABETH HUNT is currently studying for the completion of her PhD at the University of Liverpool. Her thesis, working title "A New Synchresis?: The

Recontextualisation of Music from Audiovisual Media in Live Performance," brings together research on the orchestral concert performance of music from film, television and videogames. With a keen interest in ludomusicology, Hunt has discussed the topic of videogame music concerts at several conferences across the United Kingdom and is passionate about the study of media music in general.

* * * * *

JESSICA KIZZIRE earned her PhD in musicology from the University of Iowa and studies music in popular media, including film and videogames. Her research has included explorations of the intersection between videogame music and player nostalgia in *Final Fantasy IX*, as well as her most recent research exploring the interrelation of multiple villains' themes across several games in the *Final Fantasy* franchise. Jessica also studies the role of music in multimedia adaptations, and she is currently working on her first book, which analyzes the narrative implications of musical adaptations of Lewis Carroll's *Alice's Adventures in Wonderland*.

* * * * *

T. J. LAWS-NICOLA is a disabled music scholar with a focus on music in animation. Their most recent work was an organalogical corpus study on the use of pipe organ in Japanese animation. Their current project focuses on studying the music accompanying animated women antagonists as represented in serialized multimedia from the United States. TJ was awarded the Bernadette Gray-Little Doctoral Fellowship for the University of Kansas in 2020.

* * * * *

ALEC NUNES is a PhD candidate at the University of California, Santa Cruz. He is currently engaged in ethnographic research for his dissertation. His research investigates the practice and revival of Japanese folk music in California and its entanglements with Japanese American identity, whiteness, and masculinity. His other research interests include videogame music nostalgia and the reception of Japanese videogame composers in the West. In addition to research and musicking, his other interests include tabletop RPGs, board games, videogames, bouldering, and spending time with his cat, Molly.

SARAH POZDERAC-CHENEVEY is a ludomusicologist specializing in pre-existing music. She earned her PhD in musicology from the University of Cincinnati College-Conservatory of Music with a dissertation analyzing the narrative function of pre-existing music in *BioShock Infinite* as well as the *Legend of Zelda*, *Assassin's Creed*, *Metal Gear Solid*, and *Persona* series. She has presented her research at the *North American Conference on Video Game Music, Music and the Moving Image*, and GameSoundCon. She currently lives in Akron, Ohio, with her husband, Ben, and daughters, Amelia (who loves *Pokémon*) and Naomi (a production baby!).

VINCENT E. RONE (PhD in musicology, UC Santa Barbara, 2014) currently teaches music at Franciscan University of Steubenville and directs liturgical music at Archangel Gabriel Parish in Pittsburgh, where he lives with his wife Susan and daughter Laurelin. Vincent studies how music can suggest the otherworldly, examined in religious protests of 1960s Catholic France and in the music of *The Lord of the Rings* and *The Legend of Zelda* franchises. In addition to having co-edited and written for the Routledge anthology, *Mythopoeic Narrative in The Legend of Zelda*, Vincent's work has appeared in the *Journal of Musicological Research*, *Journal of Music and the Moving Image*, and *Journal of Sound and Music in Games*.

JUSTIN SEXTRO is a PhD candidate in musicology at the University of Kansas. He holds degrees from the University of Missouri, Kansas City (MM in vocal performance and musicology) and Truman State University (BM in Vocal Performance). Sextro has an active interest in multimedia music and his thesis examined the narrative functions of 16-bit videogame music during the 1990s. He has presented his work at the Society for American Music and the North American Video Game Conference. He is currently working on his dissertation, which examines female barbershop quartets and choruses in the Kansas City area.

MICHAEL VITALINO is associate professor of music theory at the Crane School of Music (SUNY Potsdam). His specializations include nineteenthcentury art

249

song, Franz Liszt, Schenkerian analysis, music cognition, and choral conducting. He also engages with disability scholarship and its application to music theory and aural skills pedagogy. Michael has presented research on Liszt's song revisions at several regional, national, and international conferences. His archival research engendered the release of *Forgotten Liszt* (MS1538), a CD of previously unrecorded Liszt songs. His publications have appeared in *Indiana Theory Review* and *Notes*.

* * * * *

JONATHAN WAXMAN holds a PhD in historical musicology from New York University and is on the music history faculty at New York University, Hofstra University, and Five Towns College. His research interests include early twentieth-century American concert life, the works of composer Karel Reiner, and film and videogame music. He has recently published an article in the journal *Popular Music History*, which examined the influence of Ives's music on the film scores and concert works of Bernard Herrmann and is working on a manuscript on the history of the American concert program note.

* * * * *

REBA A. WISSNER is assistant professor of musicology at Columbus State University. She received her MFA and PhD in musicology from Brandeis University and her BA in music and Italian from Hunter College of the City University of New York. She is the author of three books, *A Dimension of Sound: Music in The Twilight Zone* (2013), *We Will Control All That You Hear: The Outer Limits and the Aural Imagination* (2016), and *Music and the Atomic Bomb on American Television, 1950–1969*.

Index

Page numbers in italics indicate black and white figures. Page numbers in bold indicate tables.

CPSIA information can be obtained
at www.ICGtesting.com
Printed in the USA
JSHW020251200422
24853JS00002B/127

9 781789 385519